ONLINE GAME INTERACTIVITY THEORY

ONLINE GAME INTERACTIVITY THEORY

Markus Friedl

CHARLES RIVER MEDIA, INC.
Hingham, Massachusetts

Publisher: Jenifer Niles
Production: Publishers' Design and Production Services, Inc.
Cover Design: The Printed Image

CHARLES RIVER MEDIA, INC.
20 Downer Avenue, Suite 3
Hingham, Massachusetts 02043
781-740-0400
781-740-8816 (FAX)
info@charlesriver.com
www.charlesriver.com

This book is printed on acid-free paper.

Markus Friedl. *Online Game Interactivity Theory.*
ISBN: 1-58450-215-0

Library of Congress Cataloging-in-Publication Data

Friedl, Markus.
 Online game interactivity theory / Markus Friedl.— 1st ed.
 p. cm.
 ISBN 1-58450-215-0
 1. Computer games—Design. 2. Computer games—Programming.
3. Interactive computer systems. I. Title.
 QA76.76.C672 F76 2002
 793.93'24'019—dc21
 2002011560

Printed in the United States of America
02 7 6 5 4 3 2 First Edition

To my grandfather, who has given me love and support
in both good times and bad.

CONTENTS

ACKNOWLEDGMENTS

First, I would like to thank my family, especially my mother and brother, for all their patience and support while I worked on this book.

Thanks also to all of my friends who did a lot to make me the kind of person I am today—more or less unintentionally. Thank you all very much!

A big "thank you" goes to Charles River Media for giving me the opportunity to put my thoughts on paper; especially for their faith and belief in a somewhat distinct project done by someone new to the authoring field, someone who has mainly an academic background and is not a native English speaker. It was a pleasure to work with Jenifer Niles and Jennifer Blaney who always promptly answered my many questions and provided significant assistance. Thanks also to Kelly Robinson for providing valuable feedback to my drafts, to Sherry Stinson of *The Printed Image* for her assistance in working on the cover, and to my co-worker Kirsten Kennedy for assisting me on language issues.

Next, I would like to thank the following people for their help in making this book what it is by contributing screenshots and demos or by answering my bizarre interview questions: Scott Wellwood, Andrew Edelsten, Kevin G. Clark, Johann Lotter, Dina MacDougall, Karen Cooper, Marie Delagrange, Jim Goldfinger, Brian Schneider, Kenneth Trueman, Martin Lavoie, Rémi Arnaud, Jesse Casman, Andrew Beatty, Kelly Enstrom, Laurent Abecassis, Barry Silverman, Matt Firor and Mythic Entertainment, Lionhead Studios, Frank Rogan, Compaq Computer Corporation, Greg Roelofs, Brian McGrath, Mark Watkins, Kiva Korsak, David Anderson, Matias Myllyrinne and Remedy, Lisa Tensfeldt, LucasArts, Mark Rein and Epic Megagames, Lisa Bucek, Susan Wooley, Beau Yarbrough and Blizzard, Warren Spector, Harvey Smith and Ion Storm, Jenny Shaheen, Farzad Varahramyan and Oddworld Inhabitants, Eric Ng, Genevieve Ostergard, David Devor, Scott Lynch and Valve, Amy Bruckman, Jason Elliot, Joshua Berman, Hillary Crowley, Cathy Campos, Maryanne Lataif, Per Magne

LØvlie, John Mattocks, Judith Donath, Colleen Capodilupo, Steven J Kleinvehn, Karen Green, Ben Jones, Marty Stratton and ID Software, Steve Weiss and Sony Online Entertainment, Chris Crawford, Gordon Walton, Richard Bartle, Kelly Asay, Rick Simmons, Warren Spector, Kevin McCann, Tommy Strand, Graeme Devine, and last but not least, Ernest Adams.

Thank you very much! It has been a pleasure!

These words would definitely not be complete without expressing my deepest thanks to those who significantly shaped my personality and professional career: my former head of university, Dietmar Treichel; Hannes Seifert and Niki Laber from neo Software; Brandon Gillam from Maximum Charisma Studios; David Michael from Samu Games; and Lin Shen from Papaya Studios. Thank you for strengthening and believing in my personal and professional skills!

Last but not least, thanks to all those people whose passion is developing the next generation of the fascinating and complex medium we call "computer games." Thank you for dedicating your energy and enthusiasm to push this industry another level higher with each project! It is wonderful to be a part of such a community!

INTRODUCTION

Multiplayer online games have received much attention in the last few years, both within the computer game industry and among the public. Computer games are in high demand, and with the increased popularity of online games, the market continues to soar. Online, or network-based, games are not a new concept; they are almost as "old" as computer games in general. Online games came into existence in conjunction with networks. Access to networked systems in the early stages was limited mainly to university networks, so students were the first to experiment with network games. The most commonly known traditional network game system is the MUD (Multi User Dungeon) or one of its derivations such as MUSH (Multi User Shared Hallucination), MOO (Mud Object Oriented), and MUSE (Multi User Simulated Environment). All of these systems were early versions of networked games and are the conceptual and technical foundation of many of today's games.

However, it was the Internet with its decentralized network, reasonably fast and easy communication protocols, and broad availability at affordable prices that really brought online games to the masses.

Computer games have always been one of the applications to use and push technical revolutions. Games can quickly push existing technologies to their limits, helping to generate new research and solutions to the limitations of computer technology (e.g., memory, speed, and graphics). However, no hardware accelerated 3D graphics and no force-feedback mechanism can compare to the impact the notion of online gaming will have on the understanding of computer games as a unique form of entertainment and communication media. Every media's unique nature and characteristics dictate specific rules and techniques to its designers. Computer game designers will also need to revamp their design repertoire with new methods and paradigms that account for the radical changes that online games mean for the computer player.

The computer gaming market has quickly become a multibillion-dollar industry. Those who play computer games, however, still tend to be

hardcore gamers and enthusiasts. Games have yet to reach the "masses" to the same degree as business applications or Web browsers have. Unlike movie directors or television producers, who have to produce entertainment that appeals to huge audiences, game designers still primarily have a very specialized, predictable audience. Online games, however, provide the opportunity for designing games as mass media. These games might be in the form of a simple browser-based *Flash* game or massive multiplayer online game such as *Ultima Online, Everquest, or Dark Age of Camelot*. Although these games are still primarily a source of entertainment and enjoyment, they are played by people around the world, from various cultures, age groups, and social milieus. Today's online games can be thought of as a unique combination of communication and entertainment. These changes in the nature of games result in new challenges for online game designers.

Designers can certainly use the lessons learned from developing single-player games as they design multiplayer online games; however, the experiences often need to be applied in different ways and with additional aspects in mind. Game designers need to design effective communication between themselves and a single player, and from player to player—a process that is much less predictable and controllable. They need to re-vamp their design toolbox, question their proven techniques, and think of alternative (yet revolutionary) ways to create immersive, interactive online experiences for players. How do we design immersive online experiences? What makes communication in online games effective and appropriate? What has to change during the design and development stages, and how do we test the success and functionality of our designs?

WHAT THIS BOOK IS ABOUT

Online Game Interactivity Theory is about online game design—its concepts, techniques, and tools. It is not a complete description of how to program a massively multiplayer game from scratch, nor is it meant to be a programming reference. What *Online Game Interactivity Theory* does is guide you through the process of creating multiplayer online games. It presents ideas of successful and unsuccessful online game design and what criteria you can use to differentiate a strong design from a weak one.

Each chapter outlines the various stages in the design process for multiplayer online games. We begin with what you should consider in a project's

planning phases, and move to a detailed review of the various design issues and techniques (some more obvious than others) needed during the actual implementation stages.

Part One of this book covers the points you need to clarify with you and your team before starting an online game project. These chapters provide a discussion of the importance of thoroughly understanding online game media and its unique characteristics. To put multiplayer online games in perspective there is also a brief discussion of online game history, the main differences between single-player games and online games, and the various categories of online games and how they affect design.

As the title of the book implies, the focus is on interactivity. Suggestions for defining interactivity and integrating it into online games are detailed. The definition of interactivity is based on three different types of interaction: player-to-computer, player-to-player, and player-to-game.

With interactivity conceptualized, Part Two shows possible ways to apply interactivity to your online game designs and introduces techniques for "designing" it into your games. By unfolding the key factors of each of the three types of interactivity, you will gain insight into the influence a game's "interactiveness" can have on its potential for success, and what you can do to improve it.

The book then discusses in detail various design issues that are different or exclusive to the design of multiplayer games. We provide guidelines and suggestions for those factors that need to be obeyed in online game design, ranging from community design to the unique importance and aspects of a player's avatar.

Part Three briefly discusses some valuable tools and strategies that will help improve a designer's workflow. We conclude the study of interactivity with interviews with some of the most influential and well-known people in the computer game industry. These interviews provide insight into industry experts' thoughts on online games, the unique features of online game design, and various interpretations of interactivity.

How to Use These Ideas

All this might sound like a lot of theory with little practical application; however, all of the ideas and concepts are illustrated with examples wherever possible. Additionally, you will find various case studies to demonstrate them in practice.

What might initially seem like "boring academia" is, in actuality, what makes *Online Game Interactivity Theory* different from books usually found on a game designer's shelf. It treats game design in a way that most people would intrinsically not associate with the subject of games—scientifically. As such, this book should build a bridge between academic, scientific analysis, theory and research, and the practical reality.

We have a lot to do, so let's get started.

FORETHOUGHT AND PLANNING

Welcome to Part One of *Online Game Interactivity Theory*. We begin by examining the path through the design of multiplayer online games. The next few chapters cover that vital yet frequently underrated part of the design process essential to a gratifying design concept: a thorough analysis and preplanning.

Developing online games is more than just taking a core idea and turning it into a holistic, homogenous entity. It's also about developing a set of analytical tools and a solid repertoire of mental, cognitive notions; understanding online game designs in their entirety, how all their elements are orchestrated and relate to each other; and knowing the characteristics of this unique, revolutionary media. Similar to programmers, designers also need to fully understand the problem to solve, analyze its requirements, and break it down into smaller, manageable tasks prior to starting with an actual implementation or solution. You should tap each available information source and creativity stimulus to get this significant knowledge background and fundament for your designs. Having said that, let's see what we have to offer.

LEARNING AND INSPIRATION

IN THIS CHAPTER

- History of Multiplayer Online Games
- The Market Today

What is needed and usually done in the early stages of the design process is to study what other approaches are currently on the market, and how the market can be expected to present itself in the future. Other designers' methodologies should certainly not be a copy resource for your own concepts; however, game design is a practice of mutual conversation, evaluation, and inducement. Thoroughly examining other designs helps prevent flooding the online game market with almost identical game experiences, and provides reciprocal inspiration and allows designers to learn from the strengths and weaknesses of others.

A designer's toolbox is often already filled with much knowledge and personal experience from developing single-player games. The online game media, together with its unique characteristics and aspects, is, however, mainly unexplored territory for most game designers. Therefore, learning the specialties of online games and entirely understanding what defines their uniqueness as entertainment media first requires a solid understanding of their history.

HISTORY OF MULTIPLAYER ONLINE GAMES

Why should you worry about the history of online games if you are striving to design the next generation of online game universes based on the current and future capabilities of computer networks and development tools? Of course, you should always push the game industry to its next level from both a technical and design point of view. However, as in any art and science, a clear understanding of what and who defined and shaped past technology can have meaningful implications on your future creations. Such a discussion provides insights of methods and techniques that proved to work or fail and can offer you a significantly fresh or changed perspective about the nature of the media you are designing. Therefore, let's start our road map of major events and milestones in the history of online games and their designs, and find a place for you to hook in and set the next landmarks.

Contrary to public opinion, the idea of online games is as "old" as their stationary, single-player counterparts. Not surprisingly, it is assumed that multiplayer online games are directly linked with the Internet. It is commonly believed that the possibility of playing computer games over a network was simply not noticed until the Internet exploded and offered the general public access to global computer networks. Presumably it was only under such conditions that it became relevant for developers and publishers to add multiplayer functionality to their games and advertise these features as an enticing reason to purchase their products. The development of the Internet has allowed online games to reach the level of "mass media"; however, the world of online gaming reaches far back to a time when the idea of computers connected within a worldwide network was just a vision.

1969 THROUGH 1979

The network system that will be the starting point of our tour through online game history was a service called PLATO (Programmed Logic for Automatic Teaching Operations), introduced in 1961 at the University of Illinois. The system was continuously improved, and by about 1972 was capable of hosting 1000 simultaneous users. Originally meant as a time-sharing system for exploring new ways of computer-based education, PLATO was "misused" as a gaming platform by Rick Blomme in 1969.

Blomme wrote the first "true" multiplayer game that worked on a remote network: a two-player version of MIT's famous *Spacewar*. Originally, *Spacewar* (Figures 1.1 and 1.2) was realized in 1962 by Stephen Russell,

FIGURE 1.1 Two-player *Spacewar* on DEC's PDP-1 (Programmed Data Processor 1). © Compaq Computer Corporation 2002. Reprinted with permission from Compaq Computer Corporation.

Peter Samson, Dan Edwards, and Martin Graetz at MIT on a mainframe computer, a PDP-1. Rick Blomme's version for PLATO, however, is generally known to mark the advent of network gaming. From then on, several multiplayer games regularly appeared on the PLATO service. In 1972, a game for up to 32 players, *Empire* (a *Star Trek*-based space empire game

FIGURE 1.2 Java version of original *Spacewar*[1].

[1]http://agents.www.media.mit.edu/groups/el/projects/spacewar

environment), was introduced that players joined in the form of a spaceship every time they logged on and formed teams to share resources of planets and armies.

One year later, PLATO introduced a flight-simulation game called *Airfight* and *Talk-O-Matic*, which was essentially the conceptual origin of today's Internet chat rooms. This is particularly noteworthy, as it was the first context in which people "socially" interacted and played with each other with the opportunity to mimic a virtual personality. In *Talk-O-Matic*, users could freely define how they preferred to be represented within the virtual community—what name, age, or gender.

1974 saw the birth of the first games (most notably *Avatar* and *Oubliette*, basically inspired by *Dungeons & Dragons*), of which Dave Arneson and Gary Gygax had started to sell the written rule-sets a year before. *Avatar* is commonly known as the genesis of the early *Wizardry* series, and *Oubliette* might have been the first game on PLATO to offer a line-drawn 3D view of the dungeons and group-oriented play. To provide a vague impression of gameplay experience and interface design in those days, it is worth mentioning that, for example, casting spells was done by typing their names as quickly as possible.

One of the most significant milestones in the history of multiplayer online games was set in 1978 by Roy Trubshaw and Richard Bartle at Essex University, UK. They completed the first working version of MUD1, a multiplayer game system running on a PDP-10 that later was referred to as *Multi User Dungeon* (MUD).

1980 THROUGH 1985

The final version of the original MUD system was installed in 1980 on the Essex network, which is considered the very origin of its multiple derivations. With MUDs, students from all over the world were able to share these environments, as Essex became part of ARPANet, a worldwide computer network of academic institutions and widely accepted as the basis of the Internet as we know it today. Despite the fact that the MUD code was initially copyrighted, it was (more or less accepted by its authors) shared among students and distributed around the world. Based on the original core concept, people began to implement their own unique online environments using their ideas and imaginations. This led to a variety of modifications. The capability to share these new environments with a broad audience again led to further conceptual variations, and the process began to snowball. People

who had played MUD-based games created entirely new systems and code concepts, some of which focused on a social aspect rather than on gaming. For the sake of totality, the acronyms of the most common concepts you will regularly run across include MOO (MUD, Object-Oriented), MUSH (Multi-User Shared Hallucination), MUCK (Multi User C Kernel), MUSE (Multi-User Simulated Environment), and MAGE (Multi-Actor Gaming Environment). These acronyms only describe new MUD-based programming technologies that had different goals in mind.

Internet access was slowly becoming available to a wider range of the population in the early 1980s. The very first Internet service provider (ISP), CompuServe, realized the potential financial profits from allowing people to play computer games over a public network. In 1982, John Taylor and Kelton Flinn, founders of Kesmai Corporation, received a contract from CompuServe to develop an ASCII-text role-playing game. The game was launched as *Islands of Kesmai* on CompuServe in 1984, one year after the release of Kesmai's *Megawars I*, which was mainly based on the design of the legendary *DECwar* (a *Star Trek*-based multiplayer game developed in the mid 1970s). Both of these Kesmai games offered to CompuServe subscribers can probably be considered the beginning of commercial on-line gaming. Playing *Islands of Kesmai* for an hour cost approximately the equivalent of a current standard monthly flat rate—about $12.

Marc Jacobs is credited with providing the first professionally run online gaming service based on a monthly rate ($40). In 1984, his company, AUSI (predecessor to Mythic Entertainment), offered a text-based role-playing game named *Aradath*.

In 1985, two other companies entered the market of online services, becoming the first serious competitors of CompuServe, to try to make a profit by offering their consumers multiplayer gaming services. An ASCII-based service similar to CompuServe, GEnie (GE Network for Information Exchange) was launched in October, 1985. Approximately one month later, the first graphics-based online service was introduced exclusively for C64 users: QuantumLink, the direct predecessor of today's America Online (AOL).

1986 THROUGH 1989

Both companies regularly added new or ported online game environments as part of their service, and seemed to understand the potential of these games as valuable consumer attractions. *Habitat*, developed by Randy Farmer and

Chip Morningstar at Lucasfilm for QuantumLink, was introduced, together with *Rabbit Jack's Casino*, the first graphic online game in the commercial online services industry. *Habitat* was one of the first, non-MUD-related online environments that received the attention of designers from a social-scientific perspective. The designers faced social phenomena unique to such environments and later distributed a collection of design guidelines concerning a player's special ways to act and behave in these virtual worlds.[2]

Also in 1986, Kesmai began their first tests with *Air Warrior* on GEnie, a flight simulator in a World War II setting that can be considered the first "real" graphics-based Massively Multiplayer Online Game (MMOG). However, GEnie's first multiplayer game was *Stellar Warrior*, a *Megawars I* clone rewritten by Kesmai for the GEnie service. The final version of *Air Warrior* was released in 1987.

The first play-by-email game on a commercial server was *Rim Worlds War*, a multiplayer space strategy game developed by industry pioneer Jessica Mulligan and launched in mid 1986.

In 1987, Simutronics Corporation was founded, which is commonly associated with the obligatory game *Gemstone*. The original text-based role-playing game was released as *Gemstone II* on GEnie in 1988 and soon became the most popular online game on GEnie. Prior to this, however, in 1987, a modified version of the original MUD1 was used for commercial purposes and launched on CompuServe under the title *British Legends*.

During the late 1980s, GEnie seemed to establish itself as the major online service for multiplayer online games and licensed a multitude of game environments, among them AUSI's *Galaxy II*, a real-time space strategy game, and Simutronic's *Orb Wars*, a team-based multiplayer combat game with a very basic graphical interface. Most interesting, however, was the launch of the first online 3D shooter in 1989, *A-Maze-ing*, a 3D maze combat game that at the time only ran on the Macintosh. Although only a few users had computer systems equipped with modems, in 1988, Electronic Arts published the first retail game, *Modem Wars*, which was explicitly designed for modem-based person-to-person play.

1990 THROUGH 1995

In 1990, GEnie began negotiating with Origin Systems about the development of an online version of their fantasy-based role-playing game *Ultima*.

[2] Morningstar, Chip, and F. Randall Farmer. "The Lessons of Lucasfilm's Habitat." *Cyberspace: First Steps*. Ed. M. Benedikt. Cambridge, MA: MIT Press, 1992.

The commercial release of what we now know as *Ultima Online* was still some years away, and players actually had to wait until 1997. Origin soon stopped cooperating with GEnie and began negotiations for the development of *Ultima Online* with QuantumLink in 1991.

Also in 1991, Ken Williams, CEO of Sierra Online, announced the Sierra Network. This network was the first installment of a dial-in gaming service privately held by a game publisher/developer and solely designed to support the company's own products.

Another major event in 1991 was the launch of LambdaMOO, a modification of the previously mentioned MOO code-base written by Pavel Curtis and hosted at Xerox PARC. This MUD-based game environment raised a few significant social issues of virtual communities and pointed out things that game designers would need to consider. In 1992, for example, LamdaMOO provided the first virtual environment that attempted to establish a democratic governmental structure run only by the players and without any external administrative influence. In 1993, the LambdaMOO community faced a phenomenon nobody really imagined to be possible: violence, sexual harassment, and a rape within a (text-only) virtual online environment—the "Mr. Bungle affair"—leading to Julian Dibbell's legendary article "A Rape in Cyberspace." For the first time in the history of multiplayer online environments, this incident raised fundamental questions for the accountability of a virtual persona's actions and concerns about virtual laws, justice, and a notion of a person's rights in a virtual world.

The year 1993 was extremely important in the history of multiplayer online games from another perspective as well. A few simultaneous incidents provided the necessary infrastructure to make multiplayer gaming available to more than just highly sophisticated wealthy computer game enthusiasts.

First, ARPANet was becoming increasingly available to a wider audience and was becoming known by the public as the Internet. Access to its most important technology and service, the World Wide Web, was, however, still complicated and only text based until the invention of a graphical interface named Mosaic at NCSA. Figure 1.3 is a screenshot of one of Mosaic's first versions, marking the end of text-only network communication and the beginning of what became the code-base for the first version of *Netscape Navigator*. Netscape Navigator revolutionized the possibility of making a worldwide computer network available to the general public.

The increasing popularity of the Internet and its attraction to a broader audience had a predictable and inevitable result. The three major online

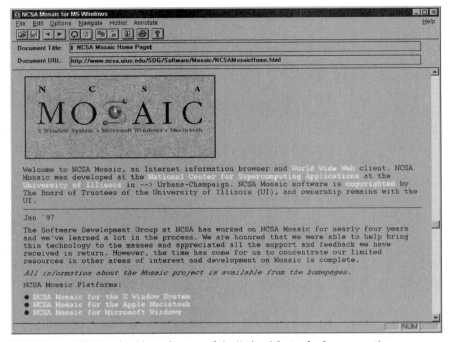

FIGURE 1.3 *NCSA Mosaic*0.6 beta. Courtesy of the National Center for Supercomputing Applications (NCSA) and the Board of Trustees at the University of Illinois.

services—Prodigy, Genie, and AOL (now QuantumLink's official new name)—entered a price war in competing for the lion's share of this tremendous subscriber potential. Prices for playing games on AOL and GEnie, like *CyberStrike* or *Shadow of Yserbius*, dropped to an average rate of $3 per hour.

The computer game developers identified the trend and began to add modem- and LAN-play functionality to their games that allowed two, or occasionally four, players to share a single game environment. In particular, ID Software's *Doom*, released in December 1993, significantly shaped the computer gaming market—both from a technical and conceptual perspective. *Doom* and its successor *Doom II* that followed in October 1994 offered the opportunity for up to four players to connect over a LAN and battle each other within a single map.

ID's "real" attempt to establish multiplayer online gaming as a common computer game activity was, however, the start of developing and openly

testing *Quake*, which featured built-in Internet-play capability. Their decision to test the approach in an open process that allowed players to easily host their own game sessions unfolded into one of the most substantial new approaches for the future. The demand for games supporting Internet-based play seemed to explode. Finally, two phenomena united: the fascination of easily, efficiently, and affordably communicating with people from all over the world, and the intrinsic human need to play together (or compete with each other).

1996 TO THE PRESENT

What *Doom, Doom II*, and *Quake* did was in fact create an entirely new section of the computer game market. For the first time, players were playing CD-ROM, retail products over networks.

After *Quake* was finally released in 1996, its popularity of being played over the Internet almost forced computer game developers to equip their products with some Net-play functionality. Developers of CD-ROM games realized that multiplayer features were significant additional attractions to consumers. Built-in Internet-based multiplayer capability became a requirement rather than an option, and according to the common trend, mostly first-person shooters and real-time strategy games hit the market at this time.

As the number of multiplayer games supporting Internet play grew, new online gaming business models emerged. Aggregation services that supported a number of online games and offered player-matching services for finding prospective game hosts in the haystack of the Internet began to pop up everywhere. Most notable were TEN (Total Entertainment Network), that later became Pogo (now part of the EA network), and MPlayer—both of which launched in 1996. Soon, however, most CD-ROM game developers and publishers entered the aggregation service market. After realizing that these companies added little value to their titles, they began to build their own proprietary sites and technologies that provided player-matching functionality, independent of any third-party service. This was when Blizzard launched *Battle.net*, which proved to be particularly successful and showed that aggregators were not essential for generating traffic and enhancing retail sales.

Today, most of these aggregators are either out of business or are syndicated with totally different purposes that span a much broader spectrum of online gaming services. The most notable is *GameSpy*, which offers

player-matching of retail products, proprietary titles, and free classic games. In addition, major game publishers such as Microsoft (*MS Gaming Zone*), Electronic Arts, and Sony Online Entertainment (*The Station*) run their own sites today to retain and attract attention to their respective titles.

The second trend, occurring simultaneously with revising initial single-player designs for Net-play, was the idea of the graphical MUD and was probably the beginning of the unique online game genre referred to as *MMORPG* (Massively Multiplayer Online Role Playing Games). In 1996, the 3DO Company launched *Meridian 59,* designed by Mike Sellers and programmed by Chris and Andrew Kirmse. This was the first commercial 3D graphical MUD and, although not a major hit, initiated some hype for the idea of persistent virtual worlds and online-only computer games.

A year later, in 1997, Origin's *Ultima Online* finally launched commercially, and despite initial significant bug and lag problems, hit the 50,000-subscriber mark within the first three months. However, it was not designed as a persistent state world. In addition, the release of Blizzard's *Diablo* played a major role in making the idea of multiplayer role-playing popular within the game community.

As already noted, multiplayer functionality was already vital for retail products to become more attractive. And so it was mainly the design and development of persistent online environments that exerted a pull on both game designers and players. Turbine Entertainment started the development of *Asheron's Call*, which was released approximately two years later in 1999 on the MS Gaming Zone. A few months earlier, however, Verant Interactive's *Everquest* (Figure 1.4) became the second star after *Ultima Online* in the newly defined MMORPG market.

Strengthened by the success of these three key players, more and more massively multiplayer world projects were regularly announced, some of which never materialized. Origin, for example, seemed to realize that their power horse *Ultima Online* was in danger of losing customers to its technologically superior competitors—particularly because of the relatively outdated graphics. While releasing a graphically improved version of *UO*, *Ultima Online: Third Dawn*, Origin also announced the development of *Ultima Online 2*, later renamed to *Ultima Online Worlds: Origin*. To everyone's astonishment, the project was suddenly cancelled in 2001. Other companies, however, pushed the idea of persistent online game worlds further in the hopes of establishing their products in today's online gaming market.

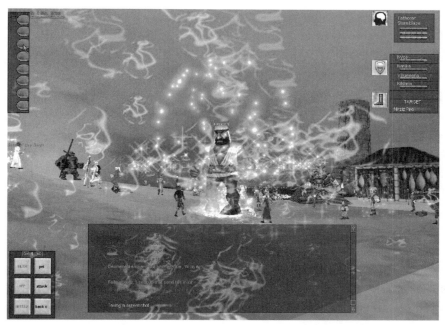

FIGURE 1.4 *Everquest*: persistent state online game environment. © 1999–2002 Sony Computer Entertainment America Inc. All rights reserved. *Everquest* is a registered trademark of SCEA Inc.

The Market Today

It is difficult to outline the online game market we face today. Perhaps the best approach is to structure it according to the two major sections: persistent online game environments and Internet gaming sites. This is not to say that large-scale persistent game worlds such as *Everquest* cannot be integrated into one of the popular Internet gaming channels—in most cases, they are. From a design point of view, however, they are "isolated universes" and undeniably different in nature from most other forms of online games. Each has its own player community and dedicated Web site, and as such is its own game channel.

Persistent Game Environments

Today's player can certainly find alternatives to *Ultima Online, Everquest,* and *Asheron's Call* , and there will be many more in the very near future.

As announced in 2000, Mythic Entertainment offers another fantasy-based large-scale persistent online world (Figures 1.5 and 1.6) named *Dark Age of Camelot*. Contrary to Funcom's *Anarchy Online*, released a few months before, it did not suffer from initial bug problems and regular server crashes when it went live. From the beginning, *Anarchy Online* has been, well, unplayable, and has thus already lost a majority of its potential subscribers. It is an appropriate example of what rules the unique nature of the persistent online game market dictate to the game developer. How many of these persistent game environments will a player pay to play simultaneously? Let's assume one or perhaps two. However, a player now has more choices in games, and if he is not totally satisfied from the beginning, he will leave (and likely never come back). Downloading and installing patches or add-ons is accepted, but only if the player has been given a reason to do so.

Most players will not simultaneously subscribe to a multitude of these persistent online worlds, not only for financial reasons, but because it re-

FIGURE 1.5 *Dark Age of Camelot*: implemented via combining past experience, continuous learning, and thorough preparation. © Mythic Entertainment 2002. Screen shot(s) reprinted with permission from Mythic Entertainment Inc.

FIGURE 1.6 Concept art from *Dark Age of Camelot*. © Mythic
Entertainment 2002. Screen shot(s) reprinted with permission from
Mythic Entertainment Inc.

quires a reasonable amount of active play time to immerse within the en-
vironment, its community, and for the game to "really make sense." This
fact actually unfolds some other significant aspects of this market. How do
we differentiate our designs from already existing ones and provide a
unique sales opportunity? Additionally, how do we capture the millions of
potential new customers expected from the growing availability of broad-
band Internet access? How do we make online gaming appeal to the
masses? Perhaps it means moving away from the traditional fantasy-based
role-playing worlds that now dominate the market.

The first games attempting to break out of the fantasy setting are already
available; for example, *World War II Online*, and *Mankind*, a large-scale

economic trading simulation. Two growing trends for differentiating new online games are to rely on existing well-known, brand games, and to explicitly focus on a game's community aspect. For example, Richard Garriott, the visionary behind *Ultima Online*, has founded *Destination Games* to launch, along with *NCSoft*, *Lineage: The Blood Pledge*, in the United States. The game, originally created in South Korea, is the largest online game environment sold on a subscription basis, with over 2 million active subscribers worldwide. Its design strongly centers on teamwork and a community-based gameplay, as does EA's *The Sims Online* that ports the already extremely popular CD-ROM single-player dollhouse game *The Sims* into a persistent online game environment. Electronic Arts offers a variety of other distinct designs while trying to bring persistent state online gaming to a broader audience. The groundbreaking *Majestic*, for example, implements a revolutionary design by blurring the line between a player's real life and game experience. Relying on a variety of different communication tools such as the telephone, e-mail, or fax systems, it attempts to make gameplay part of a player's real-life schedule. There is no immediately perceivable distinction between play time and reality. Although the player can customize when and how he wants to interact with the game world— which is a necessity from a design point of view—the game is possibly ever present and everywhere in his life; there is a totally seamless transition between game interaction and real-life experience.

A slightly different approach is *Motor City Online*, a combination of both a brand- and community-based design. While offering an arcade-style car racing simulation, players can also trade car parts to upgrade their vehicles or join one of the diverse car club communities. This design also tries to take advantage of the already widely popular *Need for Speed* brand and by licensing multiple (real-world) old-time classic cars from the major car manufacturers.

As mentioned previously, relying on eminent, established brands in computer gaming, movies, literature, or real worlds is (and will be) a promising technique to set one's design apart from the competition in the persistent online game market. Sony Online Entertainment and LucasArts do this with one of the most eagerly anticipated online games in history: *Star Wars: Galaxies*. This massively multiplayer online game, set within the time-honored *Star Wars* space universe, unites computer gamers, movie enthusiasts, and hordes of *Star Wars* fans within a single online game environment; a potential subscriber base no other game probably has realized before. However, it also presents an additional feature that is very likely to

become a common, required practice in developing persistent-state environments that rely on established concepts. The future players, mainly those who are already huge fans of the idea behind the game design, will have to play an active role during the development process. Only by listening to their comments, suggestions, and opinions will it be possible to meet the players' high expectations, and design games that do not clash with a player's beliefs of the entire concept—a scenario that Blizzard also faces in developing *World of Warcraft*, a massively multiplayer version of their very popular *Warcraft* CD-ROM game series.

GAMING SITES

Internet-based online play is no longer limited to hardcore gamers and people who do not want to spend the enormous amount of time required to become immersed in a large-scale persistent online game. However, there are other interesting opportunities that allow people to experience online game playing. Let's look at today's major gaming sites that offer a broad collection of games to fit almost any interest, skill level, or time-frame. These sites also provide an essential resource for game designers and developers who do not have the money, work force, or experience required to produce the next-generation, persistent-state game. Additionally, they are a way to bring smaller-scale games to a wide audience, and offer alternative distribution and publishing methods for a variety of game designs of any genre or scale.

Initially set up to offer player-matching services for its retail products such as the *NHL* or *FIFA* series, Electronic Art has acquired Pogo.com, and its gaming site EA.com has now grown into a service with a variety of online gaming opportunities. Although still offering matchmaking services, there are now also free puzzle- and casino-style games such as slot machines or *Roulette*, some of which even feature cash prizes. EA.com also integrates the previously mentioned premium titles *Majestic, The Sims Online, Motor City Online*, and *Earth & Beyond Online* on a monthly subscription basis, and there are other proprietary free titles covering a variety of genres (e.g., *Meteor Madness, Street Slider*, or the popular *Slingo*).

One of the best established and popular gaming channels comes from Microsoft: the *MS Gaming Zone* (*The Zone*). *The Zone*, one section of which is shown in Figure 1.7, provides player-matching functionality for Microsoft's retail products featuring Internet-based multiplayer capability, including *Age of Empires* or *MechCommander II*. There are also premium

FIGURE 1.7 Microsoft Gaming Zone. © Microsoft Corporation 2002. Screen shot(s) reprinted with permission from Microsoft Corporation.

games available for a monthly fee, most notably *Asheron's Call*, and a variety of free Web games including the obligatory puzzles, trivia, and casino games.

The third major publisher of today's computer gaming market, Sony, also has its own gaming channel: *The Station*. Sony mainly seems to trust the potential of massively multiplayer game worlds rather than free or small-scale Web games; however, they also offer a variety of brand-based titles such as *Wheel of Fortune* and *Jeopardy*. Primarily, *The Station* seems to be the news, message, and community platform for Sony's uniquely de-

signed large-scale online games: *PlanetSide* (Figure 1.8), *Sovereign, Star Wars: Galaxies,* and, of course, *Everquest.*

FIGURE 1.8 *The Station* offers both exclusive brand-based games and large-scale premium online-only multiplayer game environments such as *PlanetSide*. © 2001 Sony Online Entertainment Inc. Screen shot(s) reprinted with permission from Sony Online Entertainment Inc. PlanetSide is a trademark of Sony Online Entertainment, Inc.

There are, however, a few Internet gaming channels that are (still) independent from any of the big computer game publishers that we should discuss.

WorldWinner.com is interesting mainly because of its cash-prize game approach. Players compete against each other for cash prizes in games such as *Chess, Checkers, Solitaire,* dart simulations, and word games by paying an entry fee, placing a bet, and trying to hit the high score.

From a designer's point of view, however, three other sites are much more essential to examine: *Shockwave.com, RealArcade,* and *GameSpy.* Each offers a wide variety of online games, ranging from free, simple Web games to proprietary fee-based titles. Certainly, they cannot be directly compared to each other and differ significantly in their approach.

Shockwave.com, for example, as its name implies, is centered on games based on Macromedia's Flash and 3D Shockwave technology. Through its cooperation with Atomfilms, it is also a platform for independent film-makers, computer-generated movies, or comic series. As such, it tries to merge the artistries of computer game design with that of movie creation by showing first attempts to offer—more or less—interactive movies. Currently, however, none of the offered titles comes close to what could be called "interactive fiction."

RealArcade and *GameSpy* are conversely full-blown online gaming services. Both support player-matching for various CD-ROM retail products, and offer their exclusive online game titles, news channels, and game community features. To take full advantage of these opportunities, the player has to install a stand-alone client application locally on his system. He then uses this client as a portal to the game network and to receive the most recent game news, patches, and up-to-date lists of new games.

Both *GameSpy* (which we will examine in more detail within a slightly different context in a later chapter) and *RealArcade* are particularly outstanding examples of how the single game designer or small-scale development team can enter the online gaming market. They provide the opportunity to bring a game to the attention of their large user base, and offer the required technological infrastructure and revenue models. Additionally, they open up alternative methods to distribute and sell (multiplayer) game content to the developer. In cooperation with Into Networks, *RealArcade* allows players to play streaming, buffered games over broadband connections without initially installing software from a retail CD-ROM or downloading a large file from the Internet. This is a significant step forward and an essential supplement to the idea of online-only distribution of computer games. *RealArcade* also provides a service to rent games on a weekly or monthly basis, rather than buying the entire product.

Today, there are many fundamental ways to reach a critical mass with your games. These new delivery methods, however, reinforce the increasing importance of a traditional and widely accepted game design notion: content is king and will separate the grain from the chaff.

SUMMARY

Extensively researching past, current, and future approaches is as crucial for multiplayer game development as it is for any other product develop-

ment field. Understanding what happened in the past and what might happen in the future can help you formulate marketing strategies, identify market niches, and develop solid creative ideas for your own projects. Only through mutual inspiration and learning will we manage to avoid mistakes made in the past, and gradually (and commonly) improve the online multiplayer game media toward increasingly mature, efficient, and pleasurable experiences. Investigating these unique games in a bit more detail is not limited to only the last few years. Multiplayer games already have a long history that continues to be implemented in a variety of new approaches today. By continuing to study the past, the present, and the future, you will continue to find new ways to enrich your own game designs.

CHAPTER 2

ANTHROPOLOGY AND PLAYOLOGY

IN THIS CHAPTER

- The Human-Game Relationship
- Learning
- Mastery
- Escape
- Social Event
- Secluded Activity

Let's take a big step backward from the focused context of online games and computer games in general for just a bit and approach our problem space from the very ground. Designing online games that immerse social virtual environments and significantly set themselves apart from others in the future will require more than just decorating a simple game idea with the latest available computer technology. Especially important is a solid analytical and systematical background on the part of the designer: "real" fundamental understanding about the characteristics of the player, the media, and how they relate. This chapter starts our journey through building a solid design foundation by asking the most basic question underlying computer games: Why do people play?

THE HUMAN-GAME RELATIONSHIP

The first and foremost aspect you should examine to thoroughly understand the characteristics of the media and its user, the facets of both components that affect your designs the most, is how they relate to each other. In our case, it is a matter of analyzing what defines the relationship between the player and the media-online computer game.

The most obvious characteristic of this human-media liaison is that of media selection; that is, a person's situation-specific goals and the resulting selection of a media that he assumes will most likely satisfy his needs. At the most basic level, to look for the latest world news, for example, you can log on to an Internet news channel, buy a newspaper, turn on the TV, or ask your neighbor. Likewise, the desire to socialize makes you sign on to a chat portal or head to your favorite bar and, in case you want to play any type of game is probably the media of choice to accomplish your goals. The action (the selection of a media) depends entirely on one primary, governing plan and purpose.

However, let's stick with computer games. In the course of the game, a player forms a variety of subgoals, performs actions, solves specific puzzles, and has to cope with conflict situations. These subgoals perpetually change, interrelate, and depend on each other. However, throughout the game, they always follow a player's primary objective. Clearly, the primary objective is heavily dependent on the game, and part of a player's decision of what game and genre he favors: hitting the high score, reaching the end of the game, saving the planet from a threat, or expanding one's empire by collecting resources, building troops and buildings—whatever.

At this point, you see that a player's selection of a specific game is only part of the player-game relationship. A player opts for a game that suggests a primary objective—as dictated by the game design and the player self—which again dictates specific subgoals and action patterns to accomplish his goals. Rather than being a process of media selection, however, it is merely a decision that, among other aspects, directly relates to genre, title, or developer selection. A game's primary objective is already a subgoal in a player's problem solving; therefore, we need to go a level higher in the relation chain. Especially in online games that often do not define a clear prime game goal and feature social, multiperson interactivity, we need to understand the characteristics of the game and the highest goal a user tries to achieve through the media. Let's recap and see where we are in our ex-

amination of the player-game relationship. A person's purpose is to play, and he therefore chooses a media (computer) that is most likely to satisfy his need. He then limits his search space to a specific genre, for example, and selects a particular game that provides the context for his initial mission statement. All subsequent actions and tasks then follow this original plan and are implemented and continuously altered until the player interprets his goal and the cycle restarts. A person's purpose is to play, but why does he want to? What is his motivation behind playing games, and why do people like to play together or against each other? Moreover, how does this basic human instinct behave when transformed into virtual space? These are the questions that should be asked before analyzing why a person, whose purpose is to play, decides for or against a specific design.

The purpose to play is the initial driving force behind any player's computer gaming activities. Therefore, we should roughly examine possible reasons why to be able to appropriately design environments that allow the player to fulfill this need. Understanding the characteristics of a game in general and the player's main incentives for participating in playgrounds is critical for designing today's "multipurpose" online game environments.

What follows is a short discussion of fundamental game characteristics and possible reasons why a player would want to populate your online game world. It is strongly based on the pioneering works in this field by Chris Crawford (*The Art of Computer Game Design*) and Johan Huizinga (*Homo Ludens*, his expansion of the idea underlying a "homo sapien" [man the thinker], and a "homo faber" [man the maker] with the idea of a "man the player"). Particularly in the context of online game design and their unique characteristics, you and your designs can significantly benefit from investigating these aspects as an often eye-opening part of a solid design fundament.

Before we begin, however, let's take a quick and somewhat enlightening trip from the art of computer game design to traditional fine art. You are probably familiar with one the most famous paintings by the Flemish painter Pieter Bruegel the Elder: Children's Games (1559–1560 AD)[1]. For our purposes, this painting is noteworthy insofar as it illustrates very well how play activity was (and is) intrinsic to humankind and (unconsciously) consumes a huge portion of our daily routines. Bruegel tried to capture

[1] You can find a screenshot of the painting online at *www.khm.at/data/page2121/page2121/kinderspiele600.jpg*.

everyday people doing everyday things. The painting represents about 80 different games[2], many of which are still played today. Additionally, it is noteworthy that in the painting, play has invaded parts of the city that traditionally were reserved for adult affairs and commerce, and that those people "officially" supposed to be children actually look quite mature.

LEARNING

At its very basis, any game environment is an opportunity for the player to learn and explore aspects from a broad spectrum of different disciplines and contexts. A player has, although unconsciously in some cases, the motivation to gain knowledge of various concepts—their functionality, characteristics, and how they relate to each other. Within this context, every game environment can be seen as a simulation to some degree. The game simulates the interdependencies between various dynamic attributes and lets the player learn about these workings within the safety of the game. He can freely alter and adjust these attributes and learn the consequences of his actions and decisions. To a lesser or higher degree, a learning aspect is present in all (computer) games. Computer games, however, are increasingly explicitly used to take advantage of the potential offered through learning by doing. To combine learning with a game's fun, challenge, and engagement aspects, products are currently available that are meant to provide an instructional framework for pupils and children of all ages. Lucas Learning, for example, offers *Make-a-Hero* online, a game allowing a player to "meet" famous heroes from different cultures, places, and times. Another strategy of the company is attracting children for these learning games by basing them on the popular *Star Wars* brand (e.g., *Star Wars DruidWorks*, *Star Wars Math: Jabba's Game Galaxy*). As practically demonstrated by the game *AquaMOOSE 3D*, shown in Figure 2.1, these overt learning environments increasingly incorporate a multiplayer component in their system.

 AquaMOOSE 3D is a research project implemented by the Georgia Tech Electronic Learning Communities group, which does a lot of pioneering work in this field and is lead by well-known Amy Bruckman. Basically, the

[2] For your pleasure, here are a few of the games identified in the painting: shooting marbles, dueling on piggyback, leapfrogging, riding a hobbyhorse, drumming, making mud pies, head stands, swinging on a rail, rolling hoops, swimming, playing with dolls, blowing bubbles, dressing up, swinging, turning somersaults, cartwheels, throwing knives, playing mounted tug-of-war, and playing kick the can.

FIGURE 2.1 Learning about determination of depth and location of objects relative to one's position in 3D space via *AquaMOOSE*'s relative coordinate system visualization tool. © Georgia Institute of Technology, 2002. Screen shot(s) reprinted with permission from Georgia Institute of Technology.

game is a multiuser construction kit designed to let children create and play their own video games. As for any computer game development, the building process is elegantly pooled with learning about a variety of disciplines such as mathematics, computer science, and art. Moreover, students can share and play their mathematically oriented games together in multiplayer space and thus explore the specialties of online interaction and communication. This leads us directly to the next perspective on learning as a characteristic intrinsic to all play activity.

Computer games not only allow "subtle" learning, such as exploring historical game settings, economic strategies and workings, or mathematical or physical laws. Multiplayer online games today also supply an additional educational opportunity and purpose via their multiplayer aspect. The players can learn about the inner workings of society and what its rules are. As such, multiplayer online games are virtual social laboratories in which a player can experiment with different roles and behaviors and study the social consequences of his actions. Additionally, the social network

found in multiplayer online games is very distinct from a player's immediate real-life social environment. A networked virtual society is a fascinating mixture of different cultures, religions, historical roots, norms, and values. Thus, multiplayer online games provide the opportunity to study the characteristics of a social construct and the effects of one's individual role(s) within a society that will probably never exist in a similar form in real life.

The Turing Game (Figure 2.2) is one example of unfolding these issues very sensibly and is another project from the Georgia Institute of Technology Electronic Learning Communities research group.

This game, based on the Turing Test named after British mathematician Alan M. Turing, is a participatory collaborative learning experience and specifically addresses issues of identity online. As discussed, aspects such as gender, race, and other identity factors have significantly different meanings in online space than in the real-life physical world. *The Turing Game*

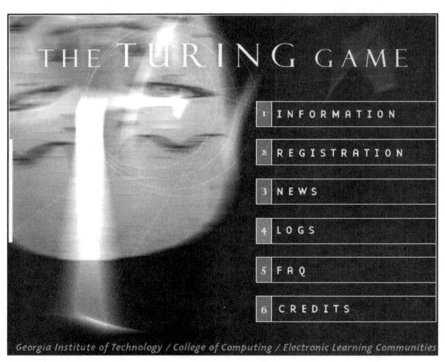

FIGURE 2.2 *The Turing Game*: Learning and understanding personal identity in online environments. © Georgia Institute of Technology, 2002. Screen shot(s) reprinted with permission from Georgia Institute of Technology.

should help both prospective citizens of online (game) communities and the designers shaping these environments to learn about, explore, and understand the phenomena of virtual identity and how it affects interpersonal online interactivity. Similar to the traditional Turing Test of whether it is possible to distinguish between an artificial and a human agent, this game's intention is (mainly) determining whether a person can differentiate between men and women without being able to see them. This is done with written responses and can be very revealing and personally relevant[3]. Briefly, the game works as follows: A panel of users all behave as if they belong to some group such as a specific gender. Each user communicates to his audience in a way that should identify him as part of that group. However, while some persons behave "normally," users who are not part of the group (i.e., not that gender) try to mask their true being and disguise themselves as members of the group. An audience of users then tries to discover who the true members are by asking questions and analyzing the panel members' written responses. Here is a sample question from a session in which people are trying to portray a woman: "What is your best beauty tip?" Jody answers: "Always, a good night's sleep!" Sam says: "Saliva on Q-tips and rub under your eyes to get rid of mascara!" Lara responds: "Less is more when it comes to wearing makeup." Jo replies: "Tricky question...I don't wear makeup . . . let's see . . . never use cream to remove hair from the face . . . only wax it, because hair grows stronger with those creams." Jacky answers: "Wash your hair with cold water, hot water strips it." In this case, only Sam and Jo are really women.

As mentioned, the primary focus of the game is on issues of gender and how to distinguish between male and female in anonymous online space. During the process, however, some sessions also reveal additional interesting factors of personal identity, such as who is an introvert or extrovert in reality, or who is pretending to be of a specific age, religion, or country.

MASTERY

Another fundamental motivational factor behind playing games is mastery and proof of control. For multiplayer online games, this aspect happens on three different levels.

[3] The Turing Game is available for free upon registration online at *www.cc.gatech.edu/elc/turing/*.

First, on a player-game basis, the player tries to prove himself as being able to master the game; he wants to demonstrate his dominance in working out the inner conflicts that arise from the rules of the game and its context.

Similarly, on a player-computer basis, the player is in conflict with a complex electronic system that he needs to master and then attempt to control throughout the entire process.

In multiplayer game environments, however, a player is no longer isolated with the game and his computer system. He is permanently observed by other players who continuously evaluate and study his abilities to master the game, the system, *and* additional problem situations that take place on a player-to-player level. Players are thus in an enduring process of demonstrating power over each other and proving their ability to survive in both the game and its accompanying social framework and mechanisms.

ESCAPE

One of the most obvious and often-stated reasons to play is a person's need and desire to escape from real-life restrictions into an imaginary world that follows its own unique rules and laws. Temporary escape into a different world that is solely constructed in one's imagination is certainly also achievable through other media such as books or movies. However, only games, and particularly computer games, let people participate within environments that directly react and change to one's roles, actions, and behaviors. By simultaneously relying on a variety of technological opportunities, computer games can present experiences and emotions that only exist in one's mind and define rules not known in real life. You know what this is about: mimicking a business tycoon and juggling billions of dollars, wandering back in time to actively take part in a major historical event, being the brave warrior in a world of elves, orks, and trolls, or learning the art of Jedi power in a distant future.

Contrary to single-player games, multiplayer online games also provide the opportunity to escape from real-world social restrictions and to overcome one's established real-life role and the accompanying expected and accepted social behavior. The trustworthy, honest, and responsible banker can pretend to be a tricky, cunning thief, and the unprepossessing, diligent student is able to represent the ruthless killer without fear of social repercussion. Murder, for example, is also possible in single-player games

without any consequences for one's real-world social position. Gender swapping has also become a common practice in multiplayer online environments. These games also offer the opportunity to assume roles that a person is unlikely to play in the real world. Escaping these social restrictions becomes a much more significant and relevant option and experience, while immediately perceiving that some computer-driven Non-Player Characters (NPCs) and one's human co-players accept or disqualify the behavior.

SOCIAL EVENT

A major driving force underlying a person's play activities is often a scenario in which the game itself plays a minor role and is only the initiator and context of a social event. The main motivational factors are socialization, communication, meeting each other, making new contacts, and discussing game- and (more often) non-game-specific topics. Multiplayer online games bring this fundamental game quality and characteristics back into the digital computer gaming world. The only difference from traditional card or board games is that players no longer have to sit around a table but can share a common virtual playground. What actually generates this fascination with games as social events? You do not necessarily require the setting of a game to socialize and meet.

A significant aspect that defines the exceptional quality of a game by means of a social experience is that contrary to "normal" life, a player can accomplish his need to be perceived not only as a person but as a personality. The player can outlive and demonstrate his individual values, thoughts, and opinions, and be sure that others thoroughly study and acknowledge his character. It is the game that assures him that he is realized as someone in existence and as a unique personality and individual. This is because the game is directly shaped by each player's personality. Everyone's values, thoughts, and the resulting actions are part of the game, and in order to succeed in the game, to react in the most appropriate way, it is thus imperative to continuously alter one's perception of each other's personality. For the game to work, it is not enough to acknowledge each player as "only" a human being as is mainly done in daily routine.

The second facet of a game's specialty as being a social event is the secrecy that surrounds a game environment. This means that as soon as players realize the specific qualities of a game, they strive to keep the game

world as something special apart from real life and try to differentiate themselves from the rest of the world. You will instantly see what that means if you examine, for example, the sometimes strict and complicated terms of admission to join a clan, guild, or team in multiplayer online games—groups that have established their unique way to play a particular game.

SECLUDED ACTIVITY

If you study more traditional forms of human play such as sport games and card and board games, you will notice a significant further play characteristic and driving motivation to partake in game environments. It is a secluded activity that differs from ordinary life, and all players know that they are only pretending as soon as they enter the game environment. Usually, playing games is a isolated activity by means of time and space. Temporary and spatial limits are necessary to distinguish the game world from its real-life counterpart. Now, how do these aspects behave in the virtual realms of (online) computer games? One of your primary goals in designing computer games is (and should be) to provide and keep the highest possible suspension of disbelief; this aspect still holds true for single-player games or games played over a small-scale network (e.g., LAN). The player will always know when and where playtime starts and ends, although he might and should carry specific game elements (imagination, newly acquired knowledge, strategic thinking, etc.) with him in his real-life routines.

For online multiplayer games, and particularly for persistent-state game environments, it is a bit more complicated to directly apply the characteristics of seclusion and limitation. The temporal context of multiplayer online games is interesting to examine. In the case of persistent-state worlds, the game continues to exist and be played by other people whose actions continuously modify and alter its state when a player decides to leave the game space and logs off. However, as with any other multiplayer online game, each player's time context and how playtime actually relates to real-world time can be totally different. Contrary to any other traditional form of game, the relationship between the game environment and the real world does not need to be the same for all players. A game's temporal framework is now an entirely subjective experience and can last from 10 hours to 10 minutes.

You cannot avoid such circumstances when designing multiplayer on-line games. However, is it still significant for multiplayer online games to keep the fundamental characteristics of play as being realizable as a se-cluded activity? Well, it should be, but the aspect probably needs to be re-vised and slightly transformed to games understood as virtual playgrounds that have an easy and instantly perceptible boundary. It is difficult to define a game's boundaries materially in nonphysical space as traditional real-life games can. However, the limits need to be perceptible in a way that a player knows at every moment where the safety of the game begins and ends. The game's limits and thus the boundaries of its protection that is vital for the player to accomplish all the previously mentioned purposes when play-ing games need to be in the form of clearly stated rules—both game and so-cial rules. Learning, for example, or proving control over game mechanics and demonstrating the ability to master the game absolutely requires a per-ceptible sphere of safety. Without this essential precondition, none of these aspects would remain such fundamental motivational factors underlying play activity. The player instantly needs to know the rules of the game and its mechanisms to be able to decide whether the safety net of its rule-set is acceptable to him. A game's rules significantly define its boundaries in vir-tual space and are a way for the player to know where the safety of the game environment begins and ends. The safety of the game allows the player to play the game as a game, as a secluded activity that differs from real life. As long as he knows where the game begins and ends, he does not need to fear potential failure or any real-life consequences. The game is a secluded ac-tivity, perceived as detached from ordinary life, and in case the player fails, he always knows that it is "only" a game.

For multiplayer online games, however, the rule-set is not only needed to provide a player a basis to evaluate the risk of failing in the game and the conflicts that are likely to arise based on these rules. Multiplayer online games are not only play environments; they are also social systems that are essentially dissimilar from a player's known, familiar, real-life comple-ments. In addition to the potential to fail in the game, a player is also con-fronted with the fear of failure in this distinctive virtual society. In real life, the player learned how to socially survive, but now he has to be afraid of being unable to survive in virtual space and handle the unique challenges of its civilization—marked by social phenomena such as imperceptible role playing, gender swapping, and mixed cultural and religious norms and val-ues. To keep a game's safety criterion, it is important to define a set of so-cial rules that supplement the initial game rules. Most likely, in the form of

a social "code of conduct," the game needs to define what is socially accepted, tolerated, or punished within the social cohabitation of players. Upon entering the game environment, the player needs to be sure that all others have accepted these regulations as well, and that a common knowledge of these policies should protect him from failure, even on a person-to-person level.

The game's rule-set—both game- and social-specific—can provide a perceptible boundary between the playground and the "outer world," thereby making play a secluded activity in a virtual environment.

SUMMARY

Designing computer games, particularly online multiplayer game environments, requires a solid analytical background that you can rely on in your designs. You must thoroughly understand the characteristics of this new media and the underlying purposes and goals of the player. This chapter provided a rough outline of potential driving forces behind the most fundamental of player's aspirations: the need to play. Examining such elemental aspects can unfold essential demands that your designs have to meet in order to satisfy a player's desires.

PERSPECTIVE AND UNDERSTANDING

IN THIS CHAPTER

- Understanding Online Games and Online Game Design
- Specialties of Multiplayer Online Games

We now continue to assemble the required solid design fundament from which you will continuously draw in later development stages. In this chapter, however, we merely focus on the media of choice, multiplayer online games, rather than on the human side of things and the player. Your designs require a detailed understanding of all the game's characteristics and of the main differences between multiplayer games and their single-player-only counterparts. You need to get your own, personal perspective on the nature of the games you are creating and build up your individual "theory and paradigm of online games" that guides you (and the team) throughout the entire development process. This chapter should provide the initial basis.

UNDERSTANDING ONLINE GAMES AND ONLINE GAME DESIGN

Computer game design is often claimed to be an art and science. What does "art" mean? At its most fundamental, art of any form is communica-

tion within the constraints of some medium. An artist or designer attempts to send a specific message to his audience in more or less subconscious ways. However, it is significant to realize that the medium not only delineates a particular framework of available methods and techniques for the designer; it also shapes the nature of the message and the way it is (and can be) received. Multiplayer online games are an entirely new medium with unique characteristics, specialties, qualities, and way of shaping the nature of a designer's messages. As any other (new) media, these game environments need to be understood and designed as such. We should stop judging them by standards for other media, such as movies or books, and principles stemming from designing more traditional single-player games.

What makes the media multiplayer online games unique, revolutionary, and new? An almost legendary notion is that online games, and mostly persistent huge-scale online-only game environments, are a service. The days of putting a game on the market, releasing two or three patches, and then being done are gone for the online game developer. It is the aspect of player-to-player communication—not present in any comparable form in more traditional computer games—that makes designing multiplayer games unique. The opportunity for players to interact with each other within the game environment transforms you from merely a game designer to a communication designer. You now have to design and provide interpersonal interaction that is symmetrical in approach, rather than merely designing the game—an asymmetrical communication between you and the player. You are the mediator, shaping a platform for player-to-player interactivity that is mostly out of your direct influence and control.

Supplementing the idea of game design as a multilateral discipline, multiplayer online games unfold additional aspects that further oblige you to incorporate new disciplines into your designs. There are now novel technical issues to consider, such as server architecture, security, or technical limitations caused by the nature of computer networks (most prominently latency and bandwidth). You also have to give your design repertoire a facelift by integrating and/or prioritizing less technical disciplines that mainly result from player-to-player interactivity. More than ever before in computer game design, the ability to rely on knowledge from disciplines such as sociology, cultural science, pedagogic or hypertext theory heavily affects the experienced quality of your designs. Likewise, the increasing value of such sophisticated studies in game design can further facilitate building a bridge between academia and the computer gaming industry.

Another fundamental quality of computer games seen as an entertainment media is that they provide a process of deconstruction rather than solely interpretation. Contrary to movies, for example, the player is trying to understand an entire system, continuously uncovers its functionality, and endeavors to grasp how the entities of the system relate and interact to build a holistic entity. For online multiplayer games, the player faces the challenge of analyzing complex game mechanisms, and playing the game expands to deconstructing the player community. To succeed in the game, he has to understand the multifaceted social system that accompanies the game; the inner workings of a virtual community that follows rules and principles not known in his real social life.

Within such a system and a game environment in which other human people play an important part of a player's game experience, each player has the power to alter the way in which others perceive the world around them. The game world is shared by multiple people and directly reacts to a player's actions, modifications, and alterations. By changing the state of a common virtual environment, the player can indirectly interact and communicate with all other people who reside in this game world. This form of player-to-object-to-player communication can be performed in any multiplayer online environment simultaneously shared by multiple players and thus, is also possible in session-based games as, for example, most first-person shooters or real-time strategy games. However, it is particularly meaningful in large-scale persistent online game worlds such as *DAoC* or *Star Wars: Galaxies*, in which alteration of the game world's state can mean a profound type of communication over the long term. This example clarifies an aspect of multiplayer online games that you should always bear in mind: online games have the potential to influence a player's common and familiar communication habits and patterns and the way in which he uses all sorts of media in his daily routine and for what purpose. Multiplayer online games have the potential to reach far into a player's real life as no single-player game could before.

It is beyond the scope of this book to discuss each potential branch of how active and regular participation in multiplayer online game environments could affect a player's real life. However, these aspects further dispel the thought of media computer games as some time-wasting activity for fanatic children and teens. Online games mean a huge additional step toward a common understanding of computer games as mature and serious media. Designing these games increasingly involves assuming a bigger portion of responsibility, while playing them more and more follows

additional purposes and needs and the underlying game self becomes a secondary motivation. Players of all ages, nationalities, and milieus will populate these virtual worlds for various distinct reasons that can significantly impact their own life or those of other players—communication, socialization, education, self-actualization, or financial profit, to name just a few. If you examine, for example, players trading their game avatars or items for "real," hard cash on e-Bay, you'll see what additional responsibility you, the designer of these environments, need to be aware of in your designs.

More than ever, there's the need for a solid framework against which games can be seriously critiqued rather than only reviewed—as is the case for any widely accepted art form. A mature medium requires a continuous and mutual declaration of design patterns and guidelines in which all affected parties can be actively involved—developers and publishers, players, and independent social organizations. Consider your new discernment of multiplayer online games and your individual experiences as another contribution to a common attempt to develop a general design language for this revolutionary type of media.

Specialties of Multiplayer Online Games

The last section gave you a somewhat new picture of the media you are designing and the need to consider the resulting additional responsibilities throughout the entire development process. However, part of thoroughly understanding the characteristics of multiplayer online games is an examination of how these games primarily differ from their single-player-only complements. Thus, let's briefly outline the main variances between multiplayer game environments and the more traditional game worlds you have probably mainly designed before—from a game designer's point of view. Some of the following aspects will vary from game to game and depend on its type, scale, and underlying technology. Arguably, the most significant issue is how you define "multiplayer" and "online"; whether your design is an online-only persistent-state environment, a small-scale online-only round-based game, or whether you implement multiplayer online capability as an additional feature for an initially single-player offline application. However, most of them hold true for each scenario and, as already noted, no matter how you interpret "multiplayer online," designing such a phrase into a game always requires scrutinizing standards and experiences that stem from distinct single-player designs.

MUTUAL DESIGN

Not only in the online game industry has it become an increasingly common practice to integrate one's potential future customers into the design process and rely on the players' comments, suggestions, and feedback throughout the development. For multiplayer online games, however, mutual design is a requirement, not an option. Each player is an active part of the game world and heavily affects other players' game experience. As with any other game element—buildings, items, landscapes, or NPCs—the player is a component of the medium and therefore needs to be involved in a game's design as much as possible.

It is not enough to react to the player's commentaries after the initial release and the game has gone live by "only" correcting some software bugs and releasing a patch. Although essential, this should only be a means of continuous improvement and appropriate reaction to insights gained from studying a player's behaviors and action patterns. Moreover, a player's role should be similar to that of any member of the design team—actively involved from the very beginning and needing to be heard. Only then will the game environment meet a player's expectations and satisfy his needs over the long term. Mutual design obviously also needs the appropriate conceptual, organizational, and technical infrastructure, but is already proved to work in practice as most notably demonstrated by the team behind Sony's *Star Wars: Galaxies*.

Slightly more interesting in this context, though, is the fact that the game's development team regularly organized online developer chat events held throughout the project's production phase.

Here are some of the questions that Raphael Koster, the project's creative director, and lead system designer, Anthony Castoro, answered during one such special event that took place on February 12, 2002:

- Can you tell us a bit more about how resources work?
- Will a character that chooses a crafting profession be able to advance in his craft without having to rely on the "kill/loot" method common with most MMORPGs?
- Will there be a limit on the number of NPC guards, pets, vehicles, or houses you can own?
- About the Bounty Hunter system: will the bounty know that a price has been put on his or her head?
- What types of regulations will there be to moderate what we manufacture?

No Zero-Sum Games

Contrary to traditional real-life multiplayer games (e.g., Tic-Tac-Toe or board games), most multiplayer online (virtual) environments are no zero-sum games (clearly, only if they are not simple one-to-one versions of their classical predecessors). A player's actions that result in some advantage for him do not necessarily mean the exact same amount of drawback for his "opponents." Even if each player always plays rationally and solely to his own advantage, the game is a "happy living together" spiced with periods of cooperation and direct competition the longer it is actively played and online. This aspect is particularly noteworthy for those large-scale persistent game worlds that often combine some type of resource- or character-skill management with a sophisticated economic system (as seen in most of the popular MMORPGs).

No Pause Keys

As soon a player enters a multiplayer environment, the opportunity to stop the game for a few moments and continue later disappears. From a design point of view, this has two consequences. First, for games not retaining a player's actual state for future continuation in case he leaves the game, you have to consider the amount of time you expect your target audience to have available. How long does one game session last? Does it make sense for the player to participate in a single session only, or does he need to play multiple short sessions consecutively for the game to work? This also brings up the second aspect to bear in mind. Short-session-based games actually force all players to take a break at the end of a session, and thus do a great job in regard to play pacing. The breaks provide a chance to reevaluate what has happened and to form alternative strategies for the next rounds. However, probably most essential for multiplayer online games is that they offer an opportunity to socialize and communicate with other players in a more relaxed atmosphere. For games involving longer-lasting sessions or even persistent-state online environments, appropriately pacing the game by such means is a bit more difficult to do. Here, one way would be by providing specific zones that all feature a particular action pattern and satisfy a specific need of the player. However, it is crucial not to handicap one activity over the other; for example, no player will ever want to socialize while others are happily collecting more points in the meantime. Therefore, to respect the rules of pacing (intense periods should follow slow ones), forcing all players to stop for a moment simultaneously is still

an option, although "enforcing" is usually a bad design practice. The time-out needs to be game relevant for the player and experienced as such (perhaps an alternative field of use for so-called interactive cut scenes and a reason to revise their underlying design concept?).

NO LOCALIZATION

The fundamental nature of multiplayer online games is that they are played over the Internet—a worldwide computer network. Therefore, even if you deliver a retail client and do not rely on alternative distribution and business models, there is no "real" way to localize your game for a national market. A retail-client model allows you to work around basic in-game language implications and can additionally feature real-time translation for player-to-player communication. Multiplayer online games, however, are (and should be) virtual environments shared by players of various cultures, religions, nations, milieus, values, and norms. Especially for multiplayer online-only games, you need to ensure easy and efficient communication between players with these distinct backgrounds. You also have to guarantee that the game world presents exactly the same information to each player. And while language is only part of the problem, you increasingly need to care about this aspect when it comes to metaphors, symbolism, NPC behavior, or color codes to avoid misinterpretation. All players might also want to be informed about potential complications in their communications and about extra responsibilities on their side resulting from this community setup. They might be encouraged to gain essential knowledge about each other's values and cultural environment and incorporate it into their behavior and decision making.

DIFFERENT TYPES OF COMMANDS

We already discussed how players could indirectly communicate with each other via altering the game world environment. This aspect illustrates very well how the characteristics of the command set available to a player in multiplayer online games differ from solo games. A player can issue commands that affect the game and its mechanics and can tangibly affect other players. Particularly significant is that these influences are not just limited to the context of the game, but can have substantial effects on a player's real life as well. With player-to-player interactivity being a critical aspect of their designs and gameplay, multiplayer online games are virtual environments that facilitate all types of relationships.

DIFFERENT MOTIVATIONS AND PURPOSES

In single-player-only setups, a player's main (if not the only) driving force behind playing a game comes from the game and the conflicts that arise through its mechanisms. In multiplayer games, however, his purposes and motivations leave this isolation and heavily engage to consider other players and the opportunities that multiplayer games offer as a communication tool. Similar to their real-world counterparts, the game is often more a reason to meet and socialize rather than merely a source of entertainment and enjoyment. Multiplayer games are increasingly viewed as a communication medium. As such, they unfold entirely new potential incentives on the side of the player and possible uses—education, discussion platforms, medical therapies, or social scientific virtual laboratories.

TECHNICAL LIMITATIONS

You are right; we decided to focus our examination on design aspects and leave technical distinctiveness of multiplayer online games aside. Gone are the days when game designers could let their imaginations run wild and then simply throw their complex creations to the programmers to come up with the necessary technical framework. You now need to design with technology in mind throughout the entire development process. For multiplayer online games, the most significant buzzwords influencing design considerations are *latency, bandwidth, server load,* and *connection loss*. Most large-scale online game environments, for example, implement some type of load balancing on the server side and assign the management of distinct zones in a game world to exclusive servers. Well-thought-out level design, evenly spreading potential point of interests across the entire world, and sensibly defining possible "focal paths" and respawn points can do a lot to increase available bandwidth and decrease server load. Another complication that needs to be addressed is what happens if a player accidentally, or consciously, loses connection to the host environment or the host goes offline and has to be migrated. During a session-based team tournament, for example, you need to compensate for the loss of a team member to allow finishing the current round under fair conditions (e.g., handicapping). Situations in which a player consciously logs off are often caused by a lack of time to finish the game and could thus be avoided by letting a player predict the required time and schedule his involvement beforehand. Players who bail out because they see themselves in the loser position are difficult to identify; however, if they leave an ongoing session multiple times, it is

very unlikely an accident. You might then want to think about giving them a slight warning slap or make their destructive behavior known to other players as part of their publicly accessible profile.

Round-based multiplayer games that require a minimum amount of players unfold a further aspect, in case you cannot rely on sophisticated AI to take over the role of a missing human player. You have to bridge the period of waiting for some players and keep them entertained—probably by providing some mini-game or actively facilitating socialization and communication. If not all player slots are filled after a certain time limit, you could suggest to the waiting players other sessions available to join.

SUMMARY

Multiplayer online games are a new media and therefore need to be designed as such. This requires a thorough understanding of these networked environments, their characteristics and potential uses, and the resulting additional responsibilities on your side. Try to establish your individual vision and paradigm about the nature of these games. Moreover, realize the necessity for a solid framework against which game designs can be seriously critiqued to regularly (and mutually) enhance the art of online game design. Part of a solid design basis is an initial analysis of the main differences between networked multiplayer environments and more traditional solo-only games and the resulting potential consequences on their designs.

CHAPTER 4

ANALYSIS AND CATEGORIZATION

IN THIS CHAPTER

- According to Online Integration
- According to Technology
- According to Genre
- According to Purpose of Play
- According to Business Model/Distribution Channel

The phrase "multiplayer online game" can be interpreted in distinct ways, and you can categorize your planned designs according to multiple factors. Each criterion has significant effects on the resulting design, so you should define your concepts in detail as early as possible in the development process. A conscientious categorization allows you to study your target audience, their characteristics, expectations, and purposes. Likewise, it provides an initial basis to determine a vague production schedule and unfolds demands on the underlying technical infrastructure. You should classify what "multiplayer online" means for each particular project—not only for yourself, but as part of the project's mission statement for the entire team.

This chapter suggests possible ways to categorize multiplayer online games. A design never entirely fits exactly into a single class and is usually a combination of two or more categories. The following sections present possible classifications, each of which we will examine in more detail.

ACCORDING TO ONLINE INTEGRATION

The first possible way to classify a multiplayer online game is according to the way it implements the multiplayer capability within the application. Primarily, it is a matter of whether the game is solely designed for multiplayer play or if it additionally offers single-player functionality.

OPTIONAL MULTIPLAYER

Most retail single-player games today provide the opportunity to play over some type of network—be it a small home network, a corporate LAN, or the Internet. Multiplayer network capability is, however, only an added value and optional feature that has become the norm rather than the exception due to the growing popularity of multiplayer gaming. From the ground up, these games are designed as single-player environments and thus face the challenge of unifying unique design methods of both disciplines within a single environment. Figures 4.1 and 4.2 show the main menu of two prominent games that provide Internet play capability in the

FIGURE 4.1 Online multiplayer optional in *Starcraft*. © Blizzard Entertainment, 2002. *Starcraft* screenshot courtesy of Blizzard Entertainment. Reprinted with permission.

form of an added value feature—Blizzard's *Starcraft* and Valve's *Half-Life*, respectively. For such games, a critical decision is what aspect to prioritize and to avoid adding the multiplayer feature just for the sake of doing so.

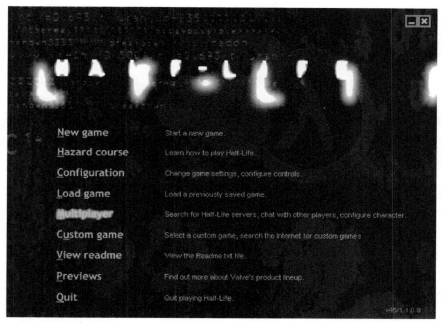

FIGURE 4.2 The original *Half-Life*.© 2002 Valve, L.L.C. Reprinted with permission from Valve, L.L.C. All rights reserved.

Some of the most popular multiplayer online games fall into this category—most notably the previously mentioned *Starcraft* and *Half-Life*, but also, for example, *Age of Empires* and *Black & White*. Each has led to the creation of exclusive multiplayer levels/maps or entire multiplayer-only modifications (most prominently *Counter-Strike*).

There is also a slight tendency to work the other way around; that is, initially designing the game as a multiplayer experience and providing solo-play functionality as an additional feature. As practically shown by *Quake III*, or the variety of downloadable bot routines for *Counter-Strike*, the game's single-player mode is primarily meant as an offline training facility for the player to improve his skills prior to entering the dangers of the virtual network realms.

MULTIPLAYER-ONLINE-ONLY/ROUND-BASED

Similar to the games of the previous group, numerous multiplayer-online-only games (MPOOG) also rely on round- or session-based game setup. This does not mean that the players have to make their moves by turn (although this might be the case), but that the game world's state is reset after a given time limit or upon a specific condition and starts from the beginning.

Contrary to the previously discussed approach, round-based MPOOG are usually not distributed as retail clients; either the player has to download and install a small client application, or the game resides only on a server and is executed from the user's Web browser. The density of these games, however, is not limited and can range from simple variations of *Chess, Backgammon, Hearts,* or *Wheel of Fortune* to very complex real-time strategy games or shooters. (Strictly speaking, *Half-Life* and *Day of Defeat* are nothing more than round-based MPOOG.)

The main characteristics of these games are that they present a (more or less) definite win-lose-draw situation and provide clear boundaries between their beginning, middle, and end. This is a significant advantage for the player, because it allows him to predict the required timeframe, and therefore guarantees that he experience his activities as a single concluded entity. However, as already introduced, a round-based approach also unfolds additional design implications that result from players leaving the game environment on a whim. Depending on your target audience, you also have to design these games from the beginning to fit the player's real-life time schedule.

Finally, we must mention that although round-based MPOOG regularly reset the world state, some of them remain the state of their players throughout multiple rounds and store player-specific statistics permanently within a database. There are also approaches in which players can specify a certain number of rounds that define a single game session (e.g., best of five, best of seven, etc.).

MULTIPLAYER-ONLINE-ONLY/PERSISTENT

There are also persistent MPOOG that solely hold one valid copy of the environment's state that is presented to all participating players and kept alive on a 24–7 basis. Usually, these games are huge-scale persistent online game worlds akin to *Ultima Online, Everquest, DAoC,* or *Asheron's Call,* but do

not necessarily need to feature full-blown graphics and sound (e.g., MUDs). They are typically designed to hold thousands of simultaneous players and therefore are widely referred to as massively multiplayer online games.

The unique nature of these environments is that they usually only present a specific framework, but in their detail are entirely shaped by the players and their decisions of what to do with the opportunities you provide them. There is no predefined plot, nor are there specific goals or overall win/lose conditions. All players can freely state their individual goals and purposes within an open-ended, probably everlasting game.

ACCORDING TO TECHNOLOGY

The previously discussed decision of the manner in which you implement multiplayer functionality into your games heavily depends on the game's underlying technology and network architecture. Each of the following approaches has its distinct advantages and disadvantages and strongly varies in complexity, involved production time, and maintenance efforts.

WEB-BASED MODEL

Web-based games are not games that use the Internet as a distribution channel, but actually execute a client application on the player's local system. They are completely online, solely reside on one server, and are accessed by only the player's Web browser. Commonly, Web games are referred to in more detail by the technology they use, all of which again significantly shape the game's design. The most common and popular development tools are HTML/CGI, DHTML, Java, Macromedia's 3D Shockwave technology (Director Shockwave Studio) and Macromedia Flash Player, WildTangent's Webdriver SDK and VRML, or a combination thereof (e.g., a client-side Macromedia Shockwave 3D content application communicates with a Java/JDBC server-database environment).

Macromedia's and WildTangent's technologies provide the necessary architecture to develop extremely sophisticated multiplayer online games. They open entirely new ways of (independent) small-team online game development, and can be valuable RAD and prototype tools for your design concepts.

PEER-TO-PEER MODEL

Most single-player games that additionally support multiplayer functionality for a limited amount of players rely on a peer-to-peer network architecture. Within this setup, each client communicates with every other participating system and broadcasts all local world-state changes to the entire network. There is no traditional server in a peer-to-peer network; one client takes over the role of an information server that responds to every request of a joining client with the required information about all currently participating players. Whereas it is the easier to implement and maintain than a client-server network, the number of simultaneous players within a single game environment is limited. Additionally, the lack of a validating central server makes cheating and hacking much easier.

CLIENT-SERVER MODEL

Contrary to a peer-to-peer architecture, within a client-server network a central server is solely responsible for keeping the environment's state and handles all communication between the connected clients. All clients solely communicate to the server to inform about a player's actions and to request the most up-to-date state of the world. It is thus easier to check the validity of a player's actions and to synchronize the environment's state throughout the client systems.

DEDICATED-SERVER MODEL

The term *dedicated server* is probably best known from popular games as a peer-to-peer architecture for networked play such as *Half-Life* or *Return to Castle Wolfenstein*. These games offer the player the option to set up his machine as a "pure" dedicated game server as an alternative to hosting a session.

The difference between a dedicated server and acting as a game server the "usual" way is that the player's computer is exclusively responsible for only handling a game's network traffic and does not process any client-side operations. On the one hand, the result is usually much better network performance because there is one machine in the network that does not have to worry about graphics, sound, or AI routines. On the other hand, it is not possible to join the game environment from the same computer that acts as the dedicated server.

Generally speaking, dedicated servers are referred to as all sorts of servers responsible for only one specific task within a game's network

architecture (e.g., login servers, database servers, or systems exclusively in charge of managing a single section/zone of a large-scale environment). Usually, however, they are used in the role of connection servers within what is essentially a peer-to-peer setup. As demonstrated by Blizzard's *Battle.net*, for example, a player initially connects to a given dedicated server that holds information of all available running host environments. A player then chooses a specific game world and is transferred to the appropriate player machine. The game then runs over a regular peer-to-peer model in which the dedicated server no longer plays a role. Dedicated servers work around the implication of having to know a host's exact IP address as required in a peer-to-peer setup, and let players choose the most appropriate environment by informing them about the map, the participating players, and latency drawbacks among them.

ACCORDING TO GENRE

You know how difficult and ambiguous it can be to assign a game concept strictly to a single genre. Games are usually a wild mixture of elements from distinct genres, and due to the lack of a common game design vocabulary, there are no established genre definitions. Let's keep this as brief as possible and focus on examining the main genre's high-level characteristics.

ACTION/ARCADE

These games rely heavily on real-time responses and are fast-paced game experiences that constantly keep a player's required focus and attention level. Their high-speed nature makes them particularly challenging to create from the perspective of network technology, as maintaining the game both synchronous and fast at still higher update rates is crucial.

STRATEGY

The strategy genre is mainly marked by the altering types of problem solving on the side of the player—planning follows execution. The length of the interval in between these phases might vary, ranging from days to zero, and most games entail a clever combination of both short- and long-term planning.

ADVENTURE

Adventures are generally a set of linear or linked puzzles the player has to solve. These challenges are frequently embedded in a unifying storyline and plot that is the most problematic aspect in implementing multiplayer capability into these games. Whereas designing a single puzzle situation requiring cooperation and organization between multiple players is less tricky, the appropriate methods, techniques, and tools to present "real" (multiplayer) interactive fiction still have to be developed.

SIMULATION

The simulation genre could be further broken up into two subcategories. Some simulations strive to simulate known real-life conditions and situations within a game environment, as flight or racing simulations do, for example. Other games try to model all types of complex concepts (real world or fictional) as homogenous entities and simulate their interrelations within an isolated, consistent, and logical game environment (e.g., environment simulations, economic models).

Most simulations implement a process of altering planning and execution phases similar to those in strategy games.

ROLE-PLAYING

Role-playing games often employ a variety of strategy elements, too, but their hallmark is their focus on long-term character skill improvement. Continuously tweaking, enhancing, and prioritizing specific skills of his character lets the player shape the avatar according to his individual preferences and intentions, and therefore define an unique character role within the virtual world.

Concluding this brief discussion of possible genre classifications, it is interesting to note that some genres initially correspond to the idea of multiplayer gaming better than others do—as demonstrated by today's online gaming market. Real-time strategy games or first-person shooters, for example, are essentially meant to be multiplayer at a conceptual level. Adventures, however, focusing primarily on puzzles and story, are not only the most difficult to adapt to multiplayer functionality, but have also been designed as solo experiences from their inception.

ACCORDING TO PURPOSE OF PLAY

As mentioned previously, multiplayer online games also serve a variety of distinct needs and purposes of the player, and can be classified according to this factor as well. Again, one design seldom belongs exclusively to only a specific category, and it is merely a matter of what its initial intention is meant to be.

IMAGINARY ENVIRONMENTS

These virtual worlds involve a process very similar to reading traditional fiction in which the player mainly builds the details of the environment in his imagination and only gets textual or vague graphical stimuli while mentally filling in the missing parts (e.g., graphics, acoustics, smells, etc.). Early text-based MUDs and e-mail games fall into this category.

LABORATORY ENVIRONMENTS

Laboratory environments mean those systems in which a player's initial purpose is not the game but mainly some form of experimentation. This can be physical, economical, or ecological simulations, but is most likely to happen at a more social level in multiplayer online games. The player experiments with himself, with distinct social roles within a virtual community and the inner workings of such complex networked societies.

GAME ENVIRONMENTS

A player's initial purpose is simply his choice of a specific game and the conflicts he expects to arise from its concept. His primary motivation is to succeed in the game and master the competitions with game mechanics or other players. Although, as we have seen, there are a variety of possible deeper conscious and unconscious intentions to play a game.

ACCORDING TO BUSINESS MODEL/DISTRIBUTION CHANNEL

Designing multiplayer online games also requires thinking about possible business models, which again affect the design of your game. The shift

from hourly fees to flat monthly subscriptions has prepared the ground for these games' breakthrough and their designs. The relation between a game's business model and its design is, however, ever present. Do you have to take a specific timeframe into account and design for perceptible end situations and clear goals? Or do you strive to keep the player immersed as long as possible within the game, supporting a revenue model based on connection time? Perhaps your screen space is limited because you have to leave room for a banner? Do you have to worry about players who remain logged on all the time even if they are not actively playing and are only eating up valuable bandwidth?

The following sections discuss today's most popular business models.

PAY CLIENT/FREE ONLINE SERVICE

The player has to buy a retail client, or is charged for a downloadable client application and then uses the game's multiplayer functionality for free on a specific online service that provides the required technical network infrastructure. The online service can be offered by the developer/publisher as shown by Blizzard's *Battle.net* or Microsoft's *Zone*. In this case, it is primarily meant to push the games' retail sales that should probably produce higher revenues. There are also third-party aggregators such as *GameSpy* to provide the required matchmaking and network services. They save the costs of building backend services, providing system operators, or implementing invaluable community tools such as chat areas or bulletin boards. Additionally, they offer an opportunity to revise the traditional retail distribution channel by attracting many potential customers who are willing to purchase a game only distributed online. However, their services are obviously not free, they hinder an immediate contact between developer and player, and mean loss of control over technology and potential significant brand awareness.

PAY CLIENT/MONTHLY FEE

Most large-scale online games rely on a model in which the player has to pay for the client application and is then, usually after a free trial month, additionally charged on a monthly basis. Today, the client is still mainly distributed over the traditional retail channel. Contrary to the previous model, however, it is not the client sales that should produce the highest income, but a player's long-term involvement, commitment, and resulting monthly subscription fee.

FLAT-FEE SUBSCRIPTION

Clearly, flat-fee subscription (on a monthly, quarterly, or yearly basis) can be used independently from also charging for the client application. Many online gaming sites offer unlimited access to their services and games for a flat fee, similar to what a player is very likely to know from his ISP. The major disadvantage of this model is that you can expect players to be online regularly and for long periods of time. You will thus have to ensure that you are able to provide the required technical framework, primarily a matter of bandwidth, load balancing, and available port connections.

ADVERTISING

Most browser games (e.g., *Shockwave*, *WildTangent*) rely on selling banner space by promising to achieve a high amount of ad impressions—either exclusively or in addition to a monthly fee as part of some premium service. Moreover, online services such as *GameSpy*, *The Zone*, or *Battle.net* try to generate additional revenue via banner sales on their lobby or news sites. As soon as games are playable in full-screen mode, however, you lose valuable (sellable) space, which leads to the idea of implementing unobtrusive in-game advertising or product placement. For some games, this might be easier and actually add realism or fun (e.g., sport games), and thus mean a relevant option. If it does not add perceptible added value to the game, however, players are very unlikely to accept such a form of advertising unless you offer the game for free.

PER-PLAY FEE

A pay-per-play model is very popular for online game shows that feature cash prizes as seen on worldwinner.com. For pure entertainment purposes, however, it is very unlikely to be accepted mainly because of the barrier to regularly submit credit card information. Relevant workarounds are letting a user charge a credit with an individual value only once from which he can then draw. Pay-per-play might become more appealing again as soon as Internet micro-payment systems are broadly established and thus help to convey an old-school arcade-like "insert coin" experience.

This model illustrates very well how a game's underlying revenue model can affect its design, and you need to consider game or session duration, for instance, as is the case in this scenario.

PER-EPISODE FEE

This model expects a player to pay for additional game content. The idea can follow an understanding similar to popular card collectibles in which the player needs to buy additional items, objects, or skills in order to advance in the game. However, it might also mainly try to take advantage of human curiosity and addiction by indicating that there would be more to come after the completion of a specific game section if only . . .

Summary

In this chapter, we discussed possible methods to categorize your designs and further establish the setting of your concepts. This process requires that you thoroughly examine your target audience and uncover promising market niches and revenue models. It also sets an inceptive design framework and exposes potential drawbacks or risks during early development phases.

CONCEPTUALIZING INTERACTIVITY

IN THIS CHAPTER

- The Importance of Interactivity
- The Interactivity Concept
- Benefits and Profits

In this chapter, we look into an idiom that the title of the book already implies: interactivity. We first unfold why interactivity is commonly claimed to be an important factor in game design. Then, we identify the reasons why a full understanding and detailed analysis of interactivity is absolutely required when we try to design it into online games. Interactivity is a difficult concept to include in online games; however, it's a requirement in online game design. As an important part of a project's planning phases, we therefore need to fully understand the concept we are trying to implement. This chapter suggests a concept of interactivity that promises more effective and accurate ways to treat its complexities in the course of designing online games.

THE IMPORTANCE OF INTERACTIVITY

Many game designers state that game design is all about interactivity, that interactivity is the actual driving force behind gameplay, and that it is the

criterion that distinguishes good games from bad games. However, as the "Holy Grail" of game design, there is not a common understanding of its definition or why it is essential.

Why is interactivity important for game design? Interactivity is a quality criterion. The term automatically provokes positive associations and feelings in media and computer games. However, rather than being a quality criterion *of* a certain media, it is much more a criterion *within* a particular media or technology. Books can be interactive and instruments can be interactive, as can television, newspapers, food, vehicles, and so forth. However, comparing each and arguing that books are less interactive than virtual reality showrooms are doesn't make sense. The media only provides the basis, and each supports totally different types of interactivity to a certain degree. This is why interactivity is so important for game design! It is the true strength of computer games in general. These games support the broadest possible range of interactivity. Within no other media can designers fall back on such a variety of techniques and tools to create and design interactivity. Possibilities range from the emotional interactivity resulting from storytelling, similar to books, to simple point-and-click activities and even conversations with computer-driven AI characters. What a wealth of potential!

Interactivity is important. However, why does this book, which focuses on the online side of computer game design, devote an entire chapter to its analysis and interpretation? Because, a game's multiplayer aspect adds yet another type of interaction and provides an additional tool and resource a designer can refer to in his designs. These games give us the chance to use interpersonal interactivity, player-to-player interactivity, in our creations. Considering that this continuous, direct connection between players is very close (but not yet similar) to real-life face-to-face interaction, which is often seen as the most effective and absolute way of interacting, you should realize what consequences this change could have. Interactivity suddenly has a meaning in game design it has never had before: the "Holy Grail" of game design, "the answer to all questions" of online game design.

Seen as a totally new media, multiplayer online games are the media offering a range of different techniques to create many types of interactivity for the designer as no other media has done before. Perhaps it's why some people love game design that much. They combine the potential that computer games have in general with a totally revolutionary opportunity and dimension: player-to-player interactivity.

Every discipline, from graphical art to music composition or psychology, has its own techniques and toolsets. Some are more experimental than

others are, but there are always established proven experiences. This is also true within computer game design. Animators have their particular techniques, as do programmers and marketers. There is both a common toolset of techniques spanning the entire discipline (e.g., IK [Inverse Kinematics] Animation), and various specialties within each subdiscipline (IK Animation has its own techniques). Each professional knows from education or experience which technique or a combination thereof leads to the desired effect. If interactivity is that important, then there needs to be a discipline called "interactivity design." This discipline is about planned, artificial, and sophisticated creation of interactivity in online games. As such, it needs an appropriate toolset and its own language, as does any other discipline. We are talking about a general design language; a general collection of techniques for interactivity design in multiplayer online games that does not exist; a language that designers can use in a discussion about interactivity in their games and those of others. At this point, we have a simple black-and-white view on interactivity. Interactivity is a quality criterion in online game design; however, it is much more a relative criterion than an absolute quality. There is no fully interactive online game, nor is there one without any interactive properties. It is a property of online game design that falls somewhere in a spectrum of gray shades. In order to identify its exact "shading percentage," and thus getting feedback if we have already reached our intentions and goals, we need to find out what determines that rank. Again, a general design language about interactivity design would obviously help. It could define the most influential factors, the variables, against which we then could evaluate our designs and gradually improve them. Is this what game designers want? It's a responsibility! Therefore, it should also be a responsibility to face the challenge and try to find out how interactivity can be designed, how it can be understood, by what factors it is influenced, and what techniques play the most essential role in its creation.

Let's take a detailed look below the surface of online game interactivity, analyze its complex system, and come up with a conceptualization.

THE INTERACTIVITY CONCEPT

The concept of online game interactivity introduced in this book differentiates between three types of interactivity as illustrated in Figure 5.1. Rather than treating interactivity as a whole, it is based on three dimensions: player-to-computer, player-to-player, and player-to-game interactivity.

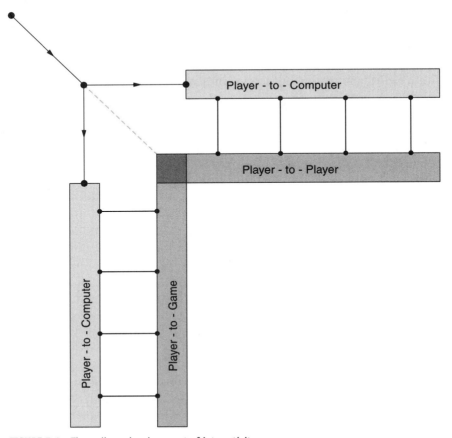

FIGURE 5.1 Three-dimensional concept of interactivity.

Player-to-computer interactivity defines the connection between a player and his computer's hardware and software. This type addresses all of the issues between the player and a game, such as a system's graphics or sound capabilities. Regarding interactivity, you could consider these issues as obstacles in the way of a direct connection between the game and the player. Figure 5.1 mirrors this interpretation by applying player-to-computer interactivity as an additional layer, a filter, to each of the other interactivity types. This filter sets boundaries and limits to what design techniques are available to the designer. There are, however, ways to impact these boundaries as a designer.

Player-to-player interactivity manifests the type of interaction within the model that is unique to the design of multiplayer online games in that form. This dimension is about all factors that play a major part in the design of functional message and information exchange from player to player. It means the creation of interactivity for which a game designer only defines a potential without having any further control over how players use the opportunities in the course of the game.

The third type, player-to-game interactivity, involves issues most closely related to traditional game design for single-player games. This dimension contributes all forms of interactivity to the concept that involve processes between the player and the media game.

Each of the three types is defined by multiple parameters or key factors. These parameters are the design techniques that the game designer can use, adjust, and alter to sharpen the big picture of interactivity in his games. These parameters (or variables) will be the tools that designers use to design interactivity. As they are defined, they will also be the foundation for a framework that defines the list of variables for each of the three types of interactivity and shows how to implement these factors in practice.

BENEFITS AND PROFITS

To conclude this section on planning and analyzing interactivity, let's summarize what advantages the introduced concept and paradigm provides to the design of multiplayer online games.

COMBINATION OF MULTIPLE DISCIPLINES

Game design is often claimed to be a multilateral discipline. Game designers must take ideas, insights, and knowledge of different studies and traditions and combine them to make successful games. They need to think about technical, psychological, cinematic, and interface issues, to name just a few, and are sometimes even bound by marketing or management. Interactivity is an issue in a wide range of different game-related disciplines as well. How it is interpreted and what is considered interactive normally depends on the field of study. Ask a programmer to define interactivity and his answer will most likely differ from the one given by an interface designer. These contradictions seem to stem from totally clashing understandings about interactivity in their respective sciences. Interactivity as

considered in computer science has nothing to do with its definition in communication and media science or social scientific traditions. Within this new model, we can try to combine all of those disciplines and viewpoints as we see fit for online game interactivity. The result would be promising: a paradigm that pays tribute to the individual nature and justifiable stances of each perspective and avoids contradictions and misunderstandings.

ALGORITHMIC APPROACH

Game design has close relationships to programming paradigms and has a lot to do with mathematics. Essentially, gameplay is a matter of processing some set inputs to a resulting set of outputs as defined by more or less complex algorithms that reflect the input/output relationship in a given situation. These algorithms primarily need to be designed by the game designer rather than the programmer. Our model illustrates this fact for the case of interactivity as well.

Suppose we know all the defining variables of each axis in the three-dimensional concept, how significant each of these factors would be for a specific design, and what defines the relationship between the player-to-computer filter and its two underlying axes—player-to-player and player-to-game, respectively. Theoretically, we could then apply some type of weight factor to each variable, giving us a mathematical value for all three axes. The two values of both player-to-player and player-to-game interactivity would represent the x and y values, respectively, within a two-dimensional grid. Finally, this would let us map an "interactivity value" to the two-dimensional "interactivity space" that is spanned by these x (player-to-player) and y (player-to-game) axes.

NEW PERSPECTIVES AND BASIS FOR FURTHER RESEARCH

A new model, built from the ground up, gives us a great chance to get totally different perspectives on the subject of interactivity. In an attempt to obtain a thorough understanding about what interactivity really means in online game design, and by what and how it can be affected, we are not bound by any historical preconceptions and assumptions. Traditional techniques and ideas are certainly useful, but are by far not the only ones. There is room again to experiment with alternative solutions. The concepts and issues discussed in this book should only be the beginning, and are meant as an initial idea upon which to build. Think about your personal

design techniques and about what you imagine could play a role in inter-activity design—no matter how silly or useless they might initially seem. Implement these ideas and try to find out their effects. As we will see later, this doesn't need to be done in the form of a huge-scale, multi-billion-dollar massively multiplayer game project. The idea is to gain your own in-dividual insights and conclusions and share them with as many other people as possible. Discuss your thoughts, reconsider and readjust your techniques. Inspire others, and be inspired by them.

No A-Posteriori Development

Mapping the complexities of multiplayer online games clarifies and visual-izes their differences to general (single-player) games. We should be aware of these games' peculiarities and special requirements in their designs. This means that we should not try to create a totally different and new type of media solely based on past experiences. All of your experiences and tech-niques are certainly relevant and you should make use of them; however, you should also consider that some of them might work differently within this new realm of online games. The discussed model can be used to re-consider your techniques and to draw conclusions from your experiences for use in the future.

Clear Boundaries

Setting a clear framework for a weakly defined term such as *interactivity* also means defining clear boundaries between what are assumptions and definite values. If game design should be considered as science, and de-signing interactivity is part of that science, it is the same scenario as with any other discipline: there are theories, and there are accepted rules or val-ues. Everyone is thus free to develop his own theories about how to design interactivity, but in order to establish values (and something like a general design language), these ideas need to be accepted by others. Acceptance re-quires discussion; but how can we discuss part of an issue without a com-mon understanding, a common ground, about the issue itself? How can we agree on particular interactivity-design techniques without knowing what makes up and influences interactivity in game design? It would be like dis-cussing English poetry without knowing the English language. The model will help establish a common interpretation of interactivity among game designers and developers to further allow a discussion of values and as-sumptions in interactivity design.

Part of General Design Language

We have already discussed some of the advantages of having a widely accepted language, or grammar and syntax of game design and its techniques, for game design as a discipline. Together with its own language, interactivity design could be part of this language. It could be an essential reference, not only in general game design but also (and much more) in online game design.

Instrument of Analysis

Carefully planning interactivity around the presented framework is similar to setting the milestones for your online game project. If we know how to think about interactivity in our games and by what it is influenced or defined, we also know what our goals during the actual development process are. Now there is a tool to evaluate whether demands on the game stated during planning have already been met. If you and your team conclude that this is not the case, you are now no longer totally lost in situations like "it's good, but something could be better if I knew what it was. . . ." This is the moment when you will briefly smile and be happy for all the detailed conceptualization you have done. You don't have to rely on wild guesses or hasty attempts to improve a game. You now have an instrument at hand to analyze your game against and identify from where the weaknesses stem. It's good if you can directly isolate and localize the source of the problem, but if not, you still have other ways to do so. By knowing what variables define your game's interactivity model, you can make small adjustments on one or even add new ones. They all influence each other to some degree, and thus a tweak or small change in one can have tremendous overall consequences. The framework is a valuable analysis tool. It allows checking the fulfillment of your goals not only after completion, but throughout the entire production cycle.

Guideline and Framework for Designers

Continuing from the issue mentioned previously, you also hopefully got the idea of using the model and list of interactivity factors as a definite guideline (or to-do list) in actual development and testing stages of your online game project. The major advantage is, again, that a big problem has been split into smaller, manageable pieces. By solving each piece in turn, you can slowly build the interactivity puzzle of your game. Moreover, if the

image you face in the end is not the one you intended, you can still take out various pieces of the puzzle again, rotate them 90 degrees, and see if they fit better. The process is similar to breaking apart a programming task into functions, classes, and libraries that finally work together to solve a problem. Maybe such an object-oriented approach is also the best way to visualize it. The (imaginary) UML class diagram in Figure 5.2 roughly reflects the previously introduced concept.

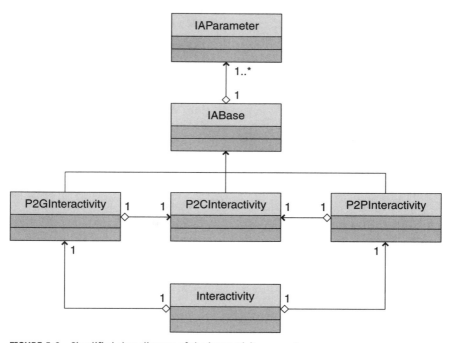

FIGURE 5.2 Simplified class diagram of the interactivity concept.

INSTRUMENT OF COMPARISON

Competition and direct comparison—be it in technology, sports, arts, or computer game creation—often leads to the best results. Understanding interactivity and its key factors is not only a tool of analysis, but can also be used to compare various online game designs (yours included). If we know the variables defining interactivity and we have a grasp of what is good or bad, we can think about what is better or worse. No longer do we need to

compare games as a whole. Similar to what we already do with graphics or sound, we can criticize interactivity features of games or the different ways in which they are implemented. This situation of competition will engender respect for each other's strengths and weaknesses, allowing us to draw essential conclusions for our own designs.

UNDERSTANDING OF MEDIA AND GAME CHARACTERISTICS

Thoroughly planning designs in early development stages is an important way to set a certain focus or vision for later project stages (and even for your professional career within the computer game industry). You and the entire team get a chance to take a deep look into what you will spend a large amount of time on over the next couple of months—a multiplayer online game. It's a way to understand all of the characteristics of the media you are creating, how they function and play together, and what consequences your game creations can have on its players and their lives. Doing a job effectively involves understanding the job. Designing games should also mean understanding games and what you want them to be (both for you and for your audience).

The framework also provides the possibility for your audience to identify the characteristics of their games. They can deconstruct games' systems and figure out how they work. This knowledge enables them to give useful feedback, to let you know about their expectations and habits, and helps them select games that best fit their (interactivity) interests.

BASIS FOR SIMULATION

The final reason why this type of conceptualizing a game creation process makes sense might initially seem somewhat far-fetched; however, because it's one of the unobvious advantages of this model, it should be mentioned. Imagine the framework being used as a basis of simulation in AI, especially in computer games, where "artificial" often means "artificially human." Artificial agents in multiplayer online games could use an understanding of player-player interaction or player-game interaction as a reference to simulate that behavior—and thus be able to act (more) human-like within the online game environment. Agents attempting to create dynamic content, for example, could also profit from understanding how players interact with the game and what their expectations are.

SUMMARY

At this point, consider yourself having passed through a very detailed and thoughtful planning process. All this detail was necessary to help you and the entire production team develop a clear understanding of your goals and intentions. Additionally, it is the most valuable guideline for further project stages and something you can rely on as you implement your concepts into a detailed design and add some meat to the bones. This is the path we will take throughout the next chapters.

IMPLEMENTATION

We now have a model and a clear concept of interactivity. We also have a thorough understanding about the nature and specialties of the media we are going to create. Additionally, we are armed with knowledge of what worked and what didn't, and have a detailed analysis of our prospective target audience. In short, we are ready to flesh out these ideas.

This second part of the book begins with building on the interactivity concept introduced in the last chapter. We will use our new paradigm to identify the most influential forces behind each of the three interactivity types and identify their key factors and attributes—the building blocks of a game's interactivity structure and the ingredients of its interactivity receipt.

Later, we will leave the framework of the interactivity model to discuss various selected design aspects that span and affect the implementation phase as a whole and therefore incorporate the interactivity concept in its entirety.

PLAYER-TO-COMPUTER INTERACTIVITY

In This Chapter

- Introducing Player-to-Computer Interactivity
- Synchronicity and Quality
- Controls and Interface Devices
- Command Set
- Network and Network Transparency
- Interactivity Focus
- Artificial Intelligence
- Real-Life Simulation
- System Knowledge and Learning Curve

This chapter starts to shed some light on the first type of our theoretical interactivity paradigm: player-to-computer. After a short introduction of how you should generally interpret this facet, we then discuss its potential key factors and see how they can practically affect your designs.

Introducing Player-to-Computer Interactivity

Player-to-computer interactivity means all processes that combine a biological system, the player, with an artificial system, the computer. It is

communication between the player and his computer—hardware and software—in both directions in which the system is treated as a persona and partner on equal footing with the player. What does this have to do with online game design? This should become much clearer if you refer back to the illustration of our interactivity concept in Chapter 5, "Conceptualizing Interactivity." Player-to-computer interactivity does not only exist once with the model; it is laid upon each of the other dimensions. Think of it as a middle-tier and filter layer between your game and the player. All information and messages sent back and forth between the player and your software creation have to pass through this filter, which thus has significant influence on the communication chain. Let's use the power of visualization to clarify this scenario.

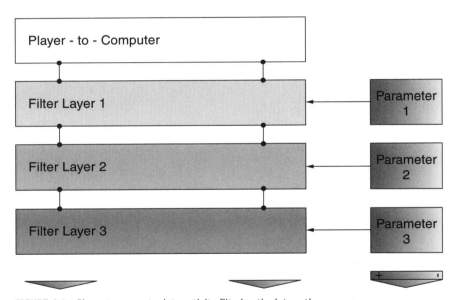

FIGURE 6.1 Player-to-computer interactivity filtering the interaction process.

Figure 6.1 illustrates why these aspects are important in designing multiplayer online games. Player-to-computer interactivity is the framework into which you have to embed your game environment. A player's computer system defines the potential to design interactive and immersing games. All of its hardware and software devices provide a pool of resources

from which to draw, delineating what is potentially possible—both in a restrictive and extensive manner.

Many of these factors are more technical in nature and sometimes out of your immediate control. However, by identifying their significance and understanding them as sources of possible implications, you are not totally exposed to their influence. Because of the dominating role of player-to-computer interactivity within a player's entire interactivity and gaming experience, some minor tweaks on this higher system level sometimes result in major improvements and a widened spectrum of design techniques.

SYNCHRONICITY AND QUALITY

If we consider a player's computer system similar to a person, it also makes sense to compare player-to-computer interactivity with real-life, face-to-face communication. What makes us actually assume direct human interaction as the most effective and revealing way to communicate? There are two criteria it perfectly meets that you should try to render in your online game framework: quality and synchronicity.

First, all sensory inputs you receive in a real-life, face-to-face conversation are distinguished in such a way that they do not sustain any loss of quality on their way from sender to receiver.

Any conversion or compression never has the chance to harm or disrupt these messages; their quality is only dependent on the capabilities of your senses. In addition, your interpretations can rely on perceptions such as facial expressions, tone of voice, reflections, smells, or temperature. These are essential "qualities" to supplement your visual impression that are not available in any type of otherwise merely visual-based interaction—such as those that occur in online games, for example.

What makes real-life, face-to-face communication effective is its instant, synchronous response and feedback. It ensures a common understanding between the interactivity partners, because the immediate succession of action and reaction allows a regular adaptation to one another's messages. You get immediate feedback as to whether your actions produced the desired outcome and can instantaneously alter your behavior accordingly. Remember, these real-life setups only serve as a reference and in actuality can be mapped one to one on conversion between a player and his computer system. Synchronicity is also the key to a common understanding between the player and the system. Both sides need to know if their actions

and information have been decoded as intended, and need to be informed about the other's purposes and plans. Regular, immediate feedback is the only way to ensure evaluation of these purposes and the necessary adaptation to another's plans.

Designing effective player-to-computer interactivity therefore means enabling the system to emulate these two efficiency criteria from real life in the online game environment. You need to enable the system to present its information and responses to the player at the highest possible quality level. Quality is essential to avoid misinterpretation of essential game information on the side of the player. To maintain the highest possible quality, it is important to remember two major complications. While we are at the forefront of current technology, game creation is still far from being able to implement the exact quality of all sensory stimuli a player experiences in real-life, face-to-face conversations. Presenting game output at the highest possible quality level is thus limited to what the computer currently does best: graphics and audio. The second issue arising from the demand for graphical and acoustic excellence is that more quality often goes hand in hand with a loss in speed—which contradicts the second criterion of efficient player-to-computer interactivity: synchronicity. Therefore, how can you deal with these complications?

Clearly, you can conclude in examining the direct dependency between quality and speed and rely on an interpretation in which increasing processor speed automatically leads to a better quality potential. Of course, additional horsepower in the form of faster processors, supplemental memory, or 3D hardware accelerators provides new opportunities to integrate real-life perception qualities. Only then is it possible to handle extra computation cycles that result from lighting, reflection, spatial acoustics, or more detailed polygon meshes and their accompanying animation in 3D space. In recent years, this is the primary course taken by the computer game industry, which is not bad. The key is synchronicity, and if you can ensure its existence while presenting your game world at a higher quality level, you should certainly make use of all the potential that computer technology has to offer.

There is, however, an alternative to Moore's law that you should consider in your designs. Well, not an alternative in the strict sense, but a slightly different paradigm. The increasing need for (mainly visual) quality has lead to a process in which the minimum system requirements a player's machine has to meet are continuously pushed to a higher level. In terms of this discussion, quality is the governing aspect to which synchronicity has

to be readjusted. This might work well if your target audience is hardcore gamers only. They are willing to pay the price for additional hardware and regular software updates if you can offer them higher quality graphics and sounds. However, online games, in many cases, mean an increasing shift of the computer game media toward entertainment for the masses, a much broader audience. At this point, you need to reverse the scenario and adjust quality according to synchronicity rather than the other way around. It's in fact a matter of prioritization. However, the key, the governing factor, in player-to-computer interactivity is synchronicity. Your game might have the most amazing 3D graphics, visual effects, and physically realistic animations, but if it has delayed reaction, to a player's input commands or lengthened intervals between action and feedback, your game is judged as both noninteractive and unplayable.

Adjusting quality is obviously difficult without knowing about the player's system capabilities. How much processor-intensive "qualities" can his machine handle without any synchronicity drawbacks? According to what your prospective target audience will be, there is surely some common denominator you need to assume and a minimum capability of the player's system you can take for granted. Based on those criteria, it is important how you handle quality adjustment for the player. He should have as much freedom as possible to tweak the quality-related variables and parameters that affect computation speed. Only the player can define the perfect balance of quality level and the resulting synchronicity. It is thus a matter of supporting the broadest possible spectrum of attributes that you think might impact your game's response intervals and that offer the player potential opportunities to tweak the game according to his system.

This could mean allowing for different screen resolutions, color depths, texture and polygon detail levels, shadows on/off, acoustic effects, or window size. It is also the support of the broadest possible range of additional hardware devices the players might have available and their supplemental "qualities," such as *T&L* (Transformation and Lightning) or spatial acoustics.

The beauty of giving the fine-tuning between synchronicity and quality to the player lies in the preclusion of risks. That is, setting the qualities of game output too high by overestimating the system's capabilities to guarantee synchronicity at such levels. However, you should also make sure that there are no uncultivated resources that once gathered would result in a significant enhancement and step toward a better understanding between player and game.

CONTROLS AND INTERFACE DEVICES

The previous discussion mainly addressed issues related to how the game and computer system can inform a player about its intentions and actions and how it responds to the user. In this scenario, the system talks to the player. Now let's address how the player talks to the system and triggers the feedback he expects to get.

The way in which the player talks to the computer system and applies expression to his intentions that his artificial partner can understand is primarily a matter of "control." The word *control*, for computer games, might initially conjure up all imaginable forms of different hardware devices—force-feedback joysticks, mice, keyboards, and rumbling gamepads. Without a doubt, communication between a player and a computer relies heavily on methods that such tools provide. However, the way in which a player controls his computer system, and vice versa, spans a more general interface paradigm and deals with both hardware and software control mechanisms in terms of quality and quantity.

Daily experience, history, and education teach us how to manipulate the real world and how the environment tends to respond to our human actions. There is a common ground on which we can rely in our conversation with the world that surrounds us. This is what makes the process effective and pleasing. Our surroundings tell us how we need to behave to reach a specific goal and what actions to apply to its objects in order to cause a particular result. Look at all the objects that surround you. Each automatically conveys an accompanying movement pattern and action set. You know how to push a button, how to lift a coffee cup to your lips, how to use a pencil, flip a page in a book, and how to orient your body in 3D space. Within the virtual online game world, however, player-to-computer interactivity cannot (yet) fall back on such a common ground.

This is a major challenge in the design of (online) computer games. The biggest complication arises from the fact that in the course of history we have developed and established unique methods to manipulate our real-world environment as we see fit and most efficient for a specific purpose. We associate a distinct action pattern to each type of intention through which it is most easily and effectively communicated. Most of these methods, however, might not be easy to adapt to the virtual game environment by only standard computer input devices. If your intention is, for example, steering your car, then the most intuitive and easiest way to express this would probably be rotating a wheel rather than pushing a button. Likewise,

being informed about running into a closed door would probably be more intuitive with a force-feedback mechanism rather than just having a flashing screen and an accompanying crash sound.

Your goal should be to allow the most natural, efficient, and convenient way for the player and his system to communicate with each other. Thus, your game needs to support the widest possible range of different I/O devices that are most likely to emulate the player's familiar action patterns within the virtual game world. Each method that a player needs to interact with his system but that differs from his real-life experiences means additional efforts on the part of the player. He either has to learn these computer-only patterns totally from scratch, or needs to modify already known ways according to your game environment. Such a re-adaptation can require a reasonable amount of time and learning involving both physical and cognitive adjustments; in terms of effective and functional player-to-computer interactivity, definitely a scenario you should try to avoid. Nonetheless, there are recurring attempts by various hardware manufacturers to establish innovative ways of "naturalizing" communication among the player, the computer, and the game. Most of these approaches are promising, but have trouble finding the necessary support from both consumers and developers, as shown by (former) DigiScent's *iSmell* technology. A new capable device system was introduced by Essential Reality at the Game Developer's Conference, 2002: the *P5* glove—a device that allows manipulation and interaction with a game environment in three dimensions by moving one's hand (Figure 6.2).

This device should let players interact with the game world without using traditional I/O devices such as a keyboard, mouse, or joystick. The required SDK to support this technology in your games is available to developers free of charge. As with most of these untraditional I/O concepts, however, there's a lot to do from both developers and customers to make such systems a commonly accepted and supported standard.

Supporting a broad spectrum of I/O devices is not the only strategy you should consider to account for these aspects. Adapting a player's familiar control mechanisms is insufficient, as "best," "most effective," and "easiest" are subjective phrases. Intuitive ways to communicate the same information to the computer system might vary by player. An often-underestimated aspect in computer game design is the opportunity for the player to adjust and personalize the game's control mechanisms. Therefore, it is not only a matter of *what* input devices a player has available and would probably prefer to use, but also *how* he prefers to operate them.

FIGURE 6.2 Alternative human-to-computer communication.
© Essential Reality, LCC, 2002. Screen shot(s) reprinted by
permission from Essential Reality, LCC.

This applies, and probably most important, for standard computer inter-
face devices as well: mouse and keyboard. For example, moving the mouse
to change your line of view is a significantly different experience than doing
the same to change the location of your entire body. Turning your head or
rolling your eyes is an utterly different action than moving from A to B. But
what does the player prefer? What will he experience as the most intuitive
and easiest pattern? Should the Up key trigger a jump or forward motion?
There is never just one right answer to these questions. You are probably
familiar with the "flight-sim example" and how to pull up the plane's nose.
Whereas some players can easily draw the line from pressing the Down key
to pulling a control lever, it can be very difficult for others adapting to the
correspondence between the Down arrow and upward movement. In your
designs, you should therefore provide the ability for the player to freely ad-

just, save, and readjust your game's control mechanisms. All controls used to communicate to the computer need to be freely mapped by the player according to his individual learned and preferred ways. Neither you nor the game should decide what is most natural or intuitive. As already discussed, it is sometimes impossible to adapt a player's real-world action patterns to computer input devices available and common today. Therefore, if a player has to learn how to communicate his intentions to the computer, you should at least try to make these learning processes as easy and fast as possible. Most of today's shooters and real-time strategy games, for example, perfectly implement this idea by providing fully customizable keyboard and mouse layouts.

It's worth mentioning that a player who feels in control of the computer system will additionally enjoy a feeling of prowess and safety in his actions. You could use this safety aspect as a design technique to your advantage and consciously distract the player by temporarily reversing his control methods. Some games already demonstrate this concept by flipping positive and negative x- and/or y-movement axes to "punish" the player or simulate some confused effect.

What finally remains to be said is that a discussion about the support of multiple I/O devices and their free customization conveys the consideration of ergonomic aspects. As long as you don't bundle an extra hardware device with your game—which might be more the exception than the rule—your impact on ergonomics on the hardware side is obviously very limited. However, regarding interfaces and control mechanisms, there's a lot you can do on the software side of things from an ergonomic point of view. For games, this is mainly a matter of resolution, readability, menu design, or a well-designed help system and online user support.

COMMAND SET

Controls, by means of both hardware devices and the accompanying software, provide a way for the player to manipulate your game environment according to his short- and long-term goals. He relies on these controls to solve any potential conflicts that might arise within the online game world. This is the basis on which we will now build.

Again referring to the real world, you know that there is seldom only one way to solve a given problem. We have a whole set of actions that we

can combine in many different ways that still lead us to the same result and serve one overall plan. It is the flexibility provided by this pool of solutions that we need to adapt and react to our continuously changing circumstances and situations. The reasons we choose one specific action (or combination of them) to address and solve a given problem are manifold and part of everyone's individuality. You could choose a particular option because you assume it to be the easiest, fastest, most convenient, most idealistic, or simply most enjoyable path toward your goal. However, problem solving in real life is only considered effective and able to meet our individual demands if we have and know about this freedom of choice—and this is why your games should follow these patterns.

The player should have the ability to solve a given problem situation and conflict in multiple ways. There needs to be a set of commands—that is, multiple alternative combinations of single actions—that all lead to the same result. Commands are a player's mental controls; a variety of opportunities to satisfy a need.

For games, phrases such as "multiple paths" or "alternative solutions" are very likely directly associated to issues like puzzle design or branching mission structures. This freedom of choice, however, should not be restricted to gameplay. A wide range of optional commands is also an essential aspect in player-to-computer interaction and with reference to tasks of the player that initially might seem trivial. Consider, for example, a plan and intention of a player that is likely to happen rather frequently in the course of an online game: quitting and logging off. Now, what does he have to do to make this happen? Does he have to open the game's main menu, access a submenu item hidden a few levels deep, and finally positively answer a security question? Apparently, this would be a way, but probably only judged the most reasonable and appropriate if the player is in the middle of a confusing, hectic situation and does not want to accidentally leave the game. At specific points, however—for example, at the end of a quest or a player's home base—a quick-logoff button or a single continue/quit dialog might be sufficient.

This is only one example, and neither possibility is better or worse. They are only alternatives that lead to the same outcome and should thus both be available. As in real life, the player will enjoy the flexibility to choose from multiple possibilities in putting one intention into action according to his current circumstances and preferences. Only then will he interpret his actions as the most efficient and feel satisfied in his interaction with the computer system.

In your designs, it is mainly a matter of what paths you think a player might take to solve the problem. Reading other people's thoughts and speculating about what strange ideas they might come up with is a tricky business. Clearly, you will need to balance what you consider worthwhile and senseless. At certain stages, a small psychological test setup with your co-workers or relatives can also be helpful and point out insightful aspects. However, the range of alternatives usually cannot be wide enough. More-over, you probably know that especially in games, the strangest ways you would not have thought of, even in your wildest dreams, are often those that players go for first. If you fail to account for their needs, the lack of such alternatives will be added to a player's wish list—and to his rant mails.

For example, what happens if your game runs in window mode and a player accidentally tries to close the window? Should he be able to quit the game by using the notorious Alt-Tab key combination? Some players might even want an automatic log-off command that allows them to safely quit the game after a predefined period of time (just in case they fall asleep or are cheating).

As mentioned, logging off is only one example of a single player inten-tion for which multiple alternatives should lead to the same outcome. There should be a variety of combinations of actions, a large command set, available to the player to communicate his plans and purposes to the com-puter system. A huge potential of this idea lies in the fact that if you design single actions as very general approaches, they can serve as a building block for not one but multiple different commands. A good example is pressing the Esc key. As an isolated action, it does not have a very special meaning, besides some expectations the player could have as a result of earlier game experiences. However, if it follows a consistent understanding of "termi-nation," the same action paradigm can be used in multiple combinations, within different contexts and for various intentions of the player. It could mean quitting the game, going up a level in the menu structure, closing the current interface window, or terminating a transaction.

Network and Network Transparency

Assuming you are interested in this book solely or mainly because of its focus on the online aspect of game design, the game's underlying net-work should not be left out of the discussion. Within the interactivity con-cept, you should consider it an integral aspect within player-to-computer

interactivity. Perhaps more than any other factor, it follows this type's paradigm as a principal layer that heavily impacts a player's overall interactivity experience.

Without a doubt, computer networks are a central topic when developing multiplayer online games. Moreover, not unjustified, your initial concerns might revolve around the appropriate network architecture, latency, bandwidth, or security issues. Considering whether a peer-to-peer or persistent game-server setup is more likely to meet your demands, or a quick prototype Macromedia Flash environment might suffice as an initial test bed for your concepts is a critical stage of the development process. Likewise, thinking about strategies of how to tackle the complications arising from latency and bandwidth drawbacks should and will be an issue throughout the entire process. As we have seen, synchronicity is the key for effective interactivity. Therefore, not only is network speed an issue; you must also ensure synchronicity between all the players and maintain an equivalently experienced game state.

Within the context of game design, however, a deeper analysis would lead us too far into technicalities. A solid examination of well-designed and functional workarounds to latency and bandwidth dilemmas would fill a book on its own, and you might want to refer to the variety of reliable, excellent references in your favorite bookstore or on the Web. However, you need to keep those merely technical aspects in mind, and it is vital to carry these "swords of Damocles" with you throughout the entire design process. Depending on the complexity and scale of your projects, we will now look at network aspects that might be part of your responsibilities.

Network-Specific Transparency

One issue to bear in mind concerns the network self—the network as a hardware and software architecture. You will agree that the network's condition, be it latency, bandwidth, or security, highly influences a player's game experience and the way he interacts with other players. This is why you should give the player a fast and easy opportunity to gain information about the network's actual status.

For fast-paced games in which speed is of utmost importance, like shooters or racing simulations, knowing about your current "ping" is extremely important. It is a key factor for a player's evaluation of whether it would even be worthwhile to participate within the online game environment. In fast-paced, competitive games the most significant factor is defi-

nitely the ability to determine potential disadvantages caused by a slow network connection with regard to other players. Then, informing a player about his most up-to-date connection state is a fundamental necessity for him in order to embed himself within the community of choice. Some players, for example, might like the additional challenge of playing against people with better preconditions. However, supplementing your game with such an additional element requires letting the players know about the state of the network.

Players of games other than shooters or fast-paced action games would also profit from getting information about the network. It provides knowledge of whether the game as a whole, without any respect to player-to-player interactivity, is in a condition that the player is willing to accept. To speak in terms of our interactivity model, the player has a way to decide if the expectable player-to-game interactivity will meet his expectations and requirements at this point. For online games, a player's connection state is an initial quality indicator of satisfying play experience. For example, it is possible for you to warn a player about possible drawbacks and that he should probably consider returning again under different circumstances— for his own sake.

This leads us to another issue: What is better? What is the usual network state? If you provide a player with information about his connection's condition, he also needs factors against which he can compare his own values. Here, as is so often the case, interpretation and evaluation is a matter of comparison that mainly relies on relative rather than absolute information. Therefore, you should also tell the player about the network's potential condition, other players' connection states, or his average rate from previous sessions. Connectivity is heavily dependent on local aspects; for example, a player's individual ISP, the game server's location, or time of day. At this point, a weekday- and daytime-based network condition graph, for example, would unquestionably be an invaluable and meaningful reference for a player's evaluation of his actual connection state.

What is finally worth pointing out regarding our discussion about network-specific transparency has been a hot topic since the very first installments of computer networks: security. In terms of understanding online games as mass entertainment media, it is, more than ever, essential to inform players not only about latency or bandwidth conditions, but also about network security. We will not talk about cryptography, privacy, or cheat prevention here; this would definitely lead too far within this context. However, the most fundamental issue you should bear in mind is

informing your players about potential security risks and what they could do to minimize these dangers. What should go without saying is to support an SSL connection for a player's account administration and transmission of any strictly confidential data such as credit card information.

All of these aspects demonstrate again the unique role of player-to-computer interactivity by means of defining a specific potential for both player-to-player and player-to-game interactions.

USER-SPECIFIC TRANSPARENCY

We have already touched on user-specific transparency in our discussion about the need to know other players' network conditions. This, however, is only one facet of what is meant by "user-specific network transparency"; that is, providing a simple and fast opportunity for the player to gain information about other persons within the network. We examine the importance of such a feature in Chapter 7, "Player-to-Player Interactivity," again when we discuss the more social attributes of online game interactivity. At this point, however, it is sufficient to recognize that the characteristics of other players within the same game environment highly affect one's own behavior. Therefore, providing this information is at this stage considered the job of the system and thus a fundamental factor of player-to-computer interactivity. A player should at least be able to get a vague idea about the people with whom he shares the game. Player-specific information is valuable throughout the entire game, as we will see, but is most important as part of one's initial decision basis prior to entering the game. For persistent-state worlds that players usually start playing with the intention of regularly participating in over a longer period of time, this might be less of an issue. However, the situation is different if a player can choose from multiple available sessions—which is the case for most peer-to-peer/dedicated-server-based games like the popular first-person shooters. There, knowing about other players' experiences, game history, skill level, or score, for example, might be an essential criterion in selecting a particular session to join. Additional useful information would be a player's detailed profile (real-life and/or game-specific), hardware and software configuration, or his "moral rank" or popularity as determined by other players' votes. All information a player agrees to and wants to be made available to others can serve as insightful reference and therefore be shared with the entire game community. The system would then not

only tell something about a technical computer network, but also about the social network of your game(s).

User-specific network transparency also deals with providing a player with the ability to gain information about a potential game environment and what to expect within these environments. Again, this aspect is not that significant if you offer the player only one game world and you plan to design a persistent-state environment. It is, however, essential if there are multiple simultaneous sessions or even a variety of games from which the player can choose. For his decision, he needs a knowledge base about the nature of player-to-game interactivity and other players' behavior that he might expect. Only then does the player have a way to interpret what environment is most likely to satisfy his current desires and needs. This could be information about the actual map, the current number of players, or a level category (e.g., deathmatch, capture-the-flag, or last-man-standing as known from most shooters).

Network transparency is implemented in practice very well by *GameSpy Arcade*. It therefore makes sense to examine this tool in a bit more detail—which we also do in the course of a case study in Chapter 7. As already intimated, however, there are some indispensable facets (particularly social scientific ones) other than network transparency that we first need to introduce. Therefore, let's continue with our discussion of player-to-computer interactivity at this point.

NETWORK TECHNOLOGY FOR DESIGNERS

We tried to stay away from the technical details that computer networks undeniably have, and contrary to what the title of this section might imply, this is also not going to be a crash course in network architecture or server programming. However, there are some important issues to cover, including middleware game engines and programming libraries. There is still a bit of skepticism toward licensable game engines, but new products are regularly hitting the market and existing ones are continuously refined and revised on the basis of the developers' feedback. The acceptability of these products is up to you; however, these engines not only promise to take away the burdens of hardware specifics for multiple platforms from programmers, but are also a form of design tool for the game designer. By hiding many of a game's underlying technical details , they offer a much more attractive interface with which to "design" games. The driving force behind

most of the engines available today, like NDL's *NetImmerse* or Intrinsic Graphics' *Alchemy*, is still graphics. However, network support will become an increasingly important part of these engines. Particularly in times of the PlayStation 2, the Xbox, and their network support, multiplatform support goes hand in hand with porting network code. Some engines and libraries, at the forefront *Quazal Net-Z, Eterna*, and *Conqueror* (Quazal Net-2 and Eterna are on the companion CD-ROM.), are already **ON THE CD** exclusively focused on a game's network aspect.

Tools such as this offer a new perspective to game designers. Your games' network implementation is no longer solely the concern of a veteran network programmer. Moreover, the designer willing to deal at least a bit with high-level network mechanics and programming concepts can play his part in designing a game's core network architecture and shaping it from a designer's point of view.

INTERACTIVITY FOCUS

Referring back to our analytical layout of the interactivity concept, you already understand the unique role that player-to-computer interactivity plays within the model. As an additional filter layer applied to the other types of interactivity, it is a central factor that heavily affects player-to-player and player-to-game interactivity.

This aspect and function is particularly interesting when it comes to examining the different characteristics of the interactivity types. Interactivity with the computer system, for example, is very different from communication from player to player. For the player it means that each interaction results in very distinct gaming experiences. Suppose that each action a player can do in your game environment is assigned to one of the three types of interactivity. The player sets and defines a specific short- or long-term plan and then has to flesh out his strategy by choosing from these single actions and combining them into a meaningful whole that promises to satisfy his needs. As all purposes of a player are distinct in nature, so are the actions that supply them and the interactivity types to which those procedures are assigned. This results in a scenario in which a player's intention conveys to select a set of actions that are very similar in nature. The player thus, consciously or unintentionally, settles himself mainly on a specific type of interactivity. If his primary goal is to socialize and converse with other human players within the game world, his actions might mostly

focus on interpersonal interactivity. On the other hand, if he is trying to "beat" the game and strive for a new high score, or simply wants to explore every corner of your huge online game environment, player-to-player interactivity might be less important. Each type of interactivity is better suited to specific demands and purposes.

Within the game, however, the player is confronted with the set of available actions and simultaneously experiences all types of interactivity. To reach his goals in the most efficient and satisfying manner, you should thus give him an opportunity to define the focus of his action. As illustrated in Figure 6.3, he should be able to maneuver freely within the interactivity pool and direct himself to those actions that are most likely to meet his needs.

Why is it essential to give a player the opportunity to define the focus of his actions, and what are possible ways to implement it in a multiplayer online game design? Let's begin to answer this question by stating two elementary requirements that each possible game action should meet:

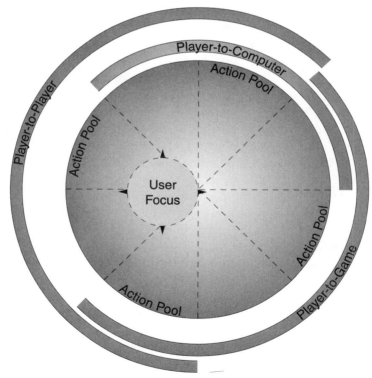

FIGURE 6.3 Defining the focus of one's actions.

- The ability to immerse within an action depends on a player's thorough concentration on the task at hand and his feeling of commitment and liability to its best achievable implementation.

- Eventually, the player's action should have recognizable consequences and cause feedback that allows him to evaluate if his action led to the desired outcome.

As you might know from real-life experiences, doing multiple simultaneous tasks that are not part of the same overall plan distracts from each other. Playing a great computer game while trying to bake a delicious pie either pressures you to interrupt the game regularly and look in the oven, or deprives you of a tasty dessert. Of course, you are able to do various discrete actions simultaneously, but not as effectively as possible. Likewise, multiple concurrent responsibilities tend to fall out of their respective context and often make you forget what the actual driving force behind a particular action was.

This is exactly the type of situation a player commonly faces in a multiplayer online game. There is this huge spectrum of possibilities and he is confronted with all types of actions and interactivities that are entirely different in nature and only serve his current intention to a higher or lesser degree. Therefore, often the issue is not a lack of available actions, but a lack of focus that is essential to meet the requirements stated previously: immersion and recognizable feedback. It is essential to provide an opportunity for the player to define an action focus at every moment in time in order to allow him to reach his short- and long-term goals. He will then have a way to immerse within a single intention and be able to experience the process as a holistic entity. Each of his actions is experienced as being a significant step on his path to satisfy a specific need. Once he reaches the goal, the cycle between tension and relief is seamlessly closed, and it's instantly possible to make the connection between the experienced outcome and the initial motivation.

Let's examine some examples to clarify this idea. By prohibiting fighting or player killing in specific areas of your game—for example, the obligatory tavern in a role-playing game—you could allow a player to focus on social interactions. This is not only a design method to protect inexperienced newbies from those who have made it their hobby to deprive others of their fun. It is also a worthy tool for even the veteran player to set his interaction focus. Within such environments he can easily follow his need to get to know other human players within a relaxed atmosphere without any

distraction. He does not have to worry about a possible attack, nor does he need to forge strategies for a potential combat situation. Still, there are multiple available actions that define the details (meaningless small talk, a trade scenario, an intense philosophical discussion, etc.), but only an action set that is of a player's immediate interest.

In a similar manner, training areas, for example, or short guided quests that center on a specific ability and emphasize a particular game mechanism would shift a player's focus to the study of the game's low-level mechanics. At this point, a player enters a realm of mainly player-to-game interactivity. The same applies if you provide the possibility to tune the game's difficulty or NPC intelligence in single-player mode. This would be one way to account for the player's interest in learning high-level strategy and focus his actions on this particular purpose.

A comparable technique is already demonstrated in a few level- or mission-based single-player games in which a player can select those stages he has already completed. His initial goal at the beginning of a level is merely to complete it and probably beat the end boss. Afterward, however, he still has the chance to reenter the mission with a different intention in mind. He might, for example, try to improve in time or score, discover all secret items, or simply enjoy the beautiful visuals of your game without any pressure. Each time he is able to focus on a specific interest and instantly recognize whether his actions have led to the initially desired outcome.

ARTIFICIAL INTELLIGENCE

Since this chapter discusses player-to-computer interactivity, we should also look at an element of computer games to which developers assign an increasingly higher amount of the system's available computation cycles: artificial intelligence. What role does game AI play within the entire interactivity concept? To come to the point, path finding, planning, and executing action scripts should not be the only tasks of your game's AI system—nor is it what we discuss in this section. There are, however, additional aspects you should take into consideration.

As mentioned earlier, AI is commonly understood in the context of computer games as "artificial real." Its primary job is presenting the player with computer-driven opponents (or more generally speaking, NPCs) that act and behave as close to what the player would expect from a human player. Likewise, it is also responsible for simulating other real-life

phenomena such as economic systems or ecological aspects as mainly introduced by the field of artificial life. All this is not mentioned to tell you what artificial intelligence has to do with computer games (what you likely already know), but to show that AI has *more* to do with your game than that when considering it from the perspective of interactivity. If game interactivity should be experienced as "really real" by the player, you should consider more than just a well-designed path-finding algorithm.

Interactivity in real life, and particularly person to person communication, is heavily dependent on mutual anticipation and adaptation. This is a fundamental quality of real-life interactivity and what makes us experience it as being efficient and meaningful. It is heavily defined by continuous (subjective) interpretation and evaluation of one another's actions, reactions, and behavior patterns. Therefore, assuming that the job of AI is to make a player's game experience "artificial-real," he should also experience this aspect of reality in his communication with AI agents in your game. You might be thinking that these academic theories sound great, but are absolutely useless when it comes to practical implementations. In fact, computer systems that fully anticipate human needs, interpret their messages, and adapt to them might still be off in the future, and you are correct that such scenarios are even farther away for computer games with limited computation power for AI routines. However, all this is not intended to present you with sophisticated revolutionary AI routines. It is intended to show you that various AI concepts are already moving in the right direction, such as those included in *Black & White* and *The Sims*. The point is that to use AI for more than real-looking movement patterns of NPC agents, it sometimes requires an altered paradigm on the side of the game developer.

Your primary concern should not always be about how much of the available resources you can assign to AI, but *what* your AI system does with the given portion of processing power. Some games are proud to announce that their NPCs are all entities that have their own unique plans and goals and follow their own schedule throughout the game. This is certainly a good feature, and certainly makes these agents appear closer to how a real person behaves. However, it would be even better if the player could influence the agents. Therefore, if you can focus on concepts and AI systems that incorporate the player in the process, and spend some additional power in anticipating and studying the player, your game will be that much better. There are, as mentioned, already different approaches to how this idea could be implemented in practice. In *Black & White*, it is a bit

more obvious. The player's avatar behaves and makes decisions according to a model that is altered by anticipating the player's actions and interpreting his "morality." *The Sims* shows a slightly different method in which the agents implement the player into their AI routines by reading the alterations and changes he makes to the environment. Metaphorically, they communicate and talk to the game objects, be it the fridge or a plant, and adapt to their state, which in turn can be affected by the player.

Let's analyze for a moment what AI in computer games is from the most fundamental point of view: a mathematical construct of numbers, equations, and algorithms. This is a huge potential from the perspective of player-to-computer interactivity in that data dynamics is key. Unfortunately, crunching bits and bytes without any influence from the side of the player and applying those calculations as only internal, hidden processes excludes a big portion of this power. AI-specific equations and algorithms need to exit the isolation of the game architecture and should be directed toward the player. They should include variables that alter according to the player, his actions, and behavior, and therefore incorporate a human aspect. Naively spoken, if $E = x + y \times z$, then x and y should be, sooner or later, the result of a player's action, decision, or reaction to a given conflict. Of course, this is a rather simplistic scenario, but you get the point.

Within the context of artificial intelligence and adapting agents, it is important that you do not limit your considerations to only *visible* NPCs and graphical agents that move around in your game environment. You should also treat the entire game system as a single agent. There are other ways of anticipating and interpreting a player's messages and adapting to his actual needs, desires, and circumstances. One way would be for an "intelligent" help system to be able to identify complications and suggest possible workarounds regarding complex game mechanics or technical problems. You presumably know the assistant available in all Microsoft Office applications. This does not mean that you should include some animated paper clips in your games, of course, but the underlying system can occasionally very helpful; given, certainly, that such a tool is desired by the player and can be deactivated. In addition, manually or automatically generated player profiles tell a lot about a player's potential interests and desires. Amazon, for example, demonstrates this technique in extreme by concluding what products you might be interested in from your previous purchases and studying your browsing behavior. In a similar manner, you could consider suggesting player-specific levels, zones, maps, items, or weapons, inform him about online tournaments and events, or even

recommend potential opponents or cooperation partners. To anticipate a player in game AI, a final approach that involves slightly more subconscious information should be noted; that is, the evaluation of additional parameters of a player's immediate real-life condition such as local weather information, his browser favorites, or the duration of his actual online session. These aspects, although not directly game relevant, can also serve as a valuable basis for studying the player and using this knowledge as an instrument to engage the player in a meaningful way.

Advanced AI used as a way to adapt, interpret, and evaluate a player's actions and messages can be an integral part of player-to-computer interactivity, and therefore an essential method in enriching a player's entire interactivity experience. Thought of as incorporating individuality and personal game style into your creations, it is a way to make a game different in two respects: your game would be distinct from player to player, and a unique experience every time it is played. A common assumption is that players particularly like multiplayer online games because they prefer to play with or against another person. Passing the Turing Test in game AI might in fact be some time ahead; however, shifting the focus on anticipating and adapting a player's actions and needs, a significant real-life communication quality, is essential in providing artificial-real game interactivity.

REAL-LIFE SIMULATION

Only a small portion of computer games is categorized in the simulation genre, let alone a one-to-one simulation of real life. The term *simulation* actually implies expectations and associations that seem to make us refer to the simulation genre; games in which the simulation of real-life phenomena is the driving force.

To a certain degree, however, all games need to simulate facets of the real world and translate abstract game concepts into models that the player already knows and is familiar with. This is absolutely necessary for the player to understand the game and act within the game environment in meaningful ways. This is why most alien NPCs usually communicate with the player in his known language and why even the most fictional game worlds normally follow exactly the same physical rules as those known on Earth. Interaction with the computer system is merely more intuitive and

easier if a player can rely on already familiar and known experiences. This knowledge can be a result of a player's previous computer or game experience, but most of the information he relies on is acquired from real-life events.

In the context of player-to-computer interactivity, it is the task of the system to simulate these real-life conditions in such a way that the player will recognize the pertinence of his experience.

As we have seen, this is generally a matter of transforming concepts that are only present in a fictional game environment into phenomena he already knows. However, under certain circumstances, it also involves simulating real-life events that in their most realistic approach would not be applicable for the context of computer games. In such cases, real-life simulation is a matter of abstraction and/or metaphors, and as such, simplification. Suppose, for example, the laser cannon of some spaceship. Implementing a single, one-time laser shot within a game exactly as it would behave in a real-world environment would be simpler for you but absurd, because the player would not be able to perceive his shot traveling through space at light speed. This is not to tell you something that should be apparent, but is just meant to illustrate an additional aspect of real-life simulation and its role.

The central idea of real-life simulation in player-to-computer interactivity and therefore the entire interactivity concept for online games is always the same. It is adding an additional layer of understanding into game interactivity by taking advantage of a player's a-priori knowledge that originates from previous experiences.

The approach is closely related to the idea of what is known in the interface design field as "direct manipulation." A player should be able to translate knowledge gained from real life into actions that are meaningful in the virtual game world. Implementing this issue in practice spans a wide range of game design issues, some more complex than others. Your game's physics module, for example, has a critical task in player-to-computer interactivity and should strive to represent friction, momentum, and gravity in sensible ways (unless, of course, you do not consciously intend to present unusual physical experiences through your designs such as vacuums or weightlessness). Real-world physical concepts are, however, a good example of how real-life simulation can reach into a variety of design disciplines. Interface and GUI design, for example, is a potential candidate for real-life simulation. The widely known and popular "desktop" metaphor

borrows real-life concepts and represents them in a visual manner. During a simple drag-and-drop operation, a player would expect the items to start to snap to each other within a certain distance. His real-life knowledge would also make him expect that sliders and knobs increase their respective value when turned or dragged to the right. Additionally, this illustrates how the idea of real-life simulations can be turned into metaphors that are powerful tools for conveying similarities between a player's familiar mental constructs and concepts unique to your virtual game world. A metaphor serves more than just the communication of visual analogies; it provides an entire semantic idea and context. As such, you should not always take real-life simulation literally in this context, but as a supplementary tool applicable to various design elements. For the player it could mean additional understanding and engagement that allows him to retrieve associated knowledge from his memory and unite it with existing expertise and game-only concepts into meaningful and efficient schemas.

SYSTEM KNOWLEDGE AND LEARNING CURVE

We have already discussed the significance that player knowledge acquired prior to entering your game environment can have on how he experiences interactivity within the game environment. We were referring primarily to information acquired from real-world events and experiences. However, in the Digital Age there is also knowledge that originates solely from binary sources and virtual realities. Moreover, this virtual knowledge is an essential aspect within player-to-computer interactivity, and thus an issue you should take into consideration in your online game designs.

Precisely, it is important to know your player's experience as a computer user and game player. Game-related knowledge can be multifaceted and range from associations to a specific genre or traditional key bindings. These bases heavily affect the way he will experience his actions (and those of other players) in the context of your game; how effective, intuitive, reasonable, and satisfying he will perceive the interactivity. All knowledge and expectations a player can rely on in his decision making and problem solving without any (or little) learning effort is a valuable resource you should use to your (and his) advantage. Let's start with two aspects the system has to take into consideration in player-to-computer interaction, and then build upon this:

- Use concepts a player is very likely to be familiar with from other non-game-related computer applications.
- Use the most common and fundamental conventions the player might know from other computer game environments, especially from those designs he is most likely to compare to your game.

An appropriate example for the first item is the obligatory Ctrl-C/Ctrl-V key combination, which is one of the functions that seems to be a convention among computer applications. Overall, there is a lack of conventions among computer applications, making it more difficult to use than other media, and computer games are no exception. Familiarity with a system and knowledge of its schemas makes the interaction process more efficient and intuitive, particularly in the short run. You should, therefore, try to support at least the few conventions that are available within your own game. Design symbols and icons for system-related functions such as "save" or "load" in a style similar to those the casual gamer is very likely to know from his experiences with other computer applications. Clearly, this does not mean that you should precisely replicate them, but you should try to keep the established correlation between concept and representation. Animating symbols, applying supplemental sound cues, or further abstraction is highly appreciated and absolutely needed to harmonize these symbols with your specific game design. "Over designing" or abstracting them beyond recognition will be detrimental to your game and a waste of the player's computer knowledge.

The second issue suggests that you use common conventions a player will likely know from playing similar games. What this means is that there is little reason to trifle with common techniques for playing a game, such as using the cursor keys to move around within a game environment. Use tools and methods that are familiar to players from their previous experiences.

A player's knowledge of computer games not only refers to controls and keyboard layouts, but also to entire concepts, mechanisms, and rules. Most of these concepts are associated with specific genres that can be translated into a general experience and action pattern for a specific genre. Although it's a good idea to roughly adhere to the conceptual rules of a genre, each game should be a different and unique experience for the player. Each design has its distinct mechanisms, characteristic features, and inner workings, even if only at the lowest level of game mechanics. Controlling such game

specifics and supporting efficient interactivity really has to be learned and studied from the player's experiences. In order to keep the player interested and challenged, however, there is a third, complementary aspect the system has to take into consideration in player-to-computer interactivity:

- Provide a steep learning curve for the player to get familiar with the actual action patterns, tasks, and game mechanisms at hand.

It is important to design a smooth transition between a player's home territory and undiscovered land where things are different. For games, probably the most applicable, efficient, and pleasing way to introduce a player to basic concepts and to familiarize him with how to control the game's core mechanisms is in the form of a tutorial. There are different approaches to implementing a game tutorial. Probably the most elegant solution is to integrate the tutorial directly as an element of the game. The intention is to give the tutorial a meaningful game-related context and not make the player feel like a naive pupil back in school. Most of the classical LucasArts adventures implement this idea excellently by letting the player do some very trivial task at the beginning (rather than immediately presenting some complex puzzle combination). This gives the player an initial grasp of how things work, and is an effective, encouraging motivation boost that is particularly worthwhile within the first minutes of play. A somewhat different approach is shown by Monolith's *No One Lives Forever*, in which the player has to run through a training course prior to each critical, "real" mission to familiarize himself with new available and required weapons and items. Probably the most noteworthy and outstanding solution to implement a tutorial seamlessly into a game is in Looking Glass' *System Shock II*. Although the player has to pass inactively through one of three training courses here, each focuses on a specific skill set of his alter ego. The decision as to which of these courses he prioritizes is already part of the gameplay. The tutorial involves a meaningful prioritization of a specific game experience and type of player-to-game interactivity. By focusing on improving a particular, tutorial-specific skill set of his avatar, the decision for a specific series of training courses is the first crucial gameplay conflict the player faces and what he knows—at least subconsciously.

Both of the last two approaches demonstrate a type of tutorial that emphasizes one or two specific elements and game mechanics, and therefore gives the player the ability to focus on only a subset of required actions. He

can, for example, begin by focusing on learning the basics of navigation, and interpreting and using interface elements such as radar or inventory menus. Other stages can then emphasize the differences between, for example, controlling short- and long-range weapons. Multiple shorter training missions, levels, or stages grant the player syntactic and semantic knowledge about the game concept in a systematic manner. This does not necessarily have to be implemented directly as part of a game. Another popular method is to offer the player a way to select each of the stages on demand, and only if he considers a tutorial necessary. The tutorials are then detached from the actual game and most usually accessible through the game's main menu. The advantage for the player is that he can freely decide what skills and information he sees as useful to improve on his previous knowledge. Some players might feel fooled when they are forced to do tasks they consider trivial. Additionally, the technique permits a player to repeat a tutorial as often as necessary and parallel to the player's actual game experience, and there is no need to succeed in the tutorial in order to advance in the game. Its disadvantages are obvious. The tutorial is experienced as a somewhat alien element in the game and thought of as being isolated from the "real" fun. Explicitly labeling a tutorial as such uncovers its intention to teach the player something, which implicitly evokes negative associations and entirely contradicts a fundamental characteristic of most computer players: self-awareness. Voluntarily going through a game tutorial means accepting one's own inabilities and ignorance, and can thus only be ensured in case the player treats the tutorial as absolutely relevant for his success in the game. Within our context, however, success does not mean the ability to beat or complete the game as considered by the player. It is merely to provide the steepest possible learning curve for the player to understand the game's core mechanics, and to ensure a smooth transition between controlling real-world and game-world processes. A player takes such a scenario as given, which most likely is not the case.

Probably the most accurate and efficient method is thus to embed some type of game introduction directly in the context of the actual game, which initially makes it appear relevant to the player and as a task for which he is rewarded. Nevertheless, a tutorial should not be the very first invincible hurdle and should not have to be completed perfectly in order to experience the deeper fascinations and challenges of your design.

Summary

Within this chapter, we covered various, probably not instantly obvious, aspects of player-to-computer interactivity, and hopefully strengthened your understanding about its role in the entire interactivity concept. Each of the aspects, some more technical than others, can be a powerful key factor and valuable tool for the game designer to tweak the potential of the game's lower-level interactivity characteristics.

PLAYER-TO-PLAYER INTERACTIVITY

IN THIS CHAPTER

- Introducing Player-to-Player Interactivity
- Range of Potential Partners
- Freedom to Define the Range of Potential Partners
- Knowledge of Partners
- Knowledge of the Game Environment
- Variety of Interaction Channels
- Case Study: GameSpy Arcade

In this chapter, we examine in detail how you can design multiplayer online games to deal with the most revolutionary and innovative type of game interaction: player-to-player. This type of interactivity does not exist in a comparable form in classical single-player games, so the issues we discuss are the ones you probably think about last (or never). In actuality, however, this type of interactivity is what makes online games as unique and revolutionary as they claim to be (and that different to design).

INTRODUCING PLAYER-TO-PLAYER INTERACTIVITY

Player-to-player interaction defines the very nature of multiplayer online games! It is what makes your valuable players perceive these games

differently from other games they have played, and is probably why they buy them. If interactivity is what computer games are all about, then it is the same with online games and interpersonal interaction between the players.

Of course, interaction between players of a game existed before multi-player online games ever hit the shelves. But in what form did it exist and what was its role in the game? Players talked about their favorite games in taverns, they exchanged cheat codes, and shared tips and tricks on online bulletin boards That was about all the interactivity they had, however, and it wasn't the type of interaction that game designers had to consider or think about in their designs. All that interaction happened as a result of people playing the game. In multiplayer online games, however, real player-to-player interactivity is a central part of the game, and possibly the most important one.

This has nothing to do with communication only. Interpersonal inter-action in online games is more than chatting or discussing. You need to think about your games as more than being some high-tech chat applica-tion embedded in a 3D rendered environment. Communication in written or spoken words is only part of the whole. Player-to-player interactivity in today's online games is more. Contrary to single-player games, each player can now directly affect how other players perceive the game world. They can influence others' perceptions either *directly* (e.g., shooting at each other, stealing, talking, trading, etc.), or *indirectly* by changing the state of the world. An online game world can be all. It could be a level in a first-per-son-shooter such as *Half-Life*, *Unreal*, or *Tribes 2*, where you could, for ex-ample, blow up a bridge or plant remote mines, or it could be the whole huge world of a massively multiplayer role-playing game such as *Ultima Online* or *Everquest*. It could also "only" be round-based multiplayer *Tetris*, where hitting the high score also means changing the game state and the circumstances under which others play the game.

What all the forms of player-to-player interaction, general communica-tion, and complex indirect affection have in common is that they drive the game and keep it alive. Often, they even *are* the game! It is thus your job to pay tribute to its importance in your design, and your responsibility to know that carefully planned design *for* player-to-player interaction could mean the success or failure of your game.

So, how do we design for that type of interaction? What do we have to take into account, and how can we ensure to make it a central part of an online game? Hold on, we will soon delve into the details. First, however,

it is necessary to realize that designing person-to-person interaction in computer games also involves totally new challenges for your side, the game designer. Disciplines such as psychology, sociology, political and cultural science play a more important role in the design of computer games as they never have before, or even for the first time in the history of game design. The challenge is to broaden your perspective, to learn, to educate yourself, and to consider issues you perhaps didn't think could play a role. Designing online games no longer means designing only for American high-school students, but for the world!

Ready to face the challenge? Let's look at techniques and issues of designing player-to-player interactivity!

RANGE OF POTENTIAL PARTNERS

Your player sits in front of the computer monitor, impatiently expecting to meet many other people from all over the world, and is already thinking about what to talk about with all of them and . . . what happens? Where are all these other people? Every form of interpersonal interaction has one elementary precondition: it requires the presence of at least two individuals within the same environment. This holds true in real life and in virtual game environments. Therefore, the first thing you need to do in multiplayer online games is to let a player know that he is not alone and provide the feeling that he could play with whomever he desired. The second issue closely related to our first requirement is that if someone knows there are other players out there ready to play with (or against), he could still have trouble figuring out where they are. The virtual realms of an online world are huge, and you probably know how easy it is to get lost in it.

Before we discuss possible design strategies to meet these demands, we should first state the goals we are trying to accomplish within this context:

- Show a player it is multiplayer!
- Let a player know the places where other players are!
- Provide easy and fast ways to find and get to these places!

All this might sound obvious, but in fact it is sometimes not that easy and heavily depends on what type of multiplayer online game you planned your game to be. Let's look at some examples of how you could address this issue!

Half-Life and *Counter-Strike*, for example, rely on a peer-to-peer, server-network architecture. They are not meant to be played on constantly running game servers that players can connect to whenever they like (however, the popularity of these games resulted in a multiple of such servers in the end). Each player can set up a server and host a game environment to which others can connect. However, technically speaking, you would need to know the exact IP address in order to connect to such a server. Every player could host a game on his computer, and the nature of IP addresses is that they are unique within a network. (Letting your players guess the address and hope there's a game server running at the moment is definitely not an option.) If all people know each other and have a specific schedule for when to play, this would be less problematic. They could exchange the appropriate IP via telephone, mail, or yell it into the next room and everything would be fine. However, we are not designing for LAN play only. For Internet-based multiplayer online games, this is obviously not an option. However, you get the idea. If you don't explicitly design for it, this is exactly what could happen. Players would start your game and even if they know there is a huge mass of other people out there playing the game, they would have a difficult time trying to find them.

The solution that Valve came up with for *Half-Life* to solve these problems is both brilliant and simple. It can be assumed that is why various other games have followed or built on this example, and thus should serve as a reference for us as well. Basically, the technique works as follows. Each time a player sets up his computer as a host and therefore decides to make his game available to others, his computer reports its IP address together with other relevant information to a central, so-called "Game-Master-Server." This allows the master server to keep a database of all host computers all over the world and their respective IPs that are running a multiplayer *Half-Life* level or one of the game's multiplayer MODs. If you simply want to join one of these environments, your computer requests a list of all available hosts from the master server and there it is: a long list of sometimes thousands of games ready for you to join with a single click on your server of choice. Players don't have to know each other or one another's IP to be able to play with each other. And if you have seen a list like the one in Figure 7.1 in practice, you know that there is no danger of feeling alone—it's overwhelming.

We probably are all used to that simple way of finding other people in that particular type of client-server-based multiplayer games, so all this doesn't seem very special at first glance. However, it is actually not that triv-

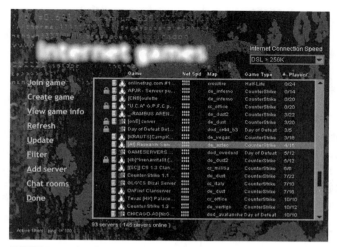

FIGURE 7.1 List of game servers in *Half-Life.*© 2002 Valve, L.L.C.

ial. It is just a very quick, easy, and effective way to meet the very first demand of player-to-player interaction: a wide range of potential interaction partners and an easy way to find them. It is online-gaming plug n' play.

Things are, however, a bit different for the design of games we usually refer to as massively multiplayer online games such as *Ultima Online, Everquest, Asheron's Call,* or *Dark Age of Camelot.* These games are also client-server-based games in nature, but run on one or multiple, constantly available servers. There is no need for players to exchange, remember, or request the server's IP address because it is the same 24 hours a day, 7 days a week. In the normal case, these persistent worlds feature a certain amount of so-called *shards,* which are different servers that run their own version of the game. Currently, this technique is mainly used for technical and geographical reasons, to keep the server load balanced or to minimize latency for players in different parts of the world. However, it can be a very interesting design issue to think about (we will look at that a bit later); the fact that multiple shards or even single shards are spread across multiple servers is less important within this context. As far as what concerns the player, he can always connect to the same login server that then hands him over to the appropriate server(s). There is no need to find out the exact IP address of this magician-type playing Siberian person you met last time. Perhaps we should leave all that to the programmers and move on to the next design

issue. We have achieved our first goal. The player has an easy to way to enter our huge virtual game environment and immediately knows that he is a part of our extremely large player community ready to interact with in any way he wants. Therefore, the range of potential partners is no longer an issue—of course it is!

Yes, the player is in a huge game environment populated by perhaps thousands of other individuals, but in our context the term *huge* is the actual problem we have to deal with. You need to make sure that players know where all those other people are and how to get there. This is an important point to consider throughout one's entire gaming session, but it is even more important at the beginning. Remember that chances are high that a person bought your game because it is multiplayer, with the intention to interact player-to-player. Providing a feeling of being alone is, simply speaking, bad. If you do that to a player who is entering the game for the first time (okay, let's call him a newbie), throwing him into a completely vast, deserted part of the world could even be fatal. The first few minutes are, here as well as in life, often the most important ones! It's the first impression that counts and leaves long-lasting marks. Let a lonely newbie explore the game for hours until he finally meets somebody else, and you have almost provoked a press on the Eject key of the CD drive.

If we analyze what our example persistent worlds—*UO, Everquest,* and *DAoC*—do, we recognize that each of them initially places a newbie within cities that tend to be reasonably crowded. These examples obviously don't mean that you have to design cities into your game or place it into some medieval setting and so on, but you get the point.

The same games also manage to keep the player informed throughout the game about the existence of others and where to find them. Even the most experienced UO player knows at every point in time at which places player-to-player interactivity is very likely and where it is not. He also knows the fastest ways to get to those points of interaction, and is thus left in a constant knowledge about the opportunity to meet others whenever desired or needed.

How can we accomplish this? How can we still reach those goals, our previously made mission statement for that issue of player-to-player interactivity? And not only during the first three minutes of play, but for the entire gaming experience?

There are three techniques that should be briefly discussed: maps, warps, and refreshers. So, we have already reached our first goal. The player knows that there are these certain places to go to meet other people. But

how does he get there? Where are they, and what does the player have to do to get there? Providing maps of such huge-scale online game worlds is a good solution. However, you should not think of maps as being only some top-down perspective on a certain walk-on landscape. Maps could mean anything from a 3D chart of a galaxy in a multiplayer online space shooter to a tree representation of a hierarchical structure. We should understand them a bit more generally: as powerful tools to visualize some content and information. There is a broad variety of content ranging from topographic, economic, political, and physical data to information about process development and problem solution—all which can be represented in various ways: 2D, 3D, isometric, and so forth.

Figures 7.2 through 7.5 show examples of different implementations of the map idea.

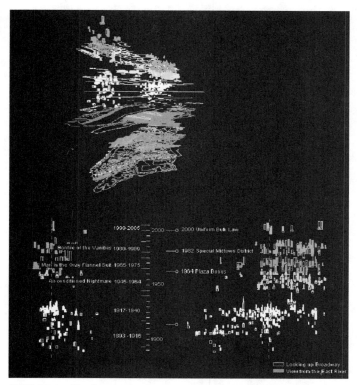

FIGURE 7.2 "Manhattan Timeformations: Mapping Manhattan's skyscraper districts through time." © urban-interface, 2002. Reprinted with permission from urban-interface.

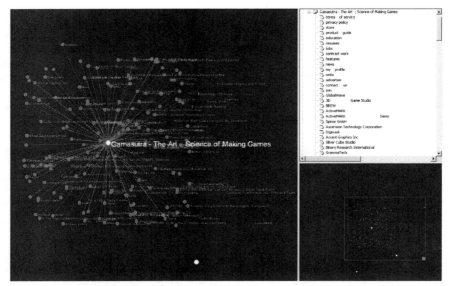

FIGURE 7.3 Visualizing the *Gamasutra*™ site structure in *Internet Cartographer*. Image from Internet Cartographer™. © Inventix Software (www.inventix.com), 2002. Reprinted with permission.

FIGURE 7.4 "Visual Who: Mapping a community according to its underlying social and organizational structure." Visual Who by Judith Donath. Sociable Media Group, MIT Media Lab.

FIGURE 7.5 Multi-resolution map of AlphaWorld (*http://mapper.activeworlds.com/aw*), a large-scale 3D multiuser environment run by *ActiveWorlds*. © Greg Roelofs and Pieter van der Meulen, 2002. Reprinted with permission from Greg Roelofs and Pieter van der Meulen.

A map is simply a navigational tool to orient oneself in unknown environments—real-life ones as well as virtual game worlds. People usually like to lay down complex things onto some sort of map. They love to visualize their perceptions to get ideas about a certain relationship. In our case, it is the players' relationship toward those special points of player-to-player interaction. Give them a way to know where in virtual space they are situated "in relation" to the point of interest, and they will know what to do next in order to get there. It's further important to remember what initial reason we had to discuss maps: interpersonal interactivity. "Interpersonal" already suggests that your map should focus on people and not landscapes! Here (other issues might require a different interpretation), players are not interested in mountain altitudes or star temperatures, to continue with our

examples. They are interested in other players. How many players are there? What kind of players? What do they do there? Those sorts of things and generally all relevant player-specific information you think would be helpful for the particular context of your game.

This was another strategy to let players know the location of (potential) person-to-person interactivity. The next thing we need is a *warp* to provide an opportunity to reach these places in a reasonable amount of time. As already mentioned, client-server-based multiplayer games such as *UO* or *Everquest*, designed as persistent worlds, are usually huge. Getting to a certain place within such an environment in real time could take you hours—hours you spend mainly traveling with the only goal to reach that location. Not really exciting and certainly not very motivational—the players of your game very likely feel the same. Therefore, you should give the player a faster way to reach certain destinations. Again, you could implement this in various ways and are only limited by your imagination and a seamless, logical way to integrate the feature into your game setting. It could be in the form of a waypoint system, wormholes, vehicles, or a magic potion. The hardest thing with such a feature is not how to implement it, but to keep it balanced. It should stay what we intended it to be—a fast way to move to crowded places—and don't want people to use it as their normal way of traveling, thus stopping to explore all the variances of the world. You could require the warp to be easily researched first, make each usage cost some resources, or limit it to a certain range. The best solution would be to engender a player to join with at least one other (human) player to do it. That way, you would have solved a player-to-player interaction issue by engendering player-to-player interaction. Perfect! It's less important *how* you implement warps than that you provide a way to reach interactivity spaces relatively fast as soon as a player decides to go there.

That leads to the third (and for now, last) technique to discuss: refreshers. After a certain period of playing persistent-world-type online games, it is a good idea to give these experienced players a little refresher. There is a point where the initial fascination of feeling part of a huge community seems to get lost and something extremely special finally becomes usual. It's sort of a burnout syndrome regarding player-to-player interaction, and often the moment players start to focus solely on themselves, on accomplishing one mission after the other or on advancing their character's skills. This is not bad and is only a different way of playing the game. Especially, a strong relationship between a player and his virtual representation in the game is something we should ensure (and will soon look at in detail). How-

ever, what we are trying to do here is to provide a constant atmosphere of player-to-player interactivity. You should remember that these experienced players are playing a multiplayer online game and not a single-player environment. Give them an opportunity to realize again what it is all about—interacting with other human beings—and its importance for the game! Show them the wide range of opportunities to act on a personal level, and what they will miss if they don't actively participate. It's a matter of reviving the fascination of "multiplayer"—most likely their initial reason to buy the game. To do that, we need to unfold all ongoing player-to-player activities directly in front of these players' eyes, to visualize it. One thing that fits those needs perfectly is a game-specific Web site (and not some subcategory of your company's site). We should give our players reasons to make it their starting point when playing the game; to make it their *home*page. Regular news, tools available for download, support, chats with the developers, or sweepstakes are possible ways to achieve that—but that is an entire topic on its own. The essential point in our context is to make the site a reflection of all players' activities and of our living game environment. Think of it as a platform for developer-player and player-player communication! People should be able to make their detailed profile available to others, publish their own screenshots of certain experiences, announce in-game events, post their personal gaming diary, or actively recruit other players for their clans, teams, and guilds. A message board might seem trivial, but it is yet another good way to visualize the presence of many other people in the game world and their activities. The effect of an active bulletin board, long lists of different threads about various topics, reminds us of the list of available game servers we saw in *Half-Life*—simply overwhelming. Yes, it's great to know that there is this mass of other people out there all following their individual online lives! Moreover, if you wanted to, you could easily get in contact with all of them!

All of these thoughts about a game's accompanying Web site are certainly also valid for multiplayer online games that actually run on the Web site itself, such as Macromedia Flash, Shockwave, or WildTangent games. To conclude this part of player-to-player interaction, we should take a quick look at what possibilities you have to reach the goals we have stated for this type of game. Although you could design them as standalone games as well, we will only consider those meant to be browser integrated. In our case, this is both an advantage and a problem. The advantages are that you don't have worry about IP addresses or issues such as that. Similar to persistent game worlds, the entrance point is always the same for all players—

it's your site's IP. Therefore, you already have them concentrated on a single point, which is definitely a good thing. The problem of getting lost within a huge game world is also less of an issue. Usually, these games are smaller (both game and project size); often, they are round based or, if real time, for a limited amount of simultaneous players only. However, this very nature, regarding player-to-player interaction, is actually the problem. You as a designer have far fewer possibilities to apply the techniques we talked about before *directly* within the game. What you need to do, therefore, is try to expand the game environment as well as the actual playing periods; try to make the game and its hosting Web site a unity, and use the opportunities of the Internet to your advantage. This sounds great in theory, but is still a bit vague. Let's clarify the idea with an example. A simple but great technique that various online community sites already use is an approach similar to the one in Figure 7.6. In order to let people know that there are others, these sites continuously display the number of users currently online (on site).

FIGURE 7.6 Visual feedback about other online users on a Web site.

For our game purposes and to visualize active, living player-to-player interactivity, we could build on that concept. We could show a categorized

list of all players—based on their names, high scores, interests, what level they are currently in, against whom they are playing at the moment, and so forth. A simple click on another's player name could directly allow contacting him via *ICQ*, *AIM*, or the like to send an invitation for a duel. Speaking of duels and tournaments, which are certainly a great feature on their own—you could even offer some type of spectator mode to watch other people playing and see your best friend close to beating your personal high score. For technical reasons, you wouldn't need real-time game TV. Showing the score will do the job, but you can almost hear your opponent crying the moment this simple number on his screen hits a certain limit. The important thing to see is that we have found a way to let players (who don't even actively play within the same game environment) know about the existence of others and what they are doing. In doing so, we introduce additional player-to-player interaction. Maybe you should invite your friend to watch your terrible revenge? The importance of discussion forums, bulletin boards, and the like should, as previously seen, certainly not be underestimated for this type of game as well. If the nature of your game hinders you from effectively communicating a wide range of potential interactivity partners, which is what we are after here, think about ways to embed the game in a context that fulfills your needs!

FREEDOM TO DEFINE THE RANGE OF POTENTIAL PARTNERS

The next issue we need to consider when designing player-to-player interactivity is to ask ourselves whether a player really desires the whole potential of interaction partners at all times. Are there times when a person prefers to interact with only a part of the game community, or even with none of the other players? Are there times when one wants to focus one's (inter-) activities on one particular group—times in which all those other people need to be limited to a more manageable, clearly arranged size? There are! And if we want to design *effective* interaction, we have to support this need in our creations. The way to think about this as a game designer is to design for a variety of possible purposes of the player. Purposes in virtual online game worlds behave similarly to purposes in real life: depending on what you are trying to achieve, they are centered on a certain group of people or even only on yourself. You have a certain need, and then you come up with a plan that you hope will lead you to your goal as easily and

quickly as possible. Finally, you flesh out this plan, build a list of consecutive actions, and find out on what (objects) or whom (persons) you have to target these actions. Therefore, obviously, finding a specific target is easier if you have some focus, a limited space in which to search. You don't want to look for the proverbial needle in the haystack, nor do you want to have to identify your mum in all the tourists on one of these wide plazas in Venice. Wouldn't it be great if you could make your mum start blinking in bright red with a simple click of a button?

This is what is meant by "freedom to define the range of potential interactivity partners." It's about limiting a player's search space and interaction radius depending on his actual purpose. A player who wants to trade a certain item, for example, or is just trying to advance his fighting skills doesn't care about a particular person or group to interact with. In this case, one's target audience is what could be called a *macro-community*: the entire range of players of the game. Needs such as sharing secret strategies, discussing game mechanics, or even voting a new guild master are centered on a smaller particular group of other players: the *micro-community*. A micro-community involves players whom one already knows about (at least about their online behavior) and has had contact with before. Often, this is a guild, clan, team, SIG, and people a user shares the same (game) interests with or whose way of playing the game is already known. Finally, there are "*friends*," players you are totally familiar with and to whom you can associate certain characteristics, behaviors, or expectations (both positive and negative). Those are your interactivity destinations if you need to laugh, take revenge, provoke, or need a sympathetic ear. Figure 7.7 illustrates the entire activity range, divided into three sections of different interest levels and proximity.

Where exactly a player draws the boundaries between these communities is his own decision and mainly a matter of knowing what reactions can be expected as a result of one's actions. The conclusion for the game designer, however, should be to give players possibilities to freely define those limits. We need to provide a way to focus one's actions on a certain range of people—only then does the player have a chance to execute the actions that meet his needs and purposes.

How can we do that? Take, for example, the possibility of chatting with other players directly within the game. This most basic form of player-to-player interaction, written communication, is possible in almost all of the popular persistent online games such as *Everquest* and *Anarchy Online*, and will thus serve as a useful example. Normally, if you type in a message, it is

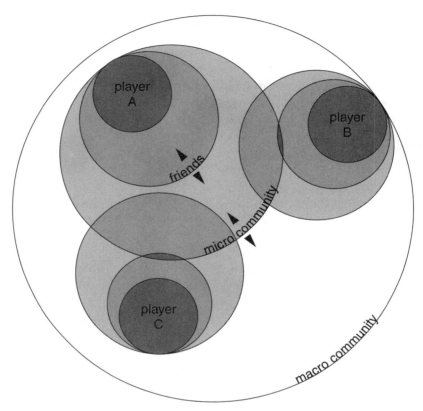

FIGURE 7.7 Macro-community, micro-community, and friends.

immediately displayed on screen to all other players within a certain range. Range, however, is usually meant as the same area of the map or as the same level; not as "range" as we should understand it in our concept of interactivity. What if you don't want talk to *everybody*; if you don't want to shout at the whole crowd hoping that somebody is listening, or the one you are intending to talk to is somewhere among them all? The most fundamental feature of a chat should be that it's possible to talk to only your micro-community when needed—your clan, guild, etc.—or to only a single other player. Similar to applications like *IRC*, you would then have different communication channels for different purposes. Such a filter could also work in reverse, only displaying the messages sent by members of that group that one has specified as his current range. This could be

accomplished in a variety of ways, such as applying a certain prefix to the messages, some console command, or easily controllable through the game's interface. And what could be done if a contacted player is not within the game environment at that very moment or not online at all? In the case of a really important one-to-one message, you might think about offering options to send a message via e-mail or check to see if this person is currently available on other popular messaging channels like ICQ or AIM. Generally, logging the messages for later delivery could be a great feature worth considering. Every time a player then logs in to the game (or visits the Web site), he could request the logs he is interested in. This could be only a personally addressed message, or include the entire communication history of his clan, team, or guild for a certain time span.

Thinking about more than "only" communication and a wider range of player-to-player interaction, another possible implementation comes to mind. Similar to assigning particular units to a squad according to its characteristics in some RTS or war game, a player could be able to add and remove others from a variety of player categories. Possible groupings include "mission-relevant persons," "people to avoid," "teammates," or "game masters." All of these groups can be freely modified—according to one's actual purpose—and simply accessible through the game interface and/or hotkey commands. This would not only allow organizing other players for chatting or communication, but one could also define specific visual, auditory, tactile (or olfactory?) feedback for the categories—"alert when online," "mark when onscreen," "display distance," or our already famous example, "show current score."

Let's shortly recap! In order to design effective player-to-player interactivity, we should give players a way to define a certain target audience that is most relevant for a particular task or goal. If we let them distinguish between macro-community, micro-community, or friends, player-to-player interaction would be easier and thus play a more important role within the game (which is what we are trying to do here).

KNOWLEDGE OF PARTNERS

Continuing, there is another issue from real life that game designers should consider when designing interpersonal interactivity for multiplayer online games. Imagine talking to (again, the most basic form of interaction) your

very best friend, your buddy at work, your project manager, and a complete stranger on the street. Perhaps you consider all of them your very best friends; but this is not the point. What is important is the way in which you communicate with each; the nature of the interaction is totally unique and different. You simply behave differently. All your actions are governed by both how you expect your counterpart to react and what you know about what your counterpart is expecting from you. Expectations and knowledge of others is a basis for the decision to execute specific actions. Go out and try it! You know that, for example, insulting your best friend might result in laughter, whereas doing the same with a stranger could end unpleasantly. That knowledge could be useful in one's decision of how to behave.

All of this can be transformed into virtual online game environments and holds true for virtual game relationships as well. Players need a chance to base decisions for or against their further actions on at least a vague knowledge about whom they deal with. They need to get an initial idea about another's character and (game) personality in order to act accordingly.

The most obvious way to do this in our designs is to provide some visual information available to all players upon request about one another's characteristics. Characteristics means all game-relevant information, a basis to interpret one's way of playing—name, member since. . . , average time online, number of kills, average ping, highest score, race, character type, member of guild xyz, most used weapon, rate given by other players, and so forth. You could, for example, display all this after right-clicking (or Ctrl-Alt-Shift-middle-mouse or whatever) on one's in-game character. Another possibility would be to separate such a feature from the actual game world and store each player together with all relevant information within a regularly updated, searchable database on the game's Web site.

The most elegant solution is probably directly embedding into the design of the game and thinking about alternative ways to communicate it rather than simply through statistics. In online games, this is mainly about giving a variety of cues to other players by your in-game character (at least in our opinion). We will have a very detailed view on the importance of online game characters and what giving cues is meant to be a bit later. However, we really should not leave off here without at least a short example of what to consider elegant.

As so often, *Ultima Online* does an exemplary job in showing us how to communicate information about a player. Do you know these hordes of players with red-colored screen names spread all over the world of

Britannia? You better! Those people are those evil player killers (PKs) who have nothing better to do than kill innocent other players and keep them from following their silent, civil, online lives. The game automatically displays in bright red every character's name that has killed more than five other human players within a specific period. See the screenshot in Figure 7.8 if you have never seen this before and don't know what this is about.

Would you agree that knowing that someone is a PK and has a slight tendency to kill other players could affect your reactions to this person? Do you think that knowledge could have some influence on how you plan to interact with that individual in the future? Perhaps we should put him into our group of "people to avoid" for future reference and documentation reasons.

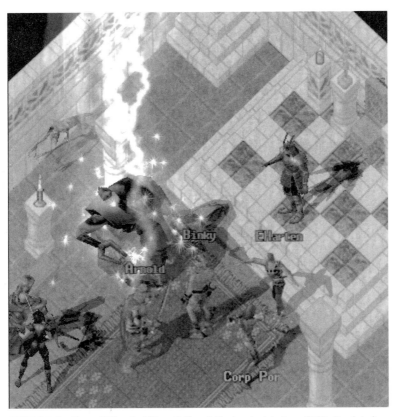

FIGURE 7.8 Player killing in *Ultima Online*. © Electronic Arts Inc., 2002. Reprinted with permission from Electronic Arts, Inc.

This is a very good example of how game-relevant information about other players (which player killing obviously is) can be communicated apart from only displaying a list of facts in a fundamental, although effective, semiotic way. It should additionally show what effect some knowledge about another's game personality could have on player-to-player interactivity, and thus why this issue should play a role in your game designs.

One last thing worth mentioning: knowledge of partners in online game design has nothing to do with knowing a person's real-life personality. We don't want to know anything about his real age, home country, religion, or whether he tends to react aggressively to insults—and other players don't either. The only things we are interested in are one's behavior in the game world, one's virtual personality, and one's gaming style. Doing otherwise would mean destroying three essential characteristics of online games (and games in general): possible anonymity, suspension of disbelief, and a boundary between the game world and real life.

KNOWLEDGE OF THE GAME ENVIRONMENT

We have already discussed why interplayer interactivity depends on one's interpretations of other players and the importance to design possibilities to get the knowledge on which to base these interpretations. However, player-to-player interactivity is not only affected by the characteristics of other players. All our behaviors, actions, and strategies are also governed by the environment in which we act. People usually behave differently within public spaces to some degree than they do at home, or even in spaces they are sure to be completely alone in. You know that turning on your sound machine in the public library could cause strange reactions, and that bursting into a conference room your boss is in to negotiate a new publishing deal could result in different emotions than disturbing a family meeting between your father and your brother. You know that and act according to your knowledge about what is expected from you under certain circumstances and in certain environments. You also assume that all other people have that knowledge and behave accordingly. This is why you can automatically associate a certain type of interactivity with a particular environment. You can *predict* another's behavior because the environment has already established certain rules of how to behave—rules that both of you agree upon as soon as you enter that space. If these rules—the way you can predict other people to interact—is not what you are after at the moment,

you have to choose: either don't enter, or never mind and risk the possible consequences.

This is the concept, but how does all that apply to the design of multi-player online games?

First, you can already assume that each player in your game has agreed to the rules of the game environment. Starting up the game normally means having at least a basic idea about the nature of the game and what types of game actions are primarily required. You know that playing a fast-paced first-person-shooter or a complicated strategy game requires long-term planning in order to succeed. Entering a game world means a decision for a particular type of actions, accepting the basic rules, and knowing that some of the rules could be different or invalid as known from real-life experience.

However, this has nothing to do with player-to-player interactivity, and is what should have been emphasized. Basically, this works (although simplified) in single-player-only games—games in which you don't expect to meet any other human players. It's nothing more than player-to-game interactivity, which we discuss in detail later. In multiplayer online games, we have to deal with a different scenario. We need to establish a rule-set for our game, and rules for our game society—for player-to-player interaction. Moreover, if you remember from where we initially started, we need to attach a specific subset of rules to different types of game environments for different behaviors.

In 1993, Julian Dibbel published an article about the first occurrence of a scary but fascinating event in one of the MUD environments of those times called "A Rape in Cyberspace." The title already says what type of problem we are dealing with here. It's serious. Since then, most online games state a general set of rules for social behavior in the game world in the form of a code of conduct similar to the one in Figure 7.9.

What follows is a brief textual excerpt from the code of conduct shown in Figure 7.9. Although this one is specifically for *Dark Age of Camelot*, the same basic rules should apply for any multiplayer online game.

Rules of Conduct
While playing Dark Age of Camelot, you must respect the rights of others and their rights to play and enjoy the game. [. . .]

Prohibited Conduct
Player may not use DAoC services to:

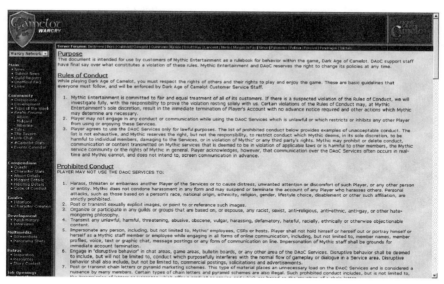

FIGURE 7.9 Excerpts from "Code of Conduct for *Dark Age of Camelot.*" © Mythic Entertainment, 2002. Screen shot(s) reprinted with permission from Mythic Entertainment, Inc. Screen shot taken from Camelot Warcry Web site. © Warcry Corp., 2002. Screen shot(s) reprinted with permission from Warcry Corp.

Harass, threaten or embarrass another Player of the Services or to cause distress, unwanted attention or discomfort of such Player, or any other person or entity. Mythic does not condone harassment in any form and may suspend or terminate the account of any Player who harasses others. Personal attacks, such as those based on a person's race, national origin, ethnicity, religion, gender, lifestyle choice, disablement or other such affiliation, are strictly prohibited. [. . .]

Harassment Policy
In Dark Age of Camelot, our goal is to build a strong community that offers a comfortable atmosphere for all of our players. This means seeing that players have the ability to combat antisocial behavior. [. . .]

What is considered harassment?
Harassment consists of flagrant misuse and abuse of game mechanics with the intention of distressing and offending other players. [. . .]

Also considered as harassment is any behavior that is incessant, inescapable, derogatory and directed specifically at you or your group. [...]

Behavior that is always considered harassment includes derogatory and/or hateful comments that are sexual, racist, religious, or related to gender or creed. Mythic Entertainment has a zero tolerance policy towards harassment of this kind, as stated in our Terms of Service, and violation of the above can result in immediate and permanent account suspension on the first offense.

So what happens when I report harassment?
When harassment is reported it is immediately escalated to a server lead or higher, and investigated as quickly as possible. We will observe the reported harassing behavior, and determine whether the harassment report is valid.
[...]

Disciplinary Policy
It is Mythic Entertainment's intent to provide a game that everyone can enjoy without the intrusion of Mythic Employees. However, there are times when issues arise that violate the Player Policy or Code of Conduct. When this happens, our in-game support staff will investigate each incident fully, ensuring that we are fair and equitable in our dealings with everyone involved. [...]

A rule-set like this is among the first things you should think about to implement for your own game. However, it is by far not the only solution to the problem, and it's not the optimal one either. Mainly there are two problems with this approach. First, such a rule-set is commonly only a long written document or list somewhere hidden deep inside your game's Web site structure. It's difficult to find and tedious to read. Second, it's only stated by you, the developer. Player-to-player interactivity in online games is unpredictable, and thus your rule-set will have to be kept very general and will never cover all potential behaviors your players might come up with in the course of the game. Therefore, what we need to do is give players an opportunity to establish their own codes of conduct. They should be able to define their own spaces for their specific needs within the virtual game environment—spaces in which their own rules apply, and spaces with recognizable boundaries. It's like defining one's own space of

privacy in which the rules of the game system still work (strategic, physical, commands, etc.), but that also defines its unique rules regarding player-to-player interactivity.

It's time again for some practical examples. Look at some of today's persistent online game worlds. It's almost obligatory that they are environments in which player killing is allowed and places where such anti-social behavior is prohibited. Generally, this is a good thing to do. It separates two different types of interpersonal interaction and two totally different needs. Players in PK-safe zones know about this rule and agree to it upon entering. This knowledge allows them to fulfill other desires safely—chatting, trading, exploring, getting to know other players, gathering resources, and so forth. There are also areas (or even entire shards) in which players solely focus on killing each other. As soon as you enter those areas, you also know that there will be no room for a flirt or a serious talk about the meaning of love and life.

The idea of different types of environments for different types of interaction does not end in "kill or talk." Let your players create (and maybe also design) their own individual space, environments for activities of their team or clan, tournament arenas, training camps, or conference rooms. There could be trade-only marketplaces, ranting areas, auctioneers, zones of total silence, liaison missions, or short-distance-weapons-only levels. The possibilities are only limited by your particular design and what type of person-to-person interactivity is relevant within your specific game world. Perfect opportunities to fall back on all the concepts and analysis you have done in the course of your planning phase! Suggesting anything specific here would not be appropriate without knowing the details of your design. However, it should be stressed again to spend some time thinking about possible ways to deal with this issue. Recognizable boundaries between these different environments, however, allow recognizing their different set of rules. This knowledge is the basis for your players to decide: stay out, or enter and deal with the consequences.

It might initially seem that all these thoughts only play a role in huge-scale persistent online games. This is true for a wide spectrum of different interactivity types as discussed previously. Each online game, however, can and should allow recognizing (and drawing) the border between the two most fundamental of these types: private and public interaction. A single player or group of players should be able to protect a certain part of the game environment for private purposes only. Two *Counter-Strike* clans, for example, can protect their game against any disturbance during

a duel or competition by defining a password for their game server. Those people who know the password also know what situation they will find themselves in, what the rules of the scenario are, and how other people tend to behave.

It is features such as this that you should think about in each of your on-line game designs. Design a "Private Only" sign and give it to the player to place somewhere! At least . . .

Variety of Interaction Channels

What else affects player-to-player interactivity in multiplayer online games? What else do game designers have to consider in their creations to pay tribute to the very characteristics of inter-human gaming? We have covered how much, with whom, and where. The next issue we will discuss deals with the how and through what transportation media subject of our most favorite type of interactivity. Again, we should start by identifying correlations in our real lives. Every day we interact with each other through many different media. There are multiple channels we use for connection: telephone, letters, e-mail, fax, or face-to-face contact. The reason we usually use all of them and don't only rely on one particular channel is that each has its unique quality and fits best to a specific purpose. They all have certain advantages and disadvantages, and it's this variety why we don't want to miss a single one.

Because you see and know from your own experience how important that broad spectrum of channels is in real life, you should also agree to its meaning for online game interaction. It would obviously change your life (or at least your relationship with other people) if you were limited to communicating only via written words. Your design should thus support the broadest possible range of channels for players to interact with each other. Let's figure out what characteristics make each channel unique and important in real life, and how we can apply them to our virtual game world.

Technology

An interaction channel can be categorized according to the technology on which it relies. Usually, this also implies the choice of a particular carrier media: analog or digital. Examples include telephone, fax, e-mail, letters,

voice-over-IP, chat, instant messaging, video conferencing, face-to-face-communication, third-party communication, and so forth.

SYNCHRONICITY

Synchronicity deals with the time that passes between sending and receiving a message (e.g., e-mail versus letter, instant messaging versus e-mail). It also means whether a channel allows both sending and receiving at the same time (e.g., chat versus e-mail).

FORM

A channel supports messages of different forms to a higher or lesser degree. Messages can be semiotic (written word), auditory (spoken word), pictorial (images, signs), tactile, olfactory, or symbolic.

CODE

All channels use encoded messages that require certain knowledge to be decoded and understood. The difference, however, is how common the code is or how difficult it is to learn. Many people in your game will probably know how to decode the English language (written or spoken). However, understanding the meaning of certain symbols or signs could either require some amount of learning or to be part of a particular group (e.g., military hand signs, heraldry, secret signs).

LAYER OF EMOTION

We also prefer certain channels over others because some let us communicate a degree of emotion with our message. In this regard, nothing is obviously comparable to direct physical communication. You also prefer the telephone to writing letters if voice tone plays a role. There, however, you have to do without the expression of your hand, and in case both of them are less essential, you could send your love letters via e-mail.

The preceding categorization is certainly not what you would call strict communication sciences, but it's definitely useful for what we are interested in: providing a wide variety of channels for game interaction.

Considering the types of communication just discussed, we see what our strengths and weaknesses are in designing online games. We have most of the technology available and know their characteristics regarding

performance and quality. We should think out of the box of chat-only on-line games. If you can technically support voice-over-IP or Web-cam communication in your game, then you should. You could allow one to leave handwritten notes on a sketch board somewhere in your game environment or on your Web site. It is necessary to be constantly on the lookout for new technological possibilities to allow players a broader spectrum of channels. Creating computer games has always meant to be at the forefront of revolutionary technologies—and sometimes new technologies are not only good for faster 3D graphics. Whether players try to use all of these channels is up to them, but you should give them a variety from which to choose.

Very often, using different technologies also allows you to cover more of the channel categories we discussed previously. For the sake of simplicity, let's stick with the most obvious and common form of player-to-player interaction for now: typed text—but even there is a lot you can do and think about. The typical chat within a game populated by many people can get very confusing. Therefore, you should provide a way to address one's messages to a particular player or certain group, thus imitating the advantages of an instant-messaging system. Players who need a less synchronous and immediate way to communicate could, for example, also type a message and save it for later delivery.

As we have seen, there are also different ways to encode a message. Consider the most common form of code: language with its signs, syntax, and grammar. Online games are played by players who speak different languages. Although you can assume that most of your players know English to a certain extent, communicating in a foreign language is always a bit harder. Sometimes it's just hard to express what you really want to say, or understand others' sentences in full detail. What we need is to let *all* players communicate with each other, regardless of where they come from or what language they know best. In large-scale persistent online worlds, this issue is obviously so important that you need to think about some type of translation tool directly inside your game. Each player should be able to type a message in his own language. Prior to sending and displaying the message, it is automatically translated into a language known by all other players (which in most cases will be English, but could even be Klingon or your very own game language). You can already see such tools in action in *Ultima Online* and *Everquest*. Such a feature certainly involves a lot of (programming) work. For smaller projects, the effort would simply be out of proportion. You certainly don't want the translation tool to be your game

and the biggest piece of work in the development process. In other games, chatting or communication in general is just not that important from a game design point of view. There are other forms of player-to-player interaction you might want to focus on (you didn't really miss a translation tool the last time you played *Counter-Strike*). However, if you only link the discussion forum on your game's Web site to one of the various online translation services such as Babelfish, you have already done something for more effective communication among your players.

Typed text as in online game chats has one major weakness: it almost absolutely lacks a layer of emotion. This is why players commonly make have use of the well-known emoticons. Especially in times when online games are increasingly meant for the mass market, this is something a game designer should care about. A real-time translation tool that explains the meaning of emoticons is certainly not a solution. They can't be translated into words without losing at least a bit of their actual meaning—that's why people use them! However, what we should do is think about ways to apply a bit of emotion to text. The first solution that comes to mind is pre-designing a set of emoticon-like symbols that players can then attach to their chat messages. Other possibilities would be to allow for a variety of different fonts, font sizes, and colors. A text's appearance communicates a sense of emotion even for the nonprofessional semiotician. You certainly don't want a word processor in your game design, and chatting is a very, very fast way to communicate when there's no time to apply some formatting. Normally, there are only five or six different emotions a player uses. To keep the chatting experience as it should be—type and send—players could predefine a certain formatting for a particular emotion, and then have those five or six different ways to send their message—"send aggressively," "send with laugher," "send stunning," and so forth. This is by far not an optimal solution and is not meant to be. However, it is an (additional) alternative way for your players to add some emotion to their written messages if they need or want to.

In our previous discussion, we used language as our code to ensure communication, because it's the most commonly known form of encoding messages that is most likely to be understood. However, using language and text is only one of many methods to encode messages and allow functional communication between those who know the code. Particularly in fictional computer game environments, there's a broad range of opportunities to implement interaction codes. Some ideas are shown in Figures 7.10 through 7.13. Two of these examples are already practically implemented in popular games. Figure 7.10 is a small outtake of hand signals

FIGURE 7.10 Hand signal analysis. © Valve, L.L.C, 2002. Reprinted with permission from Valve, L.L.C. All rights reserved.

FIGURE 7.11 Pictographic communication: Australian petroglyphs.

that players can use to communicate to their comrades in the well-known *Half-Life* modification *Day of Defeat*. Likewise, Figure 7.13 shows some spray logos that *Half-Life* players can freely design and easily integrate into the game to announce their presence or mark their territory. Figures 7.11

FIGURE 7.12 Message decoding: visual data analysis of radio signals scanned by the Arecibo telescope. © Seti@home, 2002. Reprinted with permission from Seti@home.

and 7.12 present two less game-specific approaches of how to understand interaction codes. The former is a collection of Australian petroglyphs, and the latter is a screenshot of the Seti@home client during an analysis of prospective extraterrestrial messages.

Perhaps we could also give players an opportunity to come up with their own codes that need to be learned to be understood. For example, imagine hand signs given by the leader of a squad to his troop in a military game (Figure 7.10), or leaving secret signs in meaningful places in the game environment (Figure 7.13). Everybody will be able to see them, but not all will

FIGURE 7.13 Spray logos from *Half-Life*.

know how to interpret them. This has nothing to do with cryptography in this context, but is about ways to interact on more subconscious levels. Groups such as clans, guilds, or teams would like that type of interaction. If your game features different races or character archetypes, you could

consider designing a unique message code for each of them as well—it's both secret and creates an additional sense of community.

The preceding two examples show probably the best and most appropriate techniques to support that type of communication in today's online games. Both are about giving signs, where in the first case they are given by a player's game character and are meant for immediate delivery. A player could, for example, bind a shortcut key to a certain animation sequence. In the second case, the signs are left behind somewhere within the game world and require a manipulation of the environment. This could be anything from carving symbols in the ground, putting up a flag, or launching a space buoy to warn colleagues about a minefield. The very quality of this particular interaction channel is that it works without any temporal limits. A receiver can pick up his message at a later time (or never). It should thus be clear that it is only relevant for persistent online games and those that keep changes in the game state over multiple sessions.

In this section, we addressed some of the specialties of designing different types of online game interaction channels. As some of the introduced techniques show, you will sometimes need to think out of the box and about alternatives (formatting text in online games?). Here, alternatives are the key; it's thus a matter of giving your players the choice from a broadest possible spectrum of interaction channels that all have their very own quality.

CASE STUDY: GAMESPY ARCADE

In addition to our discussion about network-related aspects in the previous chapter, we are now also armed with some social-specific knowledge about player-to-player interactivity. Therefore, and as an invaluable basis for our further studies, it makes sense to examine these issues a bit more detailed and practically oriented within a single context. An appropriate example that implements and demonstrates all these ideas in practice very well is GameSpy Industries' *GameSpy Arcade* (GSA). Together with Real Network's *RealArcade*, it defines a new generation of software tools for computer players, exclusively targeted toward satisfying the specific, distinct needs of the online gaming audience. Due to the gaining popularity of this type of tool, GSA seems having proved to be of additional benefit and value and to meet an online player's demands that were previously unsatisfied.

Let's analyze reasons why and how you could use these insights for your own designs.

For the sake of clarity and in case you are not familiar with this tool, let's first roughly outline its basic approach before we discuss some of the features and their meaning for our context in more detail. GSA is a standalone client application meant to be a platform that serves a variety of a player's needs and should be the bridge toward any game-specific information available on the Web. Its main purpose is to take the previously noted burdens from the player to localize all available host environments for the increasing amount of games that rely on a peer-to-peer/dedicated server setup for their multiplayer functionality. As a wrapper application, however, it is game independent and can support each "GameSpy-enabled" multiplayer game. From the standpoint of providing a wide range of potential interactivity partners, it therefore perfectly meets our demands (and those of the player). A player can launch already installed multiplayer-supporting games directly out of the GSA application that automatically scans the user's hard drive for available games on startup. It informs him about downloadable demos, previews and videos of new releases, and also offers a broad spectrum of available Web-only games that are part of the *GameSpy* network—ranging from simple card games to complex action-shooters, all of which can be easily accessed directly out of the GSA menu. For each game of interest the player can easily retrieve detailed information. He can browse to game-related Web sites, access various articles such as reviews, interviews, strategy tips, or previews, and download demos, trailers, or the most up-to-date patches and bug fixes. Figure 7.14 shows the application's main menu structure, which gives an initial impression of its functionalities and features.

The very core of the tool is a player's profile that is mainly built from information the player directly defines in the Profile Setup-menu, such as his name, home country, birthday, or ICQ number. Internally, however, his profile is also affected by the games that are already installed on his system and therefore tell something about his preferences for specific genres and types of action patterns.

This leads us to the first aspect of GSA that makes it worth mentioning within a context of player-to-player interactivity: player matching. The player-matching utility is, in our terminology, an easy and fast way to find prospective interactivity partners. Based on a player's installed multiplayer-enabled games, he can search for other players within the network who also have these games available on their systems. You can see whether these

FIGURE 7.14 *GameSpy Arcade*: main menu. © GameSpy Industries, 2002. Reprinted with permission from GameSpy Industries.

persons are currently online, what games they are playing at the moment, and then directly send an invitation to them asking to share a game session. This feature unfolds the unique and significant meaning of GSA as a tool of the online gamer. Rather than being a game tool, it is much more a community tool that serves the unique nature of online games as being a social activity and experience. It is a way for the player to find other people with similar or the same interests, and easily allows him to contact these prospective opponents and accomplices.

A player's GSA profile is thus not only used to his own advantage. It is further a valuable information source for other players to initiate meaningful, efficient, and satisfying interpersonal interactivity that is very likely to meet their purposes and desires. This aspect is carried on in the opportunity to request additional information about any other player that in most situations is only present on screen in the form of a screen name. At any time you can access one another's profile that is more or less revealing and expressive depending on what and how much information a player makes available to others. Clearly, this freedom to ensure a specific degree of anonymity and secrecy is an essential necessity within a virtual community. The player even has the opportunity to design his individual portrait that others see when they access his profile information. A portrait can be

anything from a self-drawn image or symbol created with some graphics editing tool to a user's scanned photorealistic portrait. Most often, this feature is merely treated and used as nothing more than a useless toy. You should, however, understand it as an essential attempt and first step to complement player-to-player interactivity with an additional level of communication that plays an important role in real life: visual expressiveness and facial expression. It is a way for the player to differentiate himself within the virtual community and to shape a part of his personality that he desires to represent in the digital domain. Seriously used, it can be used to communicate on more subconscious levels; for example, by exchanging the portrait according to one's actual mood or preferred (virtual) company assets. Players will get a better idea of what behavior and reactions they can expect from each other by getting such additional (in this case, visual) cues and therefore have an opportunity to adapt and appropriately alter their own activities. Similar to real-life, face-to-face communication, one another's visual expression can be significant in forming an initial, fundamental impression of one's opposites' characteristics.

The feature in GSA to request a player's profile by simply clicking on his screen name unfolds various other aspects meaningful to player-to-player interactivity. It offers an easy and immediate way to contact a player in a variety of ways, through different communication channels. His e-mail address is available as part of his profile, but you can also directly message him and initiate a type of private, one-to-one communication regardless of what game he is currently playing and "where" he is within the network. More important, however, is the ability to define the nature of future interactivity with a particular player. A player can be added to one's buddy list and is then a part of a prominent, instantly accessible interface menu. Thus, he is always informed about the status of those players—be it real-life friends or game companions—he already knows about, has experiences with, and who have already conveyed specific associations and expectations. He knows if his buddies are reachable at the moment and what games they are playing, and has therefore a group of players available so he can be sure to serve a distinct type of "familiar" player-to-player interactivity. Moreover, a simple double-click on one of your buddies' nickname in the buddy list directly transfers you to the game server he is currently connected to and playing on. GSA also offers the capability to search for persons whom a player might know from other, also non-game-related, online environments or platforms, such as chats, ICQ, message boards, or only from previous e-mail correspondence. A feature called "*PlayerSpy*"

lets him look for people within the *GameSpy* network by specifying search parameters such as name, ICQ number, nickname, or e-mail address. Similar to the buddy list, other players can also be added to one's ignore list for specific reasons and thus be kept mute in any future attempts to communicate. These features practically demonstrate one aspect we have already discussed: providing the player an opportunity to define the range of potential interactivity partners according to his intentions and purposes.

GSA's menu and navigation structure reflects that the tool is still centered on a game rather than a community aspect. It seems to assume a player as mainly a person looking for available game environments rather than for the specific people playing these games. Game-related information is, however, really detailed and useful. Immediately upon startup, GSA provides the player with the most recent news of the computer gaming market, a list of all available games, categorized by genre, and how many people are currently playing a game. For each game of interest, a player can then access a detailed description that covers its minimum system requirements, billing method, the possibility to win prizes, a rating score, and a list of related games. A player has thus a complete and compact source of relevant information that he needs to decide whether a given game environment and its players are able to meets his demands, purposes, and desires. Depending on what particular game he decides to play, he has additional ways to further refine his search while looking for that "perfect" online game world. In the case of *Half-Life*, for example, the first vital choice is based on which of the increasing amount of available MODs the player prefers most. Already at this early phase of his decision making, the player can choose among significantly different types of game and interactivity experiences that each require a distinct behavior and action pattern and thus fit a specific purpose. A player is then presented, as for any other game based on a similar network architecture, with a list of all available host environments he can join (or create his own new game session). Referring to our previous examinations, however, the most significant aspect of these host lists is the ability to apply a multitude of different filters; the player's opportunity to make the network of hosts and game environments transparent and informative. The listings can be filtered and ordered according to connection quality (ping), room name, the amount of participating players, free player slots, or a game-specific category or map/level type (CTF, Co-op, deathmatch, fun, etc.). Moreover, players who want to host their own session can briefly describe their environment to communicate a special purpose or rule-set, and password

protect a game from public accessibility. A noteworthy feature of GSA in this connection is also the possibility to specify custom filters—a personalized combination of filtering criteria—and save them for future reference. These filtering utilities are a very efficient and easy way to limit the often confusing and broad array of game environments on hand to only those immediately relevant to one's preferences and requirements. Providing the opportunity to restrict an environment to only those players knowing the password is a first approach to allow the definition of virtual private spaces. Ensuring that only specific persons can participate within a virtual world also results in the freedom to define unique rules or codes of conducts that govern these spaces and guarantees everyone's acceptance of them. This is, for example, often required and needed for various social and team events such as guild or clan tournaments. In GSA, however, the player is limited to protect one game environment as an entirety, what for persistent online worlds without multiple simultaneous sessions would definitely not be an option. Although sometimes more problematic, implementing an opportunity for players to define private spaces within the game environment that fit their very distinct purposes and intentions should be an issue in every online game design.

By selecting one particular host from the list that the player is interested in joining, the according game either instantly starts and automatically connects to the host, or the player gets still more detailed information about the players currently populating the given environment. At this stage, players sometimes—again, depending on the game—have to wait until enough players are available to start a new session or the game's previous round is finished. This would not be worth mentioning on its own unless it would not perfectly demonstrate how such times could be used to give the player supplemental essential knowledge needed for his decision of whether to leave or enter the environment.

Figure 7.15 shows such a scenario in GSA, which, in this case, is a game screening room for Bohemia Interactive's *Operation Flashpoint*. From a social, player-to-player interactivity perspective, a player's range of communication partners is already enormously focused on only those persons immediately relevant to his current purpose. Players have the opportunity to get an initial vague idea about each other and roughly study their characteristics by chatting in this small group environment. A very nice and also extremely helpful feature is that each player's actual (real world) geographical location is visualized by a blinking dot on a world map as you can see in Figure 7.15.

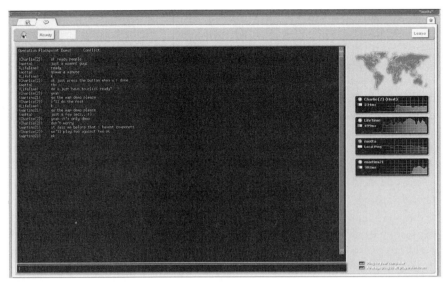

FIGURE 7.15 *GameSpy Arcade* game screening room: Small group interaction environment. ©
GameSpy Industries, 2002. Reprinted with permission from GameSpy Industries.

The map provides more than just significant impressions of one an-
other's potential social, cultural, geographic, and religious milieu. It man-
ages to remove each player's virtual mask and underline his existence as a
physically present individual and personality rather than just a virtual con-
struct of bits and bytes. Additionally, it strongly emphasizes the commu-
nity aspect of multiplayer online games and their understanding of being a
worldwide social entertainment activity.

From a network and technological point of view, the map is obviously a
useful tool as well by giving a vague indication of latency drawbacks to be
expected. In this regard, however, more important to note is the detailed
network graph that GSA provides for the player and each of his prospective
co-players. It illustrates, in real time, the player's ping(s) to the actual host
server of the game environment and to all other players of the group. A
player can thus easily compare his own network status and condition to
those of all others, which, particularly for fast-paced online games, can be
a meaningful criterion; substantial information for both a player's inter-
pretation of and expectations to the nature of player-to-player and player-
to-game interactivity.

To conclude our discussion of *GameSpy Arcade*, it should be noted that it is a valuable tool for the online gamer strongly focusing on his game's multiplayer aspect and always on the lookout for new game partners and available online game environments. Its definite strength is the support and applicability for a variety of games, ranging from retail CD games to free Web games and new downloadable fee-based applications. As such, it is not only a useful approach for the consumer, but also for the (smaller) game developer by offering a platform of alternative distribution and billing methods. Game-specific information it provides to the player is thorough, useful, and solid: detailed descriptions, reviews, related Web sites, tips and tricks, demos, trailers, and the most recent add-ons and patches.

Regarding this point, only a few suggestions for possible improvements come to mind. GSA's main competitor on the market, RealArcade, automatically checks if the user's system meets the requirements of a new game he is going to download and informs him about the approximate download time according to his connection. RealArcade also seems to emphasize the community and social aspect of online gaming a bit more rather than mainly approaching the field from only a game-oriented point of view. In GSA, the central concept is still the games and not the players—regardless of what games they play. This aspect is probably the weakest point of GSA that also reveals the biggest potential for future improvements.

All this is not to say that features such as player matching, buddy and ignore lists, and *PlayerSpy* are not efficient and valuable tools for localizing the appropriate interactivity partners within the network. Particularly, the comprehensive set of customizable filter options supplies a straightforward way to seek out those environments that are most likely to meet a player's current main requirements. A huge potential, however, seems to lie in the player's profile that could cover additional characterizing facets and thus be a personality and behavior model rather than only a list of name, birthday, and e-mail address. Additional attributes—both game and non-game related— could serve as an information basis for his profile: real-life interests, hobbies, geographic location, or records of games the player has most often played and for how long, and records about what games he has played online and how often. Such an extended information set would allow treating the player from both the perspective of a computer player and as a participant in a game community. His profile could be the basis to present him personalized information from a game and community point of view. By including real-life characteristics or attributes such as morality

and mood ratings as search criteria within the player-matching utility, the tool would allow the player to shift his focus to the human side of things; a scenario in which a particular computer game no longer plays the dominant role.

Likewise, all knowledge about a player could serve as a basis to present him further personalized information according to his proven preferences, desires, purposes, and favors. Unquestionably, GSA already offers a thorough and regularly updated information source for the online gamer. The way a player structures and accesses the mass of information is, however, mainly dependent on prioritizing a distinct game genre. An expanded profile would be one way to leave this narrow genre-specific context in delivering personalized content. What new released games would the player like to know about according to his real-life interests or favorite computer games? Does he prefer a specific type of game experience or required game duration? Is there any new supplemental information available for his favorite games, such as reviews, tips, rankings, or other players' ratings? And what games do players with similar profiles like the most?

In future eras of mobile multiplayer gaming, part of a player's profile might also include information such as his previous travel routes, "focal points," and exact (current) geographical location. This might still be some time ahead, but then—some say sooner, some say later—such data could be a factor that directly affects the course of gameplay of a specific mobile game. It could also be part of a game-independent platform such as GSA. At the airport during a business trip your cell phone will suddenly beep when you run across this person who has recently beaten your high score. What you personally would do is completely up to you. However, very likely it would be some type of player-to-player interactivity.

Here, as in most issues concerning collection of private data and recording a user's activities, it's essential to bear in mind that the boundaries between violating the right of privacy and using the information solely to a player's own advantages are fuzzy. It should therefore always be a player's own decision where exactly those limits are and to what degree he is willing to be scanned for the sake of efficient online game interactivity.

SUMMARY

Examining player-to-player interactivity from the perspective of our interactivity concept and as a governing element of online game design has

demonstrated what additional implications online game design has. The designer no longer only creates a game, but has to design a platform for interpersonal communication and interaction. More than ever before in the history of computer game design, you need to complement your design repertoire with social scientific aspects out of psychology, cultural science, philosophy, or political science.

PLAYER-TO-GAME INTERACTIVITY

IN THIS CHAPTER

- Introducing Player-to-Game Interactivity
- Spatial Representation
- Mapping
- Media Personalization
- Atmosphere
- Content Creation

This chapter completes the introduced concept of interactivity for multiplayer online games with a discussion about the third perspective on interactivity: player-to-game. It unfolds possible strategies and techniques for designing immersing information exchanges between the single player and your game.

INTRODUCING PLAYER-TO-GAME INTERACTIVITY

Player-to-game interactivity treats those issues of online game design that are most similar to techniques known from the design of more traditional single-player-only games. The dimension as a whole, as previously conceptualized, is about interactivity between the player and the game, and

covers how a person interacts with the game as a media. All variables, strategies, and attributes of this type of interactivity result from the nature of the media online game and what can be identified to shape this very nature. The game is split into the contents from which it is built—graphics, sounds, story, game mechanics, characters, and so forth. Discussing and analyzing these aspects and evaluating how they affect a player's interactivity experience with the game should lead to the factors and issues that have to be considered in the design process.

The following pages thus introduce a set of issues that play an essential role in a player's interaction with the game, and what possibilities the game designer has to incorporate a dimension of player-to-game interactivity in his online game designs. This discussion will, however, mainly focus on techniques that differ from single-player game design to a certain degree.

SPATIAL REPRESENTATION

Designing multiplayer online games and considering possible strategies to increase a player's interactivity experience with the media often leads to a discussion about game content, adapting plots or altering mission trees, and interactive storytelling. This is certainly a challenging and fascinating subject and complex enough to fill an entire book on its own. What is often overlooked, however, is that story and plot are only the temporal dimension in player-to-game interactivity. There is also a dimension of space and a player's spatial placement within the online game world that plays a significant, often underestimated role. We should examine how the techniques of presenting the game environment to a player and of representing him within this virtual space affect his interactivity experience, and how to account for it in the game's design.

Today's online games show a variety of possible perspectives used to render the world on screen, of which the most common are:

- Top-down perspective (fixed or scrolling)
- Side view (fixed or scrolling)
- Isometric viewpoint (fixed or freely adjustable)
- Over the shoulder
- First-person perspective

Each perspective has its own advantages and disadvantages, and has proved to fit best for particular types of games. The most basic issues are normally overview, orientation, interface or menu system, technical capabilities, and the players' expectations of a certain type of game. What technique you consider most appropriate for your particular game depends on the requirements of your design, your willingness to break with established conventions, and your personal experiences and favors. Therefore, we won't go into any further detail here. However, what we should do is take a more detailed look at one special concern that you should think about in your designs: experienced meaning.

EXPERIENCED MEANING

One matter in your examination of what perspective is most likely to fit with the intention of your design is to what degree the player should experience significant meaning. That is whether you want to provide a more passive experience or strive to place a player as close to important incidents in the game world as possible.

Experienced meaning is a matter of who is affected by specific events and how close that situation seems to be to oneself. Isometric perspectives, for example, as known from *Ultima Online* and most real-time strategy games, provide a more distant view of the environment and the player character. The result is a clearly arranged, strategic viewpoint, but a rather sober experience. Everything that happens to the player doesn't affect the player directly, only some pixels on his monitor; at least it is experienced in that manner. The same holds true for games that feature over-the-shoulder perspectives; for example, *Tomb Raider* or *Hitman*. Certainly, similar to real life, the closer you are to a certain event, the more meaningful and obvious it becomes. However, as long as a player can examine the affairs happening to him passively from the outside, be it a hit or a conversation with another player, the situation will not be treated as meaningful and important as through a first-person perspective.

Spatially placing the player into the virtual game world similar to what he knows from real life, perceiving the surroundings through his own eyes from a first-person view, also means affecting the player directly. The player is directly addressed and directly manipulated. The results are more meaningfully experienced game scenarios and an increasingly vivid and active interactivity experience with the media.

You should not, however, limit your considerations about the most accurate perspective only to graphics-related issues. There is a textual and aural perspective to take into account as well. Simulating real-life perception should, for example, also imply trying to mimic spatial hearing. In-game text is as another part in providing a specific spatial (re)presentation that can address a player either directly or indirectly. Do you (or the game) talk to the player, or do you narrate a story about that adventurer on screen using the third person? Do you give the player on-screen instructions from your developer's point of view, as part of a tutorial, for example, or is he introduced "personally" by some NPC?

As a general rule of thumb, first-person points of view tend to provide a higher experienced meaning. If this is what you want to reach in your design, this should be the preferred way to place a player into the game environment, or you should at least give an optional possibility to perceive the world from that perspective. It is especially important if your design focuses on game characters that try to capture and emulate their respective player's real-world character and personality—a topic the next chapter discusses in much detail. First-person POVs address and manipulate a player directly—as a person, human, and individual. However, if there are certain expectations from your audience toward a particular type of game, or if your design and game are primarily governed by the necessity to keep orientation in 3D space, a third-person POV definitely has its advantages. This is also applicable to design concepts that require the player to know his physical appearance and consciously need to keep a certain emotional distance between the player and his avatar. This is often the case if you are trying to build up some character franchise akin to Mario or Lara. However, that concern is usually less of an issue in multiplayer online games where every player is the next prospective main hero. In some games, it would even make sense to provide multiple different perspectives; either optional or dependent on specific situations in the game. Today, most online games don't have a lot of cut-scenes simply because they have remained a merely noninteractive, single-player design element. However, as fresh perspectives on the media arise and new technical capabilities open up, we should observe new ways to design a player's experienced meaning. Then, techniques as known from games such as *Deus Ex* that use a first-person point of view for the gameplay and a third-person view for the cut-scenes will definitely be interesting to consider.

MAPPING

The following thoughts about mapping could be considered a part of interface design and play a significant role in a discussion about character design. Most importantly, however, mapping is most closely related to the last section we examined: the spatial dimension in player-to-game interactivity. Why? Because it is primarily a matter of how the player moves through the virtual space, and real-life three-dimensional space is translated into the two-dimensional space you see on a flat computer monitor. It is, therefore, largely a spatial design issue.

Mapping is about how and in what ways a player can map his intentions, behaviors, goals, and actions onto the game. However, the game also needs to translate messages from game space back to player space. Mapping is thus two-way message and information processing between the player and the game back and forth, simultaneously, and in both directions. Therefore, we should look at both directions separately.

MAPPING THE PLAYER TO THE GAME

Throughout the entire game, the player continuously has to map his thoughts, actions, and desires to the game in a language that the game system understands. This language is defined by the game's manipulation rules that a player has to know and learn in order to communicate with the game environment in efficient ways. The concepts in a player's head have to be converted into game concepts. Your primary goal should thus be to make that conversion as easy and intuitive for the player as possible. Efficient mapping almost solely depends on how difficult it is for the player to translate his thought language into the game language.

There is nothing you can do to a player's thoughts, but what you can do is design your game's manipulation rules and try to minimize the gap between this language and analogies stemming from the human brain. How could you do that? There are two options.

First, you could use what a player already knows to your advantage; that is, allowing a player to map his behavior onto the game in natural, familiar ways. You ensure that the player can directly apply his knowledge and experience of manipulating the real world to the game environment—able to speak a language he already knows very well. This is another advantage of games that provide a first-person point of view. The player moves and

manipulates objects as he would in real-life environments. Objects are manipulated directly rather than by a click on a magical button on the interface, and affecting the game world is not subject to mysterious remote control. The player can map his intended actions onto the game because there are recognizable correlations between the game world and his daily real-life experience. Bridging the gap between those two language systems is easier, and results in more efficient and functional player-to-game interactivity. The conversion process is unconsciously supported by the player's real-life knowledge and practice.

The idea of intentionally known manipulation rules is not only applicable to the player's point of view, however. Consider, for example, the action of repositioning an arrow cursor on the screen by moving the mouse, which is a pretty common task in computer games. Basically, manipulating objects by clicking on them using a mouse pointer is a rather abstract action. In actuality, it's a very complex concept that only exists in the virtual computer world and is by far not trivial. We only are used to it because we learned to understand it, but the most correlating real-life action is pointing at something with your finger, which doesn't really result in the same. What we should do is think about alternatives in our designs to what is automatically assumed the known and best way to manipulate game environments. Take a stance on the subject and observe potential options to established manipulation rules that are more closely related to our real-world rules. According to the previous example of the mouse pointer, probably the best example for more diversity is now *Black & White*. The game uses a hand as a cursor that continuously changes its orientation in 3D space according to the shape of the game object onto which it is applied. The player can grab the objects, throw them around, and slap or hug his creature. Similarly, a wizard waving his magic wand can draw symbols on the landscape to cast spells or pick up villagers, trees, or stones. Figures 8.1 through 8.3 show only a small selection of these elegant ways to map real-world actions onto the computer game environment.

It is not, however, only the graphical representation of the mouse pointer as a hand. This is certainly a very efficient technique alone by seeming that obvious. We all are used to manipulating our surroundings with our hands. However, what makes mapping unique and elegant in *Black & White* is that the system also mimics the nature of the movements involved in all the actions according to their real-life counterparts. The direction of your mouse movements, for example, determines the direction of a throw

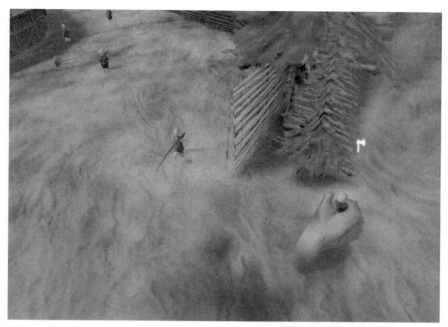

FIGURE 8.1 *Black & White*: Picking up a villager. © Lionhead Studios, 2002. Reprinted with permission from Lionhead Studios.

(Figure 8.3), and the angle from which you slap your creature will impact the way it is pushed (Figure 8.2). The player also grabs the landscape to navigate through the virtual world and uses objects as anchor points to adjust his point of view as needed. The game thus simulates an easy, imaginable scenario in which you would be restricted to use only your hand to move around in space. The player is almost motivated to try out how that would feel in real life and can intuitively map this imagination (or empirical insights) onto the game.

This idea leads to the second possible strategy you should take into consideration when trying to minimize the gap between human brain models and those of a multiplayer online game. The nature of games is that they are games and not real life, and therefore use many concepts and paradigms that simply do not have a corresponding real-world analogy. Situations in which the player cannot rely on real-life experience and knowledge in making his decisions and performing his actions are quite common in game environments. This is where abstraction comes into play. You need to abstract

FIGURE 8.2 *Black & White*: Slapping a creature. © Lionhead Studios, 2002. Reprinted with permission from Lionhead Studios.

these actions to some degree to give the player an idea of what the action is about, to what it will lead, and what he needs to do to perform it. There are different ways to abstract a certain duty, action, or sequence of them.

The most common and simple one in today's games is using some form of graphical interface element such as buttons, sliders, or pop-up menus. Clicking a button or dragging a slider with the mouse pointer executes a specific action that then further manipulates the game system in some form. The major problem with buttons, however, is that that they are the very highest level of abstraction. What does a button have to do with a particular action? A button is only a button, and clicking it could cause. . . whatever. Of course, that's why we name them or give them a unique appearance, but the problem remains. Even named buttons make it difficult for the player to recognize a relationship between a button and a corresponding action. In order to map his intentions and goals to the game, the player needs to learn and remember what button belongs to what action. This is acceptable for, let's say, five different actions, but is definitely not an option for complex, persistent, online game worlds.

FIGURE 8.3 *Black & White*: Mouse movement determining throw direction. © Lionhead Studios, 2002. Reprinted with permission from Lionhead Studios.

Especially in designing online games, there is another fact to account for regarding buttons and similar elements of the interface; more precisely, regarding their naming and symbolism. Designing symbols and using certain expressions to communicate a concept and evoke suggestive imaginations on the side of the player is critical and problematic in games for a potential world-wide audience. Different cultures, religions, and philosophies often interpret the meaning of symbols (are they in form of color, shape, or linguistic expression contradictory?) and associate different ideas with them. Therefore, what is normally a big strength of symbols as design tools being an instantly perceptible visual anchor for a player's thoughts and ideas could be counterproductive in the realm of online game design.

None of this is to say that buttons, symbols, and linguistics are a bad way to abstract the actions available to the player. They are only one way to do the job, and as we have seen are often not the most efficient or accompany other tricky resolvable design complications. Are there alternatives?

There's no way around a certain degree of abstraction in some situations when trying to make the conversion from a player's "language" to game

language as easy as possible. Therefore, there is no alternative to abstraction, but there is one to how you abstract. Rather than spending hours and useful resources thinking about what could be the most accurate and obvious symbol to portray an action, you could first thoroughly analyze the nature of the action. Try to describe the action similar to how you would examine an object for which you want to design an appropriate class implementation in some object-oriented programming language. Come up with a list of the action's properties and functions. What items are involved? What is the reason to do it? How does it affect the game world, are there any necessary pre-conditions and what are the results? Are there any subjects or verbs that immediately come to mind? Finally, revise the description, considering that "this sounds like. . . ." What we are getting at is that we can base the abstraction process on familiar, real-world phenomena. Actions that initially don't seem to have any direct real-life correlation might unfold obvious relationships and similarities to the most common real-life tasks. All this might sound stupid, useless, and tedious. However, it is a technique that can open up different ways to implement manipulation rules more closely related to real-life concepts than clicking on a button is. It means abstracting an action toward a similar, known real-world experience rather than farther from it. How many people have actually navigated a land-speeder or battle cruiser? Perhaps that works similar to steering a car or motorbike and is about turning wheels and twisting handles.

The player will recognize these analogies. He will eventually have to be informed about the resemblance or figure it out. However, he will not have to learn how to do this certain action and, most importantly, will remember it throughout the game and can draw conclusions toward many other action models of the game world. Moreover, if no optional way of abstraction ensues from that technique you consider proper for your design, it could still be a useful method for revealing what label or icon might fit best for the buttons.

What finally remains to be pointed out about mapping the player to the game is something that is especially noteworthy for the design of multiplayer online games. Not only does a player need to map a behavior or his intended actions to the game. In the course of the game, and yet throughout multiple separated sessions, he also needs a possibility to map a personality. The idea is closely related to a very general understanding of a player's game character as his "individual representative" in the virtual game realm. He should have ways to conquer the disparity between the intended "I," the personage living in his mind and imagination, and the ex-

perienced "I" in the game. All this has a lot to do with focusing on character design, which we will soon thoroughly examine. Perspective and point of view also play an important role. A first-person point-of-view setup in which the player *is* the character is most likely a smaller barrier for the player in finding a mapping for the persona he wishes to present. Therefore, this is also something to account for. Last but not least, mapping a personality is a matter of personalization—but the aspect of media personalization in player-to-game interactivity is still a chapter ahead. Let's stick with the meaning of mapping a bit and look at how this player-game process could function the other way around: from game to player.

MAPPING THE GAME TO THE PLAYER

We have seen that a player incessantly tries to convert his language to game language and to map his concepts and intended actions to the game—and the game continuously does the same conversion. What the game needs to map onto the player are its rules, states, and all the information the player needs to make his decisions. A game's thoughts are its bits and bytes and the corresponding rules that govern how they work together. The information it needs to talk back to the player is thus simple data, and its task is to give that data some expression and meaning. You might be thinking that this is why we put colorful symbols, bars, images, and interface elements on a player's screen. You could certainly call these methods "mapping," but it is very likely not efficient to simply shoot all available information at the player without any consideration. Depending on a game's complexity, there is a lot of information a player should be informed of. The challenge now is not to convert data into any visual representation, but to translate the information at hand into a meaningful, instantly comprehensible one that the player can bring into a distinctive context.

The element of the game that has to do this conversion is commonly treated as its interface. There are three main demands the interface would have to meet in order to allow more efficient mapping of game information and data to the player:

- Keep data and information away from the player that he is not interested in or doesn't need to succeed in the game.
- Abstract data and information into known, familiar concepts.
- Analyze data and information according to required granularity and detail.

Let's briefly look at each. Regularly surfing the Internet is enough to know that a certain amount of information can make you blind. Either you are unable to recognize what you are really looking for, or you get totally distracted from your initial goal and end up doing things that in fact don't bring you a step closer to said goal. Information explosion can be the end of any effectiveness and lead to information-induced panic; and so it is in computer games. To keep unnecessary information away from a player, the interface would need to be "intelligent" enough to know the type of information and to anticipate a player's needs and situation. It could then evaluate the data category against a player's conditions and filter out any useless and unimportant information prior to presenting only the revealing facets to the player. Is a player trying to defeat a horde of NPC monsters and needs to know about his health status, mana, available weapons, and strengths of the opponents? Does he maneuver through a labyrinth or asteroid field, or wander around in a deep forest? If so, then his radar or map should show possible paths or distances rather than the population of the cities, planets, or whatever. Do other players or NPCs like to start a conversation? That's where statistics about these characters, an emphasis on their messages, and a prominent chat window would be advantageous. These are just a few examples where the interface adapts the information it presents to a player's changing circumstances. However, you get the point: it prioritizes the most essential and useful aspects for the task at hand over information that is less relevant for a player's present situation. What this means for the player is an ability to focus on a particular short-term goal and base his decisions on only the data he needs for his purpose without distraction. But how can we design for such intelligent interfaces?

One method is to think of the game's objects (its data) as they would constantly send out messages to the interface that is responsible to present those objects' information. Remember, it is not yet important *how* the information is presented (pictorial, textual, acoustical, tactile, etc.), but *what* is presented. Therefore, each object continuously transmits one or multiple waves to the interface throughout the game. Such a wave, however, does not only carry the information, but also an according information type (combat, strategy, conversation, navigation, character stats, etc.) and detail level. This imaginary scenario is illustrated in Figure 8.4.

As visualized by step 1 in Figure 8.4, each game object (or group of objects defining a specific situation) continuously emits information data along a carrier wave that also holds all relevant supplementary data such as

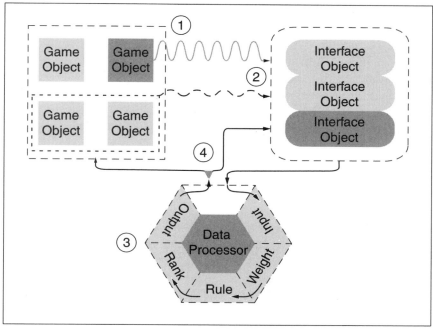

FIGURE 8.4 Communication between data and interface.

info type or detail level. The interface then captures these waves of every object for a particular game situation or game state at a given time (2). The captured information is processed by the data processing module (3) that applies a specified (and modifiable) weight factor to each incoming information stream. Together with a given rule expression reflecting the inner dependency and relationship between all streams, it's then possible to compare all these waves against each other and give them a rank. This process emulates a competition between all the information that is struggling to reach the player. Finally, only the data considered most important for the given conditions will be selected to be mapped and applied with the according expression. All processed information is passed on to the appropriate game and interface object to present the resulting changes to the player (4)—be it by means of graphics, sound, animation, and/or plain numbers.

The beauty of this approach lies in the flexibility of the weight factors and rule definitions that determine how all data relates to each other. These rules could be predefined and hard-coded, but modified and adjusted by

the player during the course of the game. By altering the rule-set, a player could specify a focus on a particular type of information and define his individual preferences in what data is considered most valuable for a specific setting. A further improvement could be to revise the rules dynamically throughout a session to account for a player's preferred gaming style, which he indicates by an increasing interest in a certain type of game objects (and thus a respective data type).

Once the interface knows what data to map, its next job is to give the information an appropriate expression and meaning that the player is most likely to understand. Again, this is a matter of abstraction. The task is to abstract the game data into representations that evoke perceptible correlations to familiar real-life concepts on the side of the player and are therefore instantly comprehensible. Today, a game designer has a diversified repertoire of methods to transform more or less complex game concepts into apparent and applicable schemes. It could be a mistake to limit your thoughts to only graphics and audio. Especially, tactile information abstraction, through, for example, force-feedback, sensitive feedback textures, or previously discussed movement-pattern abstraction, promises new perspectives in transforming virtual concepts into known, corresponding real-life phenomena. However, let's nevertheless quickly examine an example of visual data abstraction to illustrate the idea further.

An often-cited example is the representation of a player's energy or health status. *Zelda*, for example, abstracts this information elegantly by presenting a bar of full, empty, and half-cut hearts. This approach is well designed in a way that a player can easily understand the relationship between the symbol of a heart and health. It is an established link that is already known from real-life experience and does not have to be relearned. Another common practice is to visualize a player's energy level in the form of some on-screen meter. Here, the mutuality between health and its representation is much more abstract. The bar could mean a lot, but if it were color coded in red rather than white, it would be more likely associated with the idea of health it is representing. Color codes are, however, always a high-risk abstraction method and carry a high potential of confusion and misunderstanding, especially in online game design. Nonetheless, the ideas suggested by red—danger, blood, stop, etc.—will make it easier to bridge the gap between concept and representation. If it's difficult to rely on real-life correlations, it is often necessary to consider at least computer game conventions and trust in the player's knowledge from previous gaming experiences. However, you still should bear in mind potential complications

that are often not so obvious. Referring back to color codes, a rarely considered problem is color blindness. If vital information requires a differentiation between red and green, which is a frequently used technique in computer games to distinguish good from bad, some players' restrictions could render the game not only more difficult but impossible to play.

Referring back to the list of demands on an "advanced-mapping" interface, the final issue you should consider is the required detail of game data that is presented to the player. How detailed data needs to be mapped depends on both the type of information and a player's preferences. It is also a matter of where you, the designer, decide to draw the line between what you think is absolutely required, exactly enough, or totally unnecessary information needed to succeed in the game. Does a player need to know an exact floating-point value, which is often vital by means of character skills in complex RPGs? Or is it enough to provide a vague idea about a particular value as energy bars, which most fighting games do. This is again a chance where an "intelligent" interface that anticipates a player's needs and priorities could lead to a more efficient mapping process. Information that is crucial and absolutely needed by one player might be of no concern for another and his respective style. Imagine, for example, a system holding a value that describes players' sympathy/antipathy toward each other within a scale of -5000 and $+5000$; within a spectrum of absolute dislike and total goodwill, respectively. Now, persons focusing on the social aspect of the online game would probably like to know the factor's exact value, or even need to know it for their decision making and to immerse in the game. Others would not care that much about this facet and not require such a high information granularity. For them, a different, more abstract representation would be enough to deliver the required knowledge. Possible ways that come to mind would be a radar or map that abstracts the causal connection into "distance away," or a relationship thermometer distinguishing between "cold" and "hot" relationships. Such methods would give a greater abstraction and a fewer granularity; what in this case means an advantage and improvement because the information is exactly as detailed as the player requires—neither more or less.

Media Personalization

Contrary to what is often understood as media personalization, we are not talking about personalized data abstraction by the interface in this section,

as we did in the last. We will leave out personalization as understood in player-to-player interactivity; that is, establishing a distinctive personality, role, and reputation within the game community. There is another additional aspect you should bear in mind in your online game designs. Media personalization as interpreted in player-to-game interactivity is also a matter of providing the player with opportunities to adjust the game—the game as experience, event, and playful duty—according to specific moods, purposes, and tempers. A game that allows being (re)played in a variety of different styles without losing its consistency and logic can lead to completely distinctive gaming experiences. It is a way for the player to try out multiple strategies and behaviors, and to experiment with different ways of succeeding in the game. This is, however, more than adding supplemental replay value to a game. Slowly, a player will define his personal strategies and methods he considers most effective or enjoyable, and thus consciously differentiate himself from any other player. You could interpret it as a player's personal relationship toward the game. The relationship is personal by means of each player's distinctive opinion and secrets about how to overcome the obstacles and challenges the game presents. These "secrets of success" need to be protected and justified, and thus are often the source of heavy and interesting discussion among players about what they assume to be the best, funniest, or most challenging strategy.

So, how could you design multiple available paths through the game that reach beyond the selection of a particular branch in a mission or quest tree? One theory is that the more tools you give the player, the more different interaction styles are likely to suggest themselves. What tools in particular depends on the type and genre of the game: weapons, spells, vehicles, character skills, resources, power-ups, or races. Important is that each tool or a specific combination thereof can result in diverse interactivity experiences—in a unique gaming experience. An obvious example is the assortment of weapons available to the player in popular first-person shooters. Deciding to sling the sniper over your shoulder automatically suggests another set of actions and cognitions than loading the auto-rifle. If a player is further restricted to only a certain amount of tools, he has to weigh what is more likely to meet his demands, goals, and purposes. Perhaps it would be best to leave both of them behind and pick the medi-kits instead? Here, however, as so often in real life and game design, more does not always mean better. The tools you offer a player should have a recognizable significance and differ from each other by more than just graphics or sounds. They need to be gameplay relevant and convey a unique type of action,

strategy, and problem solving. Implementing a one-wheel, a tank, a bus, and a bagger would not have any consequences other than the need for more production costs and development time if the only way in which they vary is by texture or mesh. All the tools need to have their distinctive perceptible advantages and disadvantages, and suggest an additional option to succeed in the game.

Mentioning "success" leads to the next requirement such tools have to satisfy. Their specific combination of pros and cons should not be better or worse. Favoring one tool over another has to be an alternative and option and no absolute requirement to play the game. To speak in terms of a puzzle or quest, each tool has to provide a way around the obstacle. In persistent online worlds where there's no singular way from A to B most of the time, the net reward for the, say, well-disposed, social, and democratic wizard and the aggressive, resolute warrior should be the same.

Finally, you need to make sure to keep the game world consistent and reasonable for each of the alternatives and that your simulation can manage and support all those different strategies and styles. To summarize, implementing a variety of tools should thus ensure that:

- Each tool has its own relevancy regarding gameplay and results in a significantly different gaming experience and interaction style.
- Each tool has its unique combination of advantages and disadvantages.
- Each tool's pros and cons as well as what consequences its properties are likely to have are instantly perceptible.
- Each tool is an option in the game and offers the same reward.
- Each tool and its resulting style keep the game environment and simulation a consistent, reasonable, and plausible whole.
- Each tool is evenly supported and carried by the simulation of the game.

If all of these requirements are satisfied, a variety of tools lets the player incorporate his personal styles, preferences, and methods into the game and enables him to take part in the game environment as different personas and player types. The player can establish a relationship with the media that is shaped by his personal set of action and cognition patterns that very likely stands alone.

ATMOSPHERE

The online game environment provides a social atmosphere defined by the dynamic personalities of its players and an environmental atmosphere, both of which affect a player's interactivity experience and actions. We have already discussed that the game environment, similar to a piece of architecture, gives cues that tell something about the nature of the people it holds. However, environmental atmosphere also supplies cues that convey a type of game experience that has to be expected. The game world, defined by its graphics, sounds, settings, and genre, should give the player an idea of what type of actions, behaviors, and emotions are required to immerse and succeed in the game. Environmental atmosphere is about avoiding surprise and confusion. The player needs a basis for his decision as to whether he is prepared and willing to interact with the media in those ways needed to enjoy the experience. You should give the player an impression about what is going on behind the doors of your game and allow an interpretation if these expectations meet his intentions and purposes. Let's play the architect for only this section and examine what methods we could use to let the walls of the online game building talk to the player.

THE OUTER WALL

The essential task in crafting your game's exterior design is communicating a general idea and drawing perceptible lines between where the game begins and ends. What is the game about in general? What are the rules automatically agreed upon when entering the game realm? What are the dominating action patterns? The player should initially know whether the game is set within a medieval, fantasy, *AD&D*-like context, a historical WW2 simulation, or a futuristic quiz show framework. Already, such vague impressions are enough to bait some people, while others would beat a hasty retreat. Moreover, there should be indications as to whether the game primarily features a fast-paced shooting experience, rational puzzle solving, or demands long-term strategic planning. This is important in deciding for or against a specific game type, and for comparing the expected required timeframe of the game with one's real-life schedule.

You might argue that most players already know the game and what is most likely to await them as soon as they buy it. However, the times in which multiplayer online games are only huge persistent online worlds for the hardcore gamer are gone. You can see them heading toward an exis-

tence of a mass media that explores alternative distribution channels. These circumstances dictate to treat all these aspects as much less trivial than they appear to be. Especially for small-scale online games and those solely distributed over the Internet, the boundaries between game and nongame tend to be blurred. However, the requirement to define a perceptible game framework and a context for a player's actions, reactions, interactions, and emotions still exists.

One strategy to design a game's outer walls and give players an early idea about its rule-set is to embed the setting into a fully or partially known context or background. However, contrary to single-player games, there is usually no detailed thought-out story line or background plot in online games to define a guiding context. You could certainly give a type of introductory scenario, but the very nature of online games is that their events are governed by their players' actions. How the story and plot of the game unfolds would be completely out of your control and thus not really an option here as long as we don't really know what interactive fiction is or how to design it. Using story and background to draw an online game's boundaries is therefore mainly limited to relying on settings known from other media that are better suited to communicate such consistent ideas. Possibilities range from books, movies, comics, television, and historical real-life events to traditional board or card games and single-player computer games. Employing these media as a reference also means referencing their context and the concept behind them to which players very likely can already attribute specific expectations and feelings. The pioneering persistent online game worlds, *Ultima Online* or *Meridian 59*, for example, took advantage of the already familiar and very popular *AD&D* tradition and "Tolkien-esk" literature. Moreover, online conversions of popular board or card games make no bones about the existence of their offline counterparts, although they are often significantly modified or have computer-only game features. At this point, the details of the game and its rules are not important. It is not that essential, too, how exactly the connection to the existent context is made; be it a hint in the title of the game, an image of the main character, or a significant logo, color, or sound scheme. The task is to give an initial general idea and impression. As such, it is unquestionably a useful technique.

None of this is to say that embedding a game into an already familiar context is the only, best, or most creative way to design a game's main entrance. In this case, you would be limited at some point to design only movie, novel, and board game conversions, or birth the next derivation of

an already existing computer game design. It is, however, a possibility that you should bear in mind if only by means of subliminally giving a player a wink.

Now, let's shortly examine an alternative or addition. If the player doesn't get enough information for his decision to enter or stay out by the design of the game's entrance door, you should offer a quick look through the slit in the door. Therefore, in case you can't give enough impressions and evoke expectations in the very beginning, it is, as so often, the first impression and first three minutes that count. Here would be the right time to make use of all your knowledge and experience you might have from previous single-player game designs. Use all available tools, technologies, and techniques to capture the game's setting, atmosphere, and main action patterns within just a few moments. Consider this stage similar to designing a commercial spot for your game that has to communicate an entire idea in the shortest possible time. This could be done by an expressive splash screen, a series of animations, sound schemes, written or spoken phrases, a specific design of the main menu, or a short introductory tutorial section. The process could even involve the design of your game's installation routine; for games exclusively distributed over the Web or entirely browser based, it might also implicate Web site design. The idea is to provide an early impression about what the player should expect and what kind of actions or conflict solutions the game is most likely to demand later. This will help him decide whether to face the challenges and proceed or determine that your game is not what he has been looking for. He is prepared for interacting with your game and thus ready to start a more efficient interactivity process. There is a common ground in the player-game relationship.

CORRIDORS AND ROOMS

Once involved in the game, a player can receive much more detailed information from the game environment. Rather than communicating an atmosphere of "the whole," he regularly gets environmental cues that concern a single task or game section—at least he should. Lightning, world layout, textures, sounds, and the behavior of NPCs all tell their own story that the player interprets and uses in his decisions. Remember that we are talking about how to design efficient player-to-game interactivity; the messages given by the game—be it puzzles, moods, plot, or conflicts—need to be understood by the player. Suppose a simple puzzle in the form of a hid-

den trap, let's say the traditional explosive mine that protects the path to a trigger for a door. The message of the game is neither the mine nor the trigger; it's merely the conflict, the puzzle to solve. The puzzle is not communicated to the player if the only way to solve it is by trial and error. If he has to run into the hidden mine before grasping its existence, there is something wrong in the interactivity process. The game would better tell him about the puzzle, say by sound, warning blood spots around the mine, or by an NPC's indicative performance. The same is the case if the game *thinks* something different from the player does. A player observing a way to reach the trigger without passing the mine and then realizing that your game didn't assume that and doesn't support his solution would need to know a good reason why not. To speak in terms of "puzzle atmosphere", efficient player-to-game interactivity not only means telling the player that there is a problem, but also giving cues of how it could be solved and what will not work (and why).

As this book's focus is on multiplayer online games, and design techniques of such aspects don't differ much from single-player game design, we won't go into any further detail here. Puzzle design and game conflicts get a unique aspect again if they require competition and/or cooperation between multiple human players, but this is another topic to which we will return in Chapter 11, "Conflict and Competition."

Environmental atmosphere is also a matter of describing the type and nature of a whole action set rather than a single task. Here is where a game's online aspect becomes a bit more interesting again, although it plays, strictly speaking, into the field of player-to-player interactivity, too. Let's employ the metaphor of the game as a piece of architecture again. Similar to what you did to the whole building, you should also provide environmental cues about the governing nature of actions and patterns in each room. The player should know what type of behavior and problem solving the game demands next; having the chance to prepare, in case the game engenders a "next," by a linear mission path for example, or again a fundament for his decision, as in "open" game worlds. Does a section mainly feature a fast-paced action sequence, or is there a focus on rational planning and problem solving? Should the player await a gang of heavy-armed creatures around the next corner, or would there be room for starting a conversation with another player in a primarily relaxed environment? Prospective candidates for this job to craft the appropriate mood and atmosphere are again lighting, sound, textures, and all methods you see fit from your personal previous experience.

Regarding online games, this is interesting insofar as it allows players to group and join according to interests and purposes. Whether it is for a huge trade show in a marketplace or tournament shoot-out, they have an initial common ground and understanding without ever communicating directly with each other, only by sharing the same environment. If players can alter the environment to a certain degree—apply textures, change light color and intensity, or use NPCs for their intentions—atmosphere is a useful tool for defining virtual spaces of privacy. However, none of this means that the game has to be strictly structured according to action patterns only, or that there cannot be a mixture of various different processes. Solving a cross-word puzzle does not mean abandoning every conversation and starting a life in isolation. These tasks and patterns are not mutually exclusive. According to one's plans and goals, however, there is usually a focus. A game that manages to communicate the primary purpose of its "rooms," player-to-game interactivity would get an additional aspect of understanding by way of mutual agreement between the player and the media.

CONTENT CREATION

The final aspect of player-to-game interactivity that we will discuss treats the process in which players not only play the game, but also *create* parts of the game. To avoid any misunderstanding about the title of this section, content within this context is meant to be both mental and digital. It means the opportunity for the player to craft and design elements of your game on his own, be it a mental addition or modification of the existing game or a media asset in the form of graphics or music. As we will soon see, certain aspects already existent in single-player offline games but being directly involved in the creation of a game unfolds its entire potential and power only in the territory of multiplayer online games. The more "traditional" type of content creation is what we will start with.

MENTAL CONTENT

Let's take a step backward and see how content creation in today's high-resolution, three-dimensional computer game environments profoundly differs from more traditional media such as books, radio, or the telephone. Consuming these media that have a much less visual expressiveness requires the creation of a huge, if not the major part of the content in your

imagination. Everything that the media is unable to deliver has to be developed in your brain if you are trying to reach a state of engagement. The biggest strength of media that engender the creation of these missing images and their accompanying sounds smells, tastes, and sensations is the unique type of such imaginary contents the consumer has to produce. These contents are free from any constraints of time or space, and thus manage to blur the line between reality and artificial media.

This led to a discussion within the computer game industry some years ago. Promoters of the MUD and text adventure tradition pointed out potential "dangers" for the media computer game arising from blindly pushing audiovisual opportunities to the extreme. They were concerned about losing the strengths of mentally created content by only presenting predefined, instantly ready to consume pictures and sounds in increasingly realistic ways as is done in today's games—and all this to the media's and players' disadvantage.

The human imagination is unquestionably a very powerful tool, and whenever possible you should employ it to your advantage. However, this does not preclude turning away from all current or future technological possibilities made available to you to design the next generation of online multiplayer games. Mental content creation is definitely something to learn from more traditional media. The strength of computer games, however, lies in the broad spectrum of technologies to rely on in order to interact with the player in meaningful ways. It is thus a matter of combining the advantages of both worlds and designing outcomes of imaginary content with present or future artistic and technological techniques.

One method is to work a bit in the opposing direction than what the aforementioned traditional media do. Whereas novels, for example, often try to compensate for their lack of visual expressiveness by giving detailed descriptions of scenarios or character appearance, you could consciously take out information. To be more precise, you add content that raises and provokes unanswered questions on side of the player. By using all techniques you consider applicable—obscure sounds, mysterious level layouts or object arrangements or dubious characters—you would present unfilled content gaps to the player. These secrets should not be especially meaningful for the game and not be required to succeed in the game. They are not meant to be those hidden puzzles that as we have already stressed should be avoided. However, they leave room for imaginary content and almost force a player to answer the questions they raise: "what would. . . ?" "why is. . . ?" "I wonder who. . . ?" or "if I would. . . ?" Imagine a simple ever-locked

door blocking your way to a silent, mystifying mumbling. Another example would be the famous businessman who appears in *Half-Life* from time to time, although his mystery was (sadly) unraveled in the end. In moments that you decide to forget about your creative motivations or are forced to do so by your boss, such methods even unfold new marketing perspectives—they almost cry for a second, third, and forth part.

A supplemental way to treat stimulation of a player's imagination is to think in terms of incorporating play into play. This might sound silly, but all it means is presenting content in your game that makes it easy for the player to play with in his imagination. It is primarily a visual process and thus a matter of images and pictures. These images really exist (in digital form), are not hidden behind a door, and the player can perceive them as part of the (game) reality on his screen. However, they are obscure or fuzzy so you have to modify and shape the picture in your head to decipher its meaning. It means playing with a picture of reality by creating modifications in your head, thus birthing a modified picture of reality. To clarify this aspect, you very likely know the phenomenon of "reading" figures, faces, and whole scenarios in cloud patterns in the sky. The clouds are certainly real, but they never meant to be what your brain perceives. You can use these brain stimuli in your game designs, too. Possible ways that come to mind are shadows, character outlines, movement or animation sequences, textures, and all types of particle systems such as smoke, bursts, or sprinkles.

Binary Content

As already mentioned, content creation as a factor of player-to-game interactivity also involves game content out of mental space and elements made of bits and bytes: sprites, textures, 3D models, or code. Binary content means all these assets of a game that don't have a significant meaning on their own, but once combined assemble (hopefully) the one harmonic whole we love so much.

The time has past in which a player's only possibility to influence or change a game creation was by writing e-mails full of wish lists and improvement suggestions for the developer with the hope of being heard. This is still the case in other media; for example, newspapers, in which taking part in creating media content is limited to writing letters to the editor. You, however, are designing a media where a player is no longer only a game receiver but also a game creator—at least he would be, if you allow him to be. If the goal is to design interactivity, you should make use of this

potential. What else could be defined as interactive if not a player's thorough commitment and attention to the direct creation of the media?

Early single-player games, mostly arcade-like side scrollers and jump n' runs, allowed players to construct their own levels by using very simple and restricting editors. However, it was Richard Bartle who set a milestone in the history of computer games, and more importantly the online game media, by making the entire core of his MUD system available to the public. Rather than only changing the level layout of a game, players could now add objects and "rooms" to the existing core at will and alter the original concepts according to their own purpose and imagination. This was the birth of this tight linkage between player and game, the only difference being that players today don't have to spend as much time understanding and learning the complex MUD systems. Visual editing tools and game SDKs written in popular programming languages such as C/C++ provide a much easier method and shorter learning curve for a player's attempt to interact with his most favorite games in such ways. The same applies to popular or proprietary scripting languages such as Python or UnrealScript used to provide an interface with the game world. Following the examples of *Half-Life* and *Quake*, these tools are available for more and more games, and appeal, by their ease of use and "simplicity," to an increasing amount of players; which is without a doubt a good trend.

Especially, *Half-Life* has shown what profits you could gain from designing your game as an open game architecture from the very beginning and delivering the accompanying editing tools to the player. Released in 1998, quite some time ago in gaming industry terms, *Half-Life* players not only keep playing *in* the game, but *with* the game. Its open environment allows them, together with the supplementary editors (most notably Worldcraft seen in Figure 8.5) and exporters, to implement their own models (Figure 8.6), textures, animations, skins, and sprites. Most notably, it's possible to change the entire code base, altering or adding game logic, rules, and AI routines, which can result in totally new games that no longer have much in common with the original. Players built on top of the system to realize their own imaginations and designs that are entirely different game experiences or, as in the case of *Counter-Strike*, were the beginning of a new genre. Those new designs don't necessarily have to be a game any longer, but virtual conference rooms or AI test beds.

Supporting this type of player-to-game interactivity requires some planning from the initial design phase on and depends on the complexity of your game, the technology you use, and how much freedom you are willing

FIGURE 8.5 Content creation for *Half-Life* engine with Worldcraft. © 2002, Valve, L.L.C. Reprinted with permission from Valve, L.L.C. All rights reserved.

to give the player. If your game is a persistent online world to maintain, administer, and keep homogenous, it is indeed out of the question to let players "play" with the code-base. However, providing offline tools to modify one's avatar, for example, or to create new assets that can be submitted to you as a suggestion for implementation would still be something to consider. In addition, browser-only multiplayer online games offer ways to incorporate the player if online with the help of an online level editor. As a general rule of thumb, however, there are three issues to keep in mind.

First, if you have to develop in-house applications for the game's development—for example, level editors, texturing or skinning tools, plug-ins, exporters, or scripting engines—design them with the player in mind. Create the tools as you would like to sell them separately and not only for the skilled, experienced computer scientist. Adding the accompanying help file later might be less of an issue. Developing an accurate, user-friendly visual interface on top of your collection of command-line converters and batch

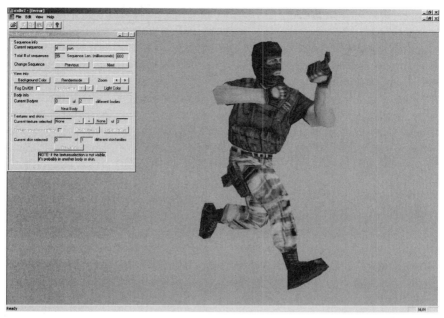

FIGURE 8.6 Editing a *Counter-Strike* model. © 2002, Valve, L.L.C. Reprinted with permission from Valve, L.L.C. All rights reserved. Screenshot taken from within MdlViewer 2.1 © 1998–1999 Ascent, Dark Yoda & Otis. Reprinted with permission from Ascent, Dark Yoda & Otis.

applications afterward, however, would be a lot more time and resource consuming.

In fact, it can be a difficult and complex task to provide sophisticated and powerful tools that allow a player to alter existing game content or create a new one in easy, efficient, and user-friendly ways. Games are becoming increasingly complex, and so are the editors and tools necessary to develop and refine their implemented assets and elements such as models, textures, sprites, or animations. It is apparent and accepted how significant it can be for a product and the community it builds to offer opportunities for players to shape the game according to their individual needs, purposes, and imaginations; especially in the long run as appropriately demonstrated by *Half-Life*. On the other hand, developing the tools needed to satisfy this demand should not shift the development's focus too much away from the actual game. The result is that for more and more newly created engines and games, content creation is based on tools that are already

widely available and used (e.g., *WorldCraft, QERadiant, UnrealEd*). Dynamix and Sierra, for example, both used Worldcraft to create maps for their games *Tribes 2* and *Swat 3: Close Quarters Battle*, respectively. Likewise, many available 3D engines such as *Genesis 3D* are able to handle data from such editors.

Game development is increasingly (fully or partially) based on one of the established engines and toolsets that then could actually be defined more as middleware. The mission/level editor Ion Storm used to implement *DeusEx* and that is provided to their players is a modified version of Epic Megagames' *UnrealEd* (Figure 8.7).

FIGURE 8.7 Creating levels for DeusEx using an UnrealEd-based editor. © Ion Storm, 2002. Screen shot(s) reprinted by permission from Ion Storm. UnrealEd is © Epic Megagames, 2002. Screen shot(s) reprinted with permission from Epic Megagames.

Although a game without any multiplayer functionality, one game that should not be left out in this context of content creation and customization done by players is Remedy's *Max Payne*. However, at the time of writing, a "full" SDK similar to the ones for *Half-Life* or *Quake III*, for example, is (still) not available, Remedy provides a broad array of impres-

sive tools to edit and create *Max Payne* content. Besides a powerful level editor, entitled *MaxED*, there is *ParticleFX*, a tool used to edit and manipulate real-time particle systems (Figure 8.8).

FIGURE 8.8 Editing and customizing particle systems such as water, fire, smoke, or explosions in ParticleFX. © Remedy Entertainment, 2002. Screen shot(s) reprinted with permission from Remedy Entertainment.

Also part of the editor collection supporting Remedy's *MAX-FX Technology* is *ActorFX* (Figure 8.9) that lets players combine their custom-made meshes with readymade bone setups and thus allows creation of smoothly moving surfaces on game characters.

Discreet recently presented another promising approach, allowing you to take advantage of developing game content in house within the same tools framework available to players. Their product *gmax* is a content and game development platform that is based on the core of the company's well established 3D modeling and animation tool *3ds max*. The main idea underlying gmax is that there are actually two distinct versions. There's the developer version for *3ds max* (*gmax dev*). You can use it as your base content editor and customize it according to your own game-specific needs via im-

FIGURE 8.9 Mesh customization in Remedy's *ActorFX* tool framework. © Remedy Entertainment, 2002. Screen shot(s) reprinted with permission from Remedy Entertainment.

plementing your own code and toolsets. Moreover, however—and this is the clue—it's possible to publish and give away these tool collections to prospective players in form of so called "game packs." These packs include all information regarding the plug-ins, *MAXScript* utilities, and the interface used for development. Additionally, they contain all game-specific content, installation routines, and all necessary supplemental documentation. Using these game packs, players can then customize their copy of the "usual" *gmax*—the second, non-dev version of the product that is available for download free of charge (and for your pleasure also included on **ON THE CD** the CD-ROM accompanying this book). Figure 8.10 shows the *gmax* dev version in action.

As soon as a player enables his version of *gmax* with a specific game pack, the software is entirely integrated and linked to the corresponding game engine. He is then ready to start customizing game content within exactly the same development environment originally used by the game designers.

FIGURE 8.10 gmax dev user interface: a GDI Humvee from *Command & Conquer: Renegade* under development. © Autodesk, Inc., 2002. Reprinted with permission from Autodesk, Inc.

By means of preparing your code for future editing, as much as possible should be dynamically loaded at runtime, and you should only hardcode absolutely required logic—for your own sake as well. A popular and useful way to provide the player an interface to your game code is via scripting languages and/or externally referenced resource collection files such as .wads. If you want to support full control, the most common way is letting your engine refer to dynamically loaded code libraries, usually in the form of .dlls. Using the power and flexibility of C++ function pointers and v-tables, your main engine could execute the external code it points to during runtime. In case the player did not supply his own pointer destinations, it could simply call your default implementation. A final point to consider concerning code that you plan to make available is to provide helpful and thorough comments in between the lines. Make your code programmer friendly, describe difficult graspable mechanics, and give the player hints where to plug in.

Finally, you should account for the real power of content creation in multiplayer online games; that is, that players alter the game for their personal pleasure, and to share their creations with others. Provide a platform for them to exchange their modifications and inform one another about what they have made. The simplest possibilities are probably offering a bulletin board or regular newsletters with links to the new designs. However, if financially and technically possible, providing server space to which new things of all types can be uploaded or hosting fan Web sites will be a valuable support. Content creation is then significant insofar as it implies, initializes, and is not only player-to-game interactivity, but player-to-player interactivity in a very complex form. Players sharing their developments take on a role that is similar to that of an artist communicating his thoughts and ideas to the audience by only his designs. By crafting entire new game environments that again feature all aspects and dimensions of interactivity, the idea of the player as content creator is taken a step further: the player as interactivity creator. This scenario definitely puts a new complexion on the idea of "active audiences."

SUMMARY

This chapter covered the third dimension of our interactivity concept for multiplayer online games: interaction between the player and the game. We saw that many aspects derive from techniques out of general game design or are closely related to what you probably know from traditional single-player game design. The interactivity concept helped to shed some light on what specialties traditional design methods can unfold within a multiplayer-online context. Our detailed analysis also provided some insights on possible interdependencies between the various interactivity types and how they can affect your designs.

DESIGNING THE GAME CHARACTER

IN THIS CHAPTER

- What Are Game Characters?
- Interactivity through the Game Character
- Interactivity with the Game Character

This chapter is the first in a series of chapters that cover aspects of on-line game design that cannot be assigned strictly to only one of the dimensions of the interactivity concept. We will, however, regularly bring the three interactivity types back into play and try to build bridges to factors already discussed. This chapter deals with the design of a substantial game element, the player's avatar, will follow this idea via examining these issues from distinct perspectives.

WHAT ARE GAME CHARACTERS?

Let's first establish a common ground so we all interpret game characters in the same way. Your game will not feature any type of character the player can steer throughout some graphical 3D-world? This is exactly the interpretation we will not use in this chapter. A game character will be understood a bit differently from what is usually associated with it. It not

only means game characters you know from popular RPGs in which players control movements and actions of a graphically rendered warrior, wizard, elf, goblin, or whatever from an isometric or top-down perspective. Online game design requires a more general understanding about what a game character can be. We should think about it generally as a player's individual representative in the virtual game world. This could be anything, regardless of form, shape, or a specific perspective. It could be the type of agent known from *Ultima Online* or *Baldur's Gate* or characters controlled through a first-person perspective as seen in *Counter-Strike* or *Tribes 2*. We should consider a spaceship a player has to navigate through space the same as a simple pixel line in a multiplayer *Snake* clone or a bar-like paddle in *Arkanoid*. Sometimes, for example in text-only MUDs, players only have real abstract game characters in form of their screen names. Generally, classic games are often an inspiring reference for a somehow broader and more abstract interpretation of what game element serves as a player's main game character. See Figure 9.1 for some examples of different types of game characters.

FIGURE 9.1 Various implementations of game characters.

Such interpretations are perhaps not your favorite ones, and usually very general and vague concepts are something to avoid. They normally make design work harder rather than easier, and at one point those definitions suddenly cover almost everything. In this case, however, designing multiplayer online games requires such a general interpretation of game characters. Why? Let's shortly recap: a game character is any instance of the game that serves as a player's representative in the game world. The key

lies in the term *representative*. A game character in online games is no longer only a player's tool to control and play the game, but also one's interface to other human players. It's the part of the game that serves the player as his individual representative within a community. Game characters are the bridge to interacting with other players. Players in online games don't interact with each other directly—from person to person, from individual to individual. They only interact with each other's mimic in the game world, each other's game character, which might or might not be a mirror of one's real-life personality. Players communicate and interact, but they communicate *everything* to each other only through their representative: part of their real-life personality, a specific gaming style, opinions, thoughts, wishes, intended roles, and so forth. You will never interact with a real person in an online game. You are interacting with what is presented to you on your monitor, what is only another's game character—his individual agent in virtuality.

INTERACTIVITY THROUGH THE GAME CHARACTER

You see how this understanding of game characters emphasizes their vital meaning for interpersonal interaction in online games, and why you should thus stress this issue in your creations. This is also how we will refer to the player's agent in this section, and look at how they relate to player-to-player interactivity.

Game characters are a bit of a double-edged sword from a design point of view. On the one hand, a player's game character has a totally different meaning and much higher importance in the course of multiplayer online games than it has in single-player-only games. This means an additional challenge on the part of the game designer creating these games. On the other hand, it is therefore a part of your game design that gives you additional leads and new possibilities to reach your goal: designing interactivity into your online games.

ARCHETYPAL CUES

What we need are techniques that allow a player to communicate more to the game world and its inhabitants than subtle information such as "now I am moving upward" or "I am shooting." They need a way to inform others of what to expect from them, how they want to be recognized in the game

world, and what behavior they tend to bring to light. We should, therefore, give them a broad range of cues that they can stick to their character. These cues automatically imply expectations, hopes, warnings, and (life) styles.

One technique often used in today's online games is to let players choose from a variety of archetype characters. The amount of different types and what they represent depends on the scale of the game, its genre, and setting. They can be found in almost every game today and are by no means limited to only RPGs. Character archetypes are most obvious in MMORPGs where the entire game design and playing experience heavily relies on a player's game character and continuous skill improvement. *Everquest* players have the choice of 14 different classes (Figure 9.2) that all have unique talents and professions, and *World of Warcraft* features a human, orc, and minotaur race. You can also find archetypes in online space simulations such as Microsoft's *Allegiance* (The Iron Coalition, Gigacorp, The Bios, Belters, Rixian Unity), real-time strategy games such as *Starcraft* (Terran,

FIGURE 9.2 Selecting a particular character archetype in *Everquest: The Ruins of Kunark*. © 1999–2002, Sony Computer Entertainment America Inc., 2002. All rights reserved. *Everquest* is a registered trademark, and *Everquest: The Ruins of Kunark* is a trademark of SCEA, Inc.

Zerg, Protoss), and first-person shooters as in *Return to Castle Wolfenstein*, in which you can act as a Soldier, Medic, Engineer, or Lieutenant. Often, the main archetypes are further divided into various professions. After selecting the human race in *DAoC*, you can additionally specify what type you want your character to be: wizard, seer, warrior, or rogue.

From our point of view, giving players the opportunity to choose from different character archetypes is their first way of defining how they want to be perceived in player-to-player interactivity. It's an essential part of what personality one likes to mimic, and how one tends to deal with both the game and other people (at least for this particular session). The archetype gives cues about a specific behavior and is the initial basis for an interpretation of what actions (and reactions) to expect from that player.

In online games, we mainly have to rely on cues in the form of graphics, audio, and animation. However, designing a different set of graphics, sounds, and animation sequences for each character archetype already means giving a player the chance to differentiate himself from others and become a member of a specific group. Archetypes don't give cues about the individual player, but they give a first impression of one's intended game, communication, and interaction style. It communicates one's lifestyle within the game world—which is important to know in interpersonal interactivity. In real-life there are hippies, bankers, skaters, oldsters, and. . . . Often based on prejudices, the visual and auditory cues these groups provide—how they differentiate themselves from the rest of the world—convey a unique set of behaviors. In online game worlds, it is the same. Gnomes will act differently from elves; and Belters are passive, peaceful traders; whereas Gigacorps are aggressive hunters and fighters. . . at least you would expect them to be. Similar to the genre of the game, character archetypes are the genre of the game's social game: effective and familiar ways to convey expectations of the experience to come.

INDIVIDUAL CUES

Players able to specify their character as part of an archetype will, as we have seen, get a chance to communicate certain information to other players without any (textual) communication. Only the archetype-specific visual appearance, particular sound schemes, and unique animations give a first idea of what character you are going to deal and interact with. We know from real life how this interpretation of first impressions we get from a person can affect the way we interact. Sometimes, it is also the reason why we

don't start *any* type of interactivity. However, we also know that our understanding about archetypes and stereotypes is only a mixture of our own experiences and prejudices. Providing archetypal cues through one's game character to other people in the game world only means giving a vague idea that includes all the prejudices associated with the archetype.

Our next goal should thus be designing ways to further refine the cues that go out from one's game character. A player should be able to communicate affiliation to a certain stream, and give his game character a sort of individuality. This is where individual game-character cues come into play. If we give players opportunities to attach their individual cues to their game characters, they can communicate part of themselves to the masses. They can build up their unique game character and game personality; and always as they see fit or intend. Their game personality says nothing about their real-life personality—it's their virtual personality that mirrors one's real-life personality to a higher or lesser degree and probably differs from session to session.

What a game character says is something about one's personal style of playing the game, treating other people, and something about expectable actions and reactions. Similar to archetypal cues, individual character cues heavily depend on their visual appearance in the game world. A certain freedom for the player to personalize the character's graphics would be a step toward more individuality. The possibilities range from very simple to complex representations, and certainly depend on the specific game.

The simplest one is obviously giving a character a unique screen name. This can be done in every online game—from round-based card games to real-time persistent online worlds—and will not produce any technical problems. That might sound too simple or too obvious, but nevertheless, there are three issues to note. Don't underestimate how important it could be for players to name their characters as they want to! Naming is a precondition for any personalization and individualization. You don't need to give players the choice of dozens of different archetypes if you then don't let them name their characters. There is neither a chance for any individualization within the entire mass of other players, nor for any type of self-identification (which we discuss a bit later). Second, you should allow it for every type of game character and in every type of online game! A certain name for a game character should have nothing to do with the player's user or login name. If the player decides it should be the same—no problem. However, you, the designer, should not automatically assume it. There is also no difference whether one plays some creature-like character in your

game or something more abstract. A game character needs a name within an online game community—be it a human-type warrior, a spaceship, or a blinking dot. The name is the first thing that everyone (oneself included) will refer to in online game interactivity. The last rule to suggest is to let players "design" their characters' names. In this case, "design" doesn't mean different colors, fonts, or font sizes. If you can technically support this freedom in your game, it certainly won't hurt. However, in this context it means the character set and letters available to a player in naming his game character. It's important to let them use all characters on their keyboard, in lower- and uppercase, including special characters. You can play many games where it is not possible to use the Space bar or any numbers and symbols. However, if you look at what cryptic combinations of letters some players like to use as their screen names, and how especially clan and guild names can be designed that they tag to the name, you should see what importance that issue can have. Sometimes it's more than naming; it's a religion that stems from traditional text-only online games in which a player's name is one's only game character. It's certainly not important for everyone. However, some players can get really angry if you don't allow them to name their characters as they are used to, and will never feel that wrong-named thing on screen is *really* personalized. This should be reason enough to bear it in mind.

There are much more complex visual cues that players could stick to their game character. Almost obligatory in popular MMORPG is the possibility to choose between different hair and skin colors, clothes, shoes, and so forth. There could be different colors, textures, logos, or symbols to select for one's racing car or spaceship. If technically possible in your game, you could give your costumers even ways or tools to design their own small texture assets such as tattoos, emblems, or personal sponsor logos. The potential seems endless and is very dependent on your technical resources, the type of game you plan, and how much freedom for design you are willing to give to your players. Therefore, we won't go into any further detail here.

The same holds true for all the other types of cues that could be used to give one's game character some personal, individual touch. Particular sound themes, for example, or unique animation sequences would be two other possibilities to differentiate a character from others. A certain way to move tells us a lot about an individual. A possibility to communicate on that level within an online game world would thus be a huge boost for effective player-to-player interaction. One could, for example, compose a unique animation sequence from a predefined set of animation building

blocks. These creations, such as attack combos, maneuvers, or individual facial expressions and gestures, could then be bound to shortcut keys for immediate availability. (A marginal note: Perhaps you should carefully reconsider this method if your game is based on acquiring skills by repetitive execution of a certain action.)

BEHAVIORAL CUES

The most complex and sophisticated way to give individual game character cues would be characters able to mirror a player's own style of both playing the game and interacting with other people. It would also have the most noticeable and useful effect on inter-player interaction. A game character continuously changing according to one's actions and behaviors would tell us something about the history of this person at the other end of the line. No other information could be more valuable for one's interpretation of another player than getting an idea of what and how he did in the past. Meeting a slow-moving, staggering, burning, clattering (or simply more pixilated, blurred, etc.) game character could lead to the conclusion that a player was wounded or damaged in previous fights. Perhaps it's better to watch out for this player. A character's speed could depend on the type and amount of items it is carrying, whatever that might be—heavy weapons or tons of presents. Its graphics, sounds, and animations could change according to the time a player consecutively spent playing online. Influences that map real-life circumstances directly onto one's game character could generally be incorporated into the game mechanics—not only affecting graphics or sound, but also a character's properties and skills. It's hard, though, to keep an accurate balance between providing useful information to other people about a player's "condition" without punishing anybody for something real. Decreasing a character's speed, for example, for hour-long play in a row should also mean increasing other skills accordingly—experience, cunning, targeting, or unique special abilities that require a certain precondition.

Thinking a step further, it would even be imaginable to parse a player's chat messages and compare them to a set of predefined word and expression patterns. A long-term analysis of the messages' nature, depending on certain keywords, expressions, sentence length, or types of embedded emoticons, could lead to conclusions about a player's communication behavior. The results could again be mirrored by the player's game character, and thus tell about one's usual way to treat other humans and communicate with them.

Characters reflecting the style of their players would be an additional dimension in player-to-player interaction that allows interpretation of one's interaction partner. Designing this type of interaction in online game design always requires remembering that others will base their decisions on a character's identification and the resulting interpretation.

CASE STUDY—LIONHEAD'S *BLACK & WHITE*

The game that managed to show perhaps the first practical installment of reflective game characters in action and should serve as a reference for what to strive for in the future in this regard is Lionhead's *Black & White*. Over the long term, a player's avatar builds up a model of his master's personality and style. It continuously analyzes one's actions and decisions and alters the model according to these interpretations. The character then visualizes the player's behavior by adapting different body shapes, colors, textures, proportions, and sizes. It also tries to predict one's behavior if left on its own and acts according to the model in memory.

This sophisticated AI system would not be that noteworthy in this discussion about providing individual character cues in inter-player interaction. *Black & White* is not meant to be played primarily online, and there is usually no other interpersonal interactivity other than communicating on the game's Web site. The real potential of this system, however, and its great meaning within that context is realized in the game's multiplayer feature. This option allows players to let the avatars that they developed and played with offline in single-player mode compete with each other in an online arena. Multiplayer maps are also graphical chat environments in which players participate in form of their creatures for a broader variety of activities than only combating or playing the game against each other. These online encounters are, contrary to many other online games, based and shaped by multiple interpretations and impressions from the beginning. An avatar's appearance and behavior tells a lot about the person on the other end of the line and gives the liberty to draw conclusions on what to expect. The game character reflects the model it has built from a player's personality in single-player offline games recognizable for all other people within the online environment. It initially allows to interpret a player and thus to adapt one's own behavior accordingly. In the case of fighting, for example, it is possible to get an idea about how much battle experience a player already has and how difficult the battle could thus be expected to be. The character also communicates whether a player tends toward a more aggressive style or prefers a mainly passive and peaceful gaming and interaction experience.

Figures 9.3 and 9.4 show the game's sheep creature throughout the spectrum of all three state extremes—evil, neutral, and good—as determined by a player's gaming style, decisions, and behavior.

FIGURE 9.3 Behavioral game-character cues in Lionhead's *Black & White*. © Lionhead Studios, 2002. Reprinted with permission from Lionhead Studios.

FIGURE 9.4 Sheep creature inside the game world in evil, neutral, and good states. © Lionhead Studios, 2002. Reprinted with permission from Lionhead Studios.

In the case of Lionhead's *Black & White*, the game character is limited insofar as it is only reflective regarding the two different paths a player can take through the game: evil or good. Of course, this is also what the game is primarily about and the most important information to get about another player for this specific design. However, there is a huge potential for other styles and behaviors of the player a game character can communicate in the online game environment. Designing for these behavior-specific cues and thus incorporating meaningful information about one's partners into player-to-player interactivity would mean a big step toward more effective interpersonal interactions in multiplayer online games.

PERSISTENCE, PSEUDONYMITY, AND REPUTATION

In our daily interactivities with other persons, the nature of interactivity is heavily affected by its persistency. In online game environments, this dimension of time also plays an important role. Before looking at what effects persistent interactivity could have on inter-player interactivity, it's important to note that this issue is not restricted to designs for persistent game environments. In actuality, it's the reason why it is discussed in the context of game characters. Game characters are a useful design tool to incorporate interaction persistency into every multiplayer online game. Even games based on multiple short sessions that could sometimes span across days can allow for persistent player-to-player interactivity. They, therefore, must manage to bind a player to one or more game characters and provide a possibility to play with an already created character throughout multiple separated sessions. In designs for online games that don't save the game world's state as a whole, it could thus be worth considering ways that allow a player to save his game character together with its properties for future games. For security reasons and to avoid prospective cheating, the preferred way in most cases will be to store it online within a database system. However, it could also be done on the client side by saving the information offline directly on the player's machine.

Why worry about all this? What advantages will online game interactivity take from persistent game characters, and why? The longer there is continuous contact between two or more players, the higher the chance to establish a personal interpretation about others and the higher the potential for more meaningful player-to-player interactivity. In persistent and longer-lasting interactivity, players can refer to the most recent messages and actions from another person in their decision making. Their behav-

iors and actions can result out of knowledge and information acquired some time ago. Persistency in player-to-player would thus avoid a scenario in which answers and reactions can only be issued immediately after a given cause. Any form of message exchanged by players could be a direct reference to previous impressions and further act as a reference for future messages sent out into the game environment. This scenario that embeds a player's interactions into a meaningful context is illustrated in Figure 9.5.

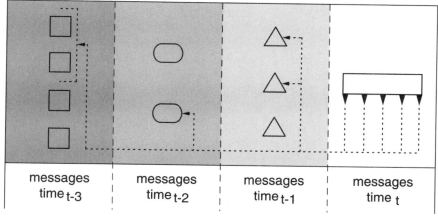

| messages time t-3 | messages time t-2 | messages time t-1 | messages time t |

FIGURE 9.5 Given a new message as a result of one or more previous impressions, messages, and conclusions in a persistent interaction environment.

Players knowing about their character's persistency within the game world and realizing that all they do could have consequences in the long term can also be expected to alter their online behavior according to these circumstances. Understanding that a game character is no longer only one's representative in a few single online encounters, but a persistent part of a whole online game community will lead to more thoroughly planned and circumspect behavior in interacting with other players. A player knows that other persons establish a set of correlations and associations toward the game character and will act according to the resulting interpretation in the future. Persistently used game characters in online games don't allow players to behave like there's no tomorrow. A player has to worry about his personal and his character's future within the game environment, and pay tribute to these concerns through much more detailed planning. At that

point, designing for persistent player-to-player interactivity has led to game characters that have a certain reputation within the online game community. This technique is very powerful and unique in designing multiplayer online games. Having a virtual reputation detached from any real-life influences and only affected by one's game character's behavior in the game world is a fascinating phenomenon and could be the driving motivation behind hour-long online game sessions. It means taking off one's mask of total anonymity in the virtual world and starting to have a so-called "pseudonymity" within the player community. The important issue is that a virtual reputation could be anything a player desires—and it doesn't have to be a good one. If a player prefers to have a reputation of being an aggressive and unfriendly person with whom it's normally not that easy to get along, he is free to do so. An intended virtual reputation could be totally different from one's desired real-life reputation—yet another fascination of playing multiplayer online games.

Of course, a player could decide to use a different game character for each session, or simply delete the existing one if his behavior and actions didn't result in the intended outcomes. Why should one worry about a game character's reputation or the consequences of one's behavior? Because a game character is an important part of the game for the player—something he will worry about and won't want to lose.

INTERACTIVITY WITH THE GAME CHARACTER

Instead of looking into the meaning of game characters for player-to-player interactivity, we should now uncover what game characters can do for a player's interaction with the game. A game character is also a way to improve the third type of interactivity, player-to-game, and thus is an essential factor in a player's gaming experience. Let's complement our discussion about game characters from a player-to-game perspective.

LINK TO MEDIA

The game character is a way to provide a continuous link for the player directly to the game, its contents, and inner workings. It has already been suggested to consider a game character as more than only some graphical representation, but as one's individual representative in the online game

world. If a player has the possibility to give this avatar a sense of personality and contribute his unique behavior, intentions, and style to the game world, he will establish an individual relationship with the character. As soon as the player realizes that the character is a tool that he can steer and control and is part of a system, he will understand its meaning and importance. The player starts to understand the character as some second self within another world that has its own rules and systems. This is where the game character becomes one's role; a role a player knows is important to play the game as desired, and thus something to protect and worry about. Such a relationship to the character would also result in a relationship to the game. There would be no game character without a game; the game is the host of one's second self that a player wants to take care of.

But what are the requirements for this relationship between the online game and the player? Providing ways to personalize a game character according to one's purposes and intentions by applying the appropriate cues is again a key factor, as is the rewarding persistent use of an avatar. Make the game as responsive to persistently used game characters as possible. Integrate game mechanics into the designs that are only accessible and meaningful over the long term, such as economic, political, research, rank, and quest or campaign systems. This would increase the importance of an avatar for a player and supplement reasons to establish a relationship with his representative.

Designing for a possible relationship between the player and the character means linking the player emotionally to the game. Emotions are a very strong and powerful connection, even in player-to-game interactivity. Knowing about the importance of one's character causes a feeling of responsibility that also exists outside of the game environment. Players think about possible strategies for the future and carefully plan their further actions even when they are offline. The game character is a single part of the game world that the players continuously carry with them. It could result in recognizing correlations between real-life behavior and actions done in the virtual online game world. The reverse is also true; the continuous player-game relationship could mean that reality affects one's behavior and actions in the game. This is perhaps the most vital expression of successfully designing player-to-game interactivity in online games: engagement. Over the long term, players will continuously alter emotional responses and engage internal associations and references that stem from their personal real-life experiences, social positions, or previous experiences from

playing other games. To conclude, dedicating a strong focus to personalized, persistently used game characters in online game design results in the following preferable forms of player-to-game interactivity:

- The avatar serves as a link for self-identification within the game.
- The avatar serves as a link to incorporate the game world into real life.
- The avatar serves as a link that can manifest the real world within the game.

INTERFACE

Speaking about interactivity usually involves a discussion about the game's interface. Strong interface design is a necessity to ensure seamless player-game interaction, and makes sure that the player can invoke the intended commands quickly and easily. Too often, a game's (software) interface is understood as a collection of buttons, knobs, and sliders, and their graphics, animations, and sounds. However, in designing online games you should also consider a player's game character as an essential part of the interface—if not the most efficient one. Contrary to those clickable buttons and icons, the game character is a type of interface that is not only invoked at certain moments and for specialized purposes. The idea of the game character as a player's primary interface is illustrated by Oddworld Inhabitants' *Oddworld: Munch's Oddysee* (Figure 9.6).

This single-player-only game demonstrates the beauty of this type of interface design that avoids any on-screen meters or displays and focuses on the character as one's dominating interface to the game. There's only the player and the game world without any additional on-screen elements disturbing the sense of illusion and bringing back to mind that it's "only" a game. The player's primary focus is his avatar. All relevant supplemental instructions are presented to him in the form of information and clues elegantly embedded in elements of the background such as signs and billboards (see Figure 9.7, page 188).

If the game designer realizes the player's character as part of the interface, he will know to embed it into the game mechanics and game system. Similar to the game sitting there waiting for a button press and then reacting accordingly, it also continuously needs to listen to changes within the subsystem player character. If the game reflects the commands a player has initially not given to the game as a whole but only to his avatar, he will un-

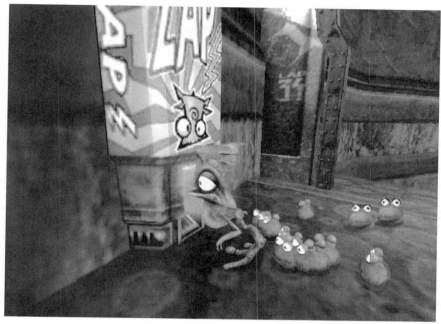

FIGURE 9.6 Character-dominant interface in player-to-game interactivity. © Oddworld Inhabitants, 2002. Reprinted with permission from Oddworld Inhabitants.

derstand to use that opportunity as an interface to affect the game. You can then consider the game character as a player's main communication channel to communicate his intentions, goals, and commands to the media. How the game reacts to these messages and thus how it informs a player about the results and consequences of the commands heavily depends on the type of game and its design. However, changes in a player character could, in the short term, have results similar to a usual click on a button, or outcomes that are only recognizable and meaningful over the long term. They could affect the game visually; for example, melting snow or burning grass as result of overheated engines, or stunning NPCs after putting on one's most glamorous armor. There could also be consequences later in the game—future rewards, advantages and disadvantages, or different mission trees and plots. The real power of the game characters as interfaces in on-line games relies on the fact that if the player recognizes changes in the game environment, he will also realize it as a way to have influence on how other players perceive the game. This is where player-to-game interactivity

FIGURE 9.7 In Oddworld: *Munch's Oddysee*, additional information is elegantly presented by elements of the background. © Oddworld Inhabitants, 2002. Reprinted with permission from Oddworld Inhabitants.

meets player-to-player interaction, and simple inputs yield complex results.

A player's avatar is an efficient game interface because it is consistent, context sensitive, and ever present. Once learned, it's always there and accompanies the player throughout the entire game and multiple sessions. Understood as a communication channel, the information transmission also works the other way around. It is a way for the player to talk to the game, and also a channel for the media to communicate changes within the game system directly to the player. As an interface, the player avatar is a method to inform a player immediately, clearly, and unmistakably about his own and the game's state, and thus to allow a player to react right away and adapt to new conditions. Changes can reflect in modifications to a character's visual design, and also impact its behavior. Potential danger—for example, a loss of energy and power—can result in wounds or visible damages. It can also lead to a different control experience, like lengthened reaction intervals or more

uncontrollable, inert movements. All this is additionally visible and recognizable to other human players in multiplayer online games, and is thus yet another scenario in which player-to-game interaction results in reasonable complex forms of interpersonal communication. The visual and behavioral aspects of the game character that change according to the game state are valuable information for the player to alter his plans, goals, and actions accordingly. Moreover, it is information for other players in the environment that shapes their reactions and interpretation of the character.

Although "only" in a graphical manner, the game that serves as a good example of using a game character as a mirror of internal game-state changes is the legendary *Doom*. This game implements the idea of the mirror in almost a metaphorical way. Part of the interface is an image of the hero's face that continuously alters its facial expressions according to the player's energy and health. The same idea was continued in the game's successor, *Quake*.

Online game designs that implement the game character as a major part of the interface will do something for a more functional and effective player-to-game interactivity experience. Interpreting the character as communication channel from a player to the game and vice versa will be a huge step toward what is commonly assumed as the very best type of game interface: the context-sensitive, consistent, but nevertheless invisible interface.

Let's complement the list of the meaning of game characters for player-to-game interactivity with the following items:

- The avatar is an interface to affect the game.
- The avatar is an interface to communicate changes in the game's state to the player.

LAYER OF ABSTRACTION

Treating the game character as a channel for the online game to talk to the player unfolds another potential of this "asset" that is reason enough to put a reasonable amount of energy and thought into the design of the player avatar. It is a way to increase a player's understanding of the game and its inner workings, and thus makes the interaction experience additionally meaningful and immersive.

What is meant by "understanding?" Understanding in player-to-game interactivity is about knowing the inner workings of the game and getting

an idea about how all the parts of the game system fit together and relate to each other. It means perceiving what actions lead to what outcomes and why. This is an important basis for a player's strategies and goals, but more importantly, it gives all of his actions a noticeable reason. Reaching such a level of understanding extensively affects the gaming experience and is a fundamental factor of player-to-game interactivity.

Therefore, how can game-character design supply a player's understanding of the game? The answer is *abstraction*. The player avatar can be seen as a very useful and beneficial additional layer of abstraction. A game system and its rules that govern the relationship between all the parts of its game mechanics are often very complex. The paradigm to use the game character as an interface for the game to continuously communicate its state to the player allows the system to make each of its inner processes instantly perceptible. The game character provides a focused perspective on the ever-changing game state and is thus a small window into the game's inner mechanisms. It abstracts the complexities of the game in a personally significant way and is thus an efficient option for the player to deal with the complexities of the game. Knowing about what is going on behind the scenes and why is definitely a step toward more understanding; understanding from which the process of interactivity between the game and the human can only profit. We have already abstracted the entire process of online game interactivity in a three-dimensional concept with the goal to identify the details of its complexity. The game character is now a further layer of abstraction within player-to-game interactivity that results in an additional simplification. Figure 9.8 illustrates this abstracting layer that lets you (and the player) better deal with the complexities of interactivity in online games.

Thinking a step further results in advantages for player-to-game interactivity and player-to-player interactivity. A player who knows the reasons and consequences of his own actions understands those of others. The result is a shared understanding of the game that embeds all players in the same context. It's something they have in common, a shared interest, and thus a common ground for their online game encounters.

This aspect ends our discussion about the meaning of game characters for now. We will occasionally bump into this issue again in the following sections, but it wouldn't make sense nor would it be appropriate to treat every factor as character related. Some of the topics we will discuss from here on will show correlations to character design, but are not specific to it and will therefore be separately examined. However, keep the broad and

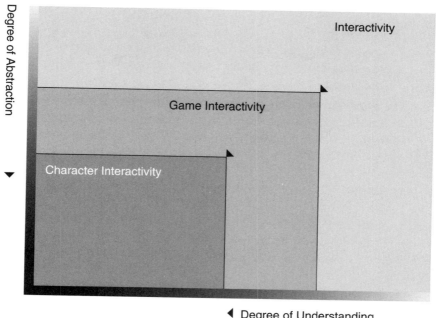

FIGURE 9.8 The player avatar as an abstracting layer and additional source of understanding.

general interpretation of a game character in mind and remember the advantages that player-to-game interactivity can take from its mechanisms. The following is a list of the issues we talked about previously, complemented with those we uncovered in this section:

- The avatar serves as a link for self-identification within the game.
- The avatar serves as a link to incorporate the game world into real life.
- The avatar serves as a link that can manifest the real world within the game.
- The avatar is an interface to affect the game.

- The avatar is an interface to communicate changes in the game's state to the player.
- The avatar supplies understanding of one's own and others' actions in the online game environment by abstracting a game's complex mechanisms and inner workings.
- The avatar supplies a more significantly experienced interactivity with the game by giving one's actions a recognizable meaning and context.

SUMMARY

A general idea and paradigm of a player's game character is the key to unfolding multiple significant aspects of character design in multiplayer online games. By employing methods in your designs that account for these aspects, an avatar is not only a valuable and efficient interface between player and game, but also a major tool for multifaceted interpersonal interactions.

COMMUNITY DESIGN

IN THIS CHAPTER

- Defining Online Gaming Communities
- Characteristics of Online Game Communities
- Community Building Techniques
- Community Management

A revolutionary aspect of multiplayer online games is direct player-to-player interaction playing a vital role in a player's gaming experience, as in no single-player environment. Similar to real life, interpersonal interactivity is an immediate catalyst for the formation of a community; in our case, a virtual online game community. These communities are commonly assumed to be a crucial part of multiplayer game design and can make or break a game. In this chapter, we look at the main characteristics of a game community and why you should treat it as one of the most significant issues in your designs. We also suggest possible methods and techniques to facilitate a game community's initial creation, to integrate it into game mechanics, and to support its long-term maintenance.

DEFINING ONLINE GAME COMMUNITIES

Similar to interactivity, the phrase "online game community" has received much attention in the game industry in recent years. Community design is

also claimed to be key in successfully crafting the next-generation multiplayer game environments. As such, however, the game community paradigm unfolds an issue similar to what we already examined in our discussion of interactivity. How do we actually define online game community? This is not a matter of defining a phrase or term, but is about delineating and understanding the characteristics of an entire concept. Virtual communities are affected and shaped by unique, special phenomena that do not exist in real-world communities in any comparable or similar form. Multiplayer online game design thus also calls for a thorough understanding and analysis of the unique characteristics of communities that only exist in the virtual space—and of those not initially game specific.

A critical question you face in designing online game environments is how to define an online game community on the whole—as a unique social construct—and what design implications can result from such an understanding. There is still no definite answer to this issue today and, in actuality, there cannot be one, simply because we have not yet uncovered all facets and inner functions of a virtual community. This will be a major challenge in online game design for some time; a satisfying definition and examination of the entire concept would, therefore, not only be almost impossible within this book, but also outside its scope. We know, however, about the significance of game communities and how their underlying player-to-player interactivity shapes the nature of multiplayer online game environments. In order to unfold at least some dominating aspects of these virtual societies and how they can affect your design, a "dictionary-like" definition of online game communities might suffice as our initial basis.

Basically, we can understand a community as a group of differently typified individuals who share a same initial characteristic. There is at least one attribute serving as a tie and common context—be it special vicinity, similar interests, hobbies, commitments, or values—which, in our case, is the game. As in real life, the members of a game community interact with each other not solely within the binding framework—the game—but also outside the game context.

CHARACTERISTICS OF ONLINE GAME COMMUNITIES

Using the last section's general interpretation, we should now examine the main characteristics of online game communities and try to unfold why

they are so important for multiplayer online game design. This should open the first potential implications of their nature and possible appropriate ways to design for their exclusive disposition.

DEFINING THE GAME

The most fundamental and significant aspect of an online game community is that it defines the game, and vice versa. Player-to-player interactivity involved in any community activities is an integral part of a player's game experience, and thus heavily affects one's perception of the entire game environment. Your design does not necessarily initially appeal to a player. If he instantly experiences a feeling to enter a social sphere that promises to satisfy his needs, and if he likes the way these people deal with each other and interact, he will, sooner or later, also love the game. This does not mean that people who regularly contribute to the community and actively participate in its activities are no longer scrutinizing a game and are no longer critical of your designs; in fact, the contrary is usually the case. The player treats the game world as a necessary and meaningful host of a group to which he belongs and in which he can mimic his individual, intended (virtual) role. As such, he will care for the game, stress its maintenance and continuous advancement, and represent the game to the "outer" world.

It is the game community that determines how "long" the game lasts and stays alive in today's rapidly changing computer game market. This aspect illustrates very well what alternative purposes might be a player's driving force to play a game other than the game itself. It is the community that makes him start up his creations again and again. For persistent massively multiplayer online environments that face the challenge to compete with more and more (technically superior) game worlds within a very limited market, the community is not just a significant initial unique selling preposition. It is also a way to strongly tie a player to one's design over the long term and probably motivates his real-life and online buddies to become durable monthly subscribers. Many people might buy a retail product (or download a client application) and try out what your game has to offer. Perhaps some of them regularly log on for some period after the free trial month, but only a strong, manifold, and active community can ensure that they will stay for longer. The community is a player's long-term ancestor accompanying the game and provides a feeling similar to "coming

home." It is individuals—even if "only" with pretend virtual identities—a player knows; people he can characterize, with whom he shares a common background and history, and to whom he already has specific expectations.

Trying to motivate people who are already strongly embedded in a game's community to switch their game of choice is thus not only a matter of providing better content or technology. You have to emphasize the community aspect of your designs and offer the players ways to accomplish additional needs to shape their intended role within a virtual society. A very appropriate example of how the community might be a stronger reason to migrate to a game than the actual game is a strategy once employed by Kesmai to lure players from one of their competitors. They offered the most influential community members, the "leaders," exclusive deals in their own *Air Warrior*. Due to the strong internal ties of a game community and the devotion to its members, those leaders promised to encourage a big portion of their entire faction to follow (and they did).

The community defines the nature of its environment, and the game shapes its community. The more obvious aspect is that your designs, the game's genre, setting, and its mechanics define the framework of potential actions and behaviors. As such, it heavily affects small group formations such as guilds, clans, teams, or companies—their nature, characteristics, variety, and the dominant actions that comprise their activities. Never forget that a community's activity is not limited solely to the actual game environment; it continues on Web sites, bulletin boards, and instant messaging systems, and might even reach into a one's real life.

An additional issue—one that is very likely to be underemphasized—is that playing the game is an integral part of *every* community and an intrinsic human need. Multiplayer online environments are a combination of player-to-player and player-to-game interactivity, both of which strongly drive each other. Therefore, a community defines how the game is perceived, and the games played by its members heavily influence its growth and establishment.

DEFINING THEMSELVES

The last aspect illustrates very well that a game community is also—similar to a real-world community—an extremely dynamic construct. As a social entity, it follows Darwin's theorem and continuously changes and evolves in order to guarantee longest possible subsistence. Following this idea, in a game community the best scenario would be a group defining it-

self by self selection of its members. It defines its own rules, values, norms, and accepted behaviors, and thus states an initial admission policy for newcomers—although usually unintended and on a mainly subconscious level.

For multiplayer online environments, this process usually leads to a differentiation of the entire game community into smaller groups such as guilds, clans, or teams. They all have their unique style (social and game specific), traditions, and notions. Therefore, they provide an opportunity for each player to identify with a specific clique that corresponds most to his individual ideas; one group that is, according to self-identification and actualization, the most promising ancestor over the long term for finding his personal place and role within the entire community. Specialization and self-identification is something you should bear in mind in your game and community designs. This is not only a matter of facilitating and encouraging small-group formation by offering distinct gameplay styles and action sets as done, for example, by implementing various character archetypes, races, or classes. You also need to support these groups outside the game; treat all of them similarly, provide them the same information and tools, and incorporate each while designing content additions and game improvements. If you don't have the opportunity to offer fan-site hosting, you should at least provide a regularly updated overview of all existing factions on your Web site. This is only one example of how you can ensure that new players can easily find their party of choice, and how you can act as a mediator in faction-to-faction communication and interaction; both being a significant aspect in acquiring new members and keeping the game community alive and "dynamic."

Regarding specialization, a self-defining game community also unfolds a characteristic that describes a merely contrary tendency. It is a way for the player to enter more general areas than the specialized context of a single game. A game community allows discussions and activities that leave the framework of a very special and narrow focus. Throughout all focused groups, the players discuss a broad spectrum of subjects ranging from general game issues and detailed low-level mechanics to real-life topics, general interests, and political or philosophical questions. They meet, converse, exchange tips and tricks, and share secrets—all within and about an in-game, online, or real-life context. Such a wide focus helps to develop strong ties of familiarity and relationships within the community. It is also a chance for you to get to know your players, their thoughts, and ideas, and to catch the attention of new potential customers and subscribers. Widely focused activities of your game community continuously generate valuable, insightful

feedback and attract people that otherwise would have never been interested directly in your game designs.

DEFINED BY ITS MEMBERS

More precise than naming a game community as self-defining is examining how it is defined by its members, their behaviors, common tasks, and its boundaries to the outer world. Therefore, the community and its underlying focused subgroups need the tools to realize what to expect from the members and where "their" world begins and ends.

We already talked about the intrinsic feature of a playground to surround itself with a sphere of secrecy that sets its participants apart from all others. This holds true for online game communities as well. Communicating boundaries in the virtual space—within and outside the actual game environment—is mainly a matter of giving visual and acoustic cues and defining unique behavior and gaming styles. You should give the players as much freedom as possible to freely define and design their communities' environments and tasks without losing control over the game's consistency and homogeny. Clearly, allowing high degrees of personalization and differentiation is, from a design point of view, much easier and more manageable if kept outside the game. Letting players freely design their individual fan or clan sites, for example, does not raise much concern on your side regarding the actual game design. Of course, you should regularly provide these players with all essential information; you could offer the required resources in the form of Web site development kits and newsletters, for example, and state policies for these sites to be entitled "official" or "site of the month."

Implementing the same degree of freedom directly into the game environment is a bit more complicated and even harder if you are crafting a persistent "one-state" game environment. Providing flexible content creation to the community in the form of game SDKs and editors is often not a convenient option. However, wherever possible, the game community should be able to define its environments and follow its rituals (also) within the immediate context of the game world. You could, for example, offer the possibility to submit in-game assets as implementation suggestions, or make parts of the game world available to rent for specific restricted ceremonies or tournaments. Additionally, community dynamics would highly profit from members able to define themselves via shared heraldry, language, historical background, and common in-game interests.

A possible method would be a player diary, a logbook of his activities that he can complement with screenshots and make available to others through his profile. Likewise, dedicated spaces, like the obligatory game tavern, might grant players the ability to create their own mini-games. Similar systems have already proved very popular and community tying in traditional text MUDs.

DRIVING THE GAME STORY

Multiplayer online games are environments in which the players are the most significant and powerful medium. Contrary to most single-player experiences, there is no opportunity for you to communicate an in-depth storyline and plot. You can only describe a rough framework and design specific game mechanics that are most likely to lead the game experience in a particular direction. Designing all these mechanisms, however, is nothing more than giving tools to the players without knowing beforehand how they will be used. Telling the details of your game's narrative and affecting the continuation of its "story" is entirely done by the community. The community and the decisions of its members drive the game's story.

This holds true for persistent world online games that are endless narratives and do not imply distinct goals or win-lose situations. There is no chance for players to reach the end of a game or *the* goal that lets them experience a concluding resolution. In exchange for this "lack," a player is very likely to look for his ultimate reward within the game community and by resolving the conflicts that arise in the game's social narrative.

A bit more generally speaking, the community with all its factions and subgroups heavily influences the ongoing story told by *any* multiplayer game environment; persistent online-only worlds as well as session-based multiplayer experiences such as *Starcraft, Age of Empires, Half-Life,* or *Diablo*. The approach of these games offers a more straightforward way to involve the community in asset creation and to give players the tools they need to shape the environment according to their individual needs. Activities such as creating (and sharing) new maps, levels, or models and thoroughly discussing lowest-level game mechanics have proved to be extremely popular and strengthen the community. This way, the players also pass on the story of the game; they refine its original concept and even form full-blown development teams that craft entirely new multiplayer experiences on top of the original. *Half-Life* and *Counter-Strike* are the most obvious example that unfold this dynamic in practice. Today, *Counter-Strike* is an

independent, standalone application and completely differs from its origin by means of concept, gameplay, and purpose. However, the entire community knows about the game's roots and understands it as part and a milestone in the history of *Half-Life*. *Counter-Strike* is only one additional chapter in *Half-Life*'s story—solely driven by the game community.

This aspect illustrates again that it is not only content and technology that determine how long the game "lasts," but also (and probably much more) its underlying community. Community design is thus mainly a manner of designing incentives into your games that facilitate and lead to such a committed and loyal group of players. No matter how long your designs are actively and regularly played or to what degree they are altered, a strong game community will continue to exist. In case players migrate to another game, chances are high that they will transfer in small tied groupings and only seldom individually. Furthermore, it is the community that can make every multiplayer game environment persistent in approach, regardless of whether it is explicitly classified as such. Similar to real life, online game communities that are aware of their origins strive to explore where exactly they stem from. A *Counter-Strike* player, for example, is thus very likely to investigate the original *Half-Life* at least once and will shape all his future preferred environments with this impression and knowledge; as a member of a game community he will pass on the story of his "homeland."

LIVING OUTSIDE THE GAME

What is more obvious for short session-based multiplayer games holds true for persistent-state online worlds as well: a game community "survives" a single game session. Actually, only a small portion of community activities and the way players define their social environment takes place directly within the game world. The community also lives outside the game and is shaped by a variety of interpersonal player-to-player interactions and communications. The game is not the sole communication tool used to develop and establish one's individual relationship with the community and its members. The contacts that mark a player's role within the group are made and cultivated via e-mail, telephone, on Web sites, message boards, in other online multiplayer environments, and even in real-life personal meetings. However, all the impressions and deductions that have been brought about by outer-game encounters with a player reflect again on him inside the actual game world.

A game community extends the moment a player makes the decision to log off and leave. It involves all types of person-to-person communication that facilitates relationships that sometimes transcend the virtual world. It is essential in designing for game communities to be aware of this aspect. As real-life friendships and social milieus can influence an online community, so can virtual relationships initially affect reality. It is a facet of game communities that seems to be inevitable at some point. As soon as people assume to know everything about each other that is possible to acquire online, they very likely want to make the "final step" and meet each other in person. You can use this to your advantage and further strengthen the ties of a community by organizing (local) real-life meetings or use popular gaming events, such as conferences or exhibitions that bring your players face to face. Clearly, such methods heavily depend on the scale of your particular project and the (financial) resources available to you. However, if you only dedicate a single thread of your Web site's bulletin board to this topic, you would have built the basis and, if necessary and desired, your community will find ways around all accompanying complications. Game communities are like all conflicts that arise from playing computer games. The player tries to resolve them: he wants to perceive how online societies relate to reality, unfold their unique issues, and see what casual relationships formed online survive the voyage into the real world. Nonetheless, questions arising out of virtual social conflicts are never completely answered—similar to their real-world complements. A real-life encounter is only an additional piece of an obscure puzzle that solely takes place on a different stage. A component that can mutate to a significantly powerful design method can strongly tie a game community in the long run. Analogous to most well-designed game elements, it conveys potential consequences of one's decisions and actions—in this case, also about prospective outcomes of one's social behavior.

UNIQUE SOCIAL SETTINGS

The previous paragraph already reveals a characteristic of game communities that is still mainly undiscovered territory and will require a lot of additional scientific research work in the future of online game design: their uniqueness and incomparability to real-world communities. Many social behaviors in a virtual environment mirror real-life communities, but some aspects need to be treated in special ways or will not exist in any equivalent form in physical space. In game community design, we need to find out

what facets of a real community seem sensible within an online-only environment and how we should design for unique social phenomena. A virtual community is a societal structure that is affected by gender swapping, players simultaneously acting as multiple different game characters, or, as we have seen, social crime. It is a setting without any explicit gender, age, ethnic group, or social class; all being fundamental affecters of real communities. This is also what role playing can be about in online games and does not mean something negative. These unique features of virtual communities make their setup fascinating and captivating for both the player and the designer. We only need to clarify their meaning and thoroughly examine how they relate to what a player is familiar with. At the moment, a novice and inexperienced community member is mainly left on his own in finding out the specifics of online social life and how to survive in such a setting. As part of the game experience, a community is a good scenario that unites two deep human intentions: the need to group together, and life-long learning that motivates all our pleasurable activities. Community design in online games is then increasingly a manner of ensuring to keep another basic requirement of playgrounds alive under such circumstances: safety. The key is uncovering how to design social environments in which players can use these unique opportunities and qualities to their advantage without harming one another's real-life feelings and notions. The game should remain a game—at least on a social level.

All this sounds reasonable and justified, but how can we accomplish this goal? Again, you see that multiplayer online game design increasingly requires incorporating additional disciplines into your designs that do not play the same significant role in offline solo games. Consulting elementary sociological or culture scientific works and introducing potential consequences into the virtual world is a requirement rather than an option; as is continuous reflection and learning from one's own and others' experiences, mistakes, and trials. Likewise, it is essential to understand online communities as not being exclusive to game environments. They are an integral part of the whole Internet that offers an almost limitless amount of potential research sources. Log on, browse, participate, and experiment; study yourself and other people's behavior and reactions.

The next strategy might rely too much on the game community's self-selecting and self-defining attribute. The best-case scenario would be a group of players that defines its own rules of what is socially acceptable or desired, and what behavior leads to punishment or banishment. A strong community core would then always provide a safety net able to compen-

sate all possible "social crimes." This means that you have to educate your players to make them aware of their exceptional social responsibilities and to encourage pro-societal activities. Providing good incentives for social investment is primarily done best via direct implementation into game-play—offering exclusive features and in-game rewards for newbie introduction, for example, or as a result of an ongoing player voting.

Additionally, you should present an opportunity for players to give feedback (positive and negative) about their own experiences with phenomena such as gender swapping or impersonating multiple identities. They need a straightforward, anonymous way to inform both other players and you about their conclusions from self-experimentation and contact with others. However, only as the very last security layer should you violate the notion of online freedom and act as intermediary judge that enforces the community's rules and your game's code of conduct.

What finally plays a significant role in designing for a virtual society's uniqueness takes into account the special environment in which all community activities take place. Unlike in the real world, game communities reside in nonphysical space and have to renounce basic sensual information, such as the sense of touch or smell. Humans, however, are mostly spatial creatures and are heavily affected by the physical organization of the space they occupy. How can a society mature and develop within an environment where there is no informative and expressive physical limitation known from real life, such as spatial distance or gravity; a world in which there is no slow or fast, no warm or cold, and no whisper or shout? What reasons will drive people to expose themselves to the "risks and dangers" accompanying a virtual social life? This seems to be another major strength of the media online computer games and the techniques available in their designs. Not only do they concurrently attract a whole set of very deep human instincts—entertainment, communication, self-actualization, and learning. Games can also provide that sense of place that a community needs. It offers methods for its members to shape the environment according to their needs via their behavior and the tools given to them. By no means is this to say that all online games should utterly simulate the physical conditions of real-world 3D Euclidean space. On the contrary, the power of this medium is presenting revolutionary and distinct settings. The important point is how they can manage to do it. Games can embed the community in a logical, reliable, and coherent environment and define a rule-set common to all players—a space that allows community members to base their interpretations on a communally valid fundament.

As noted, all the previous aspects are by far not a complete listing of all accessible characteristics of game communities. There is still a lot of work to do until we can claim to understand, at least partially, all workings of their manifold approach and how to accurately account for them in our designs. Particularly, the community aspect of multiplayer online games will merge the art of game design with solid scientific studies and further integrate the academic world into the creation of tomorrow's multiplayer environments.

What we have done, however, is examine some fundamental issues of a virtual community. What could play a significant part in developing techniques to design for such an integral element of multiplayer online games is what we should do next.

COMMUNITY BUILDING TECHNIQUES

Let's now make use of our freshly acquired wisdom and look at some feasible design methods to attract an indispensable, efficient player community for your game. What follows is a brief investigation of some essential techniques to facilitate, reward, and engender game community building; modes to plant the seed for a strongly tied, loyal group of players that promises to add additional lasting value to your environments and to lure extra audiences.

PROVIDING ALL CHANNELS OF COMMUNICATION

According to the idea of multiplayer online games being a combination of content and communication, a game community needs both an immersive gameplay context and the broadest possible set of accompanying channels to discuss. The more ways you provide to get in touch with one's fellow co-players, the more likely a player is to actively contribute to the game's social framework. Community activities can rely on Web sites, message boards, e-mail communication, instant-messaging systems, chat channels, newsletters, and even video-conferencing. In the best case, you plausibly implement all these communication channels directly into the game and make them instantly accessible from inside the application. All situations in which a player has to leave the game context and rely on third-party tools to satisfy his conversational ambitions are likely to interrupt his experience and destroy his suspension of disbelief.

Access to Web sites, for example, is less of an issue for browser-based Web games, but as soon as a game enters full-screen mode, starting up the Web browser requires a user to totally quit the game or employ the obligatory Alt-Tab shortcut. Both scenarios take his attention from the primary motivation to play the game and demand that he shift his focus to an entirely different working context. It means constantly switching one's "mental model" about the communication platform and adapt to the actual setting and its requirements; here the game, there the community. Consider your game as being the player's operating system that he starts up only once and then can seamlessly access all the tools he needs from within a consistent environment. Communication between your application and software installed on a user's system is not that complicated to implement. Even if your game's setting prevents you from simulating today's technology (e.g., fantasy, historical contexts), offering such functionalities could be worth considering—either from within the "neutral" menu or designed and transformed to make sense.

DESIGNING FOR DISTINCT CONVERSATIONAL SETTINGS

Similar to real communities, online game societies are marked by differently sized group setups and the type of conversation and content they imply. One-to-one, one-to-many, many-to-many, and one-to-all situations each fit a particular purpose best, but all have significant effects on a community's structure and its sensibleness. The player should thus have opportunities to enter all of these distinctly characterized communal spaces, know where they are (in-game or on the Web), and adjust his "range" in between both extremes; he should be able to share his deepest secrets and concerns with only his best companion in a "face-to-face" talk, or broadcast his messages to the entire community.

PROVIDING ALL RELEVANT FORMS OF COMMUNICATION

Most online conversations are currently still text based and therefore strongly differ in nature from most real-life communications. We already discussed the major drawbacks of typed messages (e.g., transferring emotions) and so will not do so again. However, we already know that each method of message encoding has its very own qualities and advantages and serves a distinct set of intentions and purposes. This holds true for both a single player and for the entire community. Therefore, you should provide all forms of communication that add up to your designs and are technically

feasible—at the very best directly within the game environment: gestures, mimics, secret signs and languages, voice-chat, and so forth.

ACCOUNTING FOR DISTINCT CHARACTERISTICS OF COMMUNICATION MEDIA

The previous aspect leads us to the requirement to precisely analyze the characteristics of all communication channels a community uses and then appropriately account for their facets. This is particularly essential for types of conversation that are elemental and heavily used directly within the game environment. Contrary to spoken language, for example, type-based communication—due to technical limitations still the most frequently incorporated way in today's online games—causes a substantial delay in gameplay. Especially for fast-paced games in which speed is crucial and directly relates to success, this condition means a major snag and hence has often no relevance from a community point of view. What this illustrates is that in order to facilitate and motivate community communication and investment, you need to ensure that conversing with one another does not have any disadvantages for succeeding in the game. Exactly the opposite should be the case: community participation needs to be rewarded. Precanned message chunks, voice transmission, keyboard shortcuts, or autotext insertion would be possible ways to deal with setbacks caused by typing messages.

Likewise, live speech also has its characteristics to bear in mind and take into consideration. Some players, for example, might be too reserved to talk to others in real time or do not have the necessary equipment. As long as you cannot assume specific tools to be standard, using their functionality should be optional, whereas freely adjustable speech distortion, for example, could be a method to resolve the social issues of voice communication.

EXPLORING NEW CONVERSATION TECHNOLOGIES

As we have seen, conversation is key within a virtual community, but some significant communication channels are not (yet) practical for multiplayer online game environments. However, you should continuously investigate new technological opportunities that promise to make communication easier and more efficient. Voice-over-IP is progressively worth considering and offers ways to overcome some of the drawbacks of typed in-game conversation. Speech data transmission is, contrary to what you might pre-

sume, even viable over simple dial-up network connections. Widely available broadband connectivity, highly effective compression algorithms, and streaming technologies make real-time voice communication increasingly relevant in online game and community design. With version 8.0 of its widely used DirectX SDK, Microsoft has paid tribute to this fact and now provides a set of programming interfaces within the DirectPlay SDK solely dedicated to live speech transmission.

Computer game development has always been at the forefront of using newly obtainable technical possibilities in practice and unfolding their results to the user. Due to their nature, online game environments are also likely to host tomorrow's virtual communities, which will redefine techniques for designing a strongly tied virtual networked society.

ENSURING STEEP LEARNING CURVES

While providing all these distinct communication channels and ways to vigorously partake in the game community, you should also consider that not every player will be instantly familiar with using these tools to their highest potential. You should, therefore, either borrow from methods a player already knows how to perfectly employ (e.g., speech, body language), or guarantee easy, fast, and pleasant approaches to learn about efficiently using unknown techniques. Game-specific symbol language, for example, like military hand signals or race/clan-dependent terminology, can heavily emphasize a feeling of belonging and exclusivity. If new players should not be ruled out from the community right from the start, they need a comfortable way to reach a similar level as any game veteran. Introducing a player to game mechanics and control is most appropriately done by seamlessly integrating some type of tutorial into relevantly perceived gameplay scenarios, as we have seen. Likewise, learning about community communication should take place directly within the game society and is not supposed to be a one-man show. Provide safe trial-and-error spaces that also offer relevant incentives to be populated by more seasoned members, or reward players for taking the time to introduce a newbie to the community and its fundamental habits.

PROVIDING EASY ACCESS TO COMMUNITY

The final paragraph essentially leads us to the next requirement for designing game communities. As in real life, players tend to congregate with those people whom they expect to be able to keep up with their skills—

both on a mental and methodological level. It's therefore harder for new-
bies to break in to an already tied and established community—a group
whose members are already familiar with each other and that harmonizes
very well. For games being mainly competitive in nature and particularly
persistent-state skill-based environments, complications arise from the fact
that a player's social life is not isolated from his gaming experiences. Game
and community are strongly linked, which is essentially a good setup but
can result in more experienced players who use others' inexperience to
their advantage. Veterans who team up to criticize newbies and feel the
need to correct them can be an immediate reason to become discouraged
and leave—both the community and the game.

Providing easy access for newcomers to the community means binding
a player to the game right from the outset. An initially steep learning curve
in orienting within the game environment and basically understanding the
world's control mechanics causes a more seamless merging with its associ-
ated community. Dealing with newbie integration is thus a critical part of
both game and community design. It has been an issue in almost all exist-
ing commercial multiplayer game systems that also illustrate that there are
a number of potential strategies to work around these complications.

For huge-scale persistent-state games, a traditional practice is designating
specific zones of the game world as newbie ghettos in which player killing is
not allowed. A newcomer is then dropped off in one of these places the first
time he logs on and can improve his character stats in an environment that
is mainly populated by comparably skilled PCs or NPCs before he advances
into the more dangerous areas. Basically, such a scheme is an appropriate
approach. It's essential, however, that you avoid segregating the newbies in
these zones from all other (more experienced) players; the community
needs to be mixed. Therefore, there need to be reasons for game veterans to
migrate to these safe areas where they probably bump into some newcom-
ers and say hello. Exclusive events, tournaments, festivities, or unique loca-
tions such as marketplaces or training facilities are ways to provide the
necessary incentives. You could also motivate players to actively introduce
newcomers, answer questions, and help them get situated by rewarding
newbie mentoring. For some "newbie helpers," the honor to be mentioned
on your Web site or being named "mentor of the month" (e.g., by collect-
ing votes or nominations) might be motivation enough. Others would like
to get an in-game advantage in exchange for their efforts that would also be
a considerable option via offering unique special items or (moral) skills that
significantly strengthen the player in different situations.

Origin's *Ultima Online* was the first online system that presented a note-worthy distinct approach to maintain balance between long-time veterans and novice players within the game community. The skill-based character development system substitutes the usual "collect as much experience points as possible to grow in level" system with a scheme that allows a player to know only a certain number of skills. Skills get better with use, but will erode over time if they are not continuously trained. No player can be proficient in all skills. This method encourages players to join forces and cooperate as a perfectly balanced squad. Moreover, the most experienced loner can lose against a small cooperative group of less powerful players. For the sake of completion, it remains to be said that Origin later slightly altered the scheme again and introduced an overall possible maximum for both an avatar's skills and stats in UO. At the time of writing, it's possible to reach a sum of 700 skill points (Grand Master level limited to maximally seven skills), and there's a cap of 225 points for a character's three stats: dexterity, strength, and intelligence.

For session-based multiplayer experiences, dealing with newbie protection schemes is even more of an issue. These systems usually do not maintain any player stats, and balanced, fair, and competitive games and communities are thus primarily a matter of a player's own skills rather than proficiencies of his avatar. A popular method is to incorporate a multitier handicap system that combines the score of players sharing a session. It then somehow handicaps the more experienced ones, gives advantages to novices, and so allows an adequate and agreeable setup for both sides. Handicapping, however, can also discourage more practiced players who like to prove themselves amongst similarly skilled users to experience improvement of their own abilities. A scoring system might thus also be employed as a player-matching criterion to funnel people to the appropriate sessions. The downside of such an approach is that novices always play with novices and experts play with experts; they do not interact, socialize, and learn from each other—at least not directly within the game. Additionally, it's important to offer such functionalities optionally and only *suggest* the environments you see fit best. Some people like the additional challenge to play with or against much more experienced individuals. Likewise, as mentioned, it's sometimes the most favorite leisure pursuit for expert players to criticize or annihilate newbies and strengthen their self-esteem. If newcomers know what to expect beforehand and grant higher scored players access to their sessions without being handicapped, there is basically nothing bad about that. In the same way, it's important for

previously discussed persistent-state worlds not to confuse newbie protection with categorically prohibiting player killing. Player killing is an essential gameplay and community element and is only one of the goals and strategies available to a player in such environments. In order to enjoy the game, player killers need to know that others fear bumping into them; conversely, non player killers need to know about the existence of such threats to facilitate the challenging and immersing formation of counter strategies.

PROVIDING EASY RETURN TO COMMUNITY

A game community is an ongoing living social construct that survives a single game session and is persistent regardless of whether the game is actually defined as such. As in any activity, it takes some time to become familiar with the task at hand, but once reaching a certain workflow, things come more easily. Returning after a longer period of absence, however, starts the entire process again. The same holds true for game communities. Even the most seasoned player who did not actively attend in the game for a while and then logs on again for some reason needs time to reorient and get situated again. Providing the easiest possible return into the game community after (intended or unplanned) times of nonattendance is thus as significant as ensuring unproblematic preliminary access.

Probably the most effective way to do so is to encourage a player to join a clan, guild, or team as soon as possible by offering meaningful advantages for doing so (e.g., team competitions, leagues, cooperative gameplay elements, personalized logos, etc.). Chances are high that not all members of such small groups stay away simultaneously. They regularly correspond with one another—if not in-game then via alternative channels—and keep each other informed. The type of audience and atmosphere in your old-time favorite nightclub might have completely changed, but if your friends are still sitting at the bar waiting for you, you won't care and you'll get used to it.

Moreover, you can log a player's session dates and times to provide a solid help file with all major changes, updates, and events since his previous visit. The opportunity to subscribe to a regular newsletter that covers all that important information might also make one's return into the community much easier. Keeping the player up to date about what has happened, changed, and what he should expect at his next stopover is vital to bind him to the game and the community.

Making the Community a Central Part of Gameplay

As already noted, a game community also lives outside the actual game world. In order to unite both experiences—virtual social life and game—within a single context, it's best to implant as many community activities as possible directly into game space. Community aspects should be a central part of gameplay and directly related to one's perception of in-game success, immersion, or improvement. Some multiplayer concepts, most notably *Half-Life* or *Fireteam*, are explicitly designed for only team-based play and essentially enforce a community-centered gameplay component.

However, the whole design needs to encourage socialization and community. The rule of thumb is to present obvious reasons, incentives, and rewards for socializing and investing in the game community. We have examined the elegant approach of *Ultima Online*'s skill system to satisfy this demand. However, implementing (noncombat) social schemes could also be a matter of quest and mission design, level architecture, or "social skills" acquired solely through event organization, newbie support, or conversation.

Considering "Community-Only" Game Elements

What is meant by "community-only" elements is primarily not those previously discussed gameplay concepts, but complete systems that are—similar to games—multiperson and social from their incentive: political, justice, or comprehensive economic setups, for example. Of course, such concepts are usually very complex in nature. Furthermore, we still need to find out how they really function or make sense in the online world—nobody, for instance, has imagined there could be something like "virtual inflation" as was once the case in *UO*. These systems are, however, very promising to add additional social involvement and value to multiplayer game environments. You should always bear their power in mind, monitor your players, and support their attempts to establish the grounding frameworks for such systems by themselves (which is, sooner or later, very likely to happen).

Designing Meta-Game Environments

Each game—be it real-world or virtual computer game scenarios—gets an additional and quite emotive deepening layer if there is not only the game but also a meta-game; the game about the game, an overall game

surrounding a single "session." Basically, you can understand a meta-game as something that transcends a single game, accompanies the game activity as a whole, and actually lives outside the game environment. If the game is the battle, then the meta-game is the war or campaign. Meta-games engender the player to form long-term strategies, thoroughly study game mechanics, and follow goals that reach far into an emotional level (e.g., impression, reputation, glory, etc.).

In terms of community design, meta-environments are a very powerful, however complex, paradigm and method to tie *all* players together, more than only the participants of a single session. As such, a strongly bonded community is already a meta-game by itself. However, often unconsciously, it involves some type of social hierarchy (the meta-game) in which a member needs to resolve a multitude of conflicts in order to climb the ladder. If you intentionally implement such a system and provide incentives to invest in it, you can provoke "mission statements" far beyond winning or losing. You are creating a structure on top of the game that implies thoughtful farsighted planning—a scenario in which losing a battle is not losing the war and sometimes is even initially calculated.

DESIGNING "WE VERSUS THEM" SCENARIOS

Encouraging players to form teams or factions is a potent technique to facilitate community building and maintenance. Often ignored is the fact that players cannot only join to compete in team-versus-team settings, but also face challenges together that are presented by the game.

They can team up to overcome obstacles that only you, the designer, place in their path in order to prove their ability to cooperate and coordinate their actions as a group. It is those "we versus the developer" and "we versus those who assume to be in control" setups that can draw players together who normally don't have that much to do with each other. The simplest puzzle might be reason enough for a player to join forces with those who happen to be around at that moment and form situation-based, temporary posses. However, once those players have shared the experience of a glorious victory or shameful defeat, they already know each other, have a common history and background, and probably keep in touch.

Possible examples that come to mind of how to practically implement this idea are uniquely powerful NPCs, cooperative switch riddles, or traditional endboss situations. Likewise, you could announce scheduled player-versus-developer tournaments in which you and the team demonstrate

how much time you have really spent with the game (and promise not to cheat . . .).

Testing a game community by such means doesn't need to be exclusively related to combat or puzzles. Everything that requires community-wide cooperation, conversation, and conflict resolution might do the job: economic crises, catastrophes, or (artificial) social injustices. Essential to bear in mind is that events like these should be the exception rather than the rule and that you precisely monitor "big" incidents and be prepared to take countermeasures at a certain limit. Always ensure that the game is still a pleasing and safe environment for the community to live in.

EDUCATING YOUR PLAYERS

Not only will you gradually have to find out about the inner workings of virtual game societies, at least on a fundamental level, but also the players have to learn how to act in these unique spaces. The conflicts that players have to tackle might be significantly different from what they might be familiar with from traditional gaming and reach far beyond the actual game. Game communities involve social quandaries marked by anonymity, pseudonymity, goal-oriented role playing, and culture, milieu, and religion mixes. How to deal with harassment and virtual crime? What about reputation, and how does it work? Who enforces virtual laws, and how can we punish violations? Questions such as these are critical to ask and should be answered. This is why you should educate your players from the very beginning, make them aware of unique moral issues, and inspire them to learn about each other's values, norms, and background.

The goal should be educating players to understand themselves as *individuals*, as more than simply players or avatars, and therefore build the basis for the establishment of a self-aware society that, in the long-term, is probably controlling itself (or demanding tools and ways to do so).

PROVIDING TOOLS TO BUILD AND MAINTAIN COMMUNITIES

The game community is a dynamic social construct that builds and maintains itself, as we have already examined; however, only if you offer the players easy ways that facilitate the process to define themselves and give them the tools they need or explicitly demand. Clearly, the complex nature of game communities also results in more or less complicated-to-implement tools. Well-designed meta-game scenarios, for example, or the organization and formation of designated player militias or jurisdictional

authorities are some of the more sophisticated issues. However, tools enabling to shape a community can also be as "simple" as hosting and/or listing community Web pages and providing the necessary resources to create them (e.g., fan-site kits, message-board scripts, chat systems, information and news about the dev team and others from other fan pages, etc.). Give players reasons to spend time on the game even if they are not playing; motivate them to analyze and study the game. Intentionally leave "holes" in your concepts that they are very likely to fill themselves and share with the entire community, such as maps, strategy guides, tips and tricks, or Easter eggs. The race to be the first posting such information or to develop the most visited, honored game resource site can be a very compelling and interesting competition setup on its own. Let players introduce themselves and their team/clan/guild to the rest of the community—both their real-life and virtual characteristics and statistics. Allow them to organize and easily supervise community events—in-game, out-of-game, and in real life—and reward, support, or sponsor these activities.

If your concept and technical capabilities can handle it, providing tools that enable a player to personalize media content to some degree is a useful method to draw people together and make them aware of each other. Logo, heraldry, map, and character editors assist players and groups to set them apart from one another, facilitate self-identification, and let communities actively shape the environment they live in according to their demands. In addition, these tools give rise to remarkable meta-game setups full of gaining reputation, admiration, and demonstrating abilities that go beyond solely succeeding in the game.

The key is to give them tools that make them communicate and interact—in more or less subtle ways. You should continuously keep in mind that your game is essentially multi*player*, but its community is multi*person* and resides outside the immediate game context. Allow people to play together and to communicate and suppose you in the role of the mediator; as the one who provides the necessary communication channels, gives each player the directory, and ensures that everyone dials the right number.

BECOMING AN ACTIVE PARTICIPANT

No matter if you are designing a large-scale persistent online world or working on a three-month Web-game project, the complex nature of a loyal, tied player community has nothing to do with the complexity of the game. To thoroughly understand your players and appropriately react to

the community's needs, it is therefore essential to become one if its members yourself. Become an active part of the community and communicate with your players. Under certain circumstances it makes sense to stay anonymous and participate in the role of someone "usual." Normally, however, players should know that you are a member of the dev team and are ready to answer their questions or are available for a brief introductory tour throughout the game environment. Participating in the community should never be confused with customer support or newbie introduction. It should be mandatory for the entire team, at least as often as production schedules allow; nobody is able to design, program, model, or illustrate for audiences whose characteristics, desires, intentions, and behavior patterns are in the dark. Of course, there are several guidelines that you and every company representative should consider while taking care of your customers: honesty, devotion, preoccupation, and open-mindedness being at the top of the list. The first and foremost rule, however, governing all communication between the staff and the devotees, should be treating the players as equal and intellectual individuals. It would be a bad idea to despise them from the stance of the "know-it-all, untouchable developer."

A second aspect accompanying your communication with the community is that you should regularly inform the fans about the most up-to-date state of the game. This is important for periods prior to the initial product launch in which you should provide information about your latest additions, tweaks, bug fixes, and so forth. It's particularly essential after the game goes online. Show the community that you understand that they are *living*, that the game *lives*, and that you still take care of it. Tell them what you are currently working on, what to expect next, and the reasons for probable technical problems.

COMMUNITY MANAGEMENT

Besides the previously discussed methods to facilitate game community building, establishment, and maintenance, there are a few additional aspects to take into consideration. Community management deals with possible ways and issues that play a significant part in supporting your community base and fine-tuning its structure in the long run. As you will soon see, however, none of these matters are worth considering after the game goes online. It is fundamental to account for them from the earliest conceptual design phases. Again, it's further essential to thoroughly study

facets of real-life society and other virtual online communities on which the following ideas heavily draw.

BALANCED COMMUNITY SIZE

An aspect to bear in mind when designing game environments for an Internet audience is that as soon as your customer base hits a certain level you will have to deal with significantly increasing administrative work. This is even more of an issue for projects explicitly targeted toward a mass-market, casual-gamer audience rather than those primarily meant for the hardcore fanatics. However, administrating game communities is not a one-time job and involves more than just creating accounts, billing, or sending out a monthly newsletter via some automatic mail system. Remember that your players are personalities who—although temporarily interacting in game space—much more define a persistent virtual society. They are a nation of which you are governor, police, mentor, judge, lawyer, pastor, and entertainer.

One way to make sure you can support and take care of the community as needed is to facilitate and reward the formation of subgroups such guilds, clans, teams, or factions from the beginning. These interest groups provide a feeling of belongingness and comradeship, serve as one's personal interaction anchor, and inspire socialization and self-awareness. They also assist you in keeping the community size at more manageable, practical, and transparent levels. By channeling a player toward a specific social focal point you can hand some of the administrative tasks over to a group that is (hopefully) sensible for watching over its members. As so often in multiplayer online game design, there is nothing you can do to compel a single person to join a faction. However, you can provide reasonable arguments and incentives to do so; let a player know where to find those other people, what their activities, goals, and viewpoints are, or suggest groupings he could possibly fit into based on his profile information. This aspect again brings up the importance of giving players powerful, undemanding, and accessible tools to build and uphold game communities. Guilds and clans need ways to express and introduce themselves—also with the intention for acquiring new members. In the same way, the player whose purposes and needs do not correspond to any of the existing alliances' ideas necessitates opportunities to found his own.

Subcommunities tend to establish their own notions and rules that again shape the game community as a whole. Defining justice systems,

laws, and code of conducts, for example, would be easier and more effective if initially done in a small group setup before carrying these suggestions to the entire player base. Similar to a parliament, it's less complicated for a smaller group to get somewhere, level out at common schemes, and then nominate a guild master for the community congress.

BALANCED MEMBER STYLES

Encouraging players to join subcommunities only for the sake of supervision should not imply neglecting their individuality and personality. It is still the final segment of the chain that shapes the game and the community—one's private decisions, plans, and action patterns. It's therefore also indispensable that you consider the distinct roles that players can possibly embody in the community. Similar to real life, a virtual society should be balanced by means of its members' individual styles. One personality type needs distinct counter-characteristics, a matchmaking piece, in order to put needs and purposes into practice in a gratifying and rewarding manner. Probably the most obligatory discussion exemplifying this idea concerns the necessity for player killers, for antisocial behavior, in multiplayer games. Player killing only makes sense when knowing there are others fearing such behavior. In contrast, would a peaceful, non-aggressive online existence be half the fun without the awareness of potential dangers and threats?

Identifying the fundamental differences between player styles and roughly outlining these variations allows you to account for their required compliance in your designs. If you allow for a variety of styles and provide reasonable rewards and incentives for each, players are very likely to balance the community on their own—automatically stabilizing themselves in the desired equilibrium.

However, what different styles can you actually assume a player could apply within a multiplayer online game environment? What are his possible roles within a game community, and how do they relate to their respective complements? Let's briefly examine by what criteria you can structure and typify members of a networked virtual world society. First, here is a list of the categories, each of which we will then discuss:

- Type of role playing
- Relationship to gaming experience
- Preferred interaction style

- Behavior in social conflicts
- The Bartle classes

The first and arguably simplest method to classify a player is according to the way he makes use of abilities to role play in the game and community context. Role playing here is not meant to refer to a specific understanding of a computer game genre. Essentially, you can consider any online multiplayer environment a role-playing game; a playground to experiment with distinct (multiple simultaneous) social roles in a setting where people do not usually know each other and can rely on complete anonymity. This is also how we typify a player's style in this context. Community members differ by the degree in which their virtual role mirrors their real-life character; how much of their personality they present to others and to what extent their online behavior, decisions, values, and norms reflect their real-world counterparts.

A different method for defining player types to analyze their relationship to the game experience and what purpose is mainly served by one's participation within the community. First, there are *gamers*; their initial driving force is solely the game, its genre, contents, or innovative elements that will remain their primary interest throughout the entire process. These are the people who thoroughly study the game, investigate each possibility offered by its low- and high-level mechanics, and strive for perfection. Their dominating motivation is proving themselves; community is secondary and is only treated as a tool to improve and advance in the game.

Socializers (who we will soon bump into again), on the other hand, focus entirely on the social aspect of things. The game is not that crucial and is only understood as the common link within the game community. Play is a social activity that facilitates communication and relationships that are the dictating objectives of these people. Contrary to *wreckers*, they usually have positive intentions and prefer pro-social behavior. The only goal of wreckers is to ruin other players' pleasure and game experience, and they don't miss any opportunity to satisfy that demand: cheats, hacks, harassment, insults, and the whole set of profanity and vulgarity.

Subsets of these antisocials are *cheaters* who, although using dishonest "helpers" to their advantage, don't initially intend to harm anybody else. These players again merely focus on the game, but cheat in order to demonstrate their abilities to others. They want to be admired, love to (ver-

bally) defend themselves against others' accusations, and use every available method to bring their name to the top of a public high-score list.

Let's call the two final player types *bug-explorers* and *try-outers*. Whereas both types can emphasize the play aspect of a multiplayer environment, only try-outers usually enter the social field as well. As their name implies, bug-explorers methodically scour your designs for probable bugs that give them a tactical advantage in the game. As such, they are normally very dedicated players, but do not immediately report their findings and keep them secret as long as possible. Try-outers are simply those who tend to switch a lot—both the games they play and the communities they join. They do not deeply delve into the abilities offered by both of these elements, and want to get a vague impression and idea from as many distinct online game and society contexts as possible.

In her article *Online Psychology*, Eli Lindert suggested a further way to specify a player's style. *No-jerks* are the most neutral players and usually do not intend to harm anybody else. The game, not the community, is the central part of these people's activities; they mainly deal only with their closest friends and only act antisocial if they need to in order to improve in the game or to get some additional experience points. Other rather distinct types of players are the *truly-nice* who help and assist others wherever possible, even total strangers. Their self-stated mission is to make the game environment a socially pleasuring world, which occasionally also makes them act to their personal disadvantage.

Ignorants are players who would need some introduction and advice the most. Most commonly they are inexperienced newbies who do not plan to ruin anybody's activities, but accidentally do so because of their naivete and their unawareness of seeking out tutorials, guides, or other players' instructions. They simply experiment with everything (and everybody) coming their way without being interested in getting the big picture or understanding what others do in the game and why.

Then there are two flavors of *arrogants*; there are very experienced veterans who apparently demonstrate their superiority and assume to have the right to be respected. Players like this have usually spent a tremendous amount of time in the game world but do not share their experiences and are inclined to look down on the majority of the community. However, there are also common, average players who only intend to give the impression of authority and leadership. They "role play" the long-time game fanatic and seek attention and admiration by founding multiple

subcommunities (guilds, clans, SIGs, etc.) to mobilize as many followers and believers as possible.

Finally, distinct versions of *evils* can populate the virtual online game world. As already mentioned, their only goal is destroying other people's excitement and embodying a prospective peril. The difference is in how they do it. Player killing, for example, is only one way to play a game and mainly results from one of the most dominant incentives driving multi-player online gaming: play with or against "real" humans. You simply cannot expect NPCs to get upset the way another person would who additionally tends to release his anger and give the desired feedback. Nonetheless, evils can also mean players who pursue their intentions in more methodological and planned ways than the usual player killer does. They develop thorough methods to satisfy their demands, and try to model and establish the "personified evil" in the both the game and community context. Contrary to in-game-only evils who are often the nicest persons once they leave the game world and enter other community spaces, these players continue their behavior as long as they are online—also in relaxed social environments and at a personally offending level.

When examining various player styles and how they add and relate to each other, we should not leave out probably the most legendary characterization of this type introduced by Richard Bartle. His suggestions conclude a long debate between veteran players of an early commercial MUD, and anyone interested in professional multiplayer game and community design is highly encouraged to consult the original, detailed work. These thoughts are by no means outdated or only applicable to MUDs or persistent-state game environments. Remember that game communities are persistent for all types of online multiplayer experiences. Balancing these virtual societies can mean the success or failure of your project, particularly in times of increasing competition, online console play, and wireless multiplayer gaming. It therefore makes sense to briefly outline Bartle's concepts in our discussion.

Killers and *socializers* alike are mainly interested in the social aspect of online game environments. Whereas killers focus on doing things *to* other people, socializers like to act (and interact) *with* people[1]. The game is primarily a tool and platform to talk to and get to know each other, and only

[1] In the original text, Bartle draws the line between acting (on something) and interacting (with something). A distinction, however, that does not entirely go along with the concept and model of interactivity in multiplayer online games as introduced in this work.

provides the necessary social framework, setting, and moods; it's the reason to meet in virtual space. Killers, on the other hand, treat the game as the context that justifies their destructive behavior and makes it socially acceptable. They enjoy proving dominance over emotionally driven humans, are fulfilled by their bad reputation among their co-players, and don't miss any available opportunity to improve their already superior power.

Contrary to these two player styles, *achievers* and *explorers* mostly focus on the gaming side of things. They differ insofar as achievers do things *to* the game, and explorers do something *with* it. Explorers want to uncover each aspect made available to them by the virtual world, know each facet of its workings, and visit every area of the binary landscape. Other people are mainly understood ornaments and almost as inessential as the hunt for more points or higher skill levels. Because they explore all you make available to them, they are the ones who do not stop until they see the "100% secret items found" or "all locked areas enabled" screen, and therefore also tend to cheat in certain situations. By no means do these players have the desire to demonstrate superiority over others; they are only proud of their finer knowledge about all the game's mechanisms and toys.

Achievers are looking for admiration and glory. They want to achieve the highest possible rank, score, or skill level; not to be in control of other players, but solely prove their exceptional ability to master and beat the game—to others and to themselves. Details of the game or dealing with particular individual personalities of community members are less significant unless they mean a significant step in advancing in the game or their status level.

To conclude our examination of possible methods to typify your games' players, you see the necessity to carefully study and monitor their behaviors and to draw conclusions as to what tools, mechanisms, and matchmaking counter-types they might need to cultivate their purposes. Balancing game communities and maintaining their "social equilibrium" is vital to the design of online games that also provide the experience of a challenging, multifaceted society—an aspect that can mean the ability to survive in future competitive market scenarios. There is a very fuzzy line between community and game; both require and supplement one another, and we therefore should not treat one of these aspects as secluded or independent in our designs.

GAME MASTER SUPPORT

As soon as your game community reaches a certain size, guaranteeing the necessary seamless support, assistance, and supervision of all its members

becomes progressively harder. You could have done everything to ease the formation of a stable, self-organizing, and defining virtual society, as we previously talked about. Similar to real life, however, the more complex and versatile aggregations of distinctly characterized individuals are, the more complicated are the problems arising with and between them. To ensure a fair, exciting, and liberal game and community setting with large numbers of people online, it has become a popular practice (particularly in huge-scale commercial online worlds) to explicitly hand some of the managerial duties over to selected players. Those players are usually experienced game veterans who offer to participate voluntarily in some form of game master (GM) program and so agree to provide services "for the good." Employing GMs is definitely a valuable strategy to conquer the additional problems and time-consuming tasks inherent in larger communities. As with every design element, however, a GM program needs to be carefully planned, at the very best as integrated part of the original concept, and also means some extra thought if it should durably work as efficiently as intended. Let's thus look at issues you should take into consideration when implementing GM support in your game and community environment.

What are GMs, and what are their tasks? Don't be confused by the terminology; some games use different terms for GMs, such as *Guides, Counselors*, or *Companions*. Usually, these distinct titles are used to designate specific types of GMs varying by the rights and "powers" they have (we will come to that in a moment); but the overall idea is essentially the same. Often, a "real" GM is referred to as someone able to change the course of the game (e.g., preparation of quest events) and is more closely related to the traditional understanding of a game master but thus only appropriately doable by in-house staff. We should not worry too much about the actual detailed definition of GMs in this context; it's the concept and idea that counts, and what we will therefore concentrate on.

You can consider GMs as the frontline of customer service. The functions they serve in the game world are more manifold than only introducing and mentoring newbies. They are mediator, tutor, police, public prosecutor, analyst, and correspondent between you and the community. It's interesting to note how closely related the idea of a GM is to the original understanding of a game master that stems from traditional pen-and-paper role-playing games. His actions and decisions affect the entire game world and shape, define, and serve the experience and enjoyment of his co-players.

Mentioning this directly leads us to the most fundamental issue regarding GM support; that is, what should make them different from their original function outside the virtual world: GMs are not meant to change the rules and laws of an online multiplayer game environment. The chief of all GMs in this sense is always a piece of software in the virtual world, and its built-in mechanics are defined by the designer. Why is this crucial? Because you need to ensure that GMs and "usual" players alike realize that fact from the very beginning. A player should know that consulting assistance from GMs is not the key to in-game success or of any help to get advantages over another. GMs do not increase skill levels, resurrect deaths, give away money or items, reveal secrets, and don't help out in battles or the completion of a mission/quest. Likewise, GMs should understand that it would be counterproductive to interfere and solve each and every (social) conflict between players. Whenever possible they should encourage players to work out most of the problems on their own, without an independent moderator and as a self-aware community. This would heavily drive the community process, provoke companionship and democratic thinking, and preclude antisocial behavior in the long run.

What rights and duties should GMs have in the game world? In some cases, there is simply no way to resolve sticky situations other than having a third party step in to clarify misunderstandings, mediate disagreements, and intervene regulatory. However, GMs are not only responsible for warning players involved in situations of harassment and other anti-social, unfair behavior such as cheating, abuse of unresolved bugs, or use of foul language (e.g., hate propaganda, racial slurs, or terminology not appropriate to the game's setting). One of the major tasks of GMs is helping newbies get situated in the game environment, introduce them to the basic mechanisms of gameplay, and answer basic in-game questions. Depending on the game, their tasks also involve compensating for significant drawbacks caused by bugs (e.g., stuck in game geometry, verified bug deaths) and to document and report these discrepancies. GMs are also often the ones who moderate in-game events, tournaments, or festivities and can be contacted to give feedback about new features or to deposit suggestions for future improvements.

Some of today's large-scale multiplayer online games put their GM program on top of the hierarchy system that defines what rights and responsibilities a GM has and doesn't have (yet). In Verant's *Everquest*, for example, a volunteer starts as "Apprentice Guide" and has to work his way up to a

"Full Guide" and "Senior Guide" to the title of an "Elder Guide"[2]. A hierarchical GM system is a valuable method to keep this concept manageable, highly efficient, and controllable—with clearly designated privileges and the resulting responsibilities. Remember that handing administrative duties over to nonstaff people usually also means making tools and functionalities available to them that a "standard" player does not have; only then will they be able to their job effectively and serve other players' experience. Therefore, you need to make sure that the players getting these exclusive powers don't abuse them, only act for their own or their best friends' benefits, and are aware of the extra responsibility that comes with their role. Letting your GMs gradually climb a hierarchy ladder is a suitable way to give them the chance to prove their eligibility and the confidence placed in them. Additionally, you would present prospective rewards and incentives for their voluntary activities; something they could strive for and indubitably be proud of. The flipside of the coin is that such systems again require additional administrative work, monitoring, and evaluation, and raise further issues you should account for. Low-level GMs, for example, need fast and easy ways to pass on those problems they are unable to solve to higher-level guides. For the player seeking instant assistance, there is (and should be) no perceptible difference between distinctly powerful GMs other than, say, the name tag or a special avatar robe.

The previous approach of a hierarchical GM support accurately illustrates some further significant aspects of the whole concept. To continue with our previous example, it's vital that even "Elder Guides"—being unknown and incontrollable to some degree—are not the final decision makers and judges. GM programs do not substitute some type of customer support from your side. There are always conflicts and technical complications that you simply cannot pass on and relinquish control over. Depending on your project's scale, the last instance of any GM system should be you, the dev team, and dedicated staff members. Keep in mind that it is your responsibility to care of your game community and to provide the framework and rule-sets with a potential to result in an increasingly self-regulating virtual society. As employing full-time customer support staff demonstrates, offering GM support to its perfection is a time-consuming and conscientious occupation—it is a profession rather than a spare-time activity. This is why you should understand GM programs as ongoing pro-

[2] There is only a single "Elder Guide" in *Everquest* who is solely in charge of managing the GM program.

jects that also have to be timely scheduled in detail. You just cannot expect players to offer the same qualitative services on a voluntary basis as done by employed teams supervising the game 24/7. It's thus worth carefully scheduling the work of your GMs to ensure that there's always someone available to help out, interfere, or clarify misunderstandings. Many players can agree to a few fixed hours a week for only a minor reward if they can easily (and flexibly) coordinate their online duties with their daily routines. For these periods, you can allow and assure professional and committed support, which is both your and the GM's driving motivation. In case you cannot rely on a precise schedule—which, in fact, is difficult to arrange on a voluntary basis—encouraging a minimum but freely schedulable amount of time spent online is definitely an option. Additionally, you could consider offering alternative, uncomplicated, per-play opportunities to join a low-level GM team to those not willing to commit to a schedule. *Ultima Online,* for example, introduced a special "Companion program"—a very interesting and noteworthy approach which, however, has been cancelled. Once officially accepted as companions, these players can set a special software flag whenever they are available and willing to assist new players. By doing so, they indicate being prepared to receive calls from the game that whenever a new player enters the game world automatically suggests the companion to lend the newbie a helping hand.

In the previous scenario, though, companion and newbie are not necessarily linked by means of communication or map geography. It's completely up to the companion to join his trainee or ask whether he might need some introductory assistance. This fact reveals the next issue to consider in designing for GM support: players need instant and easily accessible ways to contact GMs when they require their services. Within the game environment, there is a variety of possible methods to implement such functionality. Contacting a guide in *Everquest,* for example, is done by using a special chat-window command (/petition) that adds the request to a queue for guides to answer in the order in which they are received. In *Motor City Online* and *Ultima Online,* players can access a help-request form via an omnipresent interface button and then further specify their problem. We should not treat one of these approaches as significantly stronger or more efficient than the other. What we see, however, is that you might want to consider allowing ways to typify the type of difficulty a player faces. Such a method lets you prioritize a situation according to how severe it is, and initially designate the problem to those having the tools and experience to solve it most effectively. Intervening serious scenarios of

sexual harassment, for example, is definitely of higher priority than documenting suggestions for future game expansions. This is also where a hierarchical GM system could really come into its own; giving high-level GMs the opportunity to easily identify those problems only they are meant to work out.

Designing for simple tools to request GM assistance is not the end of the story. Players should further have the capability to record how a problem has come to pass, to log significant details of events and happenings. This might be as simple as offering multiple slots to store screenshots, or as complex as logging complete descriptions of the current game state on both the client and server side. It is important to allow players to justify their petition and later prove their complaint and the fact they didn't abuse the GM support system. In addition, GMs have a stronger, more reliable basis to make their decisions and act appropriately: neutral, fair, impartial, and for the sake of a generally pleasing game community.

According to the understanding of game communities that also live outside the immediate game context, requesting GM support should be available through various alternative channels. Contact possibilities via e-mail should be mandatory, as are moderated and supervised forums on the company Web page. Dedicated customer support Web sites, online GM centers, or scheduled chat sessions are considerable supplementary options. As long as you could successfully avoid abuse, you could even suggest a player to add his favorite "companions" to the buddy list of his IM application.

What these alternatives to request help further unfold is that you still have to offer ways to report directly to you or dedicated staff; no matter how dependable your voluntary helpers might be. Contacting the final authority is crucial to get help in serious situations in which no GM is available or online. It is an essential tool for you to monitor and evaluate your volunteers. After all, they are out of your immediate control, and you should allow the community to complain about and criticize GMs who do not meet the expected demands.

Finally, this leads us to the need to spend the necessary energy on carefully selecting and training members of voluntary GM programs. Normally, you should motivate the most experienced customers to join support programs—those who know most facets of gameplay and community. Besides that, you might request a minimum age, a proven clean penalty or harassment record (which could be combined with a multigrade player voting system), *and* to attend a preliminary training course. In such

courses, you should make prospective GMs familiar with the additional tools and software they will later need to help other players efficiently. Furthermore, you could artificially create potential severe conflict situations for them to solve, or directly let them experience how entering the world as a newbie might feel and see what newcomers will probably have to go through.

A final question remains: What is the appropriate payback for voluntary community support? What rewards can GMs expect for their services, and how can we encourage players to join a GM program? The first and foremost rule is to provide the appropriate feeling of being respected and heard. First, the way you treat them is essential, and only then you can consider presenting and introducing their activities to the entire community; to give them something to be a bit proud of. The honor to see one's name displayed on the company's Web site is often reward enough and could be further strengthened via links to official GM Web pages, for example, on which they could introduce themselves to the community in more detail. Consider your GMs as a subcommunity, like a guild, faction, or team. You could prepare GM-only tournaments, game sessions, or nominate a "GM of the month" based on votes cast by players, which would be honored with prizes such as giveaways or temporary free subscriptions.

SUMMARY

Throughout this chapter, we covered potential issues of designing for game communities and fundamentally understanding how those virtual societies that mean a significant change to the computer gaming media could (possibly) function. We examined the basic characteristics of networked communities and potential methods to facilitate their building and maintenance. Moreover, it's vital to bear in mind the importance of balancing such groupings at their social (and gameplay) equilibrium. Communities shift computer games back toward one of the most fundamental aspects of human play: being (also) a social activity. In fact, they revolutionize the course of computer game design and transform "community design" to a reasonably powerful tool in the designer's repertoire; a tool we still need to learn to make the most of.

CONFLICT AND COMPETITION

IN THIS CHAPTER

- Conflict in Multiplayer Spaces
- Conflict Scenario
- Conflict and Cooperation

Conflict generation is another aspect often claimed to be the very essence of computer game design—clearly, for very justifiable reasons. In all games, the player is striving to reach a specific goal, driven by motive friction, and does his best to overcome the obstacles that prevent him from effortlessly achieving his intent. Conflict is vital to all games and particularly to computer games in which these barriers are (usually) dynamically altered by some intelligent agent. For multiplayer online games, however, this "modifier" is no longer only a piece of software; in resolving his conflicts, a player now needs to take a multitude of intelligently and rationally acting agents into account. This scenario reveals that for multiplayer environments, designing these motive frictions is distinct and unique. Finding out by what means and how we could possibly account for a new understanding of conflict in our designs is what we will do throughout the next pages.

CONFLICT IN MULTIPLAYER SPACES

How should we understand conflict in online multiplayer environments, and how does it relate to competition as implied by the title of this chapter? As already outlined, a first approach is to define conflict as an intrinsic criterion of games in general. The player decides and acts in order to achieve his (primary) plan and alters his course according to the obstacles obstructing the direct path to his goal. This is a rather simplistic interpretation of conflict that makes it difficult to use conflict generation as a sophisticated tool in the design of multiplayer games. What could be applicable to strengthen the abstract concept is trying to reveal different types of conflicts and identifying what their characteristics are. Let's take a more detailed look at the nature of the obstacles in the player's way. Who creates them? How do they behave?

In traditional single-player experiences, these barriers are mainly (pre-) defined by the game self, its concept, architecture, and the designer; a piece of software creates them. Now, the game is—depending on its complexity, mechanics, and (technical) capabilities—able to change the obstacles dynamically. It is more or less capable of anticipating the player and his actions and accordingly altering the problems that prevent him from reaching his goal (too) easily. In fact, nonstatic, purposeful, and active obstacles are what, according to Chris Crawford's suggestion in his legendary book *The Art of Computer Game Design,* differentiates games from puzzles. Conflict can only arise from contact between the player and an actively responding entity—whomever or whatever that might be.

To some degree, we should revise the previous examination again. This is not to say that conflict does not need dynamic obstacles, but we should ask whether the one altering them can also be the player self. It is those conflicts that a player solely holds with himself; those that are mostly motivated by his self-stated goals and driven by struggles related to personality, experience, knowledge, values, norms, or dreams. It is competition with self that is actually noncompetitive in a strict sense because there is no distinctive winner or loser. This type of conflict is present in all computer game experiences—multiplayer and solo games alike—and shows similarities to what can be essentially called "play" (e.g., children's or animals' play). Metaphorically, play can therefore involve conflicts in which the intelligent agent that dynamically alters the obstacles is the hurdler self. Often, the biggest challenges stem from overcoming one's own notions or the desire to widen one's mental concepts.

How exactly do these motive frictions concern multiplayer online game environments? There are three issues to illustrate the idea further. Understood as a very general form of play, "conflicts with self" often comprises experimentation, tryout, and pretense. You see that these facets have a lot to do with what you might call role playing. Role play, the ability to personalize and define one's roles according to the actual purpose (the conflict) and deceiving oneself and others, can thus be a crucial element in *any* game that strives to generate conflict. Next, it's informative to examine how these challenges differ from their real-world counterparts once transformed into virtual game space. In actuality, conflicts with self are perceived as much more meaningful and eloquent in the course of a game experience than in daily life routine. Contrary to real life, only the game is capable of embedding the conflict scenario into some dramatic context and provides the necessary focus. It continuously puts emphasis on the given challenge over a prolonged period of time, and most importantly can evidently resolve it within a limited timeframe. In the game world, a player gets the required feedback to his actions and decisions for these "competitions with self" and directly experiences the consequences—something that only happens occasionally in real life. Finally, it's necessary to realize that this type of conflict is by no means isolated, but clearly still dependent on factors lying outside one's own mind to a certain degree. Only the most egocentric, imperturbable, and introverted player can totally neglect what happens around him, even if he is only concerned about himself and his privately fought combats. There is still the game and—particularly significant in this context—there are multiple other players simultaneously acting, deciding, and aspiring to resolve their conflicts. This directly leads us to the third and last type of conflict that crops up in multiplayer game environments.

We have talked about intelligent entities, and we have examined how obstacles dynamically altered by them affect a player's conflict resolution on the path to accomplish his goals. Multiplayer environments now host a multitude of players who all act and decide in order to resolve their individual conflict(s), and by doing so significantly shape one another's problem solving—more or less consciously. In most multiplayer games, this happens simultaneously and in real time. The player constantly needs to adapt his mental model of the current state and the resulting consequences according to what others do to him and the game world. He faces conflicts that only arise from player-to-player interactivity—interpersonal competitions. There are four issues that make inter-player conflicts unique and noteworthy.

Most obviously, a player no longer has to anticipate only a single "opponent," but needs to be aware of all persons within a distinct field of interest. There are various intelligent agents who all primarily act on only their behalf and personal interest. Of course, some games emphasize and motivate a cooperative gameplay aspect as well. Finally, however, cooperation leads (or more precisely should lead) to conflict; if only to a team-versus-team or clan-versus-clan scenario. Conflict is intrinsic to the definition of "game," and a commercially successful computer game without any competitive element, interpersonal or not, has not (yet) been released.

The second significant aspect is that obstacles thrown up by human competitors can be totally different in nature from those created by any computer software or by hard-coded concepts of the designer. Humans can sometimes act irrationally and not make the most obvious or expected decisions. They are extremely context sensitive, but are still able to realize the big picture; they can formulate plans toward long-range goals and see the necessity to occasionally act intentionally to their own disadvantage in the short run to achieve that purpose. Irrationality, long-term interests, and spontaneity, the obligatory "trembling hand," make it extremely sophisticated and challenging to incorporate human entities into one's conflict resolutions. This is particularly true for persistent-state game worlds that usually involve and require a great deal of long-term planning. However, session-based experiences are also heavily affected by interpersonal conflicts; most notably due to the fact that humans are, unlike AI agents, constantly tuned in to the possibility for repeated games, reputation, and imminent conflict scenarios.

Similar to what we have already seen for conflicts with game, interpersonal challenges are also different in game space than they are in real life insofar as the game intensifies these conflicts. The game sphere highlights them and lets them appear extra immanent, meaningful, and consequential.

However—and this is the final essential aspect of inter-player conflict to be covered—it's necessary to understand that it is in no way limited only to the immediate gameplay context. Interpersonal conflict in multiplayer game environments not only means some form of in-game competition, but also challenges that arise from the community. As we have seen, a game community also resides out of the game, is persistent, and most importantly, is defined by more than only the game. The community facilitates relationships and discussions beyond a narrow interest, and therefore also involves a wide array of probable conflicts: ranging from "plain" discussions over debates about game mechanics to serious, emotionally social

conflicts that have the potential to reach into a player's real life. Analogous to games and real societies, a game community is marked—actually defined—by conflicts. A community without conflict is simply not a community—at least not a challenging and exciting one. What this illustrates is that conflict generation in multiplayer game design means more than providing combat, battle, and war scenarios. This is only how inter-player conflict is often (mis-) understood in the context of computer games—from both players and designers. However, violence is solely a single, although very intense, and definite form of interpersonal conflict. Moreover, it's only a challenge as presented *inside* the game that probably penetrates *resulting* conflict outside the game space. This also works in the other direction: the community can bring about challenges that *then* have effects on the game world. We will soon examine some practical potential scenarios on how this aspect could take place. First, let's summarize the types of conflicts in online multiplayer game environments that we have identified throughout the last few paragraphs (see Figure 11.1, page 234).

For multiplayer online game experiences, players continuously face each of the three conflict types we have discussed: conflict-with-game, conflict-with-self, and conflict-with-community. Each simultaneously copes with all of these distinctly shaped challenges, tries to balance and prioritize them according to a prime goal, and by doing so significantly affects all others' conflict resolution. Therefore, it's also fundamental for the design of multiplayer worlds to take this broad range of challenges into consideration; to stimulate distinct "obstacle receptors" of the player in order to provoke differently facetted conflicts. Likewise, we need to realize conflict in game design as more than combat, player-versus-player competition, and violence. Generating tension and providing motive frictions in multiplayer game design is also a manner of facilitating community conflict—conflict initially generated *outside* the game world but with the potential to ultimately affect one's actual game experience.

CONFLICT SCENARIOS

Let's now discuss a few possible methods to implement conflict scenarios in your designs. Some might be more obvious than others and span the entire field of previously examined types. However, this should present an initial impression of how versatile and manifold conflict generation can be in the online multiplayer game realm.

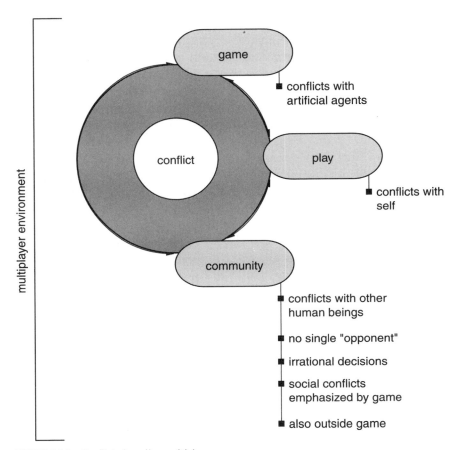

FIGURE 11.1 Conflicts in online multiplayer space.

CONFLICT THROUGH TOURNAMENTS

The arguably most obvious (and simplest) way to provoke conflict is in the form of designated, announced, and organized contests or tournaments. Within this context, this does not mean routine competition between players, which is the major aspect of practically any multiplayer game—be it *Quake*, *Age of Empires*, *Backgammon*, or *Everquest*. What we mean are planned and supervised tournaments that are either organized by yourself or a group of players and offer an immediate, exceptional reward. Clearly, the details of such contests' implementation heavily depend on the type of game. There's a broad variety of possibilities: player-versus-player, team-

versus-team, player-versus-game, and so forth. Furthermore, they can be round based, score based, strictly scheduled, timely limited, last-man-standing, or even in a way where the participators never share the same game world and all only play individually "against" the game. Regardless, it is essential to realize that tournaments manage to accentuate conflict even further than what is actually already done by the "usual" course of the game. They are events that catch a player's attention and engender him to deal with both the game and other players in a bit more detail than he might be used to. As such, they can additionally tie a game community, especially via provoking extra communication among its members (e.g., organization, negotiation, coordination, after-contest analysis, and discussion). Not to mention team-based contests that further emphasize a feeling of familiarity, belonging, and self-awareness.

What actually underlies this bonus challenge accompanying these tournaments? The main reason seems to be that they present a clearly defined and perceptible end situation and goal. Within the mostly open online game world in which the player self is the medium and essentially states all his purposes on his own, they are a secluded activity. These contests are a way to incorporate a design principle into a multiplayer setting that is already well known in offline single-player game design: letting the player know that his actions and decisions have a perceptible, significant outcome; not maybe or sometimes, but within a foreseeable timeframe and for sure. They are experienced as a holistic entity and thus can be efficiently designed as such. Similar to quest or mission design organizing, tournaments can be a powerful tool in the designer's inventory by means of implementing a storyline and narrative into a multiplayer concept that is under his immediate control. It is a way to design around some tension curve that features start, rise, climax, resolution, and end.

Another attraction of contests is definitely the ability for the player to strive for something to be proud of. This has nothing to do winning or losing the competition. You don't have to win the war to be satisfied with your accomplishments in the battle. However, players get a chance to prove their game (or social) abilities to both themselves and to each another. Moreover, they can do that within a controlled, supervised (and cheater-free!) setting and can, due to the exceptionally significant situation, count on being thoroughly anticipated.

Therefore, contests are an efficient way to resolve all types of conflicts in an expressive manner and again provide a variety of incentives to establish new purposes and plans. However, it's crucial to not misinterpret and treat

tournaments yet again as limited to violence or warfare. They can and should definitely cover a broader spectrum of topics and contexts. Auctions, election campaigns, or hunts for secret, special items, for example, are alternatives, as are trophies for level, map, and asset creation or social awards for morality scores and newbie guidance. Important is to ensure that these competitions stay the exception rather than the rule. They should be perceived as something special and as extraordinary events. If you are planning to organize such contests yourself, you might wonder how to reward a player for his special accomplishments or services. A title or prize is actually less essential (unless, of course, this is what your game is about and the main way you attract people). It should be something to be a bit proud of, even if it's only an entry in one's player profile or an interview you publish on your Web site. However, remember to keep the game non-zero-sum whenever possible. Offering unique in-game items, monuments, or avatar titles are certainly invaluable methods to motivate the participators, but only if they do not mean a significant disadvantage for those who do not possess them. The best-case scenario is to have multiple winners and no losers. Prizes or titles gained from tournaments should—as so often in real life—essentially mean nothing more than self-achievement and reputation.

CONFLICT AND EMOTION

Resolving conflicts and overcoming the obstacles on the way to a driving goal is always associated with experiencing a variety of emotions. This holds true for all real-life, single-, and multiplayer games, and it is all these emotions that make conflict resolution that tempting: satisfaction, release, frustration, hope, and fear. Emotions are therefore part of any conflict, and an extremely powerful design method to reach players on a deep level. Important to understand, however, is that distinct high-level emotions are unique to multiplayer online game environments and have never been that meaningful in traditional single-player experiences. Jealousy, glory, honor, shame, and the feeling for personal revenge are probably the most illustrious examples. Each can only take place within a group of people, a community, and are particularly powerful in the long term. They have in common that they all refer to past happenings and experiences in order to have effects in the future. Hence, these high-level emotions are mainly an issue for persistent-state worlds or any other game that keeps track of a player's activities; games in which history and continuous development

are key, and less in session-based experiences like most first-person shooters where players regularly drop in and out.

As soon as reputation has potential consequences on either one's game or social activities, these emotions are extremely prudent, not to say dangerous, and therefore have to be treated as such.

Examining these emotions in detail would reach too far into the field of psychology and be out of the scope of this book. However, there are three key aspects that you should bear in mind while using these powers in your game designs. The major trap is that due to the competitive setting of most games, they misleadingly seem to be straightforward to implement. A certain degree of rivalry, honor, and pride is not only intrinsic to the human nature (as daily demonstrated), but also a chief element in game environments. In games, however—and this is the second issue—these emotions are seldom expected to take place in the beginning. Most often, they are not taken as a given from both the player and the designer, and occur surprisingly and without any idea of how to deal with them. Finally, they are heavily give-and-take in nature, meaning that a player can usually only experience an emotion at the cost of one or more others.

The key is to realize the potential effects of such emotions on the individual player, to provide a wide array of activities and roles that all lead to the same kind of emotion, and to encourage your players to live *together* through victory, defeat, glory, and humiliation.

CONFLICT THROUGH DISCUSSION

The next conflict scenario illustrates very well that conflict is by no means only an element intrinsic to games, but also to the game community existing outside the game world. Discussion among players about a broad spectrum of topics and beyond a narrow field of interest shows that conflicts don't have to be exclusively generated by and in the game. Moreover, the community self is capable of creating challenges that can have a great deal of significance within the actual game context in the second run. It actually generates types of conflicts that would be difficult to implement directly into the game; for exactly the same reason, that is their biggest strength and power: they can be totally off topic and general. Players are philosophizing, arguing about the most recent headlines, or simply chatting with each other about God and the world in order to get to know each other. None of this is to say that the conflicts arising out of such general discussions are meaningless or nothing more than small talk. These debates have the

potential to reach a deep social and personal level and often reveal details about a player that otherwise would have never seen the light of day. A person might need a more relaxed atmosphere to take off his virtual mask and share thoughts that he assumes are misplaced in the game world. Likewise, a debate is probably so profound and meaningful that it's simply impossible for him to hide his real opinions, values, and notions—concepts he has intentionally hidden before. General discussions are more likely to unfold the real personality behind an otherwise mainly anonymous character than anything else. They can shift player-to-player interactivity to a higher level and breed conflicts far beyond violence and destruction; challenges that are not negative or disadvantageous if they follow the rules of the community. These conflicts facilitate personal relationships and (natural) opposing viewpoints; essentially, what defines, shapes, and sustains communities—in real life as in virtual space.

What are the lessons to learn from this idea and how does all that relate to the design of online multiplayer games? This question is not too difficult to answer if you agree to the necessity and significance of a game community for online game spaces. Conflict is as intrinsic to the community as it is to games. If you consider conflict generation as a powerful tool in game design, you should treat it as such when crafting your game communities. Give players the freedom and room to discuss a broad spectrum of topics and interests. This might be as simple as offering dedicated chat channels and forums. Likewise, you can actively motivate such general discussions. Regularly run online polls, for example, inspiring players to think and discuss the latest real- or online-world news. Alternatively, provide some form of designer diary, and let the players know about the philosophies and deeper basis of your designs. What books, movies, people, or theories inspired your implementations? What is the idea behind your choice of colors, shapes, and game characters? Sometimes, it's sufficient to raise the simplest thoughts and ideas to provoke ultimately deep-seated philosophical debates.

We mentioned previously that knowledge gained from these outer-game interactivities can also affect how players perceive and treat each other within the immediate game context. For this to take place, you should allow participants to carry their game identities with them no matter if they post to a forum or play the game. It's actually simpler to implement this requirement technically (the username would do) than it is to guarantee that most players do not consciously switch their identities at will. The ability to stay totally anonymous and role play a character that has

nothing to do with one's real-life personality is a crucial criterion and motivation underlying online multiplayer games. Therefore, it would be a big mistake to constrain your players to a single game identity. The same holds true for entirely neglecting the significance of shared history, reputation, and pseudonymity grown from both in- and outer-game activities. Hence, the best alternative seems to be some middle road and to motivate at least a part of the community to stick to their online identities. As so often, this is mainly a matter of providing reasons and significant incentives to do so. Again, that's easier to achieve for persistent-state worlds that mainly focus on continuous improvement of one's avatar (by means of game *and* community status), and being identifiable is key for any type of player-to-player communication. However, there are also some considerable alternatives to encourage persistent identities for round- and session-based games—personalization being the first that comes to mind. Allow a player to store his personal profile that keeps a record of "community time" (and not only play time), that contains logs or diary entries or even information about personal interface settings and preferences.

CONFLICT AND KNOWLEDGE

You probably know the scenario of sitting amid total strangers who are discussing some events they recently experienced together and you simply have no chance to enter the debate because you have no idea of what they are talking about. You don't know who mister x is who told madam y that his best buddy z did xy and found that he should have tried. . . . What then often breaks the ice is when there suddenly crops up some movie, game, book, TV series (or whatever) that you also know and have something to say about. You have an anchor, which is occasionally just a catchword or phrases, that instantly provides you a passage into the community and makes you finally find yourself within a lively, delightful chat.

What does this situation reveal and tell us? It unfolds yet another fundamental aspect of communities and a type of conflict that can arise from it: shared knowledge. Sharing knowledge and experiences is related to conflict resolution by mainly three distinct means. It can help to overcome obstacles that come with attempting to access an already established, ordered community as a newcomer. Communal wisdom is also a matter of exclusiveness and accompanying challenges to keep certain information secret to only a selected, small group. Finally, knowledge sharing can further tie and strengthen a game community—particularly smaller player groups.

Similar to clubs or SIGs, they focus on primarily a single aspect of the game. Together as a group, they then attempt to meticulously resolve every obvious (or possible) facet of the challenges it creates. They push each other with their personal experiences and knowledge in order to perfect and refine their special "hobby" and interest. As one, these players thoroughly study distinct game mechanics and develop potential workarounds and plans for these challenges. By preparing guides, descriptions, and detailed "conflict manuals" for one another, they can interestingly add a kind of storytelling, narrative element to mutual conflict resolution.

You see that this is somewhat the other extreme than the previously discussed general discussions generating conflict. Knowledge sharing, however, can also provide the personally revealing conflicts we talked about before. It can thus also create what is so crucial and fundamental to both real-world and virtual communities: a feeling of identity and awareness of each other as personalities and individuals. Moreover, shared knowledge facilitates the development of a sense of belonging, familiarity, and specialty. This aspect supports the idea of game communities being keen on surrounding themselves with a sphere of secrecy to differentiate and separate them from the rest of the (online) world. This type of conflict is not only shared by members of subcommunities such as guilds or clans, but also unites the game community as a whole. On the other hand, it might be a significant hurdle for newbies trying to gain a passage into these exclusive, secret circles, which again demonstrates the need to provide the required "community interfaces." This has nothing to do with GUI design, but is rather a matter of mediating newbie community communication yourself or encouraging community insiders (e.g., GMs, instructors) to do so. Resolving conflicts that come with accessing expert groups often requires some initial assistance to get started—on both a social- and game-specific level. Assistance, however, which is by no means totally out of your control and of which newbie support is only a single alternative. Regarding knowledge, design for a variety of roles—experts in the field in which they specialize —who all rely on each other's know-how; supportive and interdependent roles that present a more seamless integration by providing a feeling of being useful and helpful. Likewise, you should consider schemes and methods examined in the previous section; that is, provoking general discussions beyond a narrow focus that are very likely to toss up these catch words and phrases that instantly help you get situated. This closes the cycle and brings us back to the scenario with which we started.

Knowledge sharing and its underlying conflicts both tie and probably isolate a community as we have seen. Therefore, you and the team should stay neutral within this process. What does that mean? Knowledge is based on information and experience. There is nothing you can really do on the experience side of things. You can only provide the potentials and re-sources—namely the game, community spaces, and tools—but the deci-sion of whether or how often to gather them is completely up to each player. The same holds true for information, particularly information about the game or the company. Here, however, you are the only one pos-sessing this knowledge and you decide to share or not to share with your fan base. Neutrality is crucial in this case. Treat each player equally, don't favor one fan site over the others, and provide all the same amount of in-formation. If you publish dev diaries, strategy guides, or screenshots, make them available to everyone, and if you post to one clan's forum, then do that on the others'. If you send out newsletters or announce tourna-ments, then offer all players the opportunity to know these facts. Finally, you should officially clarify rumors that tend to come with "knowledge conflicts" and prospective competing "elder circles."

CONFLICT AND ROLE PLAY

One of the first conflicts a player faces in most traditional so-called RPGs, be it single- or multiplayer, is an inner challenge—a conflict with self. While creating and customizing his game character, the player usually has to adjust some limited amount of skill points between his avatar's starting proficiencies. Should he favor dexterity over physical strength, heavy armor over speed, or initially focus on veterinary, strategic, or magical abil-ities? Would it be better to push one skill set to the extreme, or would it be more efficient to go a more balanced, generalist-like way?

Initially, this seems to be a rather simplistic conflict setup and nothing worth mentioning again. This is, however, only true in case we continue seeing such scenarios as being exclusive to role-playing games or what is generally referred to as a special computer gaming genre. In their very essence, each online (game) activity is nothing more than role play. It's make-believe within an anonymous and safe environment—to oneself and to all others who share the same space.

It is, therefore, not a matter of explicitly defining your game as RPG in order to implement role-playing conflicts into your designs. On the

contrary, not employing the strengths of these conflict-generation tools as exemplified by popular avatar customization screens could be a mistake. They accompany extremely powerful and significant challenges that a player has to face that can reach far into his real life. Especially in multi-player environments, the decisions he makes in solving these problems might tell a lot about the real personality and individual sitting at the other end of the wire. Of course, one's initial impression and conclusion about one another might be solely a wild guess and totally based on prejudices and stereotypes. However, you are aware of that fact, and revealing whether the first impression was justified or totally wrong is an interesting conflict. Moreover, the other side knows about this and will therefore craft his virtual role carefully in order to be perceived the way he wants to be. Unlike in single-player games, role-playing conflicts are no longer only a matter of oneself and the nature of one's game experience, but involve relationships to "real" persons, prospective future competitors, and companions.

Role play in multiplayer online games should be understood in more general and broader terms. The more freedom you give players to define themselves, their game, and community roles, and how they prefer to be perceived by one another, the more you can use the powers of role-play conflict. These challenges are conflicts-with-self and interpersonal conflicts that automatically come with distinct roles, their underlying notions, ideas, behaviors, and values. Design opposites, poles, and a variety of elements that all facilitate and support the creation of unique roles: characters, items, objects, locations, action patterns, professions, maneuvers, languages, and so forth. Consider all of these elements similar to the skills of a traditional RPG avatar—as the puzzle pieces from which a player can choose to shape his role.

It's extremely important that all these elements not merely vary visually or feature different sounds. They should have their own characteristics and distinctive combination of advantages and disadvantages, and therefore comprise unique gameplay experiences and (social) behaviors one expects to fit to this role. Each should convey and back a notion, an idea, a particular value, and lifestyle—an entire concept. By providing these tools, your players are able to shape and define such a broad spectrum of various roles and personalities as found in real-world societies. This role variance is what makes up a huge portion of the complexity, fascination, and challenge in our daily conflicts: personalities that are, on the one hand, totally contradictious and competitive, but on the other hand, perfectly fit together in some situation and absolutely require each other.

CONFLICT AND HISTORY

Some of the most intimating and deep conflicts—be it interpersonal challenges or conflicts with self—have a very powerful and driving aspect in common: historical background. Very serious conflicts are often based on a series of past events, slowly heighten over time, and gradually become more tensional the longer they remain unresolved. The very essence of those "big" challenges is that they do not arise all of a sudden but escalate along a tension curve and are pushed toward the climax by one or more less significant conflict situations. The course of time heightens the conflict to the point where it hits a limit and triggers the need for immediate resolution. Figure 11.2 illustrates the scenario of such a tension curve.

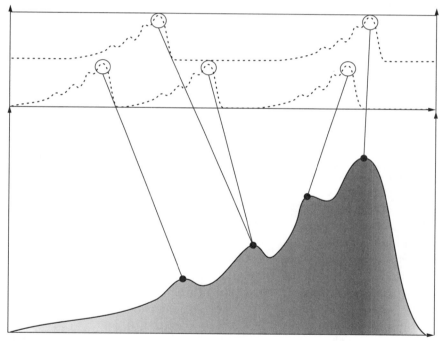

FIGURE 11.2 Conflict tension curve.

As mentioned, there could be only one or a number of these heightening reasons. If you examine civil wars, for example, you normally find numerous, complexly intertwined, and deep cultural and religious factors finally causing the breakout. Conflict pacing is also an oft-used technique

in entertainment media such as movies, drama, or videogames. Here, we usually have to simplify the scenario and limit the conflict triggers to only a few and more reasonable aspects. The most popular, although also banal, is probably some need for revenge because an evil, reckless force has killed the hero's parents or best buddy. By means of game design, all this leads us to the conclusion that for conflicts to become meaningful and immersive, a player needs to know their reasons. You should not throw him right into the scene without providing a bit of background and knowledge about how and why the current scenario came to pass. Give him a chance to evolve in the setup and gradually heighten the tension curve.

This sounds like crafting an involved, predefined, and linear storyline, which is definitely an art of its own but nearly impossible to do in multiplayer environments. It's not only a single person whose actions and decisions are unpredictable as soon as you hand control over to him and give him absolute freedom of choice and goal making. There are multiple players who, as mentioned, are the medium and the only ones who (mutually) drive the story of the game through their actions and decisions. Most of the conflicts are created by the players—simply impossible to envisage and thus hard to embed into some historical framework. However, pacing conflicts should not be confused with implementing detailed cut-scene sequences or writing page-long online novels. You can at least plan for those scenarios (e.g., quest design, level layout, NPCs). It is also a matter of adding clear or more subconscious references; it is about integrating allusions into dialogues or presenting mysterious but expressive architectures, items, or movement patterns. Make the player curious and make the need for revealing the reasons and deeper background of conflicts the conflict self. This also implies a further aspect for multiplayer environments and for delineating the pace curve of those challenges without your immediate control. Especially for persistent-state worlds that involve a longer period of regular activity, it might be valuable to give players and subcommunities an opportunity to tell others about their personal historical background—be it their real-life history or the imagined, pretended background of their virtual avatar. Moreover, they should have ways to advance their individual story with online diaries, screenshots of momentous events, or logs of significant conversations. Tools and spaces to establish rituals, anniversaries, or ceremonies are another way to retell entire stories and to bring back to mind the reasons for past, present, and probable future conflicts.

Continuing from the previous section, history is yet another extremely expressive and powerful piece in putting together the puzzle of one's unique and therefore conflict-generating virtual role. Additionally, it's worth mentioning what history can do for the game community. Shared history and common conflict are not only aspects that heavily define a community and convey a sense of belonging and familiarity. Access to information about a group's past activities or to a single player's background can also make it much easier for newcomers to enter the unknown territory and get the context of the current setup. They have an opportunity to educate themselves about why others are the way they are, and what could possibly be the reason for their current behavior and conflicts.

CONFLICT AND GENDER

There is an ongoing debate within the game industry about the meaning of a player's gender on his game experience and on the nature of player-to-player interactivity in multiplayer environments. What types of games and features primarily attract men, and what is more likely to appeal to a female audience? What expectations of another player are based on knowledge of his (real) gender, and what underlies the phenomenon of gender swapping in multiplayer experiences? Let's not go into too much detail here, and try to leave out any stereotypic assumptions about which game genres are probably favored by one or the other. There are, however, a few sociological research studies dealing with gender-specific differences in resolving conflicts that might reveal some interesting aspects for designing these challenges. Without generalizing too much, it seems to be a fact that men tend to resolve conflicts by force more than women do, who prefer resolution by negotiation. A difference is also in how they talk about their disputes. Women talk in-depth and at length about a conflict's context, its reasons and focus on their concern about their relationship with the other party. Conversely, men report conflicts using more rational, distant, and linear vocabulary. Interestingly enough, according to these researches, women also employ and try more strategies and tactics to resolve interpersonal disputes. In addition, they more often become "innocently" and unwillingly involved in others' problems only because they have been sought out to provide a sympathetic ear.

As promised, we should not evolve further into any more detail about gender-specific game psychology, ideologies, or possible sociological

reasons for the obligatory gender-swapping phenomenon in multiplayer online games. This chapter is meant to cover conflict in computer games. Nonetheless, there are some lessons applicable to our designs that we could learn from the aforementioned aspects.

Again, it demonstrates very well that there are many different ways to resolve conflicts and how to deal with their side effects and consequences. Game challenges involve more than violence or peace, black or white, and depend on a broad spectrum of aspects—of which gender is only one. Generating conflicts should therefore be a matter of providing this variety of potential conflict triggers and of building the broadest possible range of the possibilities into the game system.

Continuing with the influence of gender on resolving challenges in games, computer games are virtual environments that don't necessarily have to be limited to only two genders. Clearly, that seems a bit odd without further explanation, but is primarily meant to be taken metaphorically. Essentially, it only lies in the designer's hands and his creativity to put in hundreds of genders, classes, types, unique species, and economic or ecological entities. All these "genders" imply their unique way, behavior, and typical reaction in solving the disputes they face. Again, all these elements are powerful tools for the player to assemble the pieces of his intended virtual role's puzzle—as he wants to experience himself in the game world and as he prefers to be perceived by others.

CONFLICT AND SERIOUSNESS

A huge difference between the conflicts we face in real life—disputes with others and with ourselves alike—and those in virtual online game space is that in the real world, we get an immediate sense of the seriousness of the situation. This is heavily related to the previously examined conflict tension curve, which in reality is much more granular and thus better foreseeable than in games. Only a few of our "big" daily conflicts crop up instantly, and then we still have a lot of additional information and cues (e.g., facial expressions, voice tone, smells, etc.) to figure out how serious the situation really is. In most multiplayer game environments—particularly in session-based games—it's exactly the opposite. The player gets, often unconsciously, involved in conflicts instantaneously and hits the curve near to its climax. Then, he does not have all the cues he is used to having in real life and faces types of challenges with which he has no prior experience. This is actually, less of a problem for "simple" conflicts that the

game presents to him as part of gameplay. However, as soon as interpersonal conflicts hit a distinct personal level, or he recognizes that inner disputes start to reach into real life, it's a bit more complicated. Some questions remain for both the player and the game designer. Is it still game? Is all that only fun and role play? Does that other player only joke, or does he intend offend me personally, and if yes, why?

There is simply not (yet) a definite single solution to these intricacies. For game design, the scenario is actually a bit contradictory, as conflict is intrinsic to games as to any other entertainment media. Games are played because of the desire to tackle the challenges in one's own way. In addition, with their appropriate pacing, the higher and more serious the conflicts are, the more immersive one's game experience. As discussed, however, for multiplayer games the link between seriousness and (positive) immersion cannot be made that easily in some cases.

In multiplayer games design we still cannot rely on the required technological capabilities and tools to provide the same emotionally expressive conflict atmospheres to interpret a dispute's earnestness. However, we should continuously be on the lookout for new potential technological and conceptual ways to allow players to add more emotional depth to their messages. Of course, there is some limit; games need to stay games, different from real life; player-to-player interactivity should (and will) differ from person-to-person communication—also by means of the conflicts they create. Additionally, all this is again a matter of continuously monitoring your players, taking their feedback, reports, and complaints seriously, and stepping in if arising conflicts get too serious. Even better, you should educate them about their additional responsibilities they have in the virtual realms and therefore shape a community that is very likely to resolve the most severe conflict scenarios on its own. Finally, provide a variety of dedicated spaces—both inside and/or outside the direct game world—that already convey the type and seriousness of conflicts that are likely to come up. If players know beforehand that there could be serious disputes and that they are meant to be "real," then it should be their free decision whether to face and try to resolve them. In case of competitive in-game scenarios such as tournaments or fight-outs, you should motivate your players to reevaluate their previous activities in a more relaxed atmosphere later, like a small group chat or screening room. This way, you can pace their activity and slowly release the tension, and allow them to realize again that everything they have done and said has been nothing more than a great, immersing, and exciting game.

CONFLICT AND COOPERATION

Our most dominant understanding about conflict in multiplayer games—which is undoubtedly inter-player conflict and competition—suggests taking a look at its direct opposite: cooperation. More and more multiplayer games offer at least an optional cooperative play mode, or are entirely designed for team-versus-team competitions from the ground up. This is also how cooperation in games is (too) often understood: setups in which multiple players compete as a team with a common goal against some other cooperative group. These collaborations can last any length of time. In most session-based experiences, the casual player is most likely to join a team only to fill a currently empty and available slot. Subcommunities such as guilds and clans that regularly join and organize themselves outside the game on Web sites or via e-mail normally also go hand in hand within the game world. Without a doubt, cooperation is a very powerful tool to strengthen a game community. It facilitates communication, organization, investment in the community and the game, and provides a sense of identity, familiarity, and belonging. Moreover, cooperation is an immersing way for the player to resolve the conflicts he faces. Regardless of what the result might be—victory, defeat, shame, honor, accomplishment, development, or a distinct reputation—he is not alone in working out the challenges and can share their outcomes.

Nonetheless, implementing cooperation into one's game designs is not limited to group-versus-group scenarios, which means using cooperation as a method to resolve one or more disputes. The real power lies in employing cooperation and negotiation as the conflict self; more specifically, embedding alternative cooperation in a player's decision-making processes, which is both an interpersonal conflict *and* an inner one. Probably the best and arguably most famous example to illustrate this idea is the obligatory *Prisoner's Dilemma*. It reveals a very effective mechanism to engage a player in meaningful conflict situations in which he has to weigh risky, because trust-based, cooperation against rational, "middle-way" decisions. Primarily, he decides for only his own interest. However, as we will soon see, a typical *Prisoner's Dilemma* rewards mutual cooperation with a better outcome for *both* parties than what a sole, rationally thinking player can get from the situation. Such conflicts require players to study and anticipate each other and integrate one another into their individual decision making. This technique is therefore especially meaningful in multiplayer game design. It's an elegant method to combine conflict generation with all sorts of

player-to-player interactivity. Let's thus examine the mechanism in a bit more detail.

PRISONER'S DILEMMA

The *Prisoner's Dilemma* (PD) was initially schemed at Princeton's Institute of Advanced Science in the 1950s and exemplifies the following typical situation from which its name is derived. Two prisoners, A and B, are held in separate cells because they have committed a crime together. The police do not have enough evidence to prove their guilt for this crime, but only for a minor one that A and B committed some years ago. The officer now makes both of them the following offer:

- If A confesses, implicating B, and B does not also confess, then A will go free and B gets imprisoned for 10 years.
- If both A and B confess, then each will get five years.
- If neither confesses, then both will get two years for the old minor crime.

For both players, the possible results can be mapped by the subsequent (ordinal) utility function that is used to express the preferences within a decision in ordered, mathematical terms:

- Free $>> 4$
- 2 years $>> 3$
- 5 years $>> 2$
- 10 years $>> 0$

What to do? Suppose you are player A, not sure about what your partner might do and therefore face the following conflict: if he confesses, you will get five years for confessing and 10 years for refusing. On the other hand, if he stays silent, you will go free for confessing and get two years if you refuse as well. You see that no matter what player B does, it's better for you to confess. Likewise, player B reasons about the situation in exactly the same way, and thus chooses to confess as well. Whenever one action within a range of possibilities is superior to each possible decision of one's opponent (confession in this case), this action is called the *strictly dominant strategy*. The very essence of each PD scenario is that as both of you are rationally reasoning individuals, you both choose the dominant strategy. You

and your partner go to jail for five years. However, this is worse than what the result is for both of you if you neglect the logic of the dominant strategy and cooperate by both remaining silent. Cooperation leads to a more advantageous outcome than rational, logical thinking does.

For the sake of clarity and our following discussion of some additional meanings of this mechanism for multiplayer games, Figure 11.3 summarizes the payoff matrix of the previous scenario. As usual, the first number of each pair represents player A's payoff; the second, player B's.

FIGURE 11.3 *Prisoner's Dilemma*: payoff matrix.

For a typical PD scenario, you need to implement four elements: S ("sucker's payoff"), T (temptation to defect), R (reward for mutual cooperation), and P (punishment for mutual defection). Built from these, the payoff matrix then needs to hold the following relationship:

$$T > R > P > S, \text{ with } [R > (S + T) / 2]$$

If this holds true and both players stick to their dominant strategy, they both end up with a lesser reward than if they cooperate, trust each other, and choose to take the more irrational path.

PRISONERS IN GAMES

The PD has been used to study and model decision-making in a variety of disciplines such as sociology, ethics, economy, ecology, and political science. Probably the most famous example illustrating its broad applicability is the analysis of the Cold War between the United States and former USSR, viewing them as players trapped within such a dilemma. In this case, both players might have saved a lot of expenses of the arms race if they had trusted one another instead of fearing to be unknowingly overwhelmed. However, as a technique and methodology, it is definitely also practicable to game design. On the contrary, the PD reveals a powerful tool to engage players in tricky and immersing conflict situations regarding both long- and short-term decision making. Your game does not necessarily need to be about some prisoners, and PD scenarios can be efficiently applied to your concepts element-wise to enrich a player's problem solving. To demonstrate that, let's briefly examine a rather distinct scenario that is not a PD in the very strict sense, but employs its methodology and is probably a bit more practicable.

Consider an action-strategy game in which players can equip their avatar with a variety of inventory items. Directly before they start a fight against some outstandingly powerful monster (or endboss if you prefer), both have the chance to buy some things and prepare themselves for the upcoming challenge. Each of the players has 100 pieces of gold. They have the choice between additional lives costing 30 nuggets each and an upgrade for their standard weapon (50 nuggets) that would allow them to combine their weapons to some super-blast. Using a standard weapon, it typically needs at least two lives, worth 60, to beat the monster, but if they would unite their strengths, nobody loses even one life. Therefore, we have the following preconditions:

- Resources 100
- Usual Life Cost 60 (2 × 30)
- Weapon Upgrade 50
- Life Cost with Upgrade 0

Now, suppose both players decide to purchase the upgrade. Instead of having to spend 60 pieces for two additional lives, which they are likely to lose again shortly thereafter, they only buy the upgrade and therefore save 10 nuggets (60 minus 50). What if both of them defect and simply pick the

two lives, which guarantees that they will survive the fight? This is the "safe" way; each player spends the required 60 pieces of gold, defeats the monster, and happily continues on his way. However, what if only one player purchases the upgrade? Having no partner in the battle—nothing to connect his end of the upgrade kit to—the player would logically have to (re-) purchase the two lives needed to resist. However, he only has 50 gold pieces left, not sufficient in this case (50 + 60 = 110), and (for the sake of simplicity in this example) he loses the fight. For this conflict situation, we can thus produce a payoff matrix as shown in Figure 11.4.

	Player B	
	Cooperation (Upgrade)	Defection (Don't Upgrade)
Player A — Cooperation (Upgrade)	[R] -10 \| -10 [R]	[S] -110 \| 0 [T]
Player A — Defection (Don't Upgrade)	[T] 0 \| -110 [S]	[P] -60 \| -60 [P]

FIGURE 11.4 Funds-based payoff matrix.

If the remaining player has furthered the opportunity to grab the nuggets and items of his crushed companion, defecting or tricking one's partner would definitely be an option. There's thus not only the chance to get rid of a prospective opponent in an elegant, "indirect" way, but also to be rewarded by additional resources. If, on the other hand, both players cooperate, they could probably reuse their weapon upgrade in future combats (via, say, mutual agreement to reload) and make an effective team.

SIMULTANEOUS AND SEQUENTIAL MOVEMENTS

The PD as introduced at the beginning of this section actually conjures up a rather significant concern for multiplayer game design. We presumed that the prisoners are kept in separate cells, what implies that they cannot communicate with each other. This fact is often declared a requirement for the PD to function. The reasoning underlying this understanding is reasonable: if they could talk to each other, they would very likely realize that it would be advantageous for both of them to decline, and thus could make a contract to do so. Consciously hindering player-to-player interaction and communication is the least we want to do in multiplayer game design—and we don't need to. Communication between the players does not change the situation by any means. First, mapping the scenario to a payoff matrix means representing a strategic-form game in which players choose their strategy simultaneously. Extensive-form games, on the other hand, where players make their moves sequentially one after the other, are normally represented by trees. Therefore, we have already implicitly presumed that both prisoners decide simultaneously—a setup in which communication is not really helpful for both players. If you can be absolutely sure that your partner sticks to his promise to cooperate, you could take the opportunity, confess, go free, and send your (old) friend to prison for 10 years. However, he also reasons the same way, and you know that. Therefore, the only way for both of you to avoid the worst result is to confess.

However, what happens if we let players choose their strategy sequentially? Take a look at Figure 11.5 and let's see how the scenario would look represented as a game tree.

Suppose players A and B know beforehand—probably from looking at the previous matrix—that they would both be better off with the outcome represented by the upper-left cell of the matrix, and therefore make a contract to cooperate. D and C in the figure are used to symbolize the two available strategies, whereas D stands for defection and C for cooperation, respectively. The terminal nodes each show a possible result according to the same payoffs as before. Let's now start our backward induction analysis using a technique called *Zermelo's Algorithm*. First, look at the left subtree descending from node 2. Player 2 has the choice between a payoff of 4 for defection and 3 for cooperation. Being a rationally thinking human, he is very likely to choose defection, and we can therefore substitute the entire subtree with the payoff [0 | 4]. Now, on to the right tree; again, player 2

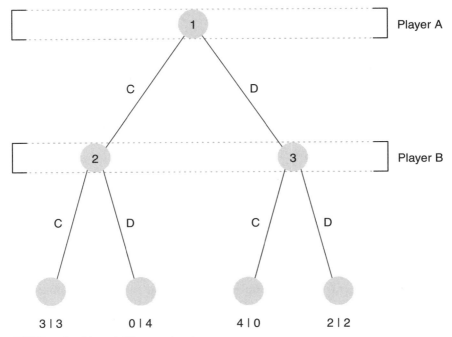

FIGURE 11.5 *Prisoner's Dilemma*: game tree.

decides for his highest possible outcome and defects—leading to the pay-off [2 | 2] for the entire right branch. Player 1 now faces the choice between [0 | 4] and [2 | 2], and clearly selects the one with higher reward, which is [2 | 2] for defection. This particular method is not applicable to solve all game setups and is only relevant for finite, sequential-move games of perfect information[1]. However, it illustrates very well again how complex and intriguing conflict scenarios can be within a game world. Player 1 realizes that if he cooperates, player 2 would be tempted to break the alliance that he could already be sure to get highly rewarded for at this state. The only possibility for player 1 is therefore to choose the safe way and assure that he will not end up with the worst result of all.

Analyzing the PD in extended form has thus shown that in this case, both simultaneous and sequential decision-making lead to the same result. Moreover, you have seen that implementing this concept has nothing to do

[1] Perfect information: whenever a player has to make a decision or act, he knows everything that has occurred up to the current situation.

with impeding player-to-player interactivity. On the contrary, you should motivate your players to actively communicate in such situations and therefore add additional spice to these conflict scenarios. Communication makes the process even more interesting. Players need to anticipate and study each other and have to find out about one another's tendency to behave when it comes to the decision. Moreover, they have a relevant opportunity to influence each other within the negation process and, most notably, are inclined to remember their co-players' trustworthiness for future encounters, resulting in players with virtual reputations.

For multiplayer games, a promising technique might also be to implement a PD scenario into group-versus-group conflict situations. In such setups, each team has to agree to a common decision in a seemingly cooperative discussion (which could also be a PD in itself) prior to posting group choice to the "big" dilemma. All of these final aspects raise some other questions that we should briefly inspect. Are there PD scenarios that involve more than two players? And what does it mean if there is the chance to face such challenges more than once and the game is likely to be soon repeated?

MULTIPLE PLAYERS AND REPEATED GAMES

In fact, and not surprisingly, repeated games significantly affect the conflict situation in PDs, as do multiple included participators. There are very few, if any, online multiplayer games meant to be played by a maximum of two players—be it if they interact in real time or on a round-by-round basis. Therefore, you might be interested in what a PD involving three or more people could look like. Similarly, establishing a personal reputation within the community that is a significant part of one's identity and role requires history and remembrance of past incidents.

We will not go into the detail offered by the various extensive scientific discussions about game theory available on the Web or in literature. However, let's briefly look at a multiperson or so-called n-person PD (NPD) first, and then roughly outline repeated games known as Iterative PDs (IPDs).

NPDs have traditionally been used to model various social, political, and economic real-world phenomena, and as such seem to have potential applicability to the virtual multiplayer computer game world as well. A very interesting and good example to illustrate the situation is the so-called *tragedy of the commons*. Consider the following scenario: There are six farmers who each possess one 1000-pound cow and who share a single

parcel of grazing land for their animals. This plot can maximally hold the six existing cows without being overgrazed and follows the rule that for each added cow, the weight of every animal decreases by 100 pounds. Now, every farmer is given the opportunity to increase his herd by one additional cow. Suppose that one of them does that; he has now two cows both weighing 900 pounds (1800 pounds in total) instead of only one at 1000 pounds; definitely an advantage. However, what happens if all six farmers "blindly" act on this intuition, which would clearly be the rational choice? Well, six additional cows mean a total loss of 600 pounds for each animal. All farmers deciding logically and only for their individual interest are now worse off. Rather than a single 1000-pound cow, they now all own two cows weighting 400 pounds, meaning a wealth penalty of 200 pounds. They outmaneuver one another and ultimately all end up in a "common tragedy." Resource sharing is only one example of how NPDs can take place; however, undoubtedly one that is practicable to multiplayer game design. What rules should NPDs satisfy in order to function? For the sake of simplicity, let's assume a three-player PD that nonetheless shows how to expand the system into n-space. The following rules are standard while implementing NPDs within a computer simulation environment. As before, D denotes defection and C cooperation, respectively. The player under consideration is represented by the first digit in the row (DCC, for example, means the payoff for a defecting player whose two opponents both cooperate).

- Defection is the dominant, rational choice.

  ```
  DDD > CDD (all opponents defect)
  DCC > CCC (all opponents cooperate)
  DCD > CCD (one opponent cooperates, one defects)
  ```
- The more of the player's opponents cooperate, the better.

  ```
  DCC > DCD > DDD (player defects)
  CCC > CCD > CDD (player cooperates)
  ```
- Leave the remaining players in a (n-x) player PD if x participants play a fixed strategy.

- Therefore, one player choosing a constant strategy in a three-player PD will result in a traditional two-player PD for his two remaining partners.

  ```
  CCD > DDD
  CCC > DCD
  CCD > (CDD + DCD) / (n-x)
  CCC > (CCD + DCC) / (n-x)
  ```

This gives us the payoffs shown in Table 11.1.

TABLE 11.1 Payoffs in Three-Player *Prisoner's Dilemma*

Strategy	DCC	>	CCC	>	DCD	>	CCD	>	DDD	>	CDD
Payoff	9	>	7	>	5	>	3	>	1	>	0

What finally remains are IPDs in which a player interacts with the same opponent(s) several times. For multiplayer online games, this is particularly meaningful in persistent-state worlds where players are usually encouraged to constantly improve their alter ego and thus keep their identity. However, every environment allowing players to identify one another as the same who has already been "met" before (if only by screen name) apply the power of history, memory, and reputation of IPDs to your concept. In fact, single, isolated PDs without any underlying context do not require a "real" strategy and are nothing more than a single decision with few further consequences. Only IPDs permit behavior to guide future decisions and facilitate mutual anticipation and remembrance. Players have a history with each other and are likely to take previous moves into consideration before choosing their next. The methodologies shown by IPD scenarios can add extra strategic and cognitive depth to your designs that can reveal to be pretty complex once studied a bit more. It's relatively easy to predict another player's decisions in case you find out that he tends stick to a specific decision pattern. However, what if he always makes a different move and there is no obvious regularity? What if he also takes your previous strategies into consideration when making his moves? Now, you don't only need to consider his previous move, but also his mind and what might go on in his brain. How would you know that? Actually, if he also tries to predict what you are thinking, then it is probably not a bad idea to trick him and consciously do what initially seems foolish. However, what if he has exactly the same idea?

A popular strategy in IPDs that also proved to do very well in simulated computer environments is called Tit-for-Tat. Playing Tit-for-Tat means cooperating on first encounter with a given person and in repeated games, and then always do what your opponent did on the previous interaction. Compared to any other "mindless" decision-making (cooperation and confession alike), this strategy is particularly noteworthy for four reasons. First, its most obvious advantage is that the player constantly sticking to it can practically be sure not get the sucker's payoff repeatedly over time.

However, if you examine Tit-for-Tat a bit more, you see that it also becomes more complex the more "massive" the game environment is. The player has to anticipate and remember each last encounter with every opponent, which results in a tremendously increasing amount of required brainpower the more players the game holds. This characteristic can affect a player's strategy on the personal, real-world side, and would not be too complicated to apply to your game's system mechanics (it does not always have to be only physical energy that counts). Under these circumstances, playing Tit-for-Tat might not always be the best strategy, but is worth considering.

The next complication in Tit-for-Tat is that in order to work, all players need to be uncertain about when their interaction ends. This is again an example of how significant it can be for a player's conflict resolutions that you provide incentives and motivations to keep a virtual identity and role over a longer period of time. Suppose a player knows beforehand when the final move comes, and he can go to the virtual nirvana for a short period of time, thereafter coming back as someone completely different. In the last round, it is more rational again to defect because he knows there will be no punishment. But what about the next-to-the-last move? Well, he knows he will defect in the last round anyway, and therefore doesn't need to fear any penalty, which yet again suggests defection as the better decision. The third-last round reveals exactly the same situation; no threat of being punished because the player knows he is going to defect in the next-to-the-last move and so.... You can easily iterate that backward to the first move in the game. As in many real-life games, Tit-for-Tat and thus mutual cooperation being a viable option in IPDs requires indetermination about the expected number of repetitions.

There is one final problem with this strategy that seems especially interesting for computer game design. Consider that it's occasionally difficult to distinguish defection from cooperation in the first place. This is often the case in conflicts and IPDs in which the participants do not initially "see" each other and interact over long distance or with a natural time interval in between their moves (e.g., economic markets). One player suddenly observes atypical disadvantages, but knows from history that his opponent usually sticks to his silent agreement and cooperates. So, what are the reasons? Did his challenger abruptly change his opinion and intentionally break the contract? What if he accidentally defected, or the current bad situation was caused by a third-party instance? A player who misunderstands the scenario and immediately and unconsciously reacts with defection in-

stantly sets off a chain reaction that means the unavoidable end for any co-operation. Again, such setups encourage your players to thoroughly antic-ipate and study each other. In case they are all aware of probable misinterpretations, they sporadically need to test their interpersonal rela-tionships and sometimes forgive defection that follows their own cooper-ative decision. Being too excusing, on the other hand, only for the sake of the common good, might also be a mistake in order to accomplish one's own interests and purposes.

STRATEGIES FOR ITERATED PRISONER'S DILEMMAS

Mentioning the term *forgive* in the previous paragraph has already intro-duced what we should shortly analyze at the end of this chapter: What are a player's possible strategies for IPD scenarios in multiplayer games? More-over, what schemes or models could you apply to your game system (NPCs, bots, etc.) to serve as challenging opponents? Some of the follow-ing possibilities are more advanced and sophisticated than others are. All tactics have their own advantages and disadvantages—specifically in the long run—and complement themselves very well by having both an easy and a difficult counter-strategy. Each tactic's efficiency depends on the re-lational occurrence of both counter-stratagems in the player community.

- **Sucker:** The player always cooperates and never defects.
- **Strict:** The player always defects and never cooperates. There is no other counter-strategy against such an opponent other than also constantly defecting.
- **Random:** This strategy means randomly choosing between coopera-tion or defection. Being not a very advanced strategy, its advantage is to make one's moves almost unpredictable for one's opponents.
- **Tit-for-Tat:** As already mentioned, Tit-for-Tat means cooperating in the first round and then responding with whatever one's oppo-nents did the move before. Therefore, if one's challenger defects in the nth round, Tit-for-Tat will defect in the (n+1)th round. Besides the previously discussed complications, this is essentially an efficient strategy in the long run, but will lose against the "Strict" who also defects on the first encounter.
- **Forgiving Tit-for-Tat:** Basically the same as Tit-for-Tat, the forgiv-ing player occasionally still cooperates when he would logically have to defect. This is the only way for two Tit-for-Tat strategists to

escape a competitive setting again once they have started to punish each other on every move by defecting.

- **Calculative:** This strategy is the most brainpower- or memory-intensive one. Unlike Tit-for-Tat that only becomes more complex as more players enter the field, it additionally gets increasingly dense over time and the longer the game lasts. A calculative player keeps record of *all* of his opponents' moves. Prior to making his decision, he examines his opponent's history and counts the total number of previous defections and cooperations. If the amount of defections is higher, the calculative player defects; otherwise, he cooperates.

- **Prognostic:** A prognostic strategy can be as high level as the calculative. A "prognostic" tries to foresee his opponents' decision, which might be more than wild guesses if based on move records that are analyzed for previous matches with the given opponent. Based on one's conclusions, such a technique can allow tricking an opponent who also proved to use a prognostic method in the past.

- **Darwinistic:** As its name implies, a Darwinistic strategy is based on the notion of "survival of the fittest." It is a compound, mixed methodology in which the player tests all of the previously outline tactics over a given period and monitors their success within a distinct opponent environment. After having collected a given amount of informational data, he then selects the one shown to be most successful under these circumstances. A variation of this approach is a liaison of players—a herd, guild, team, or clan—who each initially appraise a distinct strategy. They then regularly review everyone's performance; thereafter, the weakest player adopts the tactic of his most successful teammate. In the long run, the entire group is likely to stabilize on only a single strategy, which is definitely not the worst.

There are clearly many more alternative strategies that can be partially combined and varied, and we could analyze each of them in much more game-theoretic depth. However, we have seen a fundamental framework of possible strategies available in IPDs that is directly applicable to multiplayer game design and worth considering for adding additional depth and complexity to a player's conflict resolutions.

SUMMARY

Conflict and competition in online multiplayer environments is often routinely associated with combat and violence. In this chapter, we have seen that this is just a single (but undoubtedly the most obvious) form of conflict. It is in the designer's hands to facilitate and stimulate a broad range of challenges that provide unique, intensive, profound, and immersive conflict scenarios. Techniques and mechanisms from various disciplines as demonstrated by traditional Game Theory and the PD can further significantly enrich one's computer game design concepts. Such systems encourage players to communicate and anticipate one another and to implement human values such as trust and irrationality into their problem solving. Person-to-person interactivity being the very essence of multiplayer games would definitely profit from mechanisms incorporating these human principles.

DESIGNING WITH TECHNICAL LIMITATIONS

IN THIS CHAPTER

- Design Perspectives
- First Thoughts
- Network Performance
- Network Protocol
- Security

Designing and developing computer games always has to do with considering technical limitations of the players' hardware. For online multiplayer games, this holds true even more because there's not only the user's local machine to take into account, but also drawbacks that solely result from performance limitations of the game's underlying network (most likely the Internet). Although game design regularly pushes the technical boundaries by prioritizing creative visions over technical limitations, it's important to carefully design (networked) games with these issues in mind from the ground up. In the multiplayer era, the game designer should, more than ever before, know at least the fundamentals of probable technical limitations and realize that simply separating these aspects as engineering problems is not an option. In this chapter, we therefore cover the basics of technical limitations that you should bear in mind when designing multiplayer games for the Internet, and suggest a few possible solutions.

DESIGN PERSPECTIVES

In no other design discipline than computer game design do you regularly face the clash between your creative visions or ideas and what is technically doable at the present or within some reasonable future timeframe. This holds true for traditional game design, but is more significant for networked multiplayer games. In developing for only the offline, single-player game market, you can almost be sure that there will be a next generation of graphic cards available by the time your title is released. Moreover, designing exclusively for console platforms makes it even easier to account for hardware-related drawbacks. However, as soon as you have to deal with computer networks—be it in console or PC development—you are confronted with unique issues that comparatively improve rather slowly and will never totally vanish.

Similar to single-player design, there are basically two ways to tackle probable creativity/technology discrepancies for developing online multiplayer environments. There is the technology-driven path that means carefully anticipating what limiting factors there are (in our case, those caused by network communication) before thinking about any design concepts and then designing the game accordingly. The other way, the vision-driven approach, is undeniably the one that any game designer should prefer: creating a concept only limited by one's imagination and looking for the best technologies to implement it later. Unfortunately, however, the best is sometimes not good enough. Especially for network-based games, there will always be technical burdens on a designer's shoulders that prohibit him from realizing his ideas one to one. This is not to say that a creativity-centered approach is the wrong way to go. On the contrary, this path has made computer games and the science of their creation what they are today. However, as deep, complex, and fascinating as human imagination might be, there is still the (technological) reality claiming its victims. Therefore, what do we do if we still want to design from the concept down, and not vice versa? This is exactly why we should analyze technical issues yet more carefully and exhaustively. Only a thorough examination can avoid that we blindly take a certain issue as a given and don't endeavor to reveal promising workarounds. Let's pursue a development process chiefly driven by concepts and visions and suspiciously inspect the obstacles in our way so we don't start compromising unless absolutely necessary.

FIRST THOUGHTS

We roughly covered this aspect already in Chapter 4, "Analysis and Categorization," but especially regarding of technology it's worth mentioning again: carefully define and plan your game. In this context, however, we only focus on network technology. So what to consider? The first and foremost thoughts obviously concern the target platform(s) you are designing for (or any ports that are likely to appear in the future), and what therefore is the expectable hardware and software environment of the player. Console, PC, browser based, handheld, mobile phones, or PDA? Dial-up, high-speed Internet, LAN/link cable, or infrared? All this should– depending on your specific approach—go hand in hand with an analysis of your prospective target audience to find the most appropriate common denominator. What is the generally available type of Internet connection: dial-up modem, cable, ISDN, ADSL, satellite? Can you presume that a majority of your customers will consider an upgrade in the not too distant future? How standard are probable required plug-ins (e.g., Macromedia Flash versus WildTangent), how large would the download file be, and is your customer base generally willing to install new software on their machines?

The next aspects to think about involve the type of game you envision. Regarding limitations due to network communication, the most critical issues are the game's pace and the number of players that a single game world should host.

Implementing networked multiplayer functionality is relatively easy for round-based games such as traditional card or board games in which the intervals between the participating players' turns is reasonably long. The more gameplay relies on multiple players acting, reacting, and interacting in real time, the harder it is to find convincingly effective workarounds that manage the timing problems. From RTS games and RPGs to fast-paced action games like first-person shooters, a player's gameplay experience gradually depends more on instant reaction and feedback to his actions. Given the latency and bandwidth limitations of the Internet (which is what we concentrate on) and standard 56K modems, acceptable results thus require more detailed consideration the more speed is associated with quality. As a general rule of thumb, it's therefore favorable to start developing with a worst-case scenario in mind. If your approach adequately works in real time over a standard Internet connection, it will not be too difficult to implement it as turn-based for LAN play.

Once a game environment is simultaneously shared by two or more players, you face the challenges of process synchronization and the need to present the same game-state information throughout all users as synchronously as possible. Not all players in a game world will have the equivalent Internet connectivity and will have dissimilar latency conditions depending on their individual geographical distance to the server. Based on your project's network architecture and how many local stations a single server needs to serve, ensuring that each player can base his decisions on the corresponding (and valid) conditions is increasingly important. The most critical aspect is a server's capability both regarding available bandwidth and processor speed. In case a player's local machine also acts as the game server, it's vital to hand these additional tasks over to the most powerful of all available computers. The same holds true for implementing server migration to account for probable server drop-outs requiring the selection of a new machine as the server that keeps the (unfinished) game session alive.

For medium, large, or even huge persistent-state worlds, chances are high that you have to set up your own dedicated game servers for players to connect to. Of course, you should equip these machines with the appropriate hardware and network connectivity. At a certain level of simultaneous players in a game environment, it might be additionally necessary to distribute the server load between multiple linked servers, each of which manages only a specific task. What's finally noteworthy about server limitations has less to do with network complications, but should not be underestimated: the database. Be cautious with how much player data you persistently store in the server's database. We have seen that a certain degree of continuance of a player's virtual identity and role can heavily affect gameplay experience and interactivity. Particularly, servers of persistent-state worlds that keep a basic player profile and a comprehensive listing of in-depth stats might suffer from database size issues. As most of these games heavily involve continuous improvement of one's avatar and the associated growth of owned and produced items, it's crucial to think about problems resulting from so-called stamp collectors.

NETWORK PERFORMANCE

Undoubtedly, the most significant technical aspect to deal with in designing online multiplayer games is network performance, which is usually defined by latency and bandwidth. Latency means the inherent time a data

packet needs to be transmitted from sender to receiver—client to server, server to client, or client to client. Bandwidth has to do with data size and means the amount of data that can pass a network's wires within a given period of time.

We will look at both of these aspects in more detail in a minute. First, we need to realize that computer networks are an arrangement of multiple nodes and links; that is, at least two computers (nodes) are connected (linked). Both latency and bandwidth are measured relative to a single network link. Therefore, if we want to examine network performance we need to know how many of these links are involved during network communication and how many of them our data packets need to pass to complete a transmission process. It therefore makes sense to consider possible network architectures and topologies and see what each means for latency and bandwidth.

NETWORK TOPOLOGY

Most of today's multiplayer environments use an approach in which all clients connect to a centralized server that either you explicitly provide and maintain or is set up by players. This configuration is generally known as a client-server or star topology and is illustrated in Figure 12.1.

In this setup, the server maintains a connection to each client and is responsible for managing all communication processing between the players. Each data packet sent from player to player has to pass the server before it is transferred to the according receiver. Each player's latency is similarly determined by two network links (from client to server and back). Likewise, bandwidth is also dependent on only these two connections and is mostly limited by each player's individual modem in case the server has reasonable bandwidth (which is usually the case). Generally, a star topology is a very efficient network setup by means of bandwidth and latency. Often, however, this goes hand in hand with a slight decrease in reliability because of the longer transmission route a data packet has to pass. Because each player's network performance depends on his personal connection condition, those players with a better connection to the server might have an advantage. It is therefore often necessary to compensate for these inequalities on the server side that should then, for example, transmit new data packets first to those players having a worse client-server connection.

Another approach treats all players connected to the network equally and is generally known as peer-to-peer architecture. There are three

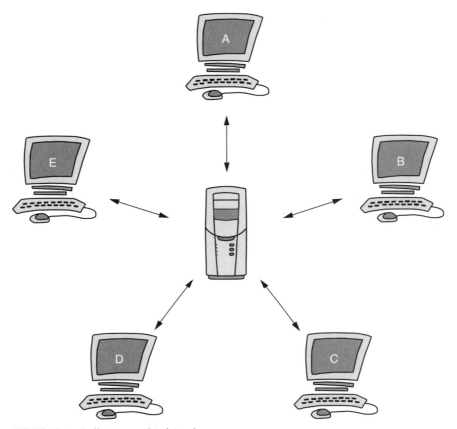

FIGURE 12.1 A client-server (star) topology.

possibilities to implement such a setup, of which the probably most simplistic is the ring topology shown in Figure 12.2.

The most significant problem with this configuration is that latency is accumulated along all links in the network. It is the sum of all latencies along multiple network links from sender to receiver, and there is only one link active at a time. In Figure 12.2, player A might have to wait until he gets the "token" when sending something to player B, and his data packet will additionally need to be transferred along four links. In the previous example, latency is at least quadrupled. For LANs, this is less of an issue, but a pure ring topology implemented over standard Internet connections is definitely not an option if real-time interaction is important. Moreover,

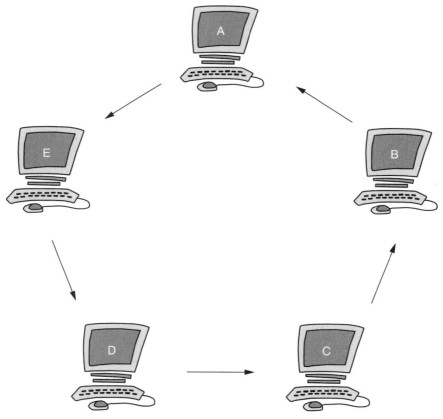

FIGURE 12.2 A ring topology.

bandwidth in this configuration is, similarly to latency, limited to all network links between message sender and the prospective addressee.

A different installment of a peer-to-peer network is a fully connected, everyone-to-everyone setup. Referring to Figure 12.3 you see that each player is connected with one another directly, but unlike in a client-server network, there is no server positioned between them.

Due to the direct link and the probably lower physical distance a packet needs to go, this configuration often (but not always) reaches lower latencies. For large-scale game environments, however, there is a significant drawback by means of available bandwidth. This also stems from the problem of having to establish and manage an increasing amount of

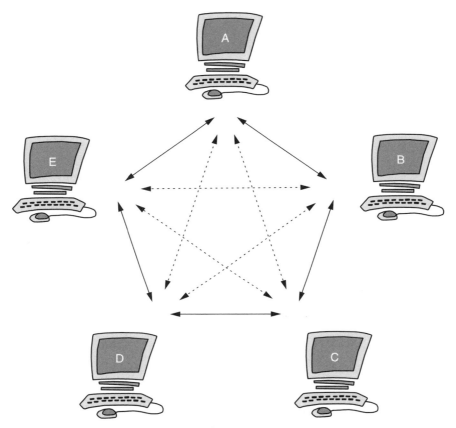

FIGURE 12.3 An everyone-to-everyone topology.

connections as more players share a single game world, making it a rather inappropriate solution for large-scale games. Communication and player management is progressively more complex, and there is no possibility to compensate for unbalanced connection quality on the server side.

A slightly advanced peer-to-peer topology is an approach that uses routing as shown in Figure 12.4. All players are fully connected, but, for example, if player C, as seen in the illustration, has to send data to players A, B, D, and E, the packet would actually pass through B—B acts as router for data transmitted by player C. Routing can be efficiently used to account for the players' probable dissimilar connection qualities in a peer-to-peer architecture, and might thus save a lot of bandwidth and decrease latency.

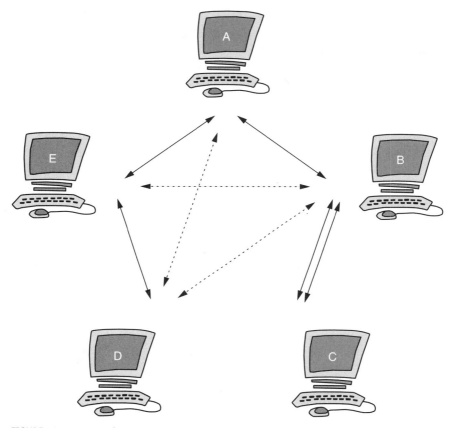

FIGURE 12.4 A routed peer-to-peer architecture (B routing for C).

Routed peer-to-peer configurations can also be used to authenticate a game and to prevent cheating and hacking by some means. For *Warcraft III*, Blizzard uses this configuration to route the players' messages over dedicated Battle.net servers that monitor gameplay. Contrary to *Diablo II*, however, they do not directly serve the game and thus still manage to take advantage of a peer-to-peer setup's strengths over a client-server model by means of machine-to-machine communication speed.

BANDWIDTH

Contrary to complications in gameplay that result from latency, resolving bandwidth issues is often still possible after you have already implemented

your design. Possible techniques are limiting the maximum number of players, prioritizing data packets according to importance and type, or using fast but efficient compression algorithms. Bandwidth is still a rather rare resource, particularly because it's mainly limited by each player's modem speed and connection quality, both of which might vary considerably. Especially if no server is involved, the most critical problem is most likely inbound bandwidth when gathering data from all participating players. Integrating an "intelligent" server is clearly more complex, but can also save a reasonable amount of bandwidth. Such a server could take some computations from the clients and sophisticatedly control exactly what and how much data should be sent to a specific client and when. Let's exemplify the meaning of carefully considering the three main factors affecting bandwidth: transmission interval, packet size, and number of receivers. Suppose in your implementation that each player sends a data packet of 30 bytes 10 times per second. Assuming that we do not make any optimizations and keep this approach at the most simplistic level, how many players using a standard 56K modem could you serve? As you should agree, 30 bytes are already pretty slim. In this simple implementation, each player would send 300 bytes per second to every other player. Given that 56K modems never really connect at 56K and reach speeds between 40K and 53K, data could therefore only be transmitted to a maximum of about 13 other players—giving a total of 14 players. This should demonstrate the need to carefully choose what's in these sent 30 bytes and how often they are sent to how many receivers.

Therefore, what technological and conceptual methods do you have to deal with concerning limitations due to bandwidth?

- **Keep packet size low and compress data.** As we have seen, transferred data size is significant for saving bandwidth. Using sophisticated compression techniques can tremendously decrease packet sizes. It is, however, still crucial to take additionally required processing power into account needed for both compression on the side of the sender and decompression on the side of the receiver.

- **Prioritize exchange data.** If there is demand for more bandwidth than is available at a given time, you should carefully select the packets you transmit first according to their importance. By prioritizing real-time data over audio information or text, for example, you can exploit the available bandwidth most effectively. However, what types of data you specifically treat as more important varies from game to game and is entirely up to your individual concept.

- **Don't send data at fixed rates.** In the previous example, we assumed to send data at a regular interval, no matter if all players are completely idle or are involved within a fast-paced combat scene. However, this is a somewhat inefficient method for saving as much bandwidth as possible. Rather than sending at fixed, predefined rates, you should transmit data asynchronously. Data with information about an event that is not immediately needed can be sent when it's easier to allocate the required bandwidth.

- **Bunch similar information.** To limit the data having to be transferred, you should also cluster repetitious or similar information into fewer packets that nevertheless lose nothing of their expressiveness. If players, for example, operate in a team, it is a waste of resources to let each player send data that concerns the entire group. It would suffice if only one of them informs all remaining players in the game world on behalf of the entire team.

- **Implement AI on clients.** Game AI running on each client machine can significantly decrease the amount and size of data packets by managing to make a lot out of "nothing"—that is, often requiring only a few start parameters to remodel an entire game state. Of course, these algorithms can sometimes be quite complex, but also as simple as the idea to generate exactly the same random-number set multiple times only by using the according random seed. Therefore, why transmit the entire set if all clients could easily compute the corresponding information from a single number?

- **Plausibly limit the number of receivers.** Previously, some basic math demonstrated how soon you reach the bandwidth limit by means of the number of simultaneous players you can support. However, this does not necessarily mean that you strictly have to limit the overall player capacity of the entire game environment. Players who don't know or "see" each other also do not exchange data; or at least not essential real-time information. Controlling the amount of necessary sender-receiver communication is often a matter of design. If players cannot "talk" to one another and therefore don't have to exchange data, there needs to be a logical and reasonable reason. A classic, efficient, but fairly obvious approach is to subdivide the game environment into levels, rooms, kingdoms, zones, and so forth.

- **Use multicasting.** Multicasting servers are another way to dramatically reduce data and save a lot of data that needs to be sent. We will

not go into too much technical detail here, but the basic idea behind multicasting is to shift the task of replicating identical packets from the server to the actual network architecture. The server only sends out a single packet, which is then replicated on the network and sent to groups of receivers rather than to single addresses. Assuming it's supported by the network, multicasting also implements a more efficient and sparing approach than plain broadcasting does. Data is only sent to those recipients who have explicitly reported a need for the information and who have registered interest.

LATENCY

Whenever you hear a player complain about "net lag," it's very likely that he has just experienced latency. Latency means the time in milliseconds from the moment a data packet is sent from one network node until it completely reaches its destination, and is calculated as follows:

Latency = ms / bit data x number of bits + ms trip time

This dependency shows that it's now solely the connection quality of both sender and receiver and the distance between them that matters, but that latency is also heavily dependent on the size of a data packet to be transferred. You should particularly bear that in mind if you are designing for very slow modems, ring topologies, or approaches in which routers are involved. The more nodes a packet has to pass within a network to reach its addressee, the more important is packet size, because each node usually has to wait until it has received all data before it's possible to pass it on.

Normally, latency is measured using round-trip time (ping time), whereas it's crucial to realize that latency in one direction does not necessarily have to be exactly half the round-trip time. Besides various other factors that we will soon briefly talk about, this fact results from so called "net weather." Unfortunately, latency can vary greatly from moment to moment, causing round-trip latency to fluctuate between a minimum of 40 to 160ms up to more than five seconds.

In order to fully understand how latency can be produced and thus affect a networked game simulation and a player's experience, we need to look at the places in a network configuration that affect and increase latency. Link-layer latency affects every transmitted data packet. It is the most common understanding and dependent on the actual network con-

nection between sender and receiver: network cards, modems, routers, and the wires. Another form is retry latency, which results from ensuring a reliable communication over a network that is intrinsically rather erratic (e.g., the Internet). It's the time lost while waiting a specified interval before resubmitting critical data until the receiver acknowledges the complete delivery. Efficiently managing packet loss can be as complex but significant as it can be to account for data that absolutely needs to be in order but is received unordered. The keys to keeping this type of latency down is carefully choosing what data you categorically need to guarantee are transmitted and wisely selecting the appropriate timeout values. Moreover, it's a matter of deciding on the most accurate network protocol for different types of data. The end of this chapter concisely outlines the two most important ones for multiplayer games. Here, however, it's necessary to consider that protocols such as TCP, for example, are affected by latency called *flow control*, which is caused by buffering methods optimized for seamless data streams rather than fast data transmission. Finally, there is transaction latency occurring once data packets are already received but still have to be passed to the game engine, that then has to approve the call and apply the necessary changes. Using threads as part of a preemptive engine, for example, can significantly reduce the delays that might be relatively large if received data is only processed between frames.

Similar to what we previously did with limitations due to bandwidth, let's now list a few ways to deal with latency in your games before we briefly discuss what is probably the most promising one: dead reckoning.

- **Use separate threads for communication.** Implementing network communication into a separate thread is crucial to keep the gameplay experience independent from probable network complications. Data exchange processes are very likely to block. However, if they are managed in a separate thread and this thread is blocking, a player does not uselessly have to wait until unblocking and can still use the main (nonblocking) threads.

- **Keep the game responsive.** Similarly, you should assure that a player can always interact with the application regardless of whether he is still waiting for some incoming data. The game should never "feel" like it crashed or is standing still. The user interface, for example, should always instantly react on a user's commands and be completely independent from any network communication processes.

- **Make actions predictable.** Giving a player the opportunity to freely act and decide within the simulation—an aspect intrinsic to most computer games—is unfortunately very incompatible to latency. As we will see, a very effective method to overcome latency is prediction. A player's actions—for example, his movements—are quite difficult to predict. One technique to make this issue a bit more manageable is to limit the player's possible paths in reasonable ways, or to attach him to game objects that you can predict—if only at specific times, giving you some time to update the game state again. Examples illustrating this idea that first come to mind are elevators, trains, wormholes, tunnels, and so forth.

- **Queue player input.** Similar to how sending network data at fixed, regular intervals is counterproductive for bandwidth, so is using the traditional method to fetch user input for latency. For example, rather than checking for keystrokes at a set rate within the main game loop, you should queue a player's input until the next packet is scheduled to be transferred. This way, you can ensure that you have gathered all necessary information and did not lose a crucial input command.

- **Limit instantaneous and sensitive events.** As there is no way to totally overcome latency, it's vital to realize what is most affected by this fact in a multiplayer game environment. Events that need to be instantly sent because they significantly alter the game state and those that perceptibly change from one millisecond to the next are most susceptible to latency. It is, therefore, often a big benefit to favor more smooth and fuzzy incidents and mechanisms over those sensitive, step-wise events. If a player, for example, knows exactly how many hit points one strike with his sword causes and how many health points his opponent has left, then he would justifiably expect the enemy to fall at a precise given moment. Likewise, shooting with an automatic machine gun is undoubtedly a less sensitive action that firing a single-shot pistol or crossbow.

- **Schedule simultaneous future events.** If you know about some future occurrence in advance and want to guarantee that all players get the according data simultaneously, it's advantageous to schedule these events. Even in cases where you do not need to rely on some real-time information, you could send the data to each addressee in

more "relaxed" times and directly register the event for future execution on the client side.

- **Make latency plausible.** The undeniably most elegant method to account for latency drawbacks from a design point of view is reasonably implementing latency into gameplay—that is, making latency (lethargy) part of the game experience. *Max Payne*-like slow motion, inertia, or weightlessness in water or space provides logical reasons for slow reaction and are fairly tolerate to latency. Likewise, particularly fast-paced games that mostly suffer from latency complications can profit from plausible timeouts (e.g., elevator rides), giving you the chance to resubmit lost packets, for example, or to recover from periodic connection loss.

DEAD RECKONING

Dead reckoning has become a very popular technique to overcome latency and is suitable for most types of online multiplayer games—both in small- and large-scale environments. It is based on the possibility to predict and extrapolate current object positions from assured past information. Basically, there's an agreement between all clients on a specific set of prediction algorithms used to extrapolate an object's position and a certain error threshold.

Now, suppose a player joins the game environment. He instantly sends a data packet to all other users with all information they need to apply the prediction algorithm. At this time, his position is synchronized at all other clients in the network that then start to extrapolate his current (assumed) position and display him moving along the scattered line (Figure 12.5).

The player self, however, still has full control over his movements via his input commands and continuously perceives his "real" position—moving along the path indicated by the solid line in Figure 12.5. His machine is the only one in the network that knows the player's exact position. So, why should this make sense by means of overcoming latency? Well, all remote machines don't have to rely on the most up-to-date information and don't have to wait until they receive the according data. The player does not regularly send any packets with position data out to the network, which allows all others' machines to display smooth motion and saves bandwidth. He does not submit any data until the difference between his true position (known by his machine) and the dead-reckoning position (recorded by his

FIGURE 12.5 Dead reckoning.

computer and perceived by all others) exceeds a specific threshold value. As soon as this tolerance limit is reached, the actual information is sent out again and all computers in the network synchronize again to reconcile the divergence. From then on, the player's position is again extrapolated using the prediction algorithm, and the entire process restarts.

If an object's position needs to be readjusted and you have to update from the dead-reckoning position to the new, true position, it's important to use some error-smoothing technique. Making the update instantly and not smoothing the transition would let the entity appear to teleport and jump without any noticeable reason. It might even suffice to interpolate between the last predicted value and the new, updated position and so smoothly reposition the object to the currently correct coordinates.

Besides error smoothing, the two most significant aspects to consider when implementing dead reckoning are selecting the most accurate threshold and using a practicable prediction algorithm.

Large threshold values certainly mean higher discrepancies between a player's correct position and the one perceived on the remote computers, and thus widen the gap between reality and prediction. Likewise, motion will appear much jerkier when receiving updated data and smoothing the translation to the most recent coordinates if the difference between the

two values is very high. If the threshold is too small, you face the complications again that come with the need to send data to the network at shorter intervals. The optimal threshold is mainly dependent on the type of concept and how players are "interested" in each other at a given moment. If they are closer to one another and more accuracy is crucial (e.g., for collision detection), then you might want to decrease the threshold and send data at a higher rate than you would if the distance between them is greater.

What prediction algorithms can you use for dead reckoning? Probably the simplest method is to transmit position only and use multiple values to predict where an object might be next. Applying some basic math, two positions would suffice to calculate velocity; considering a third allows us to compute acceleration. Usually, it is more applicable to transmit additional information other than only position. Sending acceleration and velocity should be mandatory, but orientation, rotation speed, rotation acceleration, or Cartesian coordinates come in handy to predict an object's position more precisely. More advanced algorithms even incorporate sophisticated AI and attempt to deduce each player's probable individual behavior from a locally stored and updated profile and mental model. In most cases, however, you can achieve rather satisfying results by sending only position, velocity, and acceleration giving the following, straightforward algorithms:

$$\text{position}_{\text{time } n} =$$

$$\text{position}_{\text{time } n-1} + \text{velocity} \times (\text{time}_n - \text{time}_{n-1})$$

$$\text{position}_{\text{time } n-1} + \text{velocity} \times (\text{time}_n - \text{time}_{n-1}) + 0.5 \times \text{accel}$$
$$\times (\text{time}_n - \text{time}_{n-1})$$

What's finally noteworthy is that explicitly considering strictly two states as basis for the prediction can lead to additional drawbacks. If you only consider the last sent data and the current position, the simulation is very prone to packet losses, which are likely to happen regularly in the course of the game. Generally, one of the biggest strengths of dead reckoning is that there is no need to transfer lost data again until it's acknowledged. On the contrary, resubmitting lost information could be somewhat counterproductive because it might be outdated when it finally finds its way through the wire. You should assure that crucial information and events such as newly created entities are safely received by all computers in the network.

NETWORK PROTOCOLS

In order to implement the most efficient network communication for your particular game, you should also have a basic understanding of the two most common network protocols for online multiplayer game environments: TCP and UDP. Both have their own advantages and disadvantages, mainly regarding speed and reliability. To balance these two aspects and choose the most appropriate protocol for our applications, let's thus quickly examine their strengths and weaknesses.

TRANSMISSION CONTROL PROTOCOL

Transmission Control Protocol (TCP) is the more reliable of the two. Using TCP, you can guarantee that a data packet will, eventually, reach the receiver for which it is intended because the protocol instantly invokes automatic retransmission upon a network error. Additionally, TCP guarantees that all packets are delivered in order and is probably the better choice for users of standard modems because of the possibility to compress the packets' header information. Reducing packet overheads from 34 bytes (as for UDP) to about 6 bytes is obviously a step toward more efficient bandwidth usage.

However, all that does not come without a price and can result in significantly increasing latency if a packet is lost during transmission and needs to be resent. Moreover, TCP automatically accounts for sending more data than the available bandwidth can handle. It buffers data that exceeds the limit until it can be sent, which is again positive by means of reliability but regrettably increases latency.

USER DATAGRAM PROTOCOL

User Datagram Protocol (UDP) is a so-called "best effort" service or protocol. It's very flexible by allowing you to use it as a basis and build various other protocols on top of it. However, sending data packets sent via UDP is a very unreliable method because, unlike TCP, it does not use automatic retransmission upon any network and communication errors. Contrary to TCP, there is also no guarantee that data is received in order, which usually requires you to implement your own control mechanism to manage out-of-order packets. However, because UDP is that unreliable, it can offer you what is its biggest strength; that is, a lost packet does not increase latency. The protocol allows you to hold latency to a moderately low level and

should therefore be the choice for information where prospective packet losses would not be that harmful. Dead-reckoning data is a candidate that first comes to mind.

Unfortunately, UDP headers cannot be compressed by standard modems. Each packet has an overhead of 34 bytes and therefore requires significantly more bandwidth on a modem than if sent via TCP. Additionally, UDP has no automatic congestion control, which can be quite intricate to implement on your own and is sometimes not receivable to modem players sitting behind firewalls.

SECURITY

Talking about technological aspects for multiplayer online games also conveys some consideration about security issues. The fascination and appeal of interacting not only with some computer application but with multiple other individuals who do not share the same physical space unfortunately also comes with the accompanying problems of such a setup. As in the real world, security, privacy, and fairness are definite requirements for any larger grouping of humans interacting with one another in order to assure a functional society. Again, things are a bit different and more complex in virtual space—particularly in a virtual playground. Play is only play as long as a game's participants follow and agree to a common rule-set. These rules guarantee fair conditions and another aspect intrinsic to all game activity: safety. Safety in this case also means social safety and protection from foreign threats. In real life, elected governments and public services provide the necessary sense of security needed to regulate interpersonal interactivity. But how can we do that for multiplayer online environments? The most workable and efficient way is probably yet to be discovered, and it's (hopefully) justifiable to claim that virtual game communities will mature into self-regulating societies one day. Currently, however, the one presenting and maintaining the social game spaces, namely the game developer, is in charge of ensuring the required security.

The reason for discussing all of this in this technological context is that technology and thorough consideration about security on computer networks are (still) our main tools to satisfy this demand. Unfortunately, there are some elements in a multiplayer game that actually define the nature of this medium but are not very "compatible" with security (e.g., network communication, anonymity). For the remainder of this chapter, we should

thus roughly discuss the main issues concerning security in networked games—without going into too much technical detail. Almost nothing can kill a player's game experience as quickly as a lacking sense of security; not solely regarding the game (cheating) but also on the community side of things.

Undoubtedly, security holes have much more serious consequences in a multiplayer setting than in any offline single- or two-player games. Cheating and altering game integrity do not only affect a single person or two players sitting next to each other, but ruin the fun of many others who can mainly do nothing but complain (or unsubscribe). Again, methods to effectively secure a multiplayer game depend on the particular network architecture. The central security-related aspect in a computer game network is where game event decisions are made and applied to the game state. For client-server configurations, this is done by only a single machine, whereas in peer-to-peer setups, all computers hold the entire game simulation and state or make some event decisions. It is, for example, a bit more uncomplicated to validate commands and data if all network communication runs through an authenticating server that is entirely under the developer's control (e.g., large-scale persistent-state worlds). For configurations in which players directly communicate with each other, as in pure peer-to-peer, things are usually a bit trickier. Moreover, you should carefully consider whether you should give away server code and functionality, and if so, then in what form? Allowing players to set up and customize their own game servers definitely has its advantages. The server usually performs the most critical processes and is the instance in the network that applies a given rule-set to the actual game state. Now, what if some technically proficient players can freely customize these rules according to their purposes, say, via enabling unlimited ammo or cheat codes? Chances are high that some casual gamer who is used to only the game's default configuration connects to that server and suddenly finds himself among prospective cheaters (who probably didn't even intend to harm anyone). This is only one example of what giving any essential data and code to the user might lead to.

The first and arguably most often-cited rule regarding security in multiplayer games is that the more files, data, trust, control, and so forth you give to the players, the more possibilities there are for cheaters and hackers to identify or open security holes. Generally, no mechanism and data processing can be assigned to only a user's home machine without making security compromises, although some processing—for example, audio—can

easier be done locally. However, easier does not mean totally carefree, and every bit of client software a player installs locally could either contain revealing information about the game's architecture or be a target of attacks.

Therefore, how do we detect cheaters and hackers, what spots in a game and network architecture are most open to their attacks, and how could we make it harder for those people to accomplish their goals?

The first vulnerable place is the network protocol itself. A certain type of program, so-called *packet sniffers*, is already widely available, and is used to monitor and display all messages transferred over the network. Packet sniffers make it easy for hackers to inspect the data and modify the network message to their advantage directly before it is sent by the client. Alternatively, a hacker could block specific types of messages that represent a disadvantage to him, or capture outgoing packets to repetitively resubmit exactly the same information multiple times. As mentioned, we will not cover all possible prevention techniques in detail, but encrypting the protocol could solve at least some of these problems. Moreover, to account for resent data you could compute a sequence number based on an algorithm and the actual game state that is then attached to each outgoing packet. The machine receiving a message with a sequence number other than what is expected instantly knows that there must be something wrong.

Encryption is or should be a mandatory way to secure any data files on the client machines. Besides the network protocol and the game executable, all data files residing on the player's home system are the places most vulnerable to hacking attacks. Unfortunately, encryption and the required corresponding decryption also require some processor performance and therefore slow program execution during run time. It's thus not only key to implement the most appropriate encryption algorithms, but also to consider what type of data and information you could possibly afford to encrypt with less sophisticated and costly methods. Supplementary, you should account for modified data files by letting each client perform a checksum on all files it loads and send it to the server for validation. This is a fast and straightforward technique to ensure that all players use the same program and data files. Of course, there are easier ways to check a data file. However, it simply does not suffice to rely only on filenames or file sizes to assure that the data has not been modified. Instead, you should use sophisticated checksums such as a cyclic redundancy check (CRC) to test for data correctness.

Particularly for peer-to-peer configurations, a very effective and popular method to secure both protocols and files is to use so-called "command

requesting" game engines. The idea is based on the fact that all computers run their own full copy of the game simulation. Similar to single-player games, each command issued by the player is first checked locally to see whether it's legal. For a usual multiplayer setting, the same command would then be sent directly to all other players whose systems immediately integrate the information into their game simulation to reflect the changes. This is, however, not the case for command requesting engines. Here, a triggered command is neither immediately processed locally after the validation check nor directly sent to the other machines. The engine only computes a command request describing a player's intention. This request is then placed into the local engine's command queue and is transferred to all other clients that also put it into their queue. Now each local engine has all commands—that from the player self and of all others—in its queue and validates all these requests again while working through the queue and decides whether to accept or reject the given request. Now all machines in the network have a chance to check a command's validity and whether to process it and reflect the changes in the locally running game simulation. This technique can be further advanced by adding scheduled and regular synchronization checks. In this case, all participating clients compute a detailed description of the game state they currently hold (e.g., using checksums, flags) and then exchange their reports for comparison. Theoretically, if all commands are valid, all local copies of the game simulation in the network should be the same and hold identical game-state information. Therefore, if one state summary differs from all others in the network, it's very likely it has been produced by a hacked game.

Another potential threat for security in multiplayer online games comes from programs called *bots*, which are essentially automated programs that simulate a player's action. These programs can be used for various intentions and work in more or less complex ways. Simpler ones, for example, only communicate to the game client to perform an action repeatedly (e.g., to get skill points) or issue a command faster than would be possible by the user self (e.g., rapid fire). One easy technique to prevent such activities is to require a minimum amount of time between two identical actions on the client side. You could even count repetitive commands on the server to check for a specific limit and to see whether this is what a player has continuously done for the last eight hours or so. More sophisticated bots such as aiming proxies/bots used in many first-person shooters directly modify and affect the network data stream again. Complementary to all methods securing the protocol self, a possible prevention against these types of at-

tacks is logging each player's activity and regularly reviewing these statistical records. The problem with this is that no matter how strange and unbelievable a player's statistics are, you cannot be sure if he has really cheated and whether he is being unjustly punished. Logging a player's activities is essentially not bad for security reasons and to thwart hacking or cheating. To the contrary, every mechanism in your concept that you presume to be a potential candidate appealing to attacks is worth being recorded: scores, character states, skill points, special items, special events, and so forth. However, it's crucial to be careful with interpreting all the information and to take the necessary steps only when you are absolutely sure. A dependable help and supplemental information source for such critical decisions is often the community base. Other players experiencing disadvantages and odds likely to be caused by a cheater or hacker normally complain earlier than you are able to check some statistics. Therefore, it's necessary to listen to them and provide an opportunity to take the initiative—knowledge that there is an alternative to radically quitting the game. For example, offering a simple feedback channel dedicated to report abuse in form of an e-mail address or a board thread would not only do the job, but should be compulsory. Usually, however, you cannot rely on only a single user's report and should wait until at least a few complain about the same player.

We have scratched only the surface of what could play a role for keeping a multiplayer online game a fair, exciting, and pleasing play and community environment. We also left out any discussion about issues such as firewalls or effective protection of sensitive private material and data (e.g., credit card information). Security will justifiably always be a big issue in the development of online games. However, going into further detail here would be outside the scope of this book and its intent. Hopefully, you now have a fundamental knowledge of what to bear in mind in your designs regarding security and know why it's so significant to worry about it.

SUMMARY

Computer game development has traditionally always been at the forefront of newly available technological opportunities and continuously pushes the limits of computer technology. This is mainly a credit to passionate and motivated designers and programmers prioritizing their creative vision over a given technical framework. This should clearly not

change for online multiplayer game design as well. However, as for traditional single-player design, it's necessary to be aware of technical limitations, to design to them, and in some cases, elegantly around them. Some technological aspects inherent in public computer networks such as the Internet and the way they affect and relate to a player's experience are unique to multiplayer online game design. Understanding, analyzing, and considering these limitations is the key to dealing with them and finding promising workarounds. This would allow us to continue the tradition of the single-player realms and make and adapt our creative concepts to technological boundaries only if absolutely necessary.

ADDITIONAL TOOLS
AND TECHNIQUES

In this third part of *Online Game Interactivity Theory*, we discuss a few tools and design techniques you can use to augment your game concepts and creations. Aspects such as prototyping, third-party tool integration, or episodic content often do more than just facilitate the development process or add some additional value to the game. They can drastically spice up those online multiplayer environments you present to your audience and be the deciding factor in a smooth development phase, the released product, and a lastingly appealing online environment.

PROTOTYPING

There is a popular statement about the meaning of prototyping noting that "a picture may be worth a thousand words, but a prototype is worth a thousand pictures." Of course, this also holds true for designing online multiplayer games. Prototypes are an essential tool while transforming one's mental concepts onto the computer screen in order to get the first feedback whether the thought-out mechanisms work as planned. Prototyping for computer game development can actually be understood in multiple ways. In this chapter, we examine it from predominantly two perspectives that are most relevant for the "pure," primarily conceptualizing game designer. First, we briefly discuss prototyping as understood in its original root—*usability engineering* and *user interface design*. On that basis, we look at some specific tools and authoring systems that offer powerful and efficient frameworks to prototype and evaluate entire games or only particular elements.

UNDERSTANDING PROTOTYPING AND ITS MEANING

Prototyping is actually used in a variety of disciplines, ranging from software engineering, Web and user interface design, to traditional

manufacturing and economics; sometimes, we even unconsciously use a similar methodology to solve problems in our daily routines. According to Webster's *New World Dictionary*, prototyping describes "the first thing or being of its kind; the original; the archetype; the pattern." All of these definitions hold true for game design as well. We should understand prototypes in game design as fast, comparatively cheap to develop, and an experimental model of the design concept. As we will soon see, they can be used to shape only a single, particular mechanism to test its functionality and how the user will perceive it, or to give a vague, initial impression of the entire game environment. Probably the most significant advantage of prototyping is that it is an iterative and very responsive technique. It is mainly part of the planning phases during the game development's life cycle, but as an iterated, ongoing approach practicable to model low-level mechanics it might also regularly reach into the actual implementation stage. Also remember that an online multiplayer game project does not end with the final release and a few subsequent patches. Continuously supporting and maintaining the game community, extending and refining the game experience, and adding new features or content are additional game-related projects—all in which prototyping might again play a major role.

Before we look at the various cycles of iterated design processes that incorporate prototyping methods, let's first summarize the three most important (nonexclusive) approaches to this technique:

- **Experimental prototyping:** This approach uses prototyping to determine how adequate and efficient a proposed solution to a given problem might be before delving deeper into a more thorough analysis or actual implementation.

- **Investigational prototyping:** The primary goal of investigational prototyping is an early clarification of specific requirements and exploring the problem space from multiple directions to feasibly select the best solution among various alternatives.

- **Evolutionary prototyping:** Evolutionary prototyping is a matter of adapting a new system or simulation—for example, a multiplayer online game environment—to new or changed requirements and conditions.

To fully take advantage of prototyping techniques in your designs, it is vital to realize them as iterative revisions and cyclic, evolutionary processes. All these are again a small subproject that needs to be carefully planned be-

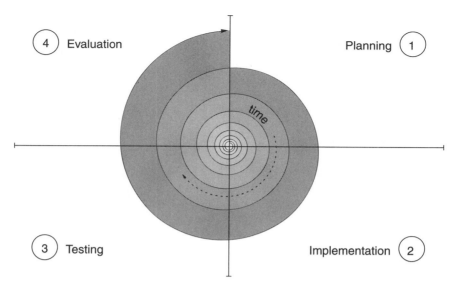

FIGURE 13.1 Iterative development process.

forehand and appropriately evaluated afterward. Basically, any iterative development process (which game design should definitely be) that is based on prototypes can be illustrated by a spiral (Figure 13.1) and runs through the following cycles:

1. **Planning:** Here, you are attempting to understand the player and what you think his needs, intentions, and purposes are likely to be. As mentioned, this does not have to concern the entire game and could only be about a single mechanism (e.g., chat system, navigation, level pacing) about a set of metaphors or a particular menu screen or game interface. Based on this interpretation, you then try to determine how you want to address the player's needs. Being all passionate gamers on our own and having game-enthusiastic colleagues, this is mainly a combination of your own preferences, experiences, and willingness to stick to established norms.

2. **Implementation:** You then implement your prototype addressing the problems within the scope of your test with the solutions you formulated during the planning phase. The prototype should now practically test your solutions and reveal their applicability.

3. **Testing:** It's then time to methodically test your suggestions and experiments. Actually, there are still many aspects you should carefully consider for the test. Who will test the prototype? It does not make much sense if only the person who implemented the prototype also tests it for efficiency. You can introduce voluntary or even scheduled sessions within the entire project and development team, or even show it to your family and friends. As for any scientific and expressive tests, getting feedback from various unbiased individuals who probably also accordingly represent your prospective target audience is specifically valuable. Local universities and high schools are a reliable source for many distinctly characterized persons who are willing to help and are prepared to sign non-disclosure agreements (NDAs). Essentially, prototyping is a user-centered design approach and about involving the end users in testing design ideas and getting their feedback in early development stages. Therefore, if there is some opportunity to incorporate the future players of your game into the prototyping process, you should definitely use this to your advantage—even if it's only a "quick and dirty" Macromedia Flash or Shockwave Player game you offer for free but that in truth is nothing else than a test bed for a single mechanism.

- Questions to ask should include everything you think is relevant for the given problem/solution and what promises to elicit insightful feedback. Do users understand your solution and, if yes, how long does it take them to do so? How long do they need to accomplish a given goal, and what solution path do they take? What problems, ambiguities, and misunderstandings arise during their problem solving?

- To compensate for the different characteristics of all participants, it's significant that the measurements in a prototype test are both objective and subjective. The particular information you monitor is clearly dependent on what the prototype is meant to reveal. The possibly best example to demonstrate the combination between subjective and objective criteria is quality and time. Only if both them are measured do you have an opportunity to weigh decreased time spent on a task against poorer quality. Therefore, you also have a chance to balance your solutions for diverse types of players.

4. **Evaluation:** In the (preliminarily) final phase, you evaluate and analyze which elements of your prototype seem to work as planned, and

which still need some refinements or appear totally impractical. In most cases, a prototypic solution that does not work as planned is a result of a big clash between what you expected from the player and what he really did. Therefore, it's likely that you have not fully understood the user. However, take advantage of this new understanding and iterate back to the planning stage armed with this fresh perspective; refining the model until it finally meets the player's needs and purposes (or is at least very likely to do so).

This might initially seem like a rather time-consuming and painstaking process. The problem is that testing and evaluating need a reasonable amount of time, but should also be done as precisely as both prototype planning and implementation. For all this to be feasible, you need to do the first two stages, planning and implementation, very fast, using only hours or days and not entire months. As soon as prototyping becomes your major task and requires the same amount of time as the actual game project, it's no longer of value. Quick planning and implementation is the main idea behind what is usually referred to as rapid prototyping.

Let's summarize the main advantages of prototyping, especially rapid prototyping:

- Reduction of development time
- Reduction of development costs
- Crisp definition of requirements
- Creativity technique by facilitating consideration of alternatives
- Early insightful and quantifiable feedback from prospective target audience
- Early contact with the game community
- Enhanced communication within the development team
- Early balancing between creative vision and technological preconditions
- Exposition of yourself and the team for potential future enhancements or additions

One final word should be said about setting deadlines for each stage of the prototyping process. On the one hand, you should definitely set fixed time limits to guarantee that prototyping does not transform to your main project. On the other hand, you have to realize that as you cycle through

the phases, iterations will tend to become longer, more detailed, and complex. Additionally, you continuously get a better understanding of a player's purposes and needs, and the closer you come to the final solution, the more likely are proved prototype elements possible to implement in the "real" product. Prototyping and actual game development can thus undeniably be a seamless, parallel process. Therefore, it's critical that you carefully consider your deadlines and time limits—especially the decision about when to end the iterative process—and that you make full use of the assigned time quotas (particularly during testing and evaluation). Before ending a cycle or even the entire process, be sure that you learned all you need to know, that you did not miss some potential problems, and that you have the required resources to implement the solution.

INTRODUCTION TO PROTOTYPING TECHNIQUES

Prototyping techniques can essentially be divided into two distinct types describing a prototype's fidelity: low-fidelity (Lo-Fi) and high-fidelity (Hi-Fi) prototyping. Whereas low-fidelity prototypes are mainly a matter of initial paper- or computer-aided sketches and storyboards, high-fidelity prototyping means partially or even fully functional computer and game simulations. Important to understand is that fidelity for prototypes does not refer to the degree to which the detailed code of the simulation or other elements that are not immediately perceptible to the player are accurate. Rather, fidelity means to what extent the prototype correctly represents a player's perception, experience, and his way of interacting with the game simulation. Figure 13.2 illustrates the transition from low- to high-fidelity prototyping.

Low-fidelity prototyping is a matter of quickly illustrating a concept, idea, screen layout, design alternative, menu, or game interface. However possible, these prototypes are not meant to model a player's interaction with the game simulation and by this means have only limited or no functionality. Usually, you should use them to give both the player and your team members an initial impression of the game's or only a single scenario's look and feel, or to visualize the inner dependencies and workings of low- and high-level mechanics. These techniques are quite helpful and can reveal potential future complications or better alternatives very early in the development cycle. It's worth mentioning that they not only visualize perceptual features. Often, they already reveal intrinsically "invisible" func-

FIGURE 13.2 Prototyping techniques from low to high fidelity.

tional relations and interdependencies from which you can inherit basic functionalities and accompanied operations. They are, however, only a rough preliminary basis for actual coding, implementation, and testing, and are primarily practical to communicate your ideas and thoughts to both the players and your teammates.

Although you should definitely not underestimate the strengths of low-fidelity prototyping, there are various powerful prototyping tools available that allow us to make the step toward high-fidelity prototypes quickly and easily. Especially in such large-scale, long-term projects as multiplayer games often are, a first prototypic low-fidelity concept can be crucial to clarify the requirements and to define a common creative vision for the entire team. However, increasingly available cheap and uncomplicated third-party prototyping or authoring systems—some of which we examine in the next section—provide the necessary tools to model a player's experience in more fidelity. These tools give you the opportunity to focus on high-fidelity techniques from almost the beginning on; and all that with very little coding efforts and a steep learning curve. High-fidelity prototypes already represent a player's experience while interacting with the simulation to a

certain degree. They simulate a single game scenario or combination thereof in a partially or even fully functional way. It's possible to operate on them, perform various given tasks, or work around arising conflicts.

For multiplayer game development and the context of this book, it makes sense to focus our discussion on high-fidelity techniques. Of course, prototypes gradually mature and can even end up as the final product. For them to be feasible, however, they somehow initially need to be reduced as compared to what you expect the final game to be. There are actually three distinct approaches to high-fidelity prototyping that are based on what should be called *"functional selection"*—that is, selecting what functions of the complete (tentative) game concept should be implemented by the prototype and to what functional degree. Referring to usability veteran Jakob Nielsen, Figure 13.3 shows the three resulting possible prototyping approaches that can be deduced from the dimensions *number of features* and *functionality*.

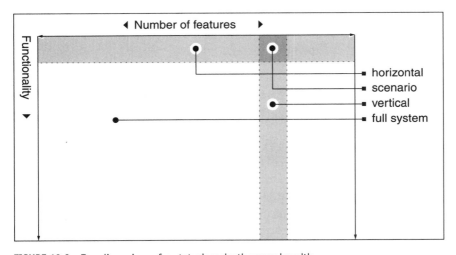

FIGURE 13.3 Two dimensions of prototyping: depth versus breadth.

As you can see, horizontal prototyping implements multiple different features, but reduces their level of functionality. For game design, this method is mainly valuable for interface and menu design. The prototype might, for example, represent a complete interface to a full-featured system but without any or very limited underlying functionality. It allows a first

impression of the expected look and feel but does not provide any (or reasonably restricted) ways to perform a given task. The main advantage of this method is that it's easy and fast to implement a broad range of alternative designs and to quickly refine promising concepts.

Contrary to horizontal prototyping, the vertical approach limits the number of different features. Those that are implemented, however, offer deep and in-depth functionality, which makes vertical prototyping the first choice for simulating single but complex game mechanisms and interactions between the player and the simulation. Features integrated into vertical prototypes can be thoroughly evaluated and analyzed, giving indispensable feedback about a player's behavior under near-realistic conditions. This holds especially true for multiplayer environments by means of studying player-to-player communication and interaction.

Scenarios are the most reduced and minimalist prototypes. This approach cuts down on both the number of features and their level of functionality, and is therefore primarily useful for screen and interface layouts. For interfaces, scenarios are able to simulate the environment only for a specific predefined path of the user; that is, he can achieve a specific given result with only a restricted set of features under only specified circumstances. The major advantage of this approach is that the prototype can be implemented reasonably cheaply and quickly, allowing you to gather immediate feedback without the need to develop a full prototype.

Concluding this brief introduction to prototyping techniques, we should look at one additional method that can be rather helpful and insightful for refining and evaluating your game concepts: *Wizard of Oz*. Referring back to Figure 13.2, you see that this technique could be described as medium fidelity, lying somewhere between a paper sketch and a fully functional computer simulation. The elegance of this concept comes from the ability to test a system and design concepts without any implementation. This makes it especially efficient to explore and investigate design concepts that are part of a rather complex and therefore demanding-to-implement system. *Wizard of Oz* derives its name from the popular movie character that everybody assumed to be a large imposing statue when in fact he was a small person controlling the statue from behind the curtain. This is how the method works: The user interacts with the game system, which is, in actuality, controlled by a developer—the wizard—who sits at another machine (and in a separate room). The wizard then responds to the user's requests, processes his inputs, and simulates the according output of the system. This approach is particularly suited to intelligent systems

(e.g., AI-agent concepts, "intelligent" interfaces) that so can be evaluated in early design stages. For game development in common, and multiplayer game design in particular, it offers the benefits of exploring design concepts early for systems that go beyond readily available technology. The flipside of the coin is that the *Wizard of Oz* scenarios might sometimes be difficult and time consuming to set up, and the "wizard" might need some preliminary training in order to have a full understanding of the system's functionality.

For the sake of clarity, Table 13.1 summarizes the advantages and disadvantages of the four techniques we discussed in this section.

TABLE 13.1 Pros and Cons of Prototyping Techniques

Technique	*Pros*	*Cons*
Horizontal prototype	Broad initial impression Entire look and feel Fast implementation	No feedback about interactivity process and functionality
Vertical prototype	In-depth evaluation Feedback about interactivity process Task-based testing	Limited to only a few elements of the simulation
Scenario	Quick and easy implementation	Limited to only a few elements of the simulation No feedback about interactivity process and functionality
Wizard of Oz	Evaluation without detailed programming Feedback about interactivity process Independent from available technologies	Difficult to set up Might require additional training

AUTHORING SYSTEMS

Within the last few years, more and more quite powerful authoring systems have reached the market and are increasingly gaining popularity due to their integration of sophisticated and robust toolsets and easy-to-learn interfaces and frameworks. Most of the popular authoring environments

come from a much broader background such as multimedia application or Web site development, and are not explicitly targeted exclusively to computer game development. The most popular of these tools include Macromedia *Director Shockwave Studio* and Macromedia *Flash*, IncWell's *Supercard, ToolBook,* and *Quest.* Although these approaches are clearly more or less related to game creation, more and more authoring systems are designed primarily for game development purposes from their incentives. Tools such as *WTStudio, Architect III, Virtools Dev,* or *GameStudio A5* are not only meant to provide the necessary development environments for game hobbyists and enthusiasts. Together with full-blown middleware engines such as *Alchemy, Renderware,* or *NetImmerse,* these tools increasingly become a considerable alternative for the professional game developer; promising reduced production times and straightforward ways of customization according to a project's particular requirements and demands. Generally, these authoring systems can be used to implement all types of game environments—multiplayer as well as single player, either simpler or more complex. In fact, most of them also define themselves exclusively as game creation environments that offer everything needed to give one's creative ideas some expression without having to program a game engine from scratch. As such, they can save a tremendous amount of production time and costs and even establish entirely new, alternative, and distinctly characterized forms of games and genres (e.g., Macromedia *Flash*).

In general, there are a few aspects to consider when you plan to incorporate authoring systems into the game development process. Today's available systems are unquestionably very sophisticated applications that are mainly designed to simplify the programming issues by providing various building blocks to create the intended functionality. They include multiple built-in "macros" that can be used to organize and assemble the desired program structure and application. This is, in fact, what makes their approach that efficient. You can call a broad variety of functions to implement the required processes without having to write all the low-level code as you would have to in pure C++, for example. Moreover, the building-blocks paradigm makes all of these systems extremely flexible and project neutral. It's possible to implement a wide spectrum of different concepts and designs that can be quickly modified and changed in (almost) WYSIWYG ("what you see is what you get") fashion. In case the offered functionality is insufficient for a given task, most systems also include proprietary programming languages to extend their capability, or provide interfaces to more powerful, popular languages such as C++.

However, this is probably also one of their weakest points. Authoring systems can become quite complex and require a reasonable amount of training if you want to get the most out of them. Likewise, even their proprietary programming languages sometimes simply don't suffice to implement more sophisticated functions and concepts. Moreover, if the underlying engine is accessible, expandable, and modifiable using advanced programming paradigms (e.g., C++), it's often cumbersome to reveal the details of the system. When it comes to performance tweaking and customization, a programmer might soon feel limited and constrained in his work by the existing system; this suggests that it might be better to build his own framework from scratch, so that he can fully control and understand it and then push it to the limit. For extending these high-level systems at low level to serve particular needs, you should carefully plan your team structure and setup. It can be enormously effective to have team members exclusively working on the system's low-level architecture even though most of the actual development will still be at the higher level of the system. The authoring environment can quickly mature to what is actually an all-in-one game creation editor used to access the extended underlying engine.

By means of code, authoring systems are essentially high-level programs operating less directly on the hardware they are controlling than low-level programs. Usually, the result is less precision, longer response times, less versatility, and more difficulty in detecting performance bottlenecks and bugs. Nonetheless, authoring systems are a very sensible and interesting game development strategy. Again, it's essential to choose the system cautiously; it should fit your needs and demands and not require you to adapt to its given framework too much. Likewise, you should bear in mind that using one of the major, market-leading products offers the additional benefits that you will instantly get the according support and software for newly emerged technologies.

The next few paragraphs cover some of the most popular authoring systems to create games available on the market today. In the current context, however, we do not understand any of them as the one and only toolset used in pure, extended, or modified form to develop an entire game. Opinions about the actual applicability and efficiency of such systems to create professional computer games might be divided. However, you should agree that all the available authoring systems are definitely useful and powerful prototyping tools—and this is how we treat them in this section. Each provides easy, fast, and effective ways to begin high-fidelity prototyping very early in the development process. The environment they offer is pre-

destined to create functional and expressive prototypes for which best performance or hardware optimization are not as significant as for the final product. Additionally, the developed prototypes are easy and fast to modify and refine, and might—based on the authoring environment— even be the starting point for an entirely new game project. If this is not feasible, you can also offer your prototypes later as a "goodie" (e.g., Web game) on the game's Web site with few additional efforts, or give them to the community for modification, expansion, or exploration. For multiplayer game design, it's notable that similar to the middleware engine/library market (e.g., *Net-Z 2.0*, *Eterna*), more and more authoring systems integrate functionality to support multiplayer online gaming.

Let's now look at some of the most valuable authoring environments— prototyping tools—available today and see what they have to offer for creating high-fidelity prototypes of your (multiplayer) game designs. By no means is the following section meant to be a review, critique, or comparison of these systems. Rather than being a product guide, it should present a rough (and incomplete) overview of what tools you should take into consideration.

MACROMEDIA DIRECTOR SHOCKWAVE STUDIO

Macromedia's *Director* has been at the forefront of the authoring system market for quite some time now. Particularly since versions 6 and 7, it has grown into a very powerful tool to create applications for a wide variety of target media, ranging from CD-ROM product demonstrations and learning applications, to online game experiences and interfaces. The system can create both standalone executables and *Shockwave* files (.dcr) that are accessible over the Web browser and an according plug-in. Almost all popular image, video, and sound file formats can be imported into the system, which makes the transition from asset creation and integration straightforward. Its proprietary scripting language *Lingo* provides a very complex and sophisticated programming environment. Learning and using *Lingo* entirely and to its potential can be considered a science in itself. This can mean a significant amount of learning effort and time, but offers everything needed to develop quite complex game experiences and prototypes.

Since versions 8 and 8.5, Macromedia's *Director Shockwave Studio* is appealing to the game developer more than ever before. It now offers seamless integration and support of streaming *RealAudio* and *RealVideo*, which can then be controlled and modified using *Lingo* (e.g., panning, volume

control, quad modification, and real-time imaging functions to create video effects). Especially noteworthy by means of (multiplayer) game development are the now integrated 3D support and the so-called *Shockwave MultiUser Server*. The server technology allows you to develop full-blown online multiplayer games, lobbies, and community platforms. While this technology has been part of earlier versions, there are now added key features such as support for both TCP and UDP, server-side scripting, and the capability to hold up to 2000 simultaneous users. Via the system's 3D support, it's possible to create 3D content in your favorite tool and system, import these assets into the authoring environment, and then control them using specific *Lingo* commands. The system supports multi-resolution meshes (MRM), subdivision surfaces (SDS), bones animation, particle systems, multiple shading effects, and hardware accelerated rendering, and integrates Havok's popular real-time physics engine.

Both *MultiUser Server* and the *Havok* engine are integrated into the system's architecture in form of *Xtras* that are essentially plug-ins to extend Director's base functionality. Everyone needing to customize or extend the system can develop similar *Xtras* using specific development kits to access Macromedia's *Open Architecture*. The concept is based on the common idea of defining classes whose behaviors are described by one or more interfaces that are implemented into a class definition. You then have to provide the necessary implementation for those methods that are described by the associated interface, and so can develop entire new classes to extend the system's functionality.

MACROMEDIA FLASH

Macromedia *Flash*, which at the time of writing has reached version MX (successor of version 5), is Macromedia's second tool that should be suggested as a worthwhile prototyping environment for the game developer. Similar to *Director Shockwave Studio*, Macromedia *Flash* also produces *Shockwave* files (.swf) that are then executed by a standalone player or by a Web-browser plug-in (Macromedia *Flash Player*), but should not be confused with *Shockwave* output generated by the *Director Shockwave Studio* (.dcr).

Traditionally, *Flash* has its strengths in vector-based animation and interface design. With version 5, its internal scripting language (*ActionScript*) has been enormously revamped and extended, making it possible to also develop small- and middle-scale game experiences. Nevertheless, *Action-*

Script is by no means such an advanced programming framework as *Lingo* is. Of course, this fact also means certain advantages by means of required learning and implementation efforts. Prototyping game interfaces, menu structures, or simple user interactions can be done quickly and easily. If you quickly want to gain feedback or visualize your concepts regarding these issues, Macromedia *Flash* should probably be your first choice. However, it's also possible to integrate Macromedia *Flash* content into the final version of a game. As noted, the tool is predestined for any interface creations particularly by means of reducing the need to modify the actual core code whenever you make changes to the interface (e.g., localization, reading screen coordinates). LucasArts has already successfully integrated Macromedia *Flash* into their engine used for *Star Wars Starfighter* and has built the user interface with this authoring environment.

Moreover, Macromedia's Flash Player needed to access Macromedia *Flash* content is integrated into more and more hardware devices and has already been ported to Microsoft's PocketPC and Sony's PlayStation 2. Via communicating with a server and processing output from server-side scripting languages such as ASP or PHP, you can also realize simple online multiplayer experiences.

3D GAMESTUDIO A5

Unlike the previously examined authoring environments, Conitec's *3D GameStudio* is exclusively designed from the ground up for authoring game environments. Its heart is a world editor used to assemble the game architecture based on the concept of constructive solid geometry (CSG). The editor can handle a wide variety of file formats, allowing you to create all needed assets such as textures or models using those tools with which you are already familiar. It supports *3ds max*, *Truespace*, *Milkshape*, and *Bryce* formats as well as already finished level layouts done in *WorldCraft*. GameStudio's underlying 3D engine is quite sophisticated and advanced, incorporating a BSP-based culling system, level of detail (LOD), particle systems, and shadow mapping. Additionally, the game engine is equipped with network code based on a client-server system that also uses a dead-reckoning algorithm that provides the opportunity to set up quite complex and large multiplayer environments.

For scripting purposes, this authoring system uses a proprietary language called C-Script that in its syntax draws from popular third-generation programming languages such as C, C++, or Java. In case you

need access to low-level functionality for higher flexibility, performance, or customization, it's possible to write advanced routines in your favorite programming environment that you can then link to the system through its DLL plug-in interface.

WILDTANGENT WEBDRIVER SDK

WildTanget's *WebDriver* is driver software (plug-in) connecting a user's hardware devices to the Internet. It is mainly designed to bring high-quality 3D content to the Web—although it can also produce standalone applications—and as such, is a main competitor to Macromedia's *Shockwave 3D* technology. Developing content for this system is done via the *WebDriver SDK*, which is a sophisticated high-level API with an underlying graphics engine. A definite advantage of this system is that the API is designed for all COM-enabled programming languages such as C, C++, Java, JavaScript, and Visual Basic, making the initial learning curve quite flat for experienced programmers. Therefore, the system is also easy and fast, customizable, and extendable according to your individual needs. It also comes with a set of additional tools that make it comfortable to integrate, develop, and manage all types of assets. *WT Studio*, for example, is a world editor to create BSP geometry, whereas *WildCompress* can be used to compress and encrypt bitmaps, sounds, and models that you plan to integrate into the environment. In addition, there are appropriate exporters available for both *3ds max* and *Maya*, and a separately offered Multiplayer Toolkit. The multiplayer API provides a range of multiplayer modules, allowing a developer to use a variety of network protocols, communications, and lobby systems. It supports all basic network messaging, lobbying, and matchmaking functionality. There is a module that allows access to *DirectPlay* and all its lobbying architecture, which is a big plus by allowing you to make use of the large installed base of *DirectPlay*-capable machines. This would make it less complicated if you plan to give away your prototype multiplayer game elements for testing to selected players. Likewise, similar to most of the tools discussed here, the entire WildTangent architecture offers powerful approaches to prototyping, and also presents a sophisticated game creation framework on its own; in this case, particularly for developing 3D (multiplayer) browser-based experiences.

VIRTOOLS DEV

Virtools Dev, offered by the French manufacturer Virtools, is an authoring environment that presents a slightly different approach. Through its

graphical interface, the developer defines all assets' behaviors by visually as-
sembling an object's behavior using a variety of (reusable) behavior build-
ing blocks. The system consists of four modules: the visual interface, the
behavior engine, a rendering engine, and an accompanying SDK used to
implement additional customized behaviors and providing low-level access
to the system's sound, graphics, and import/export engines. In addition,
Virtools Dev supports all popular 3D, image, sound, and video file formats,
including *3ds max*, *Maya*, x-files, TIFF, PNG, JPG, BMP, MP3, WAV, and
AVI. Its engine's capabilities are quite sophisticated and advanced. Motion
blending, warping, and a skin-and-bones system are supported, as are pro-
gressive meshes, multitexturing and procedural textures, mipmapping,
billboard sprites, and hierarchical culling.

For assembling behaviors, you can use the integrated readymade behav-
ior library, create new behavior sets by newly combining existing ones, or
develop additional building blocks according to your individual needs
using the SDK. By composing several building blocks, it's also possible to
implement additional functionalities such as particle systems, collision de-
tection, environment mapping, reflections, lens flares, or motion blur.
What finally might be beneficial regarding its rendering engine is the abil-
ity to substitute the rendering system with any other self-made or third-
party engine.

At the time of the 2002 Game Developer's Conference, Virtools released
version 2.1 of its authoring tool. The new version's rasterizer is now
DirectX 8.1 based and supports cubic environment mapping as well as the
capability to create and render vertex buffers. In addition to enhancing
the GUI—most notably with the ability to automatically create and posi-
tion portals—the new version includes a variety of new behavior building
blocks covering, for example, volumetric fog, light maps, texture filters,
lens flares, and stencil shadows.

There is also a collection of enhanced physics behaviors available via the
Virtools Physics Pack that is based on the popular Havok technology. This
add-on provides you access to additional sophisticated features such as
elasticity, friction, mass, force field and buoyancy models, and special car
behaviors.

Obviously, this has not been a complete overview of all authoring sys-
tems available today that you could consider for implementing high-fidelity
game prototypes. It would be difficult to cover the full range of such tools or
related ones that you can find on the market today and all those that are reg-
ularly added to the list. Moreover, it's sometimes difficult to draw a concrete
line between all the different approaches that manufacturers use with their

specific product. It's especially problematical to make a distinction between how all those systems define themselves or how they are understood among the majority of game developers. Definitions and terms tend to be a bit slippery. What is a "pure" engine: *Unreal 2, Lithtech, Quake 3,* and *Genesis 3D*? Or should we define them as authoring systems as well because of all the additional tools that come with these systems? What's the exact difference between authoring systems and so-called game development kits? Do tools like *NetImmerse, Alchemy, Auran Jet,* or *Net-Z* fall into a definition of authoring environments? All of these questions are not that easy to answer, but as mentioned it does not mean that a specific system is less qualitative, effective, or appropriate for prototyping if it has not been discussed in more detail in the previous paragraphs. On the contrary, you are highly encouraged to check out the aforementioned alternatives and evaluate whether one specifically satisfies your individual needs, purposes, and demands. You can find some of the tools—both those covered in a bit more detail and other highly considerable alternatives—on the accompanying CD-ROM. Therefore, simply start up your machine to see what tools(s) you can use to implement your prototypes and design concepts best and most effectively.

ON THE CD

SUMMARY

This chapter covered some basic methods and techniques you can apply to the prototyping processes during the game development cycle. Prototyping is by far not a waste of time and is a very effective design strategy. It allows you to lead your own concepts and ideas in the right direction early in the development process, and is useful to break out of often-unconscious standards or unquestioned personal hypotheses. However, it's not only a method encouraging designers to think about alternative solutions. It's also a way to involve your prospective target audience in the design process, gain valuable feedback early in the development phases, and balance the players' demands with your implementations. As we have seen, there are plenty of powerful authoring systems and tools available that all have a huge potential to simplify the prototyping process and transform prototypes from "only" test beds to reusable components and game design bases.

PLAYTESTING AND BETA VERSIONS

IN THIS CHAPTER

- Alpha, Betas, and Release Candidates
- The Testing Process

For online multiplayer games, as for any other game project, playtesting is a crucial phase in the development cycle, and for many designers probably one of the most thrilling. You and the team have worked on your masterpiece for months or even years and are now ready to show your creation to people outside the team. As soon as other people's opinions and thoughts become an active part of your considerations and concepts, their opinions and input can mean the success or failure of the final product. In the previous chapter, we saw that such collaborative design can be done throughout the entire development process using an element-wise approach and prototypes. Within this chapter, we look at issues to consider when setting up organized, planned, and managed game testing sessions and periods that are most likely to happen near the end of the development cycle. What are the keys in preparing and running public or closed testing environments that can add the finishing touches to your designs?

ALPHAS, BETAS, AND RELEASE CANDIDATES

Referring to this chapter's title and because there are various different testing and development stages, it makes sense to talk a bit about terminology first in order to avoid confusion throughout the rest of this discussion. Playtesting is actually somewhat different from testing done in what is usually referred to as alpha or beta test. Basically, we can understand playtesting as an ongoing process done throughout the entire development cycle from an initial prototype to the final release (e.g., prototyping). The major difference to later testing at beta stage is that it primarily addresses gameplay mechanics, and is about checking for any design ambiguities and refining the way all gameplay elements affect and relate to each other. Probably the best examples of a typical playtesting task are tweaking weapon properties, avatar stats, or a game's economic system. The more the development process reaches its final stages, the more gameplay functionality is basically already in place only waiting for final balancing and fine-tuning. At later stages, it is simply no longer feasible to make major changes to the game's overall gameplay structure or add significant additional elements. This is where testing starts to focus more on identifying and resolving bugs and performance drawbacks.

An alpha version of a game usually refers to a game that is not really close to being fully completed, but is already seamlessly playable as conceptualized by the design team. Most of the design, gameplay, and content are already in place at this stage, where then testing normally increasingly concentrates on bug fixing, balancing, and fine-tuning. Then, as the project hits beta stage—the final state before the game is published or otherwise made accessible to the players—all testing is commonly only a matter of identifying bugs and fixing them to ensure a stable and homogenous gameplay. At this point, the project already follows a rather tight schedule, meaning that the primary goal is typically to bring the game out the door rather than applying detailed changes to game mechanics that introduce a potential to break the system. Finally, there are one or more release candidates of a game that are builds you consider being ready to ship. A release candidate also has to pass through a series of tests before it can ultimately go to press. This testing, however, is commonly limited to only a few days and, depending on the specific project, is used to check whether it's in the condition to be accepted by the publisher.

The governing question that differentiates all these testing stages is "who tests what and when?" We have examined that playtesting is a continuous

process starting in early development stages (e.g., prototyping) and more and more shifts the focus from thoroughly refining game mechanics to overall technical debugging. Likewise, there are also slight changes by means of who tests the game.

In early phases, it's most likely the designer himself and the development team who take care of the fine-tuning. If additional feedback is required, you probably occasionally show parts of the game to some external industry colleagues or other persons whom you know understand the game development process and whose opinions you highly appreciate. Under certain circumstances, it's also possible to gather valuable feedback from selected players by showing them a prototype scenario. These persons should either test in-house or be ones whom you already know—for example, from previous projects—and whose opinions you trust.

As time moves on and your game increasingly takes shape, more and more persons from outside the actual development team become involved in the testing process. A huge part of alpha testing is often done by full-time employed QA personnel. These people dedicate their entire working time to check each smallest detail of the game and write the according reports. Their extensive in-house testing is most often done using specific testing scripts—outlining a particular path through the game and stating various mandatory tasks to do for each session—and based on some bug-tracking tool or database. For beta testing, it has become a popular strategy in the games industry to offer beta versions of their creations to "usual" players for download over the Internet and public testing. This is a very efficient way to get a large amount of helpful feedback from a broad variety of distinctly characterized gamers. You have a chance to test your game for applicability within groups of different ages, genders, playing styles, and gaming experience, and check for system compatibility within various differently set up systems and machines. Moreover, beta tests are a great way to build an enthusiastic, bound (but constructively critical) game community before the game is actually released, and to create bonds between you and the player base.

What's also often different between earlier testing stages and later phases such as beta testing is that during beta, testing is most likely to be unguided. Earlier analyses such as prototypes or as done by an in-house QA department are frequently guided by the designer and the dev team and follow predefined paths or are aimed at specific mechanisms or elements. The product is not complete, requiring persons to guide a test, to know what parts are incomplete or are not ready to analyze. For beta tests,

however, it's not only common practice but also significant to let people play the game as they prefer to—according to their individual styles and experiences. Only then can you ensure that your game can pass a test in an "artificial" setting and in reality. However, under specific conditions—most commonly if you need additional feedback about a specific element or mechanism—you can clearly ask your beta testers to perform some pre-defined tasks and let you know what they think of them.

THE TESTING PROCESS

We have now clarified some of the most common terms referring to testing a game and have seen that some test types can actually happen analogously, and the transition from one stage to the other is quite fluent. A lot of testing takes place in house and is an ongoing task of the entire development team. However, we have also shortly introduced the additional benefits and advantages that a public beta test can provide to test your creations on a variety of systems and for a wide spectrum of player types.

Offering a game for review and test to the public in the course of a beta test period can be done in various ways. It can be entirely public—usually called "open beta"—meaning that you simply make the game available to download for all and "hope" that this will provoke some discussion and feedback. The second approach is a bit more organized and planned: a closed beta for which interested players have to apply officially and are selected as testers according to various criteria. A closed beta is generally a bit more complex to set up and, as with any previous in-house testing, requires a reasonable amount of organization and management. Therefore, we'll next examine what you should consider when arranging these extremely helpful "private" testing periods, and how such a process could efficiently be managed. Prior to discussing a few typical steps for setting up a beta program, however, there is one final note to make. We have previously seen that testing progressively becomes a matter of bug detection and fixing the more the product approaches its final state. Figure 14.1 illustrates this classic and inevitable (but reasonable) scenario. The dashed line denotes "pure" playtesting (checking gameplay mechanics and design ambiguities), and the solid line represents bug tracking and fixing.

Pure playtesting (checking the game for playability from solely a design point of view) increasingly transforms toward bug fixing (mainly technical testing) and final balancing. There are very few changes applied to actual

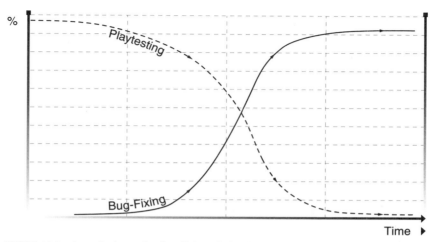

FIGURE 14.1 A rough playtesting/bug-fixing relationship curve throughout the development process.

game mechanics and the overall system once the product reaches the beta stage. However, that does not mean that you should not facilitate and encourage feedback regarding gameplay from your beta testers. The final decision as to whether it's feasible to implement their suggestions or to apply changes according to their concerns is still up to you and the team. If something is impractical, unrealistic, or lower priority, then try to give the tester at least a reasonable explanation. The first and foremost rule for beta tests is to listen to these testers, make them feel like they're being heard, and treat them as more than just bug-tracking machines that do the work for free.

GAME DESCRIPTION

The first step in setting up a beta program is to write a brief game overview or description. This document should contain a rough general explanation of the game, its underlying idea, objective, and mission statement, together with a brief description of its main features, the systems it supports, and other necessary technical information. Most likely, you might have already written all you need for this description and only have to update the information to its last status and compress it into a more compact size. The design document is definitely a good starting point. Its introductory focus description or executive summary is a suitable basis to compose a brief

game overview that is then complemented with the most important technical information. The purpose should be to give the reader an idea of the game's big picture through a quickly readable summary, and to explain the project to people who have never heard of it before. This game description serves various purposes, of which the primary one is providing basic information for prospective testers and helping them decide whether your game is what they would love to review and provide feedback on. It's also an in-house consent for avoiding misunderstandings and ensuring that everybody in the company communicating with beta testers does so on basis of the same information. Here is a suggestion of how such a document could be structured:

- **Document History:** A history record is usually quite helpful for both players and team members needing to change or update the description.

- **Game Overview:** A brief description of your game, its unique features and elements, and what makes it unique with respect to other similar experiences.

- **Player Profile:** It might be useful to include a concise description of what types of players you think the game would most appeal to, and what type of individuals are most appropriate for the beta test.

- **Technicalities:** This section describes what platforms and operating systems the beta supports, and what other hardware and software is required to run the application. Additionally, you might want to include for what minimum connection types will be needed to play a networked game in a satisfying manner.

- **Weighted Feature List:** You should not list every little feature the game offers here; the unique and outstanding features implemented into the beta version will suffice. Optionally, you could weight them according to how "important" you consider each for the overall game concept, or by what features you think need special attention (e.g., because they have already proved to be unstable in certain circumstances). How in detail you weight them is entirely up to you, but is most likely similar to a bug description categorized into A, B, and C list features.

- **Timetable and Schedule:** Finally, there should be a schedule defining the beta program period and probably a timetable telling when additional features are added to the game's beta version and go live.

PREFLIGHT CHECKLIST

It's a good practice to set up a checklist that the entire development team should work through directly before the public beta version is released. The list should provide a set of common requirements (e.g., right colors, sounds) and tasks to follow that roughly mirror a quick, general game session (e.g., produce x amount of item y, wander to city z and trade a for b, save game, then exit, restart, and load, and so on). Again, the checklist's contents depend on the particular project and the central mechanisms, elements, and functionalities of the game. It should also include starting the game on a few common and standard hardware and software configurations.

All this might initially seem similar to a test script as daily used by a QA department. However, this final beta checklist is not supposed to be the same as for QA. Its purpose is simply to run the beta version through a final check to ensure that each team member is happy with it and that the testers get what they await. Everyone on the team—programmer, designer, producer, QA tester, or artists—has the opportunity to take a last look at the game from his personal point of view and can use the checklist to give the game a final scan before the testers start. Moreover, the checklist will allow testers to focus on more severe bug finding and feedback, rather than having to deal with issues that should be mandatory.

FINDING TESTERS

We are, however, not yet ready to run a beta version through the final test. The next step is to publicize the beta program, find prospective testers, and encourage them to apply for the test. In case the beta test is not an open program, you should certainly already have an online registration form up and running through which you capture all essential information from the applicants: demographic data, hardware, software configuration, motivation, and so forth.

There are a number of ways to publicize the program. The first, which is surprisingly often not the most obvious , is with your own Web site and existing customer base. Post the news about your beta being open for enrollment on your site, and get in touch with players for whom you already have contact information (e.g., previous testers, players who have registered on your site, newsletter subscribers). A very efficient way is also to inform popular gaming channels and online game magazines about the start of your beta test. Possible candidates that are usually happy to include such news on their frequently visited sites include *Adrenalin Vault, Blues News,*

Demo News, IGN, Betawatcher, or *Beta-World*. You can also report to game-related newsgroups (using *Deja News* to search for appropriate ones) or post to some of the many industry-related message boards.

TESTER REGISTRATION

We already discussed that one way to beta test is to make the game available in the form of an open beta program and invite everyone who is interested to provide feedback. The advantage of such a strategy is that you can increase the amount of reactions and comments of prospective future customers, and therefore compensate for the typically low response rate in beta tests. However, if you are looking for a specific type of player, or want the game to be tested for a wide spectrum of different systems and Internet connections, you will have to categorically select the actual testers from all applicants. These persons then get the beta version and access to all sections on your Web site (e.g., dedicated beta site, forums) that are inaccessible to people who have not been officially selected. All this is unfortunately also a security issue. There are some people who give away passwords, offer the beta version to one of the various Internet hacker/cracker groups, or share the files through popular file-sharing systems. On the other hand, a closed beta' is much easier to screen and gives you the chance to have testers who are more likely to provide the feedback you are looking for.

All information gathered from players during the application process is helpful in choosing the right kind of testers and to get an idea about what to expect from them. Understanding the testers' personalities is fundamental for the testing process. The brief initial description they provided about themselves, their system, their gaming preferences, and experience is the first step. In the course of the testing process, you then get additional impressions and further ideas about all those different personalities. How expressive is a tester's opinion regarding specific issues? Is he an experienced veteran or a first-time player of this type of game? Can you trust his feedback, or does he regularly report outdated bugs or is one of those "whiners" who generally complains about everything?

Selecting appropriate testers is often a matter of choosing people who mirror a game's supposed target audience. Let all prospective testers fill out a short online survey to collect key metrics revealing their relationship to games in general and your project in particular. Potential criteria to as-

semble a tester group are demographics (age, sex, income, etc.), system (operating system, processor, RAM, I/O devices, Internet connection, etc.), and game relationship/experience (gamer in general, preference for specific genre, experience with similar products, etc.). The purpose is simply to gain some background knowledge on testers to understand how a particular type of feedback relates to your goals and the game's supposed characteristics. It might also be a good idea to include people who show absolutely no correspondence with your target audience because they could provide feedback you would otherwise never receive. Absolute nongamers, for example, who usually do not spend their spare time playing computer games probably report faults, ambiguities, or complications that hardcore gamers are already familiar with and thus forgive. Unfortunately, such persons usually also don't consider enrolling for any game beta programs, meaning that you actively have to draw on them and get them excited about the project (e.g., selected newsgroups or message boards).

TESTER INTRODUCTION

The next step prior to starting the actual test period is to prepare all participants accordingly and give them instructions on how to proceed. Supplementing the game description document that each tester should have already accessed, you should definitely provide a set of guidelines available online to the testers. They need to know how to set up the game, how to resolve common technical problems, and how to report the issues they encounter. For multiplayer online games, you should also inform them of potential security issues and educate these early users about their additional responsibilities in anonymous multiperson and multicultural game space.

In addition, make sure that your testers understand the special relationship they are entering into with both you and your product, and that they know of the special behavior that comes with the job and what is expected from them. For example, a tester should know to inform you if he has far less time than he had anticipated so you can make arrangements to look for replacement testers. Encourage him to stay in regular touch with you or with a beta manager so you know that he is still with you. Most likely, such "strict" rules only apply to a closed beta program. For each beta test, however, open and closed alike, you should present some type of binding tester

ethics to each participant. Each tester needs to keep in mind that you put a lot of trust in him, and that betraying that trust is a violation of the test's rules. A tester's proper ethical behavior, for example, includes not distributing any officially unreleased game versions and data. Likewise, he should keep all of his experiences and bug findings confidential even after the game's public release, and not publish any review or critique (that's supposed to be objective) about the tested product. In addition, a beta tester needs to agree not to offer any helping hints or complete game guides immediately after the game's release. Unfortunately, the line between this issue and what you would call newbie introduction is a bit blurry. At least for a while, however, players should have a chance to make their own experiences—figure things out on their own and help each other—without any guidance from a tester who already knows better.

If there is not yet a Web site online that provides a basic game guide with information about controls, gameplay, and the most important features, you might consider setting up such a document and making it available before the test starts. Of course, a game-specific Web site or a section on the company pages dedicated to the product should be mandatory. For the beta test, it's a good idea to offer some type of "beta zone" on your site—a single online destination and tester meeting place where a tester knows he will instantly get the most recent news and find answers to his questions. Such an area could include a searchable bug database, forums, FAQ, development news and plan files, game information (e.g., game guide, common chat abbreviations), and all the latest patches and tools. A beta zone has the advantage to provide a clear, instant focus for each tester in satisfying all his specific needs, and provides the opportunity to separate testers from "normal" Web site visitors. You can present features such as very detailed news, special files, or chat rooms that only a tester is really interested in and might find useful, but would be information overflow for anyone else. There's even the option to limit access to the beta section to only official testers and secure those special areas. It's not that difficult and time consuming to secure the system in a sophisticated way on the server side, linking it with a tester database and therefore allowing each participant to access these sections using an individual username and password. For closed betas where you release information and files that are not meant for the public, it's crucial to secure beta zones. Independent from that issue, however, this strategy instantly builds a very strong tester community by providing a sense of exclusivity, specialty, and a binding "sphere of secrecy" intrinsic to all game communities.

TEST START

Once you have set up and prepared everything for the test program and given the latest beta build the final check, you are ready to start the test. Most of the game is complete, and now it's time to find and resolve as many bugs as possible and do the final gameplay balancing. As soon as people who have not been involved in development play the game, you will also probably get the first feedback on how appropriate the difficulty level and its balancing throughout the game really are. Difficulty adjustment is one of the biggest advantages of beta tests. At this point, you and the entire team have already spent a tremendous amount of time playing the game and have dealt with all its facets thousands of times. Many games are thus often designed to be too difficult for newbies who now have the chance to let you know.

The actual test period clearly also needs some management and screening. For multiplayer online games, most important is actively participating in the game environment whenever there's some room in the development schedule. Testers like to meet the people behind the game, and you can also lend them a helping hand and spend some time getting them situated in the game environment. Depending on the implemented network architecture, it might be a good idea to occasionally announce a tester meeting at a specific time and take the opportunity to run your servers through a load test.

A beta test should also build the very core and basis of the game's future community, meaning that you should foster collaborative leaning in the process and encourage testers to correspond with each other and exchange their experiences and thoughts. Finally, it's clearly necessary to communicate with your testers and continuously let them know that their reports and suggestions are heard.

TRACKING FEEDBACK

Intrinsic to any beta program is the ability for a tester to report encountered bugs or point out other ambiguities, concerns, or problems regarding both the technical system and gameplay. The details of your bug/report tracking system depend on the game's complexity and the type of beta program—that is, whether it is open or closed. Generally, however, you will most likely have some network-enabled bug database used to record and update all complications that arise. Probably the most simplistic way to use such a database is by letting testers send you (or a dedicated beta program

manager) "pure" e-mails according to which the database is then manually updated for internal use. Undoubtedly, this is quite a cumbersome and impractical method, and so the least you should do is provide a Web form communicating with the database via ASP, PHP, or basic CGI. A better way is to set up a more sophisticated bug-tracking system that allows more than solely submitting a report. It's obviously possible to implement such a system on your own. However, there are various advanced but reasonably priced bug-tracking systems available for licensing (e.g., *BugCentral, Census, Aardvark, Bug/Defect Tracking Expert*). Some systems such as the one used by the Mozilla project, *Bugzilla,* are even open source and usable for free but still offer a broad range of functionalities and features. In fact, these tools offer multiple significant advantages for making the test program as efficient and smooth as possible. On the one hand, it's an easy way for the dev team to track reports according to specific criteria, or easily sort out those assigned to a specific tester or game feature. You can quickly get in touch personally with a tester whose feedback is a bit unclear or is so crucial that it's worth answering for more information about how the issue came to pass in order to recreate the situation. Additionally, you can ensure that each bug is immediately routed to the responsible team members, and that each of them can primarily focus on those in which he is most interested.

So, what are the most important features and fundamental functionalities that a bug/report tracking system should support? Here is a short list of what a bug-tracking system should minimally allow the tester:

- Adding a simple bug description.
- Adding detailed information about a bug and how to reproduce the problem.
- Browsing through all problems reported by any tester.
- Applying various filter/sort algorithms to database records.
- Defining the bug category according to a given choice of types.
- Ranking the bug according to one's individual sense of severity.
- Checking current bug status throughout the test period.
- Modifying/updating/complementing one's own entries.

Probably the most significant thing to have in a bug-tracking system is the ability for the tester to specify a particular category for each of his entries depending on the type of problem he encounters. You should present

him with a list of choices to choose from in order to typify the "area" in which a problem belongs. What categories you provide varies from game to game and depends on what specific game elements you are most interested in for the test. Typical specifications for games often relate to the responsible department (e.g., gameplay > design, cosmetic > art, technical > code). Alternatively, the categories could correspond to the game's main features or be supplemented with more generic areas such as navigation or security. Moreover, you might want to consider adding a category that does not exclusively belong to bugs in the strict sense, but is used for general feedback, suggestions, and requests.

For ranking the severity of a bug, there should be a similar gradual scale available for the testers. A standard and appropriate grading system outlining a bug's severity in descending order could include options such as crash, game stuck, gameplay affection (game runs but in a different state than it's supposed to), distraction, cosmetic/aesthetic, "could be. . ." (optimization, additions, etc.). Closely related to a classification as to severity would be one describing a bug's priority and how important it is to resolve the problem. Such a scale that you might alternatively (or additionally) include in your system could look like: holdup (impossible to continue testing), serious, requirement, option, improvement.

What finally remains to be mentioned is that for more complex projects, it's definitely worth considering even more advanced bug-reporting mechanisms, thereby simplifying the process for both you and the tester. A good idea is allowing a tester to record a problem from directly within the game (e.g., command line), thereby eliminating the necessity to regularly switch between applications or even writing a bug on a piece of paper. The perfect solution is to link this functionality directly to your online bug-tracking system and database. A further improvement is incorporating the running game application self into the reporting procedure. The game is possibly the best bug reporter you can have. If initially supported by the code, it can provide exact information about its inner conditions and settings under which the problem occurred—information that no human tester can provide.

In case the game is not able to communicate directly with the bug database, there are still options to enhance bug reporting. One alternative is saving an appropriate log file locally upon a tester's in-game command. After a test session, the beta tester could then submit these files containing all necessary bug information to the bug reporting system at once. An even simpler version is a plain-text file saved on the user's machine and logging

a user's bug-related commands issued from within the game. The idea here is not to save any game state information, but simply to let a tester record bug reports without having to leave the game environment.

FEEDBACK EVALUATION

At the end of the test period and throughout the entire process, you obviously cannot simply wait for feedback coming in from the testers; you need to do something with it. This does not mean that you should strive to resolve as many reported bugs as possible, which should be obvious. The question is how to process and evaluate all the feedback in the very first run? As mentioned, the first and foremost rule is to be responsive, respect a tester's time, and actively acknowledge bug reports and recommendations whenever your schedule allows. Second, you have to make sure that the entire team is always up to date about the most critical reported issues, and that specific feedback is routed to the appropriate person (e.g., automatically done by back-tracking system, update mails sent to the responsible department). Of course, this aspect also concerns customer support for which a beta program might actually be the first meaningful test run. Testers are likely to call for help occasionally and they should get the necessary assistance as quickly as possible to avoid frustration. Requesting support can simply be done via e-mail. For multiplayer online games, however, it's good to have a mechanism that allows doing that directly from inside the game. Similar to the idea of contacting a GM, development staff, customer support, or other beta testers can then easily locate the player in trouble and provide real-time, context-sensitive support directly in the game environment.

At the end of the beta program, you probably face more bug reports and suggestions than you could ever fix and handle within the supposed production schedule. It's important not to disregard any issue. Pay attention to things that initially seem insignificant or impractical, but weigh the feedback against the project's objectives and prioritize all issues according to type and grade of severity. A valuable strategy at this point is to write a brief concluding test report that summarizes the test program, the most important feedback you have received, the game's current condition, and all resulting next development steps. The purpose of this is to keep the project on track (what is often difficult when feeling overwhelmed by all these reported problems) and to force you to think through all the harshest issues again without missing something crucial.

Regarding reports, it's also worthwhile to ask your testers to write a final report that includes their (subjective) toughest issues, overall impression, individual likes and dislikes, and feature recommendations. It's good to ask for both a final qualitative feedback and various quantitative metrics (e.g., average number of bugs found per day, overall testing time, average connection speed, number of bugs still unresolved, etc.). Compiling all this information and statistical data aids in evaluating the beta program, promises to reveal additional aspects, and is a helpful knowledge basis for future or following tests.

SUMMARY

Playtesting, bug tracking, and gameplay balancing are increasingly no longer limited to a game's development team or in-house QA personnel. Involving prospective future audiences—but also more critical, nongamers—in testing procedures can help in identifying critical technical drawbacks and initially unobvious design ambiguities. Together with adjusting a game's difficulty level to people who have not been playing the game on a daily basis for the last few months, this strategy allows you to round off your creations to experiences that finally reflect the players' needs. Especially for multiplayer online games, a well-organized beta program can mean a game's success or failure. Dedicated beta testers are the very foundation and core of a game's player community, and assist in preparing both its social and technical framework for the critical mass.

MASSIVELY MULTIPLAYER GAMES AND MIDDLEWARE

IN THIS CHAPTER

- Overview of Game Middleware
- Interview with Rémi Arnaud and Kenneth Trueman
- Case Study: Tesseraction Games' *Enigma—Rising Tide*
- Case Study: Artifact Entertainment's *Horizon*

In this chapter, we look more thoroughly at a catchword that has increasingly become a subject of debate in the game industry for the last few years and has been briefly mentioned various times in previous chapters: *middleware* for game development. In discussing the multiple aspects and issues involved in (considering) incorporating middleware into the game development process, we will now take a slightly different approach. After a quick overview of game middleware, its major facets, and how to understand these systems, we will let those who definitely know best speak. First, two members of two different middleware dev teams who for the purpose of this book agreed to share their thoughts and opinions on middleware and provide some revealing insights into the subject matter: Rémi Arnaud, Director of Technology at California-based Intrinsic Graphics, and Kenneth Trueman, Director of Business Development at Montreal-based Quazal. Both regularly strive to improve their middleware products—*Intrinsic Alchemy* and *Net-Z, Conveyor* and *Eterna*, respectively—in

order to fit the game developer's needs and offer solutions meant to meet the demands of today's and tomorrow's computer game market.

Then we will listen to those who practically rely on middleware technology and have used such systems for developing their most recent games. Referring to this chapter's title and the subject of this book, the two introduced games are massively multiplayer online environments and are therefore particularly interesting for uncovering the meaning of middleware for creating those kinds of games in which we are most interested. Kelly Asay from *Tesseraction Games* and Rick Simmons and Ben Spees from *Artifact Entertainment* tell us of their experiences using *Intrinsic Alchemy* and other middleware technology for the implementation of their large-scale multiplayer online experiences *Enigma, Rising Tide*, and *Horizons*, respectively. These interviews are the first in a series of interviews continued in the next chapter, and should provide a deeper and practical knowledge about the major topics we have covered up to this point. This approach should give you an additional understanding, valuable inspirations, and an opportunity to learn from others' experiences and thoughts, and aid in pushing the online game media to its next higher level with your next projects.

OVERVIEW OF GAME MIDDLEWARE

Reading a feature list of one of today's major middleware products—Criterion's *RenderWare* (Graphics, Audio, and Physics module), Intrinsic's *Alchemy*, *Havok Hardcore* physic engine, the LithTech Product Line (*Jupiter, Talon, Cobalt*, and *Discovery* System) or NDL's *NetImmerse* to name a few—promises a lot and there also seems to be a common agreement among most developers about their potential and the advantages they offer. Among the most significant advantages of basing game development on such systems are shorter development times, lesser risk through proven reliable and stable technology, facilitation of cross-platform development, and usage of highly sophisticated out-of-the-box (but still customizable) dev packages in which all components perfectly harmonize.

The final decision whether a particular product has the potential to live up to all these promises is up to you and heavily depends on your individual project and demands. Moreover, it should not be a harum-scarum decision, but should result from a thorough market analysis and detailed evaluation of each solution against your creative and business goals. Undoubtedly, middleware seems to have the potential to significantly shape

the future of game development. Likewise, they could finally introduce times in which game designers and developers can primarily focus on what is most important: crafting immersive and challenging game experiences and worlds that people love to be a part of.

DEFINING MIDDLEWARE

Referring back to our earlier discussion of authoring systems, we see that a definition of middleware is somewhat fuzzy and that a clear line between a pure authoring environment, a game creation kit, and sole middleware is difficult to draw. Basically, authoring systems also provide an approach we could call "middleware" as soon as elements of their own (proprietary) architecture are melded with those of the game system. Perhaps this is the best way to define middleware and how these systems differ from pure development tools and utilities. Unlike the case for any tool, elements of middleware also make it into the final product. Seen as such, DirectX and OpenGL are nothing more than middleware. Whereas these technologies are available free of charge for game developers, the products we are talking about here typically require some financial invesent. Middleware needs to be licensed from one of the various providers, who then make their systems available under specific licensing terms—most likely depending on the specific product together with a set of tools, utilities, documentation, and ongoing support throughout the development process. As such, these technologies are development architectures and frameworks providing generic, game-independent functionality (whereas this general approach is most often seen as the biggest disadvantage). Most middleware is delivered in the form of APIs and libraries provided as full source code, .LIBs and/or .DLLs. Generally speaking, creating MODs is game development on the basis of a middleware framework in which part of the core system is packed into a complete .EXE.

MIDDLEWARE DISCIPLINES

Middleware solutions are available for all fields involved in game development, and cover each aspect required to implement sophisticated (online) experiences for nearly all platforms. Ranging from graphics, audio, physics, and SFX to scripting, networking, and AI, it is possible to create all game components on top of some middleware product. Some systems, such as *RenderWare* or *Alchemy*, try to span the broadest possible range of functionality and bundle their multiple middleware components, each covering

a specific functionality set, into one nicely interlinked package. Others such as *Net-Z* or Louder than a Bomb's *Spark!*, and *MASA*'s *DirectIA* (used for the development of Ubi Soft's *Conflict Zone*) are middleware solutions specializing in a specific area—in this case networking and AI, respectively.

- **Graphics/rendering:** The majority of middleware available today is aimed at handling the graphics and rendering aspect of game development. There is a broad range of libraries, each dedicated to a specific portion of the rendering pipeline, that are either available separately or bundled into an "all-in-one" graphics solution. Virtually each demand on highly sophisticated indoor and outdoor game environment rendering can be met using middleware technology: rasterization, lighting and shading, material and texture management (e.g., bump maps, environmental maps, etc.), skin-and-bones animation, particle effects, transformation, culling, and hidden surface removal (e.g., PVS, BSP, etc.).

- **Audio:** Both DirectX and all next-generation consoles already offer the most fundamental methods to implement game audio and sound. There is also middleware explicitly dedicated to providing ways to create and manage special and more complex aspects of game sound. Music and sound are increasingly treated as a significant element of immersive and innovative computer game experiences. Enabling audio engineers to implement their creative visions more and more requires a wider spectrum of tools and techniques: 3D positional audio, filtering, acoustical rendering of specific environments (e.g., underwater effects, sewer pipe), and special effects (e.g., moving sound-emitting objects, near-field proximity). Various middleware products promising to offer such support are already available, among them Sensaura's *3DPA*, Criterion's *RenderWare Audio*, Sony's *S-Force 3D Sound Library*, and *fmod*.

- **Networking:** For online game development, implementing stable, fast, reliable, and secure networking functionality is definitely vital, but also often a difficult and time-consuming task. Highly skilled and experienced network experts are still rare, and issues arising with developing networked simulations usually require a tremendous amount of research, analysis, and testing. A few middleware providers offer solutions promising to free you from the need to design sophisticated network capabilities from scratch. Similar to every other game component, its multiplayer aspect also involves

multiple elements that depend on the particular project and finally build the entire network architecture. There is, however, a variety of available network middleware solutions—most notably Quazal's *Net-Z, Conveyor,* and *Eterna,* Kalisto's *K-Net,* and Zona's *Terazona*—covering all these aspects. These libraries provide solutions for issues such as protocols, distributed systems, lobbying, matchmaking, front- and backend services, connectivity, account management and techniques, and network performance optimization (e.g., dead reckoning, hierarchical messaging, load balancing, client-side inconsistency corrections, etc.).

- **Physics:** Analogous to sound and audio, more and more developers are also aware of the necessity and importance of highly sophisticated and realistic physics for improving a player's gameplay experience. However, complex, fast, and robust physical simulations are again a science in their own right and therefore reasonably hard to realize. This has led to multiple middleware solutions proving that ready-made physics libraries together with rendering systems are probably the most accepted and often used third-party middleware technologies in the game industry today. The *Havok* game SDKs (*Havok Total, Havok Hardcore,* and *Havok Xtra,* a rigid body physics simulation engine for Macromedia *Director Shockwave Studio*) is one of the most popular physics modeling technologies for game development. The same holds true for MathEngine's *Karma*[1], which is also integrated into the *Unreal* engine and has been used for the PlayStation 2 and Xbox versions of *Black & White.*

 Libraries such as these are capable of handling simulation problems such as collision detection and response (for both simple geometry and more complex convex or arbitrary polygon meshes), rigid body dynamics, constraint systems, soft body, cloth and rope modeling, as well as aerodynamics or vehicle-specific behaviors.

- **AI:** We are still some steps away from the moment when players can no longer distinguish behavior of artificial agents from that of real human beings. Sophisticated AI will therefore stay one of the most challenging and weakly understood fields in computer game development. This is probably the reason why middleware attacking the

[2] MathEngine has been acquired by Criterion in order to integrate the *Karma* physics libraries into their *RenderWare* product line.

AI side of things is quite rare. The main problem is combining the game-independent, abstract, and flexible nature intrinsic to middleware with aspects of AI, for which only a few of these "proven" and generic concepts exist. Typically, for AI to be adequate, it's necessary to shape the architecture entirely according to a specific game's needs; AI follows the game concept, not vice versa. Nevertheless, for those few generic AI techniques (e.g., finite-state machines, path finding, flocking, reactive behavior, perception, standard genetic algorithms, and neural nets), there are already some middleware solutions available to the game developer. These systems are definitely worth a look and are a next big step in researching and developing generic game-AI functionality; among them BioGraphic Technologies' *AI.implant*, Louder than a Bomb's *Spark!* (a fuzzy logic editor of which the core library is available for free), the *Kynogon* engine, and MASA's *DirectIA*.

- **Scripting:** The increasing importance and efficiency of using scripting languages to access, define, and alter a game's underlying core functionality somehow seems to go hand in hand with more and more middleware solutions incorporated into game engines. As discussed, middleware should be generic and game independent, but often needs to operate on low-levels of a system (e.g., the rendering pipeline) in order to achieve best results. Providing a simple, easy-to-learn but nonetheless powerful high-level interface to an engine's low-level functionality in the form of scripting languages is a predestined solution to guarantee the required generality and flexibility. Likewise, they take away the unproductive and time-extensive need for regular compile/link/debug cycles. More and more middleware solutions, and especially most of those full-blown all-in-one game engines such as the *Unreal* (scripting system included) or *Quake III* engine (extended by Ritual's *Morpheus* and Raven's *ICARUS* scripting languages), make use of these advantages and provide some form of scripting language. Most outstanding is probably the very flexible, efficient, and advanced approach presented by *UnrealScript* as part of the Unreal engine. Good, free, and engine-independent solutions are also available for scripting that are not difficult to integrate into your own (client- and server-side) code architecture. Python, PHP, and *Pike*, for example, are very advanced, object-oriented languages with C/C++-like syntax and

thus among the first candidates to be used as extension languages for systems that need a programmable interface.

You now see that it's possible to approach nearly each aspect of game development using middleware technology, and that lengthened project schedules and the need for cross-platform development make such systems increasingly attractive. Still, many developers are (often legitimately) a bit skeptical about using middleware. In order to facilitate the formation of our own opinion, let's now additionally listen to some opinions and thoughts from people who don't solely approach this idea theoretically. What do those think who try to present the most practical middleware package to game developers and sell their concepts? And what are the experiences of development teams that have already used middleware extensively for implementing their most recent game projects on a daily basis? Moreover, what meaning and potential does middleware have for developing multiplayer online games?

INTERVIEW WITH RÉMI ARNAUD AND KENNETH TRUEMAN

What follows is an interview with two leading members of middleware manufacturing teams—Rémi Arnaud from Intrinsic Graphics, and Kenneth Trueman from Quazal. The interviews were conducted separately covering the same questions, but the two men had no opportunity to comment on each other's opinion directly. However, it makes sense to present you their thoughts in parallel, resulting in the roundtable-like approach you will find here. First, let's introduce Mr. Arnaud and Mr. Trueman.

RÉMI ARNAUD

Rémi Arnaud is currently Director of Technology at Intrinsic Graphics, the developer of *Intrinsic Alchemy*, a highly recognized middleware product supporting development for all major platforms. Rémi's origins are in France where he also completed his doctoral thesis on Real Time Image Processing. Prior to joining Intrinsic, he worked as an engineer with the IRIS Performer team at Silicon Graphics, Inc. Before his promotion to this group's manager, he contributed to the design of next-generation graphics hardware and was involved in the implementation of the Fahrenheit Scene Graph.

KENNETH TRUEMAN

As Director of Business Development for Quazal, Kenneth Trueman manages the company's relations with platform providers such as Sony Computer Entertainment, Microsoft (Xbox), Nintendo, and Intel. He also spearheads the company's efforts to partner with other middleware providers, such as Criterion Software, Numerical Design, Intrinsic Graphics, Havok, GameSpy, and others. Previous to Quazal, he worked for a number of companies developing shrink-wrapped graphics software on the Mac OS.

How would you personally define middleware? Do you think there are some key differences between your product and what could be called "pure toolsets" and authoring systems?

R. ARNAUD: The term *middleware* has been around for a while. There even is an ACM Middleware annual conference dealing with distributed computing middleware. I would say that Sony has been at the origin of the term *middleware* for the game industry with the official middleware program for the PS2. A common definition of middleware is the glue between a hardware platform and an application. In the case of the ACM conference, it is "a layer of software between the network and the applications." Unfortunately, the word *middleware* has been used by all kinds of tools used to make games, such as modelers or even DVD burners. Therefore, it has become very hard to clearly define what is middleware.

The word *middleware* also brings a bad connotation with it; it is often seen as a black box layer. This is true of most of the technology currently available that makes it very hard for game developers to access hardware-specific features, or to get the maximum performances.

Intrinsic Alchemy technology is exactly the opposite of that design philosophy, as it is an object-oriented design that is fully extensible. The term *software platform* is what defines best what Alchemy is. Game developers use the word *platform* as the target hardware for which they are programming. With Alchemy, they can program for the Alchemy platform once, and get their application working on all hardware platforms that Alchemy supports with a simple recompilation. With Alchemy, even the game data is stored in a cross-platform

file format, which is optimized for each target to get the maximum performance. Another aspect of Alchemy is that it does not prevent the developer to get directly to the hardware, but it provides tools and methodology to do so.

K. TRUEMAN: While the original view of middleware was that of pieces of a puzzle or building blocks that developers can mix and match to create a game, the middleware industry is now moving beyond that. Now it is more a question of outsourcing a part of the game, and trust is one of the more important factors. In effect, we are asking developers to forgo the development of one or more key parts of their game, exposing them to potential problems if the technology falls through or support is not provided.

Middleware can be broken down into two categories: specialized components that do one thing well, and complete game engines that offer a wide range of functions. Our products are uniquely specialized for networking.

How about popular licensable engines like Quake III, Unreal, or LithTech?

R. ARNAUD: That is a good question; actually, we are often asked if *Alchemy* is a game engine. From my experience with developers' definition and expectation relative to game engines, the answer is yes for some and no for others.

It is true that there is a different category of middleware that *LithTech*, *Quake III*, and the *Unreal* engine are defining. Those products are the tools that had to be developed to make a particular game; they are complete application and art path for which it is possible to create MODs and new art to create new games. The good thing about using those tools is that the game is almost done; the bad is that the game is almost done.

If you want to make a game that is exactly like *Unreal* but with different art and a few different features, licensing *Unreal* is a very good thing. If you want to make something different but you still want to base it on this game technology, you will have to get the source code and hack into it. It happened recently that about 80 percent of the original code had to be replaced to get the result wanted.

It is actually possible to license a lot of game code. If there is an existing game that is exactly what you need, you should try to license the source code and asset pipeline instead of re-inventing the wheel.

However, if your game is more different than just adapting the art and scenario, you need to get a software tool that is designed to build an application with, rather than starting with an existing application and do risky heart transplant surgery.

Another issue with licensing a full game engine is that they usually come with their own model/world editors that are not standard, so you will have to specifically train your art team. So, in summary, full game engine is the right answer in very specific cases, but non-game-specific tools like *Alchemy* can be used in all cases.

K. TRUEMAN: Complete game engines are interesting for developers who just want to "add water and watch it grow," meaning those game developers who have a great game concept but no technology whatsoever. The upside is that developers can get up and running pretty quickly. The downside is that most of the existing game engines are fairly genre specific (first-person shooter (FPS), etc.). If you want to develop a sports game or an action game, you might not be well served by a game engine originally designed for a FPS. For those developers looking at developing massively multiplayer games, scalability might be an issue, too.

Can you explain the approach of your product a bit more? What does it handle for developers to save them development time?

R. ARNAUD: I used to work at Silicon Graphics as manager of the Performer team. Performer is actually a middleware (even if the word is not used in the visual simulation market) that lets you write an application on a low-end workstation, but will automatically extend to multiple processors and graphic pipes when running on a high-end system. We saved developers a lot of time and money because they could develop at their desk, instead of having to share a unique and expensive machine. There still were integration needs on the target equipment, but most of the problems would have been solved beforehand.

Alchemy is using the same principle; the program can be developed using *Microsoft Visual C++* on a PC with all the great tools (debug, tune, lint, purify...) that are available on that platform, and simply recompiled on the expensive (>$10,000) tools that have specific compilers and system, complex hardware to handle.

Another advantage is that one can develop one game, and have it available on multiple hardware, with the same source code and data, which further reduces the cost and time to market.

Another principle of *Alchemy* is to reduce as much as possible the feedback loop to the artist. Tons of time is lost in a game team when you have an artist who will take a programmer's time by asking him to change this or that parameter. We have integrated Alchemy inside the most popular artist packages, such as Discreet *3ds max* and *Alias | Wavefront Maya* so the artist can directly see the result on the engine. Alchemy also integrates the same viewing technology for the target platform, so the artist can look at the result on a PS2, Xbox, or GameCube with one single click in the modeler application. That by itself has been saving an enormous amount of time for our developers.

We also provide a new type of tool, the artist/engineer tool. The Finalizer, as we call it, lets artist and programmers communicate and solve art and performance issues in a very efficient way. Our support team is using the same tool to communicate with the customers, and that gives us a clear advantage to better support and fix their problems faster.

Perhaps even more important, *Alchemy*'s core is based on an object-oriented design that actually is extending C++ with a proprietary Object Definition Language (ODL and the IGEN compiler) that enables the developer to add/remove or replace any functionality of our tools. It also provides more features with less code to write, as every object declared with ODL knows how to allocate, initialize, delete, load, save, print. . .themselves without having to type one line of program. Less code to type leads to double time saving, as it is also less lines of code to debug.

Actually, the best way to save time developing is not to develop a feature that already exists. There are plenty of middleware companies that provide very specific features if you need them in your game; for example, physics, artificial intelligence, spatialized sound, Doppler effect, movie compression, character animation, potential visibility set. . . . What is unique with *Alchemy* is the fact that it has been designed to be extensible to pre-integrate any of those technologies, so the game developer can pick and choose those features without the headache of having to integrate them himself, and to try to figure out how to get the best out of each. The worse for a game developer is

actually to figure how to integrate the new features in the content path so the artists and game designers can add the new data into the game. Most of those issues are solved by Alchemy.

K. TRUEMAN: Our products were designed with the idea that most game developers are not network experts. Consequently, we take a very high-level approach to network game design. First, our products deal directly with network protocols so that game developers don't have to. They also free developers from other tedious tasks by automating the publishing, updating, and destruction of resources as players join and leave the game. Second, the philosophy behind our Quazal *Net-Z* (for multiplayer games) and Quazal *Eterna* (for massively multiplayer games) products is that a game is a collection of objects that needs to be published and updated as the game goes on. Therefore, when adding the network aspect of the game, the developer is thinking in clear terms about what needs to be shared and when it should be updated. We developed our own Data Description Language to do this—developers use our natural C++-like syntax for describing their game objects, their contents (data sets), and update policies.

Net-Z and *Eterna* can be added to existing projects just as easily as they can be used to create new projects. If the existing project code is already fairly object oriented, both products are even easier to add. We have even had game developers tell us that they have swapped out a competitor's product and plugged in *Net-Z* in a day or two.

What is the main benefit that game developers get from using middleware for their projects? What is it that makes such an approach appealing?

R. ARNAUD: Games are becoming increasingly complex, and the hardware platforms they are running on are also more complex to harness. Many more very advanced features are required from the game developer, but at the same time, the budgets are tighter and the schedule is increasingly aggressive. It seems an impossible challenge to meet all of those milestones, especially in a massively multiplayer game where the network technology and persistent world problematic adds to the complexity.

However, all that is now possible as the tools for building games are now available to game developers and will help them concentrate on the game rather than the integration and technological issues.

Most multiplayer games are now developed with the help of one or several middleware.

K. TRUEMAN: The main benefit and the reason for buying middleware probably vary from developer to developer. For some, there is the realization (after much hand wringing) that games have gotten so complex that it is impossible to provide homegrown technology for all the aspects of the game. For others, it is the desire to concentrate on the game, and leave the technology up to others (shall we say the experts). For more and more game developers, it is the desire to maximize their development and marketing budgets that is driving them to develop their games on multiple platforms. Since each platform is very different (consoles particularly), middleware is the only solution that allows them to minimize the development risk inherent in cross-platform development.

Despite the common claim that middleware is the future of game development, there still seems to be some skepticism toward such an approach. Do you personally believe that as well, and are you confident with the prospects of this market (in the short/long term)?

R. ARNAUD: How many developers still program their console game entirely with assembly language? Who is not using a graphic library such as DX or OGL?

The answer nowadays is that everybody is using a low-level graphic API and a high-level programming language. The tools are getting better and better, and once they are stable enough, they are used by everybody. Many developers have started to use C++ instead of C now that compilers and debuggers are good and reliable on consoles. The same thing is happening for graphic, physics, sound, and platform tools such as *Alchemy*. Actually, it has already happened; almost half of the games currently available for PS2 for example, have been using a middleware, including two of the top five sales.

K. TRUEMAN: When we launched our product over two years ago, it was still arguably the case that people were skeptical. Today, adoption of graphics, physics, and audio middleware is pretty advanced with a number of high-profile titles (*Dark Age of Camelot* for the PC, *Tony Hawk 3* for the PlayStation 2, *Munch's Oddysee* for the Xbox, etc.) having shipped. This has led to much greater visibility for middleware in general. The overall trend is very encouraging. As games become

more complex in general, game budgets and team sizes are forced to increase. Left unchecked, something has to break. Game developers increasingly see middleware as a solution that lets them better control their game development costs, thereby freeing them up to deliver the complex gameplay experiences that their users are clamoring for.

As game developers move to support multiple platforms, and game consoles go online, powerful reasons for choosing middleware are coming into play as I mentioned earlier.

From your point of view, what are the key factors for providing efficient and successful middleware solutions to game developers? Flexibility? Simplicity? A broad range of accompanying tools? Training and support?

R. ARNAUD: Education is what is most missing. Developers do not know what is available or even possible with current technology. Every time developers have been trained on the product, they are amazed by what's possible and what they have been missing. I offer to do technical sessions about *Alchemy* at GDC every year, but those are not retained, as the panel that selects the papers does not know what they are missing and think that it is only a promotional presentation.

Our effort to solve the education issue that is hurting middleware in general, and games as well (I am convinced that the games could be better if more developers were taking advantage of middleware), is to have a free university and research license for our entire product, to have an open forum to talk about Intrinsic (*http://dev.intrinsic.com*), to make our graphic tools available for free (as in this book), and to get the word out as much as we can.

K. TRUEMAN: I think that there are three key factors. Obviously, you need technology that is as strong as or better than what the game developer can develop in-house. Second, you need to document every possible angle of the product, including the samples that you provide with the product. Third, and this is probably the most important factor, is product support. Great product support can make your reputation in the market as a whole, while bad product support can break it. Game developers need to be able to get product support wherever and whenever they need it—Web, e-mail, telephone, or on-site. If you do not provide the proper support in this industry, you will not last for long.

Continuing from this, is there a "golden rule" about choosing the most appropriate middleware software and provider for a particular game project?

R. ARNAUD: Support. This is the main issue. How good is the support you will get from the product you are about to license? How will you be helped when you are in crunch time, can you count on those folks to help you just as if it was their own game? In general, licensing a source code that has been written by a team that is now working on another project or disseminated is the worst thing to do. The product is stalled and you will have to count on yourself only to make it evolve and fix all the issues.

The second issue would be the performance of the tool, and even more important, how you understand and have an impact of the performance of the middleware you will be using. What tools are provided that let you try optimizations and see the result immediately? What tools are provided that you can use to debug a problem with the database?

The third issue is to understand the completeness of the tool and the limitations that you will have to deal with. Is that tool covering memory management, threads, sound, graphics, and so forth? Basically, how many functions in your game code will have to be direct calls to the platform-specific API or operating system? What platforms are supported? Will your game be stuck on one console, or will you be able to make it available to everyone if asked by the publisher?

There are many more questions to ask yourself, so once you have checked the preliminary issues, you need to get a complete package and spend about a month trying it out and then start working with it with real game code and data. Then you will have a good feel for it. You should not take a decision without taking the time to look at several technologies as it is very hard to switch from one technology to another, especially in the middle of a project.

K. TRUEMAN: I think that what we are truly offering to game developers is not technology but a relationship. Technology, while it needs to be great, is merely a starting point. It's the support relationship that truly makes the difference in good times and bad. We are asking game developers to entrust the success of their projects to us. Those middleware providers who understand this the most will likely have the most success.

Although quite a few middleware technologies exist today, they mainly target the rendering portion of a game. There is (still) only a handful dedicated to networking or AI. Is there a particular reason for this in your opinion, and do you think the near future will see some changes in this scenario?

R. ARNAUD: Full game engines have AI, script, and, most of the time, networking included. If you look at what professional commercial products are covering graphics, there are only three of them: Intrinsic *Alchemy*, Criterion *RenderWare*, and NDL *NetImmerse*. In the past, there were many more good products such as *Surrender3D*, but they all have suffered from the complexity and diversity of the next-generation platform to which they could not adapt to for technical or economical reasons. It is very hard and complex to develop such technology. It takes years, millions of dollars, and the best engineers and design. Therefore, I do not think that many more products will be available. On the physics side, whose market is a subset of the graphic middleware market, there were also four players: *Mathengine*, *Criterion*, *Havok*, and *Ipion*. *Havok* consolidated with Ipion, bringing the count to three. The AI is different as it is harder to package as less work has been done on what should be an AI toolset. Two companies have taken that challenge: Kynogon and Biographic. In the sound area, there are at least four companies: Analog Device with *Sound Max* that is licensed to most PC manufacturers; Sensaura ,that has licensed their technology to the Xbox; *RadGameTools* that have a huge success with the *Miles Sound System* and other companies like Yamaha and Sony that license software synthesizers; and more recently, Dolby that offers 5.1 and surround encoders on most game platforms.

On the network side, it is less clear what is going to happen, and that is mainly the reason why currently massively multiplayer games are available only on the PC. The network strategy needs to be put in place by the console manufacturer. How will people accept that the Xbox has a hardware packet encoding that makes it impossible to play with anything other than another Xbox? Both GameCube and PS2 will come with an add-on network adapter. In general, an add-on for a console is a disaster, as only a very small percentage of the console users will buy an add-on. Will it be different for PS2 and GameCube? What is the software strategy that the companies will have in place? For example, Sony has bought R-Time and is pushing it as

the solution for PS2 networking, but will it be available for other platforms?

Still there are number of companies such as Quazal that are ready with great technology to catch the ball when it starts rolling.

Therefore, my opinion is that currently there are many products available in all the categories, and that in each category you have a handful of strong players, and that is a very good thing for game developers.

K. TRUEMAN: For a long time, graphics was the main area of effort in a game. Many years of work have been done to bring graphics up to speed. The introduction of video boards like those from NVIDIA has enabled game developers to offload the graphics processing from the CPU to the GPU (graphics processing unit), freeing up a lot of cycles for more complex functions like physics and AI.

For networking in particular, the key to our success is game consoles. On the PC, our biggest competitor is the game developer who "knows how to do networking." That's not the case on the console side, where there is definitely less networking expertise. That being said, the launch delays for online networks from Sony Computer Entertainment and Microsoft, along with some waffling by Nintendo, have caused many game developers to take a wait-and-see attitude. Now that firm launch dates have been set for the PlayStation 2 and the Xbox, we are seeing renewed interest by game developers in using networking middleware.

What are your thoughts on middleware packages trying to cover a broader spectrum of issues (e.g., RenderWare) versus solutions specializing on a single development aspect (e.g., Havok, Net-Z)? What are the strengths/weaknesses of one approach over the other?

R. ARNAUD: To follow your categorization, I would say that there are products that cover the entire gamut but are not very flexible (*Unreal, Quake. . .*), then products that cover only a specific need (*Havok, SoundMax. . .*), and products that try to provide a complete but flexible answer.

NetImmerse is actually to be classified as a specific-need product, as they are covering only the graphic. They have worked on several projects where more than one middleware was needed and made sure that it was possible to integrate *NetImmerse* with other tools. It has

been successful most of the time, but was sometime a disaster such as in the case of *Prince of Persia*.

RenderWare is the only company currently providing a commercial offer that covers most of the needs with a physics, sound, PVS toolsets in addition to their graphic product. The problem is that they are lacking a modern integration technology and have numerous issues with integration of completely separate products into one game, which they compensate with lots of sample code and good support.

Only *Alchemy* is providing the technology to help the game developer to pick and choose pre-integrated technologies and provide a real broad answer.

K. TRUEMAN: Until now, it has really been a question of individual developer's needs. Some developers require only a specific piece of the puzzle (e.g., physics or networking), while others prefer to concentrate on the game concept, leaving it up to the game engine to do the rest.

One of the clear trends now is that of a one-stop shop for sales and support for a broad range of middleware products. Purchasing multiple middleware products has meant that developers are particularly interested in a single point of contact for product support. These one-stop-shop efforts are being led by the graphics middleware providers who are developing additional middleware products, or who are licensing and/or reselling leading middleware products from providers like Havok and Quazal. Expect to see some announcements from us on this by the end of 2002.

In addition to these partnership efforts, we are working on a number of plug-ins for other middleware products to insure added compatibility and integration.

Do middleware libraries generally cover a specific range of games/genres, or is it possible to design a system generic enough to target any game design concept?

R. ARNAUD: It depends on what middleware and what game. It is quite impossible to use a 3D rendering engine for a 2D game, or a physics engine in a game that does not need physics ☺.

In general, the full game engines answer very specific game genres; for example, the *Quake* engine would not be very useful for a flight simulator. The real question is how we can provide a product that has all the options necessary to cover all the specific needs of all the different game genres. The answer is that the need is for a lot of very specialized middleware and one very good integration platform that

those third-party technologies have been ported to. If you look at *Alchemy* and *RenderWare* customers, you will see that the same product is used in all genres such as massively multiplayer games, puzzle games, first person, third person, sport, and so on, which proves that such products are definitely genre agnostic.

K. TRUEMAN: Speaking from our own experience, we have designed a product that is fairly game-genre agnostic. It can be used to develop games of any type, from card games to car games to 3D first-person shooters in space, like *Zero-G Marines*, a game developed with our *Net-Z* product. That being said, we are taking it one step further by developing a series of game-genre specific frameworks that can be used in conjunction with *Net-Z* and *Eterna*. These are basically templates for developing games and should save a developer even more time. Our first framework, RealTime3D, is a collection of foundation classes for game objects commonly found in action games: characters, power-ups, vehicles, and so forth.

We think that a generic system combined with genre-specific templates is much more flexible than, for example, trying to wrap an FPS engine around a football game.

In your opinion, does middleware have a particular meaning for online game development?

R. ARNAUD: Today's massively multiplayer games target platform is the PC, which has good resolution, a mouse, and a keyboard, and network access. However, the coming generation of games is going to be available also on game consoles. The Xbox has a built-in network interface; PS2 and GameCube are proposing an option for connecting to the network as well. There are many challenges that the game designer has to face given that the video output is now a low-resolution TV screen, and the input a game controller. In addition to the design issue, porting a game from the PC to a console causes all kinds of problems and necessitates lots of specialized engineering due to major differences in the hardware design.

Fortunately, some middleware now have tackled the difficult cross-platform portability issues, and that is one more reason for massively multiplayer games to look at middleware as the platform to build the game upon.

K. TRUEMAN: Most definitely it does, and on two fronts in particular. There is great opportunity for middleware as consoles move online.

Console developers don't have the networking expertise that you find with traditional PC game development. To deliver online versions of their games, they are turning to middleware rather than attempting to do it themselves. Moreover, because each console has its own particular, and very different, architecture, cross-platform online games are even better candidates for middleware. Using our *Net-Z* product, you can make an online game that mixes PCs and PlayStation 2.

Going back to the PC front, many game developers don't have the technical expertise to develop the game engines that will scale up to their visions of massively multiplayer online games and do so in a cost-effective manner during game development and deployment. From our estimates, over a third of operating costs are related to bandwidth and data center issues. That is a lot of money going out the window each month. Middleware like *Quazal Eterna* that can demonstrate cost savings before and after the game ships is a winning proposition.

CASE STUDY: TESSERACTION GAMES' ENIGMA: RISING TIDE

As so often in game creation and design, there is much to learn from others' experiences by means of integrating middleware technology into the development process. This is even more important for comparing a variety of solutions against a specific project's requirements, and for finally choosing an approach that entirely fits the needs of both the game and the dev team. Finally, what meaning and potential does middleware have for multiplayer online game development in particular?

A massively multiplayer game heavily based on middleware is Tesseraction Games' premier title *Enigma: Rising Tide*. Kelly Asay, the company's president and co-founder, now shares his experiences and thoughts of using Intrinsic's Alchemy and various other technologies for implementing this large-scale multiplayer environment.

Can you tell us what Tesseraction Games is about?

K. ASAY: Tesseraction Games is a very strong team of people who have an impressive history in the computer game industry: eight of us are for-

merly of Dynamix. When Dynamix closed, there were a group of us who enjoyed working together and didn't want to leave Eugene (Oregon). We decided to sit down at the local pub and have a chat about our options; over a pretty short period we decided to try putting together our own game company. We did, and are now in our sixth month of development on our first game.

Can you tell us more about yourself?

K. ASAY: I am President and Producer of Tesseraction Games. Starting up a game company is one of the single most interesting experiences in my life. . . and I spend most of my life as a musician. I bring 12 years of solid programming and business owner-manager experience to the company. I am a networked software specialist, and have developed technology for online games and complex business applications. Most recently at Dynamix, I was the database programmer for the Internet-based game *Tribes 2*.

Can you tell us more about the game?

K. ASAY: The game is *Enigma: Rising Tide* (Figure 15.1). This is an alternate history naval battle. We officially announced our first game in March 2002, as well as opened the Web site for it. Our first game is an online, persistent-world, massively multiplayer game that looks to be creating its own genre, or at least blurring the line between an FPS and an RTS game. We will be releasing later this year.

You have licensed Intrinsic Graphic's Alchemy for the development of this game. Why have you decided to use middleware for your project?

K. ASAY: We are pursuing a very aggressive initial development and release schedule for our first game, which pretty well ruled out developing our own technologies. We have signed a long-term licensing agreement with Intrinsic Graphics and have chosen *Cybernet* for the network layer technology; a very interesting technology originally designed for use by the military to support massive distributed simulation training. Our server farm/bandwidth agreements are being finalized, and several other strategic partnerships are being completed

FIGURE 15.1 *Enigma: Rising Tide*—a massively multiplayer environment developed using middleware technology. © Tesseraction Games, Incorporated, 2002. Screen shot(s) reprinted with permission from Tesseraction Games, Inc.

that collectively are giving us a huge boost toward release. Our team is doing an incredible job and we are currently running a couple of weeks ahead of schedule.

There is already a variety of middleware frameworks for game development available on the market. What was the key factor for choosing Intrinsic's solution?

K. ASAY: We started looking at the *Torque* engine from *Tribes*. It is nice engine, but it is not set for the scale we are heading for. We are looking for persistent world, which the *Torque* engine does not handle. We looked at *LithTech*, we looked at the *Quake III* engine, but they did not answer our needs. Therefore, we needed to find something with a new technology, maybe new to the industry, but some-

thing that is cutting edge. I saw a quote about *Alchemy*, found a post on Gamasutra, and from there decided to evaluate. We put it head to head with the other engines and made our decision. We were sold on the flexibility of the Alchemy design, as well as the flexibility of the business proposal that matches our needs of releasing updates every quarter for another minimum three years.

Is it easier for you to use a development platform like Alchemy than a game engine like Quake or LithTech?

K. ASAY: Right. It is also the fact that *Alchemy* provides a graphic abstraction layer that will let us do a port to an Xbox or a PS2 latter. Having your engine separate from the network, and being designed to integrate other middleware technologies. . . it's an ideal engine. The cross-platform capability of *Alchemy*, even if not needed immediately, was important.

Isn't it a challenge to design an RTS game for PC and consoles?

K. ASAY: The interface has to be quite different due to the video display and the absence of a mouse on the console. We will design our next game with that goal in mind.

How much 3D content will the game have?

K. ASAY: There is a heavy 3D content in the game that requires a very efficient rendering engine. We will have lots of ships, different kinds of supplies you can salvage from sunken ships. Submarines will be coming to the port under the shadow of a bigger ship. It is designed to be a cinematic first-person game. For example, in a submarine in the surface, your camera will be standing in the conning tower, and you have a wonderful compact head-up-display that stays with you and lets you control the ship. You can put on binoculars; you can man your gun and shoot at planes. When you are immerged, we have a full-length modeling of the vehicle. You will be able to use the camera to look inside the submarine, and still have your HUD. We will have cinematic elements and special effects in the sub, light flickering, spark. . . . We also have real time of day, a very good visualization of the sky and the sea.

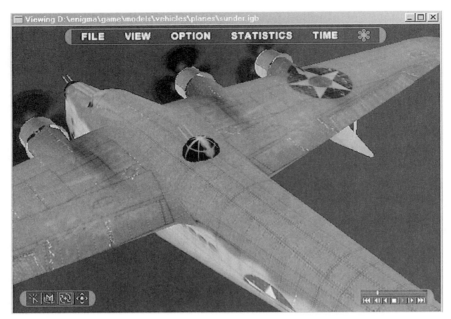

FIGURE 15.2 The Insight Viewer, a tool providing real-time visual feedback, is embedded into Intrinsic's *ArtistPack* plug-in that is a subset of the company's Alchemy middleware product. © Intrinsic Graphics, Inc., 2002. Screen shot(s) reprinted with permission from Intrinsic Graphics, Inc.

How much impact did Alchemy design philosophy have on your own design?

K. ASAY: We did all our engine design, including the object model, before we started evaluating middleware. The *Alchemy* ODL object model and its extensibility matched what we envisioned doing. We have been able to integrate our own design with almost no changes. Our lead engineer is very meticulous; he lays out all the core design and object relationships before he starts coding. When we evaluated Alchemy, it was apparent that it is what you guys did, it was a very good match for the way we work.

Alchemy does not have any multiplayer technology embedded, but there are nonetheless several teams doing massively multiplayer games with Alchemy. Why is that the case?

K. ASAY: That's probably one of the reasons, as it let us design or use our own network technology, and as *Alchemy* is designed to help inte-

grating additional features, this let us get the best of all technologies: the best graphics with the best network. We do not have to rely on what the game engine has to provide. We can get the best water simulation from Areté software; we can get the best physics from *Mathengine* or *Havok*.

Have you been using Alchemy ArtistPack?

K. ASAY: The ArtistPack (Figures 15.2 and 15.3) was what put *Alchemy* in the forefront in the first place. We are trying to do our game in an aggressive nine-month schedule, while it usually takes two to three years. We have lots of outside contracting and licensing. And as soon as we hooked up your ArtistPack with *3ds max*, compared to the other evaluations we were doing, that by itself made all the artists vote for Alchemy.

FIGURE 15.3 A submarine as shown by Alchemy's Insight Viewer. © Tesseraction Games, Inc., 2002. Screen shot(s) reprinted with permission from Tesseraction Games, Inc.

Unlike the programmers' point of view, the artists' opinions are not always in-cluded in the evaluation of middleware.

K. ASAY: We are taking a cinematic approach for our game, which is part of our strategy. We need to be able to speed up the artist's pipeline, and the Alchemy ArtistPack has made that so simple and seamlessly integrated with the modeler and the engine. Our lead artist and game designer work with the ArtistPack to test the asset, and it looks the same when we put it in the game.

CASE STUDY: ARTIFACT ENTERTAINMENT'S HORIZONS

Another highly anticipated massively multiplayer project is Artifact Enter-tainment's *Horizons*. Rick Simmons, Artifact's Director of Engineering, and Ben Spees, Lead Client Engineer, agreed to answer the following ques-tions and let us know about their experiences with using middleware sys-tems for multiplayer game development.

Rick, what is your background?

R. SIMMONS: I was a software engineer in the telecommunications indus-try where I led the development of large-scale software systems for maintaining and managing the infrastructure and operations of telecommunications networks. Prior to that job, I developed several commercial and private applications that continue to be used within the petroleum industry.

And what about you, Ben?

B. SPEES: I worked for a small game company called Ambrosia Software. While there, I developed a cross-platform (Windows/Mac) 3D out-door game engine for networked action games. I also worked on *Fer-azel's Wand* (1999, Ambrosia Software), a side-scrolling action RPG for the Mac; *Harry the Handsome Executive* (1997, Ambrosia Soft-ware.), an office-themed arcade game; and *Derrat Sorcerum* (1996, Hopkins Technology) a Myst-style fantasy adventure game.

What is Artifact Entertainment about?

R. SIMMONS: Artifact Entertainment was founded in November 1999. It is a privately held software development company that currently is focused on the subscription-based massively multiplayer online game *Horizons*. The mission of Artifact Entertainment is to provide subscription-based quality online entertainment experiences using superior technology, proven design methods, broad market appeal, customer satisfaction, and the highest quality staff. It is planned for release in 2003.

You are using Intrinsic Graphic's Alchemy for you current project. How and why did you become an "Alchemist?"

R. SIMMONS: We needed to make very quick progress toward defining our asset pipeline, so that content production could begin as early as possible. Faced with a decision about whether we should continue to develop an engine in-house, or if we should use an external technology, we evaluated many products in the industry. We identified the following factors as required features to make a decision:

- **Massive world:** Our game is oriented toward a large and complex environment. An engine with support for a large world, or at least without limitations, is required.

- **Code structure:** Modular code and good design allows us to better understand development decisions in the engine, as well as make modifications if necessary.

- **Documentation:** Documentation of the source and engine architecture reduces the amount of time required to understand the engine, and implement our product.

- **Open file format:** An open file format allows us to store all aspects of the world in a database and easily export data to the engine file format. This approach allows multiple editing tools to be used with world data, as well as allowing us to place the data in a format that is accessible in the best format for both client and server.

We did not consider any products that had poor visual quality, or poor performance. A second set of criteria was established in case we came to a close tie: long-term viability, customer support, and cross-platform support. The reason that customer support was placed in the second set of criteria, rather than the first, was that we feel that technical support should *augment* the documentation, rather than *be* the documentation. It's much more useful to sit down for an hour and read about how a system was designed and works, than to get piece-meal descriptions over several technical support calls. We chose Alchemy over other products because it met all of our base criteria, is an excellent technical decision because of design and extensibility, and received incredible, glowing praise from several references provided by Intrinsic, as well as references we found independent of Intrinsic.

What hardware platforms will you release your game on?

R. SIMMONS: Our product will be released on the PC platform.

So the cross-platform feature of Alchemy was not a criterion in your choice?

R. SIMMONS: The cross-platform features of Alchemy were very attractive, but were not instrumental in our decision. Being able to release on the PC is a short-term decision, but long term, having the console market available to us is important.

What other technology are you licensing?

B. SPEES: We are using *Granny Character Animation*, *Miles Sound System*, and *Hybrid dPVS/umbra* that we are integrating with *Alchemy*. We also employ *Geodesic* tools to help write cleaner code and ease error detection and code diagnosis. High availability is very important for a massively multiplayer application that is always on.

Since when have you been using Alchemy?

R. SIMMONS: We've been working with *Alchemy* since the second half of 2001.

What is your experience with Alchemy so far?

B. SPEES: We like the architecture of *Alchemy* a lot. The exporters are quite polished, and the Finalizer is extremely useful in visualizing the scene graph. Performance for the most part has been excellent. We haven't run into nearly as many mysterious problems as expected. After a few hiccups in the beginning, tech support is good with generally quick response time.

What impact has Alchemy's object-oriented design had on your own design?

B. SPEES: *Alchemy* has allowed us to buy into its object model to different extents based on our needs. We've been able to create our own types of nodes to place in the scene graph when necessary. We have also been able to integrate and synchronize *Alchemy*'s objects with our own external object system fairly easily, which is sometimes preferable.

Would you recommend Alchemy for massively multiplayer games?

R. SIMMONS: *Alchemy* has allowed us to put together an excellent game engine. As for applicability to massively multiplayer games, we have not encountered any reasons not to use *Alchemy* for a massively multiplayer title.

B. SPEES: None of our networking code interacts directly with *Alchemy*. We have a dynamic loading design that takes advantage of *Alchemy*'s asynchronous loading. This feature of *Alchemy* is very helpful in dealing with an unpredictable, dynamic game world. At any given time, with no warning, the server might inform about 50 new models and textures that are needed. We have to load them up and present them to the player as quickly as possible with no hitches.

SUMMARY

Nearly every game development project relies on middleware integration in some form or another nowadays—if only DirectX or OpenGL. In times of lengthening production schedules, an increasing amount of different

platforms, and the accompanying necessity for cross-platform development, this market seems to keep growing. There's already a large diversity of solutions available to the game developer covering each distinct discipline commonly involved in creating (multiplayer) game experiences: rendering, physics, networking, AI, and so forth. Middleware is—and undeniably needs to be—generic and game independent in approach. On the one hand, this is a quite appealing and promising model, making these systems cover a broad array of possible designs and genres. On the other hand, it's necessary to understand the need to adapt underlying middleware architecture to each game's specific needs, and to put high priority on evaluating carefully what particular solution best fits your concept's demands and offers you this necessary flexibility.

Middleware architectures can heavily reduce risk and time to market, enabling you to focus on designing immersive game experiences rather than on technological details, and to implement your creations on time and on budget. As with any other technology and third-party solution, these systems should not dictate your designs. Select, customize, and expand middleware according to your creative visions, and use the technology to emphasize your concept's strengths—not vice versa.

INTERVIEWS AND OPINIONS

Welcome to Part Four of *Online Game Interactivity Theory*. Hopefully, you enjoyed thinking about the previously discussed concepts and ideas and are now inspired to consider some of them while working on your own current and future projects.

This closing part of the book, which is actually only a single chapter, continues where the last chapter left off and is also somewhat different in approach. We should now listen to what some of the most notorious people in the computer game industry think about various aspects of game design and development. These individuals have played a significant role in shaping the computer gaming media as it is today and agreed to share their opinions on issues of game design in general, the specialties and meaning of multiplayer game development, and their understanding of interactivity. Whereas some of the questions are a bit more general, others cover particular aspects covered in previous chapters. This final section provides a valuable opportunity to learn from these people's experiences and offers an additional in-depth and practical look at the concepts and theories covered in previous chapters.

CHAPTER 16

SHOP TALK: MEETING OF THE MINDS

As promised, we will now give the floor to some people who have all left noticeable marks on the (online) game development landscape throughout the past few years, and still do. You might initially know some of them better than others, and most of them have their individual relationship to game development. However, they all have something in common: actively contributing to design and development of the next generation of computer game entertainment and thinking about ways to push this media another step further. Everyone gladly agreed to answer a few questions for the purpose of this book and to impart their thoughts, ideas, and beliefs about the key aspects we discussed throughout the previous pages.

INTERVIEW METHOD AND PROCEDURE

The following answers have been collected via an interview conducted with each of the persons separately. To make it easier to follow, the subsequent paragraphs are assembled in a form similar to a roundtable; that is, each person successively commenting on a question before moving on to the next point. On the one hand, this approach is possible because each person had exactly the same questionnaire and should let us focus on each issue in turn. The downside of such a fictive roundtable assembly and the fact that

everybody was unaware of the answers of the others, however, is that no attendee had the chance to adapt or directly react to each others' opinions as would be intrinsic to any "real" roundtable. Clearly, the results are occasional conflicting points and disagreements without the possibility for all participators to defend why they believed something to be to be right as opposed to somebody else. Nonetheless, this approach allows you to concentrate on one point at a time and weigh any differences and similarities as you move through the questions. This alone can be quite insightful and constructive by clearly showing the diversity in opinions about these types of issues of game development.

The chapter starts with a brief bio and introduction of all attendees. All subsequent sections are logically grouped by various key topics being addressed by the interview questions, which should help to follow the interview more easily. Similar to all previous chapters, this one closes with a summary that should pull it all together and give suggestions on what to conclude from the statements.

THE ATTENDEES

Let's thus start with a short introduction of all interviewees in no particular order.

WARREN SPECTOR
Studio Director, Ion Storm Austin

Warren Spector received his BS in Speech from Northwestern University and earned an MA in Radio-TV-Film from the University of Texas, Austin. After joining Steve Jackson Games as an Associate Editor in 1983 and working on several games, including *TOON: The Cartoon Roleplaying Game*, he accepted a position with TSR, Inc. in 1987. While acting as supervisor of TSR's game division, he collaborated on the design of the *Top Secret/S.I* and *Bullwinkle & Rocky Game* role-playing games, saw the publication of a novel entitled *The Hollow Earth Affair* and a Marvel Superheroes Adventure Gamebook (*One Thing After Another*). He also worked on several board games and role-playing adventures for TSR, West End Games, and other publishers.

Warren left pen-and-paper gaming in 1989 and joined ORIGIN Systems, Inc., where he co-produced *Ultima VI* and *Wing Commander*. He

went on to produce *Ultima Underworld, Ultima Underworld 2, Ultima VII: Serpent Isle, System Shock, Wings of Glory, Crusader: No Remorse, Cybermage: Darklight Awakening, Bad Blood, Martian Dreams*, and others. In 1997, after a one-year stint with LookingGlass Technologies as Producer of *Thief: The Dark Project* and General Manager of the LG Austin office, Warren founded the Austin office of Dallas-based game developer, ION Storm, where he was Project Director on the award-winning action/role-playing game *Deus Ex*, published by Eidos in June 2000.

Warren now acts as Studio Director and Executive Producer on all titles developed at ION Austin, and is on the board of the International Game Developers Association.

RICHARD BARTLE
Game Designer

Professionally, Richard Bartle started out as a university lecturer in Computer Science/Artificial Intelligence, but gave that up around 1990 to concentrate on designing and developing games full time. As a student, he co-wrote the first MUD, which is also the direction his work took. He has been involved in multiplayer online gaming since the very beginning.

Richard Bartle has worked with virtually all of the major industry players over the years on a variety of projects. He has seen the industry change immeasurably during this time—in some cases, taking the rest of the world with it.

Now he spends his days designing games and acting as a consultant for other designers and developers. From time to time, however, he also does some programming ("just to stop myself from getting rusty. . . well, OK, and because it's fun!").

GORDON WALTON
VP/Executive Producer, Maxis

Gordon Walton has been authoring games and managing game development since 1977. He has personally developed over two dozen games and managed the development of hundreds of games.

Gordon has spoken at every GDC since its beginning on topics ranging from game design to programming to business. He has had his own development company (twice), been Development Manager for *Three-Sixty Pacific* and *Konami America*, Vice President of Development for *GameTek*, Senior Vice President and General Manager of Kesmai Studios, Vice

President of Online Services for Origin Systems managing *Ultima Online*, and is currently Vice President and Executive Producer of *The Sims Online* at Maxis.

CHRIS CRAWFORD
Freelance Game Designer

Chris Crawford is very likely known best as the founder of today's annual Computer Game Developer's Conference, as author of the infamous book *The Art of Computer Game Design* (written during his time managing the Games Research Group in 1983), and publisher of *The Journal of Computer Game Design*. He is also the designer of such uncontested game classics like *Eastern Front* (a strategy war-game based on the eastern front in WWII from 1981), *Tanktics* (a tactical armored combat game, 1981), *Balance of Power* (a geopolitical simulation game released in 1984), *Trust & Betrayal* (a social relationships game from 1987) and *Balance of the Planet* (an educational environmental simulation published in 1990). Chris worked as game designer, supervisor, and research manager for Atari from 1979 to 1984. Currently, he is a freelance game designer, book author, and spends lots of time researching the magic of interactive storytelling in the course of his work on the according development environment for this concept.

MATT FIROR
Producer, Mythic Entertainment

Matt Firor has been producing online games since the infancy of the industry. He has produced more than a dozen online games, including *Aliens Online*, *Silent Death Online*, *Rolemaster: Magestorm*, and Mythic Entertainment's most recent massively multiplayer RPG, *Dark Age of Camelot*. In his (spare) free time, Matt can either be found in his apartment in Arlington, Virginia, near Mythic's headquarters, or at a horse farm in Hunt Valley, Maryland.

TOMMY STRAND
Producer/Designer, Funcom

Tommy Strand is currently employed as a producer at Funcom Oslo where he started as a 3D modeler. Previously employed as a programmer and designer, he possesses a wide range of skills and characterizes himself as a Jack of All Trades (master of none).

During his time in the game industry, he has been involved with a several titles, including *Casper* (Interplay), *Dragon Heart* (Acclaim), *Pocahontas* (Disney) and *The Longest Journey* (Funcom). His last achievement was as producer and lead designer for *Anarchy Online*[1], Funcom's flagship in the MMORPG genre.

GRAEME DEVINE
Game Designer/Programmer, ID Software

Graeme Devine is an industry veteran who's worked on seminal titles such as *Pole Position* and *Double Dragon* for platforms as diverse as the Commodore 64, Tandy 1000, Collecovision, and Nintendo Game Boy, Devine has seen it all. As a designer and project manager at id Software, he oversaw the day-to-day development of *Quake III: Arena*. Before joining id Software, Graeme founded Trilobyte, producing classic PC titles such as *The 7th Guest* and *The 11th Hour*. Graeme has also spent time at gaming giants Atari, Activision, and Virgin Games.

KEVIN MCCANN
Creative Director, PlanetSide, Sony Online Entertainment

Kevin McCann has been in the massively multiplayer gaming industry for five and a half years now. He first came onboard halfway through production on a game called *Tanarus*, which was a team-based tank game playable only over the Internet, serving as lead designer and co-producer. Since then, he has worked on multiple projects within Sony Online Entertainment, leading up to becoming Creative Director on *PlanetSide*.

ERNEST ADAMS
Game Design Consultant

Ernest Adams has been in the interactive entertainment industry for 12 years. He is currently a game design consultant based in England, and a member of the International Hobo design consortium. He was most recently employed as a lead designer at Bullfrog Productions, and for several years before that, he was the audio/video producer on the *Madden NFL Football* product line at Electronic Arts. In a much earlier life, he was a soft-

[1] To try *Anarchy Online* free for seven days, go to *www.anarchy-online/free/ogit/*.

ware engineer. He has developed online, computer, and console games for everything from the IBM 360 mainframe to the PlayStation 2. He was a founder of the *International Game Developers Association*, and is the author of the popular *Designer's Notebook* series of columns on the Gamasutra developers' Webzine.

INTERACTIVITY AND COMPUTER GAMES

Interactivity is often assumed to be the key in game design. However, what actually are the keys in designing interactivity from your point of view?

W. SPECTOR: The most important thing, to me, is to provide genuine interactivity rather than just a close approximation. Most games—including some truly excellent ones—offer completely linear experiences that offer players little more control over events than a good book or movie does. What designers need to do is focus on the ways in which they can cede creative control to players, rather than showing off their *own* creativity. Giving players power to impact a game world, plot events, character responses, and so on, is key.

Allowing players to express themselves in collaboration with developers is key. Accepting those two "keys," then, simulation is the *real* key. . .

R. BARTLE: Interactivity is not the key in game design. It might well be a key to the games that are designed, but it has little or nothing to do with game design itself.

The key to game design is imagination. If you don't have it, forget game design as a career.

Imagination is critical because:

- You need to generate original concepts.
- You need to think of new ways of doing old things.
- You need to envisage what the final game will be like.
- You need to predict what the players will do.
- You need to anticipate the consequences of design changes.
- You need to envision that you're going to make a ton of money (because that's the only way you're actually going to see it . . .).

G. WALTON: Interactivity is expressed by the player feeling a sense of control within the game. The mechanisms are only the means to that sense of control. It's easy to add interactivity, but difficult to add the right level and pacing of interactive elements to achieve player immersion within the game, letting them achieve the suspension of their disbelief while they engage in a gaming experience. I look to the core of the experience we are trying to convey or simulate to build the first interactions, and then try to keep all other interactions in alignment with that core. Just because you can add more interactions doesn't mean you should add them.

C. CRAWFORD: The biggest design problem lies in what I call "listening": designing the inputs for the player. The first and most important question a designer of an interactive application is "What does the player *do*?" The answer to that question determines what verbs should be made available to the player, and how the application "listens" to the player.

T. STRAND: Interactivity needs to be balanced between challenge and usability. Most game systems suffer from a poor balance between the two and a too broad focus. The whole market is often taken as a unified gamer mass and abstracted into advanced players and new players. Trying to create one unified challenge and one unified interface that will both facilitate the new players for ease of use and the advanced player for depth, you usually end up with something in the middle.

The market you are aiming for needs to be segmented, and separate focus needs to be put on the interactivity within each segment. This will put additional strain on the development process unless you narrow down to specific segments in the markets. The current MMORPGs, including *Anarchy Online*, try to please too many segments with one system.

G. DEVINE: Well, it's also about guiding the emotions of the player to pull him or her through the story. Building up attachment to objects, other players, and providing a believable context to which the player can relate.

K. MCCANN: Effectively anything that the player can interact with in the game falls under *interactivity*—it's extremely broad in what it entails. There are two very top-level categories that interactivity can be classified as: social and environmental.

No matter what type of online game is being designed, the social and environmental aspects must be addressed. However, it's what the designer is trying to achieve with the game that's important for how the interactivity is designed. For example, standard online RPGs to date have typically focused on level advancement—the player's character gets more powerful fighting NPCs, leveling up over time. However, the majority don't have 'resource gathering' that an online RTS might—whereas in an RTS, collecting wood, metal, oil, and so on to build units (infantry, vehicles, etc.) and structures is pretty standard. The point here is that it's important for the game designer to lay out on the table in advance what he or she is trying to achieve in the interactivity of the game. For example, if I'm making a fantasy RPG, do I want to have resource collecting play a role? Can players harvest wood and mine metal and make items out of this (or sell to merchants or other players who can use the resources)? Or, do I simply want to focus more on the social and combat aspects.

The main thing for the designer again is to clearly identify the vision of game and what interactivity would best suit the game. In general, the more interactivity that can be put into a game, the better—it gives players more ways to possibly entertain themselves. But again, the interactivity shouldn't necessarily be random, but instead try to complement the overall vision of the game.

E. ADAMS: The essential question to keep in mind at all times is, "What is the player going to *do*?" Too many game designers, and wanna-be game designers, get caught up in the world they're planning: the narrative, the characters, the sights and sounds. However, these are secondary to the question of what the player will actually spend his or her time doing.

The answer to this question is partly determined by other things: "What is the player's role—what is he or she pretending to be?" There are also issues of pacing. Old arcade games just got faster and faster and faster until the player eventually lost the game. Nowadays, we like to vary the pace of a game, just as we vary the pace of a novel or a movie, to give the player some variety. We don't want them to become bored or tired. Another issue is one of complexity. The more complicated the game, the more complicated the interactivity usually is; and we have to think carefully about how to design the game to keep the complexity of the interactivity within reasonable margins. If it's too simple, the game can become boring; if it's too complex, it will turn people off. These are a few of the keys to interactivity design.

Interactivity is a rather abstract concept. Do you think it's possible to take it as a given, or is there some way designers can (or should) concretize interactivity as a tool?

W. SPECTOR: Interactivity should never be taken as a given. Providing anything more than a hint of it is very hard work! Concretizing it involves thinking outside the box that typically defines games (as real-time puzzles. . . as several linear experiences woven together to give the *illusion* of interactivity. . .) and providing rules-based or system-based interactions among objects, characters, geometry, and so on. Simulate enough simple interactions and all sorts of complex and unpredictable behaviors emerge.

When that happens—and players realize it's happening and that it's in their control—you get something closer to the grail of genuine interaction between a human player and a machine world.

R. BARTLE: Concerning interactivity, this is the way I do it. . . . There are two kinds of interaction in (shared) virtual worlds: interaction with the world (i.e., the game) and interaction with the occupants of the world (i.e., the players).

Enabling interaction with the game world is a simple matter—you increase its depth and its breadth. Breadth concerns the number of choices available, and covers things like how big the game feels, how many commands there are, and so on. Depth concerns the level of detail in the game, and covers things like how real the game feels, the subtle side-effects of actions, and so on.

For interaction between players, the approach is to provide a wide range of mechanisms by which people can communicate, express themselves, identify, and organize. Again, there is a breadth and depth angle to this: more options mean a greater breadth, but meaningful effects for those options mean a greater depth.

Contrary to what you seem to suggest, it's not actually hard to design interaction.

Something that many inexperienced designers don't seem to appreciate, however, is that in a virtual world, not everyone wants to interact. Some people would rather just do things, and don't particularly care whether they get an intelligent response.

Why are these people playing in a world that boasts interaction as its major selling point? Well, maybe some of the time they do like to interact, or maybe they want to interact in the real world with reference to their exploits in a virtual world that their real-world friends

inhabit; or maybe they like bossing people around or being beastly to them. Indeed, there's an argument that only players who treat other players as game objects rather than people are actually playing a game—for everyone else it's a toy, or a sport, or a pastime, or whatever.

The crucial point concerning interactivity is not, therefore, whether you can have it, or whether you have to do anything to have it—you're going to get it to some extent whether you want it or not. Rather, it's how you balance the game to accommodate those who don't want it. If you force interactivity, or give those who practice interaction huge advantages, then people who don't want to interact might as well leave.

G. WALTON: I don't find interactivity abstract at all, since it is always expressed in user input and the reactions from that input. Again, ensuring that the interactivity gives the players a feeling of controlling their experience is key. Too much interactivity makes a game feel like work, and too little makes the game seem random and uncontrollable.

C. CRAWFORD: No, designers must understand interactivity if they are creating interactive applications. It's not a given, it's a tough concept, which is why so few designers understand it.

M. FIROR: My comment on this is that interactivity can be considered a "tool" only in its most basic sense—that it is the glue that brings together game players in an online environment.

T. STRAND: There is no way around using interactivity in a game. It is a given, and interactivity defines what makes games separate from movies, for example. Interactivity breaks up or conceals the linearity and introduces unpredictability in addition to the feeling that you can change how the story ends. These are strong tools for a designer. If you are designing an adventure game, for example, where the story is set in stone, you can still keep the player enthralled by introducing very simple means of interactivity to break up the linearity. The players don't need much to think that they are in fact making this story happen, not the designers.

G. DEVINE: Hmm, well the tool is now, and always will be in my opinion, the word processor and the brain. I don't think it's possible to come up with a formula or algorithm that can be defined as "the formula for interactivity."

There are certainly formula games out there, but that tends to be related to the copying of some earlier game design.

K. McCANN: I'm a firm believer in that there are many ways to design a game. The most important aspect to me is first establishing the vision, and then putting together an outline of what I want the game to entail (both social and environmental), then fleshing out the outline into the design document. Design documents are often called "living" documents, because they're really never finalized per se—they change during production as some things become technically impossible, or time is running out, and so forth. However, starting with a clear vision and design is still extremely important for both productivity as well as the team understanding what the game is trying to be.

E. ADAMS: "Interactivity" is rather like "vision" or "hearing": it's a dimension of experience. The term is too broad to allow for much generalization. There are certain technical limits to vision and hearing, but defining those limits doesn't tell us much about the paintings of Picasso or the music of Mozart. Interactivity is the same: there aren't many meaningful statements you can make about interactivity as a whole. It's more useful to talk about it in the context of a particular work.

MEANING OF "MULTIPLAYER" FOR GAMERS AND GAMES

What is the dominating effect resulting from multiple people interacting in real time in multiplayer environments on the design of these games?

W. SPECTOR: Real-time multiplayer games are a completely different animal from single-player games. Once you throw real people into the mix, interactivity is limited only by the expressive tools the developer chooses to give them.

In a single-player game, interactivity is, inevitably, more limited. Still, the single-player space is fascinating to me because, even in a more limited environment, you (the developer, that is) can actually *say* something of consequence. You can have a virtual conversation with the players about specific things. You can collaborate with them in a creative, dare I say it, artistic endeavor that's completely without precedent. In massively multiplayer games, the creator really does fade into the background, at least as I see it, whereas in a single-player game, it's just the developer and the player, negotiating every second. The former is a ceding of creative responsibility to players; the latter

is a sharing of responsibility that seems much more creatively interesting to all parties.

R. BARTLE: It's the very practical one of resource usage. The more players you have, the more bandwidth they'll use, the more processing power will be required, the more customer support you'll need. All these are very expensive commodities.

If I design a single-player game in which players can scan in their own designs for their character's shield, people might think it was a nice idea. If I do the same for multiplayer games, lag reigns as 40,000 players exchange texture maps whenever they meet.

If I design a single-player game in which you can shoot an arrow, it arcs through the air and hits whatever happens to have moved into its landing spot since the bowstring was released, that's fine. If I do it for a multiplayer game, the rest of the world grinds to a halt when 50 archers simultaneously launch an assault on an orc encampment.

If I design a single-player game where being hit by 20 arrows kills you outright, there's no problem—you just load from your last save. If I design a multiplayer game where this happens, customer service complaints quadruple as distressed players blame everything for the incident, starting with computer failure and going through lag, bugs, and client hacking until it ends with the behavior of their overweight cat. They want their character to be resurrected, and if making an appeal to the constitution is what it takes, so be it.

The virtual world is governed by the real world. You can't have anything in the virtual world that the real world can't run on computers. Vast numbers of players interacting in real time drastically reduces what can feasibly be achieved for the kind of money people are prepared to pay to play.

G. WALTON: Well, there are several effects apparent from having many real people interacting in real time. The best things that happen include the never-ending sense that something unexpected could happen at any time, the cooperation of players to accomplish goals, the ability to make new friends within the game and the immediacy of a live performance during every play session. The negative effects center on people being inappropriate in their actions and chat.

M. FIROR: The magic of online games is that you are playing with and against other human beings. Even with the most advanced artificial intelligence code in the world, playing against a computer-controlled adversary is not as exciting and ever changing as playing against a

human opponent. The goal of the designer is to ensure that there is a strong framework inside the game that allows player versus player (or team-based play) to flourish. Of course, the base design of the game must be strong, because no one wants to play a poorly designed game, no matter if you are going head to head with another human or not.

T. STRAND: Dominating the design of multiuser systems are the problems of tackling unplanned player behavior. When you are designing a product for an individual or a small group of players, you can still cope with the complexity of what players might do with the game and with each other. Once you introduce a persistent world where players have access to thousands of items and other players, you have little or no control over the actions that the players choose to take. You need to design your games to handle unexpected behavior; for example, 200 players deciding to cram into a disco on New Year's Eve. Managing the open-ended number of possibilities the players eventually end up with is one of the biggest challenges in designing interaction in a multiplayer environment.

G. DEVINE: So far the interaction is poor because many people don't act as they should in the world, and the world only offers so many fixed ways to interact with the players. This becomes such a problem that people line up to kill the monsters and so forth. Some of the newer game designs being talked about offer more, and someday we will cross the threshold and create something truly interesting.

K. MCCANN: One of the biggest challenges in designing an online game is making it persistent. This is often through character advancement, but does the world change as well over time? There are hardcore players who can dedicate 10 to 12 hours a day on the game, and will drastically advance faster than anyone expected (including the designers). And then there are the more casual players that might only dedicate two to three hours a day in the game. This "advancement" can vary based on what the game is, but generally, this is character advancement where the player's character becomes stronger—a warrior becomes more powerful, as does a magician, and so on in an RPG.

E. ADAMS: The dominant effect on the design of the games is that they cannot be narratives. Many single-player games have a storyline: like the novel and the movie, the game takes the player by the hand and leads him or her some place. In multiplayer environments, there cannot be one story, because there is more than one player. Rather, the game has to establish a world in which players can enact stories of

their own making. This is a considerable challenge, especially when there are hundreds of thousands of players and a universe of a limited size. It's also not as interesting to those designers who are really authors or film directors at heart. On the other hand, the players themselves often provide a great deal of action without the designer's intent (or consent!): they form clans, start wars, negotiate treaties, and so on without the designer having to lift a finger.

This doesn't mean that the designer has *no* freedom to create narrative in multiplayer environments, but the nature of the narrative is necessarily large scale rather than personal.

In your opinion, what are the most influential changes that online-play functionality in most games has had on the public understanding of computer games?

W. SPECTOR: I'm not sure that online-play functionality has had as much impact as people like to think. I mean, when I look at the multiplayer landscape, I see hundreds of thousands of players—and that's nothing to sneeze at—but it pales in comparison with the number of players who buy the most successful single-player games. And, if we extend the comparison to, say, a television program or a successful movie, well, online gaming is still a niche, a blip on the radar. Online games are hot these days, but I think the heat is as much hype as it is reality. . .

R. BARTLE: People either play computer games or they don't. I guess by "the public," you mean the ones that don't? In that case, online-play functionality for computer games has merely added everything that people fear about "online" to everything they already feared about "computer games." The public doesn't get its ideas about computer games by playing them; it gets it from what it hears in the mass media.

As more people come to use and understand "online" and it enters the mainstream, this will change. People will either lose their fears or have them reinforced (I'd hope the former, but there are a lot of crazy people out there . . .). I also believe that in the long term, games themselves will become less cause for concern, as people who have played them when young get older (although, yes, they might go in the opposite direction after seeing how games have wrecked their lives).

Where I believe that virtual worlds have a particularly important role to play is in addressing the needs of people who don't find regu-

lar games interesting. For example, which do you think has the higher proportion of female players, an online role-playing game or an offline role-playing game?

For the moment, though, the most influential changes that online play functionality has had on the public have nothing to do with their understanding of computer games—it's been to do with the development of the Internet.

M. FIROR: Now that online RPGs are quite popular, the public has become aware that you can "go" online, play a game, and meet other people. In most cases (with online RPGs), you communicate with these people, can group with them, chat with them, and become friends. This co-operative aspect of online games is a relatively new phenomenon. Previously, the public's perception of computer games was that you interacted with the game designer's world in the way that he wanted you to interact with it. Now, you can play the game while interacting with other people, which opens up a totally new dynamic.

T. STRAND: Online play functionality has brought games up on the undocumented ladder of leisure entertainment. Online interaction makes it possible to spend time with your friends in an environment other than reality. The barrier to communication between people is much lower in an online environment than in real life, due to the perceived anonymity that people have on the Net. This brings people who might lack the social skills necessary in the real world seeking to communicate with other people. As more diversity of people with different experiences and social communities start playing these games, a new understanding of what computer games are and what they can become starts seeping into the collective consciousness of the public.

G. DEVINE: The increasing availability of broadband has made a huge difference. Better UIs for talking to each other in game (voice, text etc.). It's still not very good, though. There's lots of low-hanging fruit there to grab.

K. MCCANN: I feel it's created a much bigger community within the respective games. For massively multiplayer games, we're talking about thousands of players within the same gaming world. This is a sharp contrast to someone hosting a *Quake* server, where 16 to 32 players jump in but roam different servers. Here, players have a virtual world that's home to their character, so they recognize faces when they log on, make friends, and so forth. One of the more interesting facets is

literally how a player can at face value recognize hundreds of players from playing over time—he or she might never talk to them, but will know them in terms of what they are. It's sort of like being in school or at work in a large company. Everything's much more alive.

Do you think some type of multiplayer online capability is (and will be) essential to establish a product in today's (and the future) gaming market? Why?

W. SPECTOR: No. Multiplayer is a nice addition to some kinds of games and a nice starting point for some kinds of experiences. However, single-player gaming is still in its infancy. Multiplayer gaming is here to stay, but it's not The Future—it's just one part of gaming's future and, I genuinely believe, not even the biggest part.

R. BARTLE: Yes it is essential, because otherwise you won't get a development budget and won't get your game produced. If the marketing people think that some type of online capability is essential, essential it is. Okay, there are exceptions. If you have a game for a big license (*Star Wars, Star Trek, Lord of the Rings, Harry Potter*, etc.), then an online capability is unnecessary as you're going to sell the game whatever. Gameplay isn't necessary either, come to that. As long as it looks good in a screenshot, the marketing people are going to be happy. Personally, I don't see that an online capability is essential. It doesn't bother me that I can't play *Civilization III* online, it doesn't bother my elder daughter that she can't play *Minesweeper* online, and it doesn't bother my younger daughter that she can't play *The Sims* online. Indeed, none of us would actually want to play these games online— we'd get slaughtered. If online makes sense from a gameplay point of view, sure, add an online capability. Don't bolt one onto a game that doesn't need it, though. Personally, I'm more interested in the question of whether games designed for online play should have an offline capability.

G. WALTON: I think there is a very valid place for solo games, just as there is a valid place for multiplayer games. I do believe that multiplayer gaming, particularly massively multiplayer gaming, is a very compelling experience and will help us reach customers who will never consider themselves "computer gamers," but this doesn't mean that solo games will be less successful.

M. FIROR: There's still many fun and compelling single-player games. I still enjoy single-user role-playing games, first-person shooters, and other types of man-versus-computer AI games. This might become

less and less common in the future, but for now, there's definitely a place for single-user games.

T. STRAND: I believe that most games down the road will have an online presence in game. There will still be a place for games with no on-line capabilities, but the numbers shows that people like to interact with people. I don't see that an extremely large segment of the game market will become massively multiplayer, but both a cooperating and competing moderately multiplayer setting will become even more commonly planned for in games to come.

G. DEVINE: Single-player games are going to remain huge and by far the biggest-selling games. I could be totally off base here, but a single-player game can offer a lot more emotion, attachment, and interaction for the player than anything online can.

K. MCCANN: I don't believe that every game needs to have an online component. While I'm certainly inclined to play online games in general, there's always going to be a strong market for games that are single player, that deliver a tight story and gameplay. Players don't always necessarily want to interact with other players. Single-player games can also tell stories easier than online games can—the player can save at any time, then come back a day, week, or month later and pick up right where he or she left off in the game, and thus the story continues. In an online, a story or narrative is more difficult, because not everyone starts playing on day one of the game, nor does everyone play every day. Subsequently, if an online game was telling a really involved story from day one, but players are joining six months later, a year later, and so on, then it's difficult to convey what's happened and bring them up to speed.

E. ADAMS: Multiplayer online capability will never be absolutely needed to establish a product, either now or in the future. It's a valuable addition to some games for which it is appropriate, but it isn't appropriate for all games. Adventure games, although now a fairly small segment of the market, are necessarily single-player games. And not all players want to play against other people; some prefer to play alone. Suspension of disbelief is easier to maintain when you're alone; it's harder in groups and harder still when some of those people are strangers. For those who enjoy being immersed in the fantasy, single player is still the best way to go.

The requirement that multiplayer games be fair, and be perceived by the players to be fair, sometimes actually weakens the game. For example, *Dungeon Keeper* was an excellent single-player game but a

poor multiplayer game. As a single-player game, it depended on hidden information to provide the challenge to the player. As a multiplayer game, it used symmetrical starting conditions to guarantee fairness to all players, but this removed the hidden information and therefore much of the challenge. It simply became a race to grab resources. This is true of many real-time strategy games at the moment: they're not significantly improved by being multiplayer.

From those who play your games, what seem to be the strengths and weaknesses of multiplayer environments over single-player games (and vice versa)?

W. SPECTOR: The multiplayer patch for *Deus Ex* on the PC was an experiment—a way to see if our character development/experience differentiating gameplay ideas would translate to the multiplayer space.

Turns out, the ideas worked well in that context and, while we have no immediate plans to make a multiplayer game, it wouldn't surprise me if we moved in that direction at some point. And I'm now confident that we could make that leap relatively easily, if we chose to.

R. BARTLE: The strength of a multiplayer environment is its players. The weakness of a multiplayer environment is its players. For single-player environments, substitute "lack of players" for "players."

G. WALTON: The strengths really revolve around the relationships they form with other players and the realization that the world is populated with thousands of other real people. The weaknesses mostly seem like growing pains of a new medium to me. As we learn to design more appropriately for the medium and audience, and overcome some of the technical and quality issues, we can overcome all the currently apparent weaknesses, in my opinion.

M. FIROR: The short answer is, "community, community, community." The great strength of online games is giving gamers a place where they can feel comfortable, a place where they want to spend their free time exploring with their friends. The weaknesses of online games boil down to a few hurdles that will have to be overcome soon: for online RPGs, you must be able to type relatively quickly, for that is how you communicate with other players in the game. In addition, online RPGs (although not necessarily) tend to be complex games that require many hours to become familiar with. This is sometimes too daunting for the average gamer.

T. STRAND: The single player experience is still superior in controlling your immersion. Because the environment is completely controlled by the designer, tailored to a single player, the story being told will have few unaccounted holes and fallouts. In an online game, on the other hand, stories tend to be created by the players themselves to entertain their peers or emerge by themselves from the interaction between players. In *The Longest Journey*, your avatar is taken on a journey, tailored from beginning to end. There are very few strays from the path, since the world outside the scripted environment is empty. The character can never get there. In *Anarchy Online*, in contrast, the story is not directly experienced through the gameplay. The MMO gameplay becomes open ended and virtually impossible to script. Because there are so many actors in your story, it is extremely hard to tell it from a singular perspective.

G. DEVINE: Mostly I don't like to play with strangers online, and many worlds only really allow you to play with strangers. Skill levels become an issue; say I play for 16 hours a day and my friend plays for 8, then I'll advance quicker than he does and play will become frustrating for both parties.

There are many issues.

K. MCCANN: I feel the biggest strength of multiplayer games comes through the community aspect. Forming friendships and guilds is a powerful thing. I know many people who have played online games well after they were bored with the game itself because of their friendships and affiliations.

Single-player games benefit from just being able to deliver a solid story that the player can play through at his or her own pace. If they're getting tired, they can just save and come back later.

In an online game, a major event might happen on a Wednesday night, and not all players can make it. Likewise, a player might be on a really cool quest, but the player's really tired and needs to log out to get sleep—so the quest continues and possibly finishes while the player is gone.

Effectively, a single-player game allows the player to look into virtually all of the content that the game might offer. In a multiplayer game, it's not necessarily the same—the player might miss major events due to time conflicts or not knowing they're happening, that sort of thing.

MEANING OF "MULTIPLAYER" FOR GAME DESIGNERS

How does single-player game design differ from designing online-only environments? Are there aspects (besides technical limitations) a designer has to take into consideration when only designing for multiplayer experiences?

W. SPECTOR: Single-player gaming and multiplayer gaming are cousins, but that's about all, really. I've often argued with Raphael Koster and other online adherents about whether what they do for a living even qualifies as making games! We don't even speak the same language, a lot of the time.

R. BARTLE: The process of design doesn't differ at all—game design is game design. Online-only games tend to have more designers on staff than most offline games do, but not more than the biggest offline games (e.g., *Baldur's Gate*).

Yeah, I know, that's not what you were asking. What you actually wanted to know was whether the designs of online games differ from the designs of offline games in any significant way. Well, yes, they do: player balance. Players want to play in different ways, and the game design must make efforts to accommodate their contrasting approaches without spoiling the experience for any of them.

In a single-player game, I might be given the choice of playing an elf, a dwarf, or a human. I choose an elf, because I look at the stats and see that elves are far better at missile weapons than the other two are, yet only slightly worse at melee combat than dwarfs and only slightly worse at magic than humans.

In a multiplayer game, I make the same choice. Hey, it'll be fun to get together a party with some humans and dwarfs and go clean out a nest of undead. Well yes, it would be, except that I find that half of the other people there have chosen to play an elf for the same reason as I did, and the rest have chosen to play an elf because they identify with elves' spiritual nature. Every player in the entire game is an elf!

This is bad. People like to be different, to be individuals; if they're indistinguishable from one another, it can be very frustrating. A party of identical characters means everyone wants to do identical things, which causes friction. A mystical elf in tune with the forces of nature isn't quite so mystical when everyone else is exactly the same.

Player balance is the process of ensuring that players can follow different career paths and undertake different roles without suffering either individually or (the hard one) collectively as a result.

G. WALTON: There is a huge amount of things that an online-only game must be take into account that a single player game would not. How will the gaming environment react when there are 1, 10, 100, 1000, or 10,000 people in it from a gameplay perspective is a question a single-player game never has to answer. How can players moderate their chat experience (no chat in single-player games)? How will we ensure that we don't leave any ways within our design to cheat or hack the game (no one cares if a single-player game is hackable or can be cheated)? In the same vein, how will we ensure that we have systems that don't allow players to cheat each other? My experience is that it is at least 10 times more complicated to design an online-only game as it is a single-player game due to these and many other questions.

C. CRAWFORD: The biggest difference here lies in the need for believable AI in a single-player environment. Designers have yet to come up with good AI for most games, even simple shoot-em-ups. With a multiplayer game, you skip that problem: your players provide the AI.

M. FIROR: I'm not experienced in designing single-player games; up until now, I've concentrated solely on multiplayer. However, I know from talking with single-user game developers that designing multiuser games has some significant differences from single-user ones. First and foremost, with multiplayer games you have to have a server component that stores all player data and handles positional updates, as well as serving as the governor of game rules. With single-user games, you don't have to worry about being in an open environment—you can control how the player interacts with the game environment almost totally. In multiplayer, the player is interacting with the game as well as with other players, and this human element is what makes it difficult to foresee all possible design scenarios.

T. STRAND: In a single-player game, the designer can envision in her mind how the game is played from the player's perspective. As you introduce more players, the number of possible cases the players might encounter grows to proportions so that the designer can no longer keep the perspective. Where do you place the balance between the player-versus-environment interaction and the player-versus-player

interaction? If one player can disrupt another player's interaction with the environment, he will also effectively alter the game experience of that player. Giving freedom of movement and action comes with a price. Features intended for players to help each other might end up being used to cause grief by malicious players with a sole purpose of disrupting other players' gameplay experience. This is something you never have to consider in a single-player or a single-purpose multiplayer game like the traditional shoot-em-ups.

G. DEVINE: Oh yes, two completely different game designs. In a single-player game, the AI has to play all the other roles, and deal with only one human. It's almost the other way around in the multiplayer world. Moreover, and perhaps more importantly, a single-player game can be designed in a fairly linear manner (level 1, level 2, etc.), while a multiplayer game will have a hard time achieving this (notable exceptions are *Diablo*, *Gauntlet*, etc.).

K. MCCANN: In single-player games, it's the player versus the environment. The social aspect doesn't need to be worked on. And again, it's easier to tell a story in a single-player game.

Designing a massively multiplayer online game brings a lot of extra baggage with it. The social aspect needs to be developed as much as possible. Then there's the "grief" potential that needs to be addressed—making sure that players can't cheat or really harm another player's enjoyment. And that is a huge task. In single-player games, if a player cheats, big deal—it doesn't affect anyone else. If the player harasses an NPC, so what—it's a single-player game. In a multiplayer game, if the player cheats, it is very big deal—whether it's advancing a character faster than others (in an RPG), or killing other players (such as in a first-person shooter). Players do not tolerate this, and aim their frustration at the game company, not so much at the cheaters themselves. Subsequently it's imperative to be proactive during design to look for potential loopholes where players might be able to grief other players, advance through means that aren't wanted, among many other things.

E. ADAMS: Single-player game design includes designing some type of artificial opponent, unless the game is (like *Sim City*, etc.) in a genre that doesn't have an opponent. If you're designing a multiplayer-only experience, you typically don't have to create an artificial opponent because the players provide that for you. On the other hand, you do have to include social mechanisms that people expect from multi-

player games: chat facilities, a bulletin board, high-score tables, a player-matching service if it's not a massively multiplayer game, and so on and so on. Most of these are outside the game proper. However, if it's persistent world, then you need social facilities within the game itself as well: mechanisms for creating clans, sending messages within the game context, perhaps voting or otherwise exercising democratic functions if the game allows that.

What is the biggest challenge for the designer of multiplayer online environments?

W. SPECTOR: I'd imagine the biggest challenge is finding a way to reward frequent users without penalizing casual players while making everyone feel like the central character in an engaging drama. Talk about a challenge! Wow!

Related to that, I'd guess the next biggest problem would be making sure that powerful players don't (a) prey on weaker ones, or (b) have all the fun! There are all sorts of issues revolving around in-game economies and storytelling, and a hundred other Big Knotty Problems!

G. WALTON: Ensuring that your game mechanics serve forming social bonds within the game, more than being an end to themselves. After all, very few game mechanics can hold up for years and thousands of hours of play.

M. FIROR: Without question, the biggest challenge in creating multiplayer online games is trying to outguess the players of the game—which after long experience I'm sorry to say is impossible. No matter how bulletproof you make a design, there are legions of fans out there who can find a way to exploit it.

T. STRAND: The absolute biggest challenge to the designer is designing mechanisms to control the flow of people within the world. Mechanisms for creating content in such a way that the players will themselves want to distribute over the game world is a huge challenge.

G. DEVINE: You've got to think new. Sure, you could go out and copy *Everquest*, but there is *so* much else yet to be done that can add much, much more to the environment. Use the brain, Luke.

K. MCCANN: To me, the persistent aspect is the biggest challenge. To make the game feel like it's continuing, that it's not static. Again, one primary form of this generally comes in the form of character

advancement, which can be advancing in level, or trade skill sets, professional advancement, or all of these. And while character advancement is a common aspect of single-player games too, it has a more persistent value in online games because the player isn't just seeing him or herself advance, but a lot of other friends and players, making it feel more persistent.

But that's not enough to really achieve a feeling of persistence. Persistence is generally introduced via retention (adding more content after release), and expansion packs (retail additions to the existing game).

E. ADAMS: The single biggest challenge is finding and closing loopholes that allow players to cheat in some way. The definition of "cheat" is a bit vague, of course. Some types of cheating, like hacking the code or the data transfer protocol, are direct and overt; others, like player-killing of newbies, is allowed but frowned upon by some games. Still others, like exploiting bugs in the software, aren't really cheating but are definitely undesirable behavior. The one thing you can be sure of is that if you have left a loophole of some kind that allows players to obtain an advantage, they will exploit it ruthlessly, even if it's not very much fun. It's almost impossible to imagine all the things that players will think of to try, which is one of the reasons why it's good to have extensive beta testing of multiplayer environments.

How would you personally define a game community? What are potentials, risks, and requirements to consider when designing for a virtual society?

W. SPECTOR: A "game community" can be the people participating in the shared experience of a massively multiplayer world. However, from my perspective, as a developer of single-player games, community has to encompass the fans of the game who express their enthusiasm not only through play but through building their own content to extend the game experience, through commenting on the game in online forums, through the creation of fan fiction, and so on. In the single-player sense, there aren't any significant downsides to the creation and nurturing of a fan community. In the online space, community has other connotations and probably carries more risk. I mean, you have to consider the ramifications of character selling and profiteering, of real-world bullying via ICQ, real-life interaction, and other forms of person-to-person communication outside the

game context. . . . Community is critical in multiplayer gaming—without the community, there's literally no game—but managing the community has to be a nightmare.

R. BARTLE: I would define a game community as a community associated with a game.

Communities form by themselves; all a game designer can do is provide the objects about which the communities form, and give the players the necessary tools to smooth interaction between a community's members. This might well allow the general shape that a community is likely to take to be predicted, but there's no certainty that things will develop as the designer might hope.

Game design is all about presenting choices to players. You can either force a choice, or present an opportunity. Some game designers like to make players' minds up for them, and some players like having their minds made up for them; if you're one of those designers, how you arrange the construction of a community is an important design decision.

I, however, am not that kind of designer. I prefer to present players with options, but whether they take them or not is their decision. If they want to form a community, okay, well here are the tools, form one. I like players to make up their own minds, and some players like making up their own minds.

G. WALTON: Communities are defined by a sense of shared interests and purpose, so any successful game will have one (single-player or multiplayer). A vibrant, passionate, and committed community is a requirement for an online-only game, so the design must measure each element by its effect on the community. It is easy to add game mechanics that detract from community, and many stand-alone game mechanics fall into this category. Creating fun game mechanics that contribute to the formation and building of community is not something well understood at our current level of understanding.

M. FIROR: This is a complex question, and the answer could take many pages or even books. In general, though, a game community is a place where players of a single game come together on the Internet to play the game and to share their abilities among one another. The potential of these types of games is that players who communicate with one another, make friends, and feel part of something larger will play the game much longer than a person playing a single-player game will.

T. STRAND: Communities are the driving force of our everyday social lives. We are all members of a large number of communities without even thinking about it. You might be part of a chess club, sports team, and church group, or be a teacher in a school. All these have communities and subcommunities. They constantly change and merge as well as split into subcommunities when the number of people reaches a magical number.

This type of behavior is directly mapped to game communities. In a hierarchical way, the game community as a whole has no specific game affiliation, single player or multiplayer alike. It is the current fads and driving forces within the community that make it divide into subcommunities of subcommunities that eventually get focused around a single game. The community is in no way loyal to the game as they are to the gaming experience. As the game itself is only part of this experience, the community depends on the interaction of other members of the community. When the game mechanics stop meeting the growing expectations of the community, it will start to migrate or dissolve back up the hierarchical ladder. Keeping the community infatuated with your game in such a way that they strive to increase in size is the ultimate goal when designing an online game. Making community management available to the players in game gives retention in that you ground them with functionality they start to depend on. Be careful when monitoring the community to hear the voices of the silent majority as well as the vocal majority.

G. DEVINE: There are two types of communities that I identify with. The first is the overall community devoted to a single game. The second is the factions of that group, including clans, guilds, mod makers, level builders, and so forth.

I think it's best when designing the game to make the world you're designing something that could be real, and then you'll find that the community will form.

It's a bit like playing *Sim City*.

K. MCCANN: I look it as being more of a social community, period. Making sure that players can't be actively harassed so that enjoyment is impaired is a big thing. Things like profanity filter options are essential, but there's still a ton of ways to harass other players. In an online game, the players themselves tend to be bolder in what they say and how they act because they're behind their characters. That said, the vast majority of players behave pretty well.

E. ADAMS: Well, I would call a "game community" that group of people who have a common interest in a game, a shared sense of involvement with it, and a desire to interact with other people who feel the same way. It doesn't have to be a virtual society, or anything to do with computers at all; there is a community of chess players, for example.

If by "virtual society" you mean the society in a persistent world, then I think your greatest requirement is to establish, make clear, and enforce some type of system of ethics and justice. A game world is a fantasy world, and most of them involve a lot of fantasy elements: "fighting" and "killing," for example. However, how far are we prepared to take these fantasy activities, and what are we willing to allow people to do? Can they betray friends and attack their own side in war? Can they "get married?" Once they've gotten married, can they engage in domestic violence? Can they cheat and steal? If Player A promises Player B to do something in exchange for money, and then doesn't do it, is that just the breaks, or is it a violation of the rules? In *Monopoly,* if you sell someone a property and then refuse to hand over the deed after accepting the cash, we would all agree that that's unfair, even though that possibility isn't explicitly covered in the rules. But people expect computer games to enforce rules automatically, and they tend to assume that anything that isn't prohibited is permitted. It's therefore up to you to think hard about what is and isn't permitted in your virtual society, and what you're going to do about it.

Are there any types of characters/locations/game objectives that fit better (or solely) to multiplayer online games than to single-player experiences? Vice versa?

W. SPECTOR: Anything involving a storyline is better served in a single-player space, where the developer can mandate that the player be the star of the show. Other than that, the trappings of gaming—character, geometry, etc.—seem like they'd translate between the two forms without any trouble.

R. BARTLE: Of course there are! There are many, many differences—it's a completely different medium. Virtual worlds are places; single-player games are events. Just because you use computers for both doesn't

make them the same, any more than air traffic controllers are same as DJs because they both wear headphones and use radios.

G. WALTON: My experience is that rules-based virtual worlds work best in online only, but this doesn't mean it is the only way to success. The stronger the players identify with their persona in an online game, the more likely they are to enjoy the experience and become long-term subscribers is another thing I've noticed. Games that reward player devotion over innate human skill seem to be more accessible also.

C. CRAWFORD: There is one important factor that I can identify. In a single-player game, you can give the player special capabilities unavailable to the computer-driven players. This is not the case in multiplayer games; there must be a rough egalitarianism. This in turn limits the capability of any single player to influence the overall system. This can be frustrating for many players.

M. FIROR: There are no hard-and-fast rules to this; it's up to game designers to come up with new and innovative ways of erasing the line between online and single-player games. Games that are slower paced and can be "paused" generally have to be single player, but other than that, there's not too much else that can't be done.

T. STRAND: The environment in single-player games versus multiplayer games can be virtually identical. Multiplayer games in themselves contain single-player experiences, but single-player games cannot include game objectives that include other players. All the gameplay experiences can be simulated cross platform, so with good enough simulations, the two types of games would be indistinguishable. There is still some way before game AI will rival that of human interaction. Many are drawn toward online games today because of the interaction and the challenge in fighting human opponents. Some players only thrive on this even in environments where the player versus player combat is not the main focus, causing grief among the population of non-killers. Conclusion is then that most characters, locations, and game objectives can be and are used across the two, except the direct human-to-human interactions.

K. MCCANN: There are many things that can be done in both. For example, a single-player RPG might allow the player to have a party of six characters. To successfully defeat creatures, the player might need to balance out his party—a couple warriors, an archer, a couple offensive magicians, and a healer. In an online RPG, there are often simi-

lar scenarios where this same template is needed to defeat creatures, except now every character has a different player behind it.

E. ADAMS: Single-player experiences allow intricate storylines with plot twists and surprises. Multiplayer experiences simply don't, unless all the players discover it at once. The minute the first player discovers a plot twist, it'll be broadcast on Usenet or a fan site, and all surprise will be gone.

Because persistent worlds allow players to, in effect, live out their own stories, they have more freedom to create and role-play characters of their own choosing. Single-player games tend to force players into a particular character type or role as required by the plot; usually a hero of some sort. *Baldur's Gate* allowed the player to be male or female, good or evil, but the only way to get through the game was by fighting. In addition, of course, persistent worlds offer all the kinds of things that you can do when interacting with real people, from gossip to gambling to commerce to cybersex. Persistent worlds have the potential to offer players experiences that single-player games can't, because we can't (yet) simulate real people well.

Many games offer both solo play and (added value) multiplayer functionality. Is it possible, in your opinion, to combine both multiplayer and single-player experiences within a single game in a satisfying manner? Or do you see the need for "exclusive design" focused only on a single design aspect?

W. SPECTOR: Any time you try to do more than one thing well, you run the risk of not doing anything well. . . Having said that, it would certainly be nice to allow players to experience a game alone or in small groups. Tough, tough problem, though, and one that's only been solved, I think, in games where the illusion of interactivity far outweighed the reality. . .

R. BARTLE: I believe it is possible, yes, for certain definitions of the word *game*. Unless it's absolutely trivial, the experience you get playing under a single set of rules is different depending on whether you're playing against/with a computer or against/with another person. Strictly speaking, it's the same game, just a different opposition. However, from a player's perspective, the strategies that must be employed to become successful are hugely different; it "feels" like another game.

So is it the same game? Well, yes and no. The rules are the same, but the play is different. I see no real reason why a game that is to be played both multi- and single player could not be written such that it was satisfying to players in both cases. However, the nature of the players' satisfaction would be different for each mode.

G. WALTON: I believe it is possible to combine an online and single-player gaming experience, although there are few extent examples. I think we will see this as a standard by two generations beyond the current massively multiplayer games (about 2004–2005).

C. CRAWFORD: It is very difficult to combine single-player capability with multiplayer capability and achieve high-quality design in both portions of the game. A good single-player game gives the player lots of power; a good multiplayer game spreads the power over many players. A good multiplayer game requires effective cooperation among the players; a good single-player game does not require such cooperation. It can be possible, however, to design a game that has different scenarios for single-player and multiplayer use. For example, a shoot-em-up could have a single player face only a hundred charging monsters, where a multiplayer game might have a thousand charging monsters.

M. FIROR: Yes, the success of games like *Diablo* and the near-infinite number of *Half-Life* mods show that a single-user game can also be great multiuser games. The major problem that game developers have run into so far with these hybrid games is making them stable and hack-free. It is difficult to create an online game that can withstand the many hack attempts that will undoubtedly occur—sometimes the hybrid games have not done a good job of anticipating client-side hacks. I think that this will change, though, in the near future, and hybrids will be just as stable and hack-free (as much as can be expected) as online-only games.

T. STRAND: Many of the top first-person shooters that once started out as single-player experiences with multiplayer add-ons are now exclusively designed for multiplayer action. It is possible to combine multiplayer and single-player experiences within a single design, and you will see that more and more multiplayer games will aim to make the single-player experience become available to more players at once in a cooperative setting rather than a purely competitive setting.

G. DEVINE: Oh yeah, it's possible to design for both. There's always a bit of a tendency to favor one or the other during the production

process, but a good development team knows balance and the value of producing both a strong single-player game and online experience. Look at *Diablo, Quake 2, Command & Conquer*, etc.

K. MCCANN: Yes, it's certainly possible—games have done this. But that said, it's how the two are combined that's the question. For example, in a first-person shooter such as *Half-Life*, there was a solid single-player game, and the multiplayer component was the modding aspect of it (*Team Fortress Classic, Counter-Strike*, and many others). However, the multiplayer component was separate from the single-player game—not cooperative play through the single-player game. If cooperative play is a multiplayer component of a single-player game, then it's really important to design this into the single-player experience. For example, if there's a door that closes behind a player at some point, never to open again, that's fine in single-player. But now if you're playing cooperatively, and one player steps through first, the door closes, and now the other player is trapped on the other side and can't enter. I know that's really a basic example, but with involved puzzles, it can much more difficult in designing a single-player game that has cooperative mode as well.

E. ADAMS: It's possible to create multiplayer and single-player experiences satisfactorily in a single game, *provided* that the design of the game is such that the nature of the experience is enjoyable either way; that is, the game does not depend so heavily on the features of single-player play that it doesn't work well as a multiplayer game, and vice versa. At first glance this might sound like a tautology. But the trick is to discover whether such games exist, and how to design them.

We can rule out certain genres immediately. Adventure games can't be made multiplayer, at least, not without losing their plot. Construction and management simulations, or god games in which the essence of the game is exercising power over the whole game universe, can't either unless you give up the universality of the player's control.

War games, on the other hand, are especially amenable to either single-player or multiplayer game designs. I think the success of the *Warcraft* and *Command & Conquer* series demonstrates this pretty clearly. For one thing, in a war game the player's role can be scaled to any level from an individual soldier to a general commanding entire armies, and that enables us to create games in which players can play alone or in groups of nearly any size. For another, we're moderately

good at creating artificial opponents in war games. We can't include the element of surprise or psychological operations very well, but single-player war games are still great fun. War games don't usually have a large social component, so the fact that single-player games don't implement this well doesn't hurt them much.

Half-Life also demonstrates that first-person shooters are also very amenable to both single- and multiplayer play, and the inclusion of both in a single game doesn't do it any harm.

THE FUTURE OF MULTIPLAYER ONLINE GAMES

The gaining popularity of persistent-state massively multiplayer environments raises the question of how many of these games the market can simultaneously support. What will be the key in developing and designing "this single" game of choice in such a scenario?

W. SPECTOR: Certainly, the MMPG market is getting crowded. And once players invest their time and money in one of those games, getting them to switch is probably a difficult thing to do. The way I see it, the next big leap for MMPs is to break out of the hardcore market—I mean, *Ultima Online, Everquest, Asheron's Call?* Where's the mass-market property? They're still appealing to the D&D crowd... And to attract "civilians," MMP makers are going to have to look to licenses, I think. *Star Wars... Star Trek... Lord of the Rings... Harry Potter...* Game developers have to go where the market is, with content ordinary people already want. We're not big enough to create a mass-market property in the MMP space.

R. BARTLE: Dumb luck. The market is going to expand, so even though these games are really sticky (i.e., you have a terrible job inducing people to leave the one they're currently playing in order to join yours), there's still plenty of opportunity for newcomers to carve out a niche. Anyone who makes the attempt is in with a chance.

And chance might be what decides it. No matter how good your design, your license, your game, your graphics, your support, your marketing, or your experience, you can't beat being in the right place at the right time. You can improve your chance of success by doing things right, of course, but just because yours is the Manchester United of online games doesn't mean that someone else's non-league

side can't come along and beat you—and there are a lot of non-league sides out there at the moment.

G. WALTON: Well, I'm not sure we want a single game of choice. Diversity in consumer choice of gaming entertainment is critical to market growth. I do believe we need PSWs in a lot more topics than we currently see, and that there will be dozens of successful games, in dozens of categories, by the end of this decade. The keys to reaching the broadest market in gaming are the same as those for other entertainment media. In the simplest terms: pick a topic that can appeal to broad and diverse audience, make a high quality product, ensure that it is accessible to that audience, and promote the heck out of it.

M. FIROR: If I knew the answer to that, I'd be out doing it! Seriously, there are so many different qualities that go into making a dominant online game that it is difficult to put all of them together—and, of course, no one can agree on what all the different factors are, much less put them all in one title. The goal is to make a compelling game that takes place in a game world that players can feel comfortable in—a world that keeps expanding and adding new content to keep long-time players of the game interested.

T. STRAND: These games all take an immense amount of time to play. Time is also what we essentially compete for. The market is still large enough if you measure in time units of more MMOG, but it is craving for more variation. Currently, all the MMORPGs are focused on the constant experience drive. Killing enemies stands for 90 percent of the gameplay experience. I predict that we will see more niche products in the next couple of years. Games that focus on a smaller segment of the market will be needed to drive people away from the major competitors. With these focused gameplay experiences, you might not have a single game of choice but a series of games to fulfill your gaming and social needs.

G. DEVINE: Well, I think there's room for lots of these games. My version of the single game would be quite different from what's out there right now. It might succeed or fail. But my preference is more along the lines of providing a holo-deck for a few rather than the many.

K. MCCANN: Currently, the number of massively multiplayer games coming out is exceeding the growth rate of the player base. Each new offering doesn't magically make 500,000 new customers to the massively multiplayer demographic. This said, it is growing steadily, but it can definitely be likened to the movie industry—these games

cost a lot of money to make and support, and a development house requires a big studio behind it to finance. This is not something that a small team of developers can really pull off now.

The current successful MMO games are in the fortunate area to having branded their names for future releases (expansion packs and sequels). This is another hurdle for an outside company to overcome with a fresh title. And now there are some very large licenses coming into play—*World of Warcraft*, *Star Wars Galaxies*—again, another obstacle for a development house new to the MMO market.

As of right now, the biggest market to have been somewhat saturated is MMO role-playing games. This gives an advantage to MMO games in development that aren't in this genre. First-person shooters, real-time strategy, and so on. But again, there are only so many genres.

With that stated, designing a stand-out product to get attention is definitely a challenge. One really important note as a designer in this industry is to be absolutely sure you play the competitor's products. Designers need to keep an open mind. A lot of design is emulation and improvement—not revolutionary steps forward. I'm not saying copy a competitor by any means—but by playing their games and studying them (yeah, this is the fun part usually) you'll see what they did right, see what they did wrong, how they fixed things that went wrong (or didn't), and so on. If a designer shelters him or herself from competitor's products and is making a similar genre game, he or she is bound to repeat mistakes that already happened in the competitor's product—mistakes that could have been prevented if it had been played by the designer.

Now onto the design aspect, the lead designer should really feel comfortable with the genre. This shouldn't be a huge first-person shooter fan who's never touched a real-time strategy game working on a real-time strategy MMO game. Familiarity with the genre is essential—it should be second nature to the designer. This way, the designer should have a pretty good idea of what the audience likes and dislikes because he or she is part of that audience. And familiarity with the market breeds innovation, not direct emulation or stagnation.

From here, the designer needs to clearly establish the vision, the key components of the vision, and carry these into a design document. Out of all aspects of design, the one thing that should never

change is the vision– this is the foundation and should be what every-
thing else is built upon. It sounds generic, but if the vision changes, so
does most of the accompanying design, and generally not in a good
way. The framework of the design should also do its best to support
retention after release—both in the form of content updates as well as
expansion packs. If the designer doesn't make the game design so
that it's flexible post-release, it will stagnate.

E. ADAMS: The key is creating a broad and continuing appeal. Right now,
most MMORPGs appeal chiefly to people who want to play role-
playing games set in quasi-medieval fantasy worlds. We need to
branch out from that, to offer people new things to do and new places
in which to do them. That will attract a broader base of players.

Continuing appeal is the other requirement. A multiplayer envi-
ronment must not only attract people, but keep them. Character
growth in a purely numerical sense—building up statistics and pos-
sessions—will work for a time, but after a while it becomes too repet-
itive. In order to keep players for longer, the world needs new areas to
explore and new global events to change the environment: either the
physical environment or the social environment. For example, a
world could suddenly be invaded by hostile peoples from outside (as
Europe was by the Huns), or it could enter an Ice Age and have its
economy severely disrupted.

*Do you think that the typically very time-consuming persistent-state environ-
ments have the potential to appeal to a general (mass) audience, or will they
stay mainly hardcore-gamer oriented? What do you think about possible other
uses of such virtual worlds besides entertainment purposes (e.g., education, sci-
entific laboratories, etc.)?*

W. SPECTOR: Until and unless someone finds the right pre-existing, pre-
sold, mass-market property and implements a game that *doesn't* re-
quire a life online, time-wise, MMPs are hardcore, niche products.
Profitable? Sure. But niche. . .

As far as other uses go, you have to think there are dramatic lan-
guage-learning possibilities. And with the right content, you could
probably learn a lot about foreign cultures, military tactics, and a host
of other things.

R. BARTLE: Of course they'll appeal to a wider audience! We're seeing it al-
ready. This is already something being recognized by developers. The

newer games that are out or that are coming out are being designed with the mass market in mind. There's no general reason why hardcore gamers wouldn't want to play these too, if they're designed right, but if some are not to their tastes for other reasons (e.g., they're pornographic), then I'm sure the hardcore gamers will find plenty of other virtual worlds to choose from.

As for other uses, sure—again, we're already seeing this. There are a number of educational MUDs out there, along with others for things like counseling, storytelling, and commerce. I do expect that entertainment is always going to be the driving force, though.

G. WALTON: One of the biggest challenges for persistent world entertainment designers is to figure out how to deliver a compelling entertainment experience that works as well at 2 hours a week as it does at 20 hours a week. The amount of time the current PSWs take dramatically limit their potential market appeal in my opinion. I think there will continue to be a place for games that require a significant amount of time, but a truly mass-market experience must allow for less player participation.

C. CRAWFORD: These are definitely hardcore games, as they require a commitment of time far greater than most people are willing to make. Persistent-state virtual social environments could have value in training social skills.

M. FIROR: There is a perception right now that you have to play online RPGs for hours a day in order for your character to be "useful." This is not necessarily the case, although your character will advance slowly if you play far less often than the more hardcore players. Just like life, the more time you put into something, the better you get, although you can be patient and spread your playing time out over a longer period.

Online game technology has great potential for uses other than games. I'm sure that with minimal modifications, it can be used for military tactical training. Eventually, of course, given enough time and art resources, the education aspects of these types of games is very strong—you could quite easily make a walk-through tour of ancient Rome for a history classroom, or recreate the battle of Waterloo with students in the roles of the generals directing the action.

T. STRAND: The time-consuming nature of these games automatically cuts away a large portion of the mass market. The general public has better things to do than play games all day. They want to play games for

a limited period of time and be entertained 100 percent of the time while doing so. Extended periods of gameplay require a sin/cos wave of entertainment in order to not create an overload and boredom. The non-hardcore player in her short game sessions needs only the entertainment peaks. MMORPGs will to a large degree stay hardcore in the same way as today unless major genre changes are introduced.

There are many uses for this technology in all workplace, school, and military simulations. Students cooperating within a multiplayer environment to learn about physics, programming, or chemistry should be no problem. The problem usually lies in the game industry's interest in using the limited funds of the education community. A military simulation, on the other hand, is something I foresee will be reality within five years using game engines. Multinational training exercises simulated and enacted by thousands of soldiers over the Internet will not only save billions of dollars, but will give the soldiers a clear overview of the operation and a much higher chance in real life when forced to re-enact in a war scenario.

G. DEVINE: When we stop having so many stats to track and start just having fun, then yes, we'll get more mass market.

K. MCCANN: I certainly feel they have the potential to appeal to mass audience. I don't consider a lot of players hardcore in online games right now to be the traditional hardcore gamers. These are casual gamers who are finding the online game experience. And this will be steadily growing in the future.

E. ADAMS: As the question intimates, the key difference between hardcore gamers and the mass audience is the amount of time (and to a lesser extent, money) that they're prepared to devote to game playing. Persistent-state environments can certainly appeal to a mass audience if they don't demand too much time from them. An environment that lets a player dip in for a few minutes every two or three days, and still have a highly enjoyable time, would certainly do well. Part of the problem is that we're designing these worlds with core gamers in mind, and rewarding very intensive play. This isn't sound economics: the longer a customer is online, the more money it costs us as providers. Now that we're charging people a monthly subscription fee rather than a per-minute rate, it makes sense to design games that don't require so much customer time.

For massively multiplayer-only games, the traditional retail client/monthly subscription revenue model seems to work the best. Do you assume that this business/distribution model will be the future standard, or is there still room to consider alternatives?

R. BARTLE: There is always room for alternatives. Experimental business models involving the use of real-world money to buy in-game objects are already under way, for example. In Korea, people play their massively multiplayer games subscription free at Cybercafes, that take out site subscriptions to encourage people to come inside and rent an Internet terminal for an evening. For the mass market, though, at the moment, the monthly subscription fee is the only method most people are prepared to accept. When micro-payments come along, who knows, but until they do there is still the problem that people feel they've "paid" their ISP for their Internet access and that everything that happens afterwards ought to be free. As reality dawns, this attitude is changing, but whether it will change enough to make other business models for massively multiplayer games acceptable remains to be seen.

G. WALTON: I do believe that the subscription model is the primary model for this medium, as it fully rewards creation of value and supports the ongoing costs involved. While retail distribution is currently required for success, this will not always be the case. We need the ability to offer a sample experience to potential players, because without this capability we cannot take full advantage of one of the great strengths of the Web, viral marketing. Deeper broadband penetration would help us with sampling significantly.

C. CRAWFORD: For the current class of games designed for aficionados, this is the best approach. Inasmuch as there is little likelihood of expanding the industry out of the hardcore gamers, this model will likely remain the best available.

M. FIROR: There's always room for alternatives; quite possibly, the best model has yet to be developed. So far, selling the game in stores, and then charging per month seems to be the most popular way—it certainly worked for *Dark Age of Camelot*. However, I'm sure there will come a time when cheap, large-bandwidth Internet connections are available to everyone and games will start to be sold per download.

T. STRAND: Bold actors in the market will introduce business models other than the traditional monthly subscription. The monthly sub-

scription model is the one that works best now, covering up for lack of content. Player will log out when the content is exhausted and come back another day since they already paid for the whole month (or six) anyway.

As for distribution, I believe that more and more will move away from traditional retail toward a download-only model. This approach becomes even more interesting with the expansion of broadband.

G. DEVINE: Well, the whole world is moving to this. I suspect before long, you'll be able to buy a regular toy that has a monthly subscription. Subscriptions mean control. And businesses like to control.

K. MCCANN: I definitely believe this will continue as a business standard. I view it as the premium cable TV model—basically, you pay per channel. There are many associated costs with running a massively multiplayer game, and therefore pay-to-play subscription models make sense. Now as companies begin offering more and more online products, they'll naturally start special "package" pricing, where they let you play some or all of their games for a set discounted price (just like getting an HBO package versus paying for all of the channels individually).

E. ADAMS: There's definitely still room for alternatives. We don't yet have the technology to collect "micro-payments" conveniently—fractions of a cent per transaction, without needing to record the customer's name and personal details—but once we have that, it will enable much more efficient pay-as-you-go gameplay. There are times when I don't want to have to subscribe to something for a month; I want to try it out for a few minutes or for a few days.

How will widely available broadband and high-speed Internet connectivity shape the computer gaming market? Will such a scenario change the nature of computer games or demands on their designs?

W. SPECTOR: I think it's inevitable that some portion of the games market will turn to downloadable content that takes the place of a trip to the software store and the purchase of a boxed game.

R. BARTLE: The first impact will be that games will suffer from terrible lag as people who use their broadband connections to download music and pornography stretch the Internet to its limits.

In terms of games design, the immediate response will be to produce bandwidth-heavy games so that people who have invested in a

broadband connection feel they're getting their money's worth. "I didn't get ADSL just so I could play games that only need a 56K modem."

After things have settled down, though, broadband will be used far more sensibly. Its main advantage in the medium term will be in passing player-generated content between individuals. Games themselves won't be sending anywhere near as much information down the pipe as they could, simply because it's too computationally expensive to generate it. That leaves plenty of bandwidth for players to send real-time speech and images to one another.

Eventually, computing power and bandwidth will be available in such quantities that generating multimedia experiences on-the-fly for tens of thousands of individuals in a virtual world will not be a problem, and then the quality of games possible (if not available!) will change immeasurably.

G. WALTON: Yes, broadband will change things, but mostly in the area of delivery of content. While there will be games developed exclusively for broadband, the vast majority of games don't need broadband to be successful from a gameplay standpoint. Getting players the client and assets would be greatly assisted by broadband, though.

M. FIROR: I'm no visionary, but it seems to me that the first advantage of widely available broadband Internet access will be in the delivery of client software, not necessarily to make changes in design or gameplay. Of course, in a truly broadband environment you can have voice and video transmission, which will realize the next large step in online gaming.

T. STRAND: Broadband will not change the face of gaming that much. The problem is usually not the bandwidth on the player side but on the server side. On ECTS two years ago we ran eight clients of *Anarchy Online* on a double ISDN line. Bandwidth is a large server cost for these games and will continue to limit the amount of data the providers for these games are willing to send out. Broadband will, however, change distribution. More and more content and products will be available online only.

G. DEVINE: Well, it will mean we will compete with more mass entertainment movies, music, etc.. Generally, everything else is a technical change. 2D worlds become 3D. 3D worlds become less barren.

K. MCCANN: These allow for a couple of things—first, larger retention packages that can be auto-patched. Second, they allow for more

twitch-based games, such as first-person shooters. The lower a player's ping in a first-person shooter, the better, so action games really benefit from higher-speed Internet connects. RPGs tend to be more character-skill based than twitch based, but they'll still benefit from higher-speed Internet connectivity as well.

E. ADAMS: Yes, broadband will change the nature of computer games, and by implication their designs, in a similar way to the way that the CD-ROM changed games. The ability to deliver hundreds of megabytes of content on a single CD changed games dramatically and permanently. The ability to exchange hundreds of megabytes of data in the course of a game session will change them dramatically and permanently again.

Broadband will also allow for electronic distribution, which will have a significant effect on the market. When games don't have to go through retail channels, there will be room for a lot more variety.

UNDERSTANDING OF (MULTIPLAYER ONLINE) COMPUTER GAMES

Would you describe computer games in general in terms of media, and what does this medium primarily offer that is unique compared to more traditional media?

W. SPECTOR: The one thing that sets us apart from other media is that we turn users into creators. We collaborate with our users in ways that are unique. That's the magic of gaming. . .

R. BARTLE: I would describe computer games in terms of media, yes. As for what the medium offers, well, it depends on whether you mean single player or (massively) multiplayer—the two are different.

In multiplayer games, it offers you the chance to be someone you're not; I don't mean to "identify with" or "feel as if you're" or "act the part of" someone you're not, I mean to be someone you're not. Absolutely no other medium allows this. There are other effects that follow on from this, some of which might be more important to individuals than the root cause (for example, the ability to participate in a narrative, or to experience a sense of discovery). The heart of the medium, however, is that it allows you to become someone different with complete freedom.

As for single-player games, or small-scale multiplayer games, they do offer their own set of features that together qualify them as a medium in their own right, but they're not exactly unique—they're certainly nowhere near the magnitude of what massively multiplayer games offer. They can imbue a sense of achievement, a mild sense of place, an intellectual challenge and so on, but so what?

Regular computer games speak to the senses. Virtual worlds speak to the mind. Okay, so can certain other media, but, uniquely for virtual worlds, the mind can speak back.

G. WALTON: Today computer gaming is a niche hobby. The vast majority of games sell far less than a million units worldwide, so our reach into society in general is nowhere near where we need it to be. The good news is that gaming, and multiplayer gaming in particular, is quite compelling once sampled, so the opportunity exists for our medium to be huge. The primary difference we offer is entertainment that engages and immerses people at a level they rarely experience with linear mediums. Interactivity is key to this for games, while socialization and communities offer something incredibly compelling in multiplayer environments. The opportunity to take the interactive entertainment medium into the mainstream is in our hands.

M. FIROR: I often compare playing online computer games (at least online RPGs) to watching a movie, except you get to play a part in the production. The critical advantage online games have over movies, television, books, and other sorts of static media is that you can actually change what happens. In an online RPG, the story unfolds before you, but your character interacts with the environment and other online players to make his own story inside the structure of the game. Try doing that with a movie!

T. STRAND: In the early 1990s, a buzzword used almost as much as *multimedia* was *interactive TV*. Games are probably the closest you can find to interactive TV today. You control the life of an avatar within a near-realistic environment. The only thing that seems missing is the quality story direction you get from the TV media producers. The introduction of the Internet in games will take the experience of interactive TV to an even greater level once the platform matures a few years.

G. DEVINE: Ha. Well, we fit on one disc, and they all take up boards, pieces, and so forth. We're tidier when you play a board game with us than when you play one in real life.

It's a very different production process and I don't think there can be a fair comparison. It's as if we compare toys to books.

K. MCCANN: The biggest thing that computer games offer is interactivity. Traditional media is noninteractive, such as television, radio, movies, where the person just sits back and enjoys a scripted experience. In computer games, players can choose their own path, make decisions—do I save this guy from a monster or ignore it—players become the actors. The game itself is the set.

E. ADAMS: Computer games are an entertainment medium, and they belong to that class of entertainment media that is participatory, or interactive. Most entertainment media—books, movies, and television, for example—are presentational and passive. Most other forms of participatory entertainment—for example, playing amateur sports, board games, or gambling—don't have any presentational elements: they don't include any content. This is what makes computer games unique: the combination of content (pictures, sound, perhaps a storyline) and interactivity.

From a purely development standpoint (and generally irrelevant to the customer) what makes computer games unique is that they require engineering. Every computer game is a unique piece of software that requires its own engineering project. No other medium is saddled with that burden. Imagine if you had to reinvent the television for every television show! That's what happens with computer games, and it's part of why developing them is so uncertain. Engineering is problem solving, and problem solving doesn't have a timetable.

Advancing and establishing a common understanding of game design as art and science requires. . . ?

W. SPECTOR: We need a shared critical vocabulary. Until developers from one studio can talk to developers from another studio without a dictionary in hand, and until academics can talk to each other and to us in a language we all understand, we're in trouble. Also, we have to find a way to approach game design as a discipline requiring the same rigor as programming and graphics.

Right now, design can't be taught, at least not easily. That has to change.

R. BARTLE: Time. January, 2002: the UK government awards the first ever national honor to a computer games developer simply for being

nothing other than an extremely good computer games developer. Jez San is now Jeremy San, OBE (Order of the British Empire).

The computer game industry in the UK makes more money for the country than the film industry, and yet directors, cinematographers, actors, and actresses—even screenwriters—have been honored by the government for decades. Only now have they finally got around to noticing the computer games industry. It all takes time.

Computer games are currently judged by how they sell. How they sell depends on how they look, how much publicity they receive, and how well the game they're ripping off sold. The financial bottom line is the only critical aesthetic available to assess whether a game is "good" or "bad" or something in between.

Now there are plenty of reviews of computer games, and a passing glance at these might suggest that a consensus among reviewers of what makes a game good or not is emerging. Sadly, however, most of these reviews tend to be written by wannabe journalists with little sense of the scientific method and no concept whatsoever of any creative dialectic. If the graphics look cool, it needs a top-of-the-line computer to run, and its publisher is taking out two-page full-color spreads in their magazine, they're happy.

I'm not suggesting that 50 years from now people will judge computer games by a set of inaccessible criteria that only make sense if you've spent three years at St Martin's School of Art. That said, playing a game that's 20 years old won't perhaps seem as odd then as it does now, and perhaps people will appreciate those exquisite touches that at present are only noticed by other designers or by very aware and switched-on players. Give it time, it'll happen.

G. WALTON: It requires a much better understanding of how to design fun than we have right now. We are seeing a few academic institutions offering a curriculum in this area, but we have a long way to go before it is well understood. There also needs to be a lot more research into game design.

C. CRAWFORD: That game designers abandon their greed and pursue game design as a form of expression rather than a way to make money while having fun. We are very far away from this.

M. FIROR: That's one of those questions that will have to await time to truly answer. There's a big part of game design that essentially boils down to spreadsheet maintenance and formulas—obviously a kind of science. The creative aspects of game design are more elusive and

much harder to quantify. A general acceptance of design as art and science would really have to depend on the academic world embracing the idea of games and game design.

T. STRAND: In my personal opinion, an opinion that has been fought both in my own company and between other game designers is that the art of game design lies in the architecture of the game engines. Other than the absolute proven game elements, new elements must be played and tweaked and changed hundreds of times before they become art. To do this, you need a powerful and flexible architecture that enables the designers to experiment and work with trial-and-error techniques. Statistics and monitoring tools become the designer's most important tools in the design of a fun, massively multiplayer game experience.

G. DEVINE: Better representation and recognition of our industry in academic bodies. Without this, we'll continue on as we are.

K. MCCANN: Post-mortems on game design can be quite useful for this for the general public. They tend to be very summarized, and focus on the key points of what happened to the game design during the project development. These also tend to be short enough so that the public wouldn't be bored reading it, nor are they necessarily overly technical.

E. ADAMS: Game design is neither an art nor a science, it is a craft. Computer games are an art form, but they are a collaborative art form in which many people make a contribution. Game design per se is not an art, partly because the designer doesn't really have as much aesthetic freedom as a real artist requires, and partly because it has too many non-aesthetic considerations. Nor is it a science: it doesn't posit hypotheses or seek truth.

Obtaining recognition for computer games as an art form requires four things:

- We need an aesthetic, or rather a variety of aesthetics. We need a way to judge games aesthetically. We already know how to judge their graphics, music, and storyline; we also need a way to judge their gameplay and interactivity in aesthetic terms.

- We must experiment aesthetically. We must break new ground and take artistic risks, to challenge the player to achieve new forms of understanding. The Impressionist movement in painting is a good example of this: it challenged conventional notions

of what painting was for, what it was supposed to do. Great art always breaks new ground; if it does not, it is merely decoration.

- We must change our awards so that we place more emphasis on artistic merit and less on technological prowess or craft. Works of art are not rewarded based on their technical proficiency. If they are technically incompetent, they *don't* get awards, but technical competence alone is not enough. Right now, we have too many awards based on technology: best programming, best AI, best sound. Some people think that "best graphics" means graphics that are rendered at a high resolution or frame rate. That's not good graphics, that's good graphics technology. We need awards that recognize artistic talent.

- We need not merely reviewers, but critics. Right now, we don't have in-depth criticism of games; we have reviews. Reviews only compare games to other games; they don't analyze games in their larger cultural context. *Real* critics bring to their profession not just a knowledge of the medium they are discussing, but a wide reading and an understanding of aesthetics and the human condition.

I believe that once we have accomplished these four things we will begin to see public recognition for interactive entertainment as an art form.

What role will the academic world and the approach of more and more game design-specific courses play in the future of game development? Do you see any relationship between "academic" game design and the increasing significance of social design aspects for multiplayer online design?

W. SPECTOR: The academic world will assist us in creating a shared vocabulary for the discussion and criticism of games. It will help us identify a canon of important and influential games. It will bring new ways of looking at games to the table, meaning would-be developers will bring new ideas to their work, and consumers will bring new demands to the store. Education will change the landscape of the games market and the nature of the game development community, and we'll all be better off as a result.

R. BARTLE: Academics have only scratched the surface of game design, and those who have looked at it have usually done so from the point of view of some other discipline. Game design is rarely studied for its

own sake—it's as if film studies are only undertaken by artists or musicians or dramatists, rather than by people who know about movies.

Academic courses on computer games are still at the "put together a course out of bits of other courses" stage at many academic institutions. They tend to concentrate on development tools, 3D modeling, and case studies. Students will probably get a grounding in areas like AI, networking, human-computer interface, and so on, or even (if they're lucky) some drama theory or composition. However, they'll get it from people who are experts in those particular fields, which means they don't necessarily know the particular requirements of computer game design.

So, as far as academic courses on computer games go, it's nice that they exist but at the moment, they're somewhat limited. There just isn't the theory, and no way of easily proving it even if there were. Social design aspects for multiplayer online games: very nice.

Academics like bandwagons, and social scientists like them more than most (because they're social!). A social scientist discovers an area, publishes a paper; a flock of other social scientists descends to pick over the remains, then they fly off somewhere else. In the mid 1990s there was a flurry of papers about MUDs by people whose area of expertise lay in gender studies. We've also had waves of psychologists, anthropologists, sociologists, geographers, and linguists. Although doubtless the frontiers of human knowledge were advanced by this research, the progress was made in the particular field of study of the researchers concerned.

What's exciting now is that people are beginning to look at game design for its own sake. The consequences of aspects of game design on the players (and vice versa) are being described, and ideas advanced. Although this is a very young field of study, still mainly drawing its ideas from more established areas, nevertheless it is making progress on its own terms and exploring areas that more traditional research has yet to discover.

There is more to do, though; in particular, there doesn't seem to be any kind of consensus as to what moral issues are important in computer game design. Until some sense of what constitutes "right" and "wrong" in a game design, and where the boundaries between the two lie, people will still be tempted to take theories that are used in other disciplines to explain behavior and apply them to engineer it.

We live in interesting times.

G. WALTON: I believe academia will play a major role as our mediums grow. I don't know if there is a direct relationship between academic game design and multiplayer games, but there is a huge amount that can be learned from human history, sociology, and psychology that is directly applicable to online gaming.

C. CRAWFORD: So far, the academic world has had no impact on the games industry. This is changing, but I don't think that it will be a significant factor for many years. A professor of English or fine art or computer science is not necessarily competent to teach game design. Only when we have experienced game designers teaching game design will the academic world begin to have an impact. There are very, very few experienced game designers willing or able to teach.

M. FIROR: There will always be a healthy independent aspect to game development that cannot be fully understood in a classroom.

T. STRAND: Today, the availability of game designers is actually very small. It is hard to find people who are good candidates for this position. The academic world with classes and courses on game design will raise people's understanding of what the role consists of and give the students the base skills needed before they enter the workplace. I think, maybe wrongly, that the best learning of game design is through implementation in an actual development environment. You might learn the basics and the theory behind proven gameplay mechanics in school, but the hard reality of interacting with real customers is something you just need to experience.

G. DEVINE: I sure hope so! I think this will help define our industry and give it the people it needs to move to the next level. The game designers make up only a small percentage of the game development community. Producers, programmers, artists, level designers, all need to be recognized and have game-orientated skills coming into the game industry instead of learning on their first job (which is probably not very good).

K. MCCANN: I'm always partly wary of "academic" game design. While I believe there are certain fundamentals that can be taught, there are a number of ways that designers can approach games. The instructor should be open-minded too, because it's very subjective. An instructor should learn from students as well. It's similar to art in that regard.

I believe a great deal of game design is inherently learned by just playing a lot of other games, period. I've been actively gaming both on PC and console since 1982. And while for the majority of time I wasn't "taking notes to become a designer," I was learning a lot about design and game balance. Now as a professional designer I still play games to have fun, but I'm also looking to see what they did right and what they didn't, were there any cool innovations, that sort of thing.

If an academic class of game design can at least teach a designer to be more organized in the vision, outlining, and writing the design doc, great. But there needs to be a wide margin of freedom from designer to designer—it's a creative process, and how one designer might come up with an idea can be quite different from another.

E. ADAMS: As more people study game design and development in colleges before they get into the industry, it's possible that we might start to develop standard ways of working, as Hollywood has generally done. One of the problems with the industry at the moment is that game development is largely ad hoc, and no two companies go about it in quite the same way.

Game designs done in college, where there are no commercial pressures, are bound to be more creative than those done in industry. As those students move into industry, I hope we'll see that creativity come with them. At the moment, too many designers learn to design games by looking at other games that are already on the shelves. This (along with other factors) leads to a perpetuation of the same old ideas and genres.

Academic institutions are storehouses of knowledge that otherwise tends to be stored in a very inefficient way and is often lost. As soon as a company gets out of a given line of business, it tends to get rid of all the people in that line who know anything about it. If it tries to get back in, it often has to start from scratch. With respect to social-design aspects for multiplayer online games, academic research can build up a body of knowledge about the issues involved, and teach them to new students, without having to discover them the hard way: by treating the players as guinea pigs in a social experiment. Right now, all the MMORPGs are just feeling their way blindly in social design terms, because there is no body of knowledge collected anywhere, and the players are the ones to suffer from their mistakes. Academic study of computer games will help with this.

What do you think is the key to the fascination with playing computer games over a worldwide computer network?

G. WALTON: I think the immediacy of environment, the fact that your time online is very much like a live performance that you participate in that will never be repeated has a lot to do with its fascination. The fact that these virtual experiences can engage our emotions at the same level as "real" experience ensures that they will remain fascinating.

M. FIROR: For most players, it is the social aspect of online games that keeps them coming back—and the knowledge that the people they are playing with could be from anywhere in the world just adds to that mystery and sense of adventure.

T. STRAND: The key is social interaction. Interacting with players will for some time still outclass game AI. Games like *Counter-Strike* and *Unreal Tournament* give players adaptable enemies that actually teach you something and are social. Massive multiplayer environments create in-game communities and social interaction that emulate real-life social patterns.

G. DEVINE: Certainly right now it's the geek factor. You can qualify the DSL line when you shout, "Hey honey, look at this guy on the screen, he's playing from Russia!"

Going on, as I said before, I prefer to play with people I know. That is, people I know wherever they live in the world.

K. MCCANN: Initially I think part of it was just the "wow, it's cool to be playing games with people all over the world." The social aspect is key to the fascination. That's why people are playing the game in the first place. Even a player who wants to play solo typically likes having other real players around—it makes the world more alive and dynamic.

E. ADAMS: The fascination of playing over a network is fairly obvious: the ability to interact with real people in social rather than mechanical ways. The fact that it's a worldwide network is really neither here nor there. There's a certain gee-whiz factor in knowing that some of the players are in Los Angeles and some are in Ulan Bator, but in fact, the language barrier still prevents much real communication from taking place. If we were able to use these mechanisms to exchange real cultural information, that would be enormously valuable—for example, Americans could learn the social customs of the Japanese by

playing in Japanese "gamespaces" and vice versa; but in fact we don't make much effort to enable this at the moment, and there's still the language problem.

SUMMARY

Some of the previous questions were quite complex and, as mentioned, the opinions of the interviewees heavily vary at some points. This is not to our disadvantage—quite the contrary. The diversity of thoughts undoubtedly provided some additional valuable viewpoints and raised issues to think about further.

As expected, everyone's individual understanding of interactivity and how we could (possibly) facilitate and design it in our games differs greatly. Key points mentioned vary from focusing on giving creative control to players and guiding the players' emotions, to balancing challenge and usability as key in creating interactive games. We also heard about an approach to categorize interactivity in a way closely related to the way introduced in this book—social and environmental interactivity. Another interesting notion was that it could also make sense to ask ourselves as multiplayer game designers occasionally whether there are also people who do not want to interact (socially) with other human players in the first place.

Everybody agreed upon the fact that designing multiplayer online environments has its own peculiarities as compared to single-player game design. Multiplayer experiences and their designers are influenced by unexpected happenings and player behavior, as well as the possibility for players to cooperate and make new friends. Particularly, large-scale massively multiplayer games have some unique aspects the designer has to bear in mind—the limited possibility of "traditional" storytelling being a major issue. Providing persistent worlds that nonetheless allow for less time investment on the side of the player (than is usually the case with massively multiplayer online games today) is another aspect; even more, given the fact that shorter game sessions make sense from both a financial point of view and as a means of appealing to a broader audience. The designer of such persistent environments needs to ensure that a design is flexible for content updates and expansions after its initial release.

END NOTE

What all this has proven is that designing multiplayer online games is definitely a fascinating, challenging, and complex profession. For creating your future game designs and crafting the next generation of virtual multi-user game environments, these people's experiences and thoughts are undeniably very valuable—a fact that (hopefully) also holds true for *Online Game Interactivity Theory*.

BIBLIOGRAPHY AND ADDITIONAL RESOURCES

Aldersey-Williams, Hugh. "Interactivity with a Human Face." *Technology Review* 99 (1996): 34–39.

Anders, Peter. *Envisioning Cyberspace: Designing 3-D Electronic Spaces.* n.p.: McGraw-Hill Professional Publishing, 1998.

Apple Computer. *Apple Human Interface Guidelines: The Apple Desktop Interface.* Reading, MA: Addison-Wesley Publishing Company, Inc, 1987.

Baron, Jonathan. *Glory and Shame: Powerful Psychology in Multiplayer Online Games.* Proc. of Game Developers Conference, 1999.

———. *Heat into Light: Community Generating Conflict in Online Multiplayer Games.* Proc. of Game Developers Conference, 2000.

Bartle, Richard. *Interactive Multi-User Computer Games.* MUSE Ltd, British Telecom plc., 1990. 15 Mar. 2002 <ftp://ftp.lambda.moo.mud.org/pub/MOO/papers/mudreport.txt>.

Bernier, Yahn W. *Half-Life and Team Fortress Networking: Closing the Loop on Scalable Network Gaming Backend Services.* Proc. of Game Developers Conference, 2000.

Blumer, Herbert. *Symbolic Interactionism: Perspective and Method.* Englewood Cliffs, NJ: Prentice Hall, Inc. 1969.

Bordewijk, Jan L., and Ben van Kaam. "Towards a New Classification of TeleInformation Services." *Inter Media* 14 (1) (1986).

Bruckman, Amy. "Finding One's Own in Cyberspace." *Technology Review* (Jan. 1996): 48–54.

———. *Identity Workshops: Emergent Social and Psychological Phenomena in Text-Based Virtual Reality.* College of Computing, Georgia Insti-

tute of Technology, 1992. 11 Jan. 2002 <ftp://ftp.cc.gatech.edu/pub/people/asb/papers/identity-workshop.rtf>.

Burgoon, Judee K., Joseph A. Bonito, Björn Bengtsson, et al. "Testing the Interactivity Model: Communication Processes, Partner Assessments, and the Quality of Collaborative Work." *Journal of Management Information Systems* 16 (3) (2000): 33–56.

Butler, Dianne P. "MUDs as Social Learning Environments." *Imaginary Realities* 2 (8) (Aug. 1999).

Costikyan, Greg. *The Future of Online Games.* Industry Report. New York: Creative Good Inc, 1999.

Crawford, Chris. "Lessons from Computer Game Design." *The Art of Human Computer Interface Design.* Ed. Brenda Laurel. Reading, MA: Addison-Wesley Publishing Company, Inc., 1990.

———. *The Art of Computer Game Design.* N.p.: n.p., 1982.

———. *Understanding Interactivity.* N.p.: n.p., 2000.

Csikszentmihalyi, Mihaly. *Beyond Boredom and Anxiety.* San Francisco: Jossey-Bass, 1975.

———. *Flow: The Psychology of Optimal Experience.* New York: Harper & Row Publishers, Inc., 1990.

Curtis, Pavel, and David A. Nichols. *MUDs Grow Up: Social Virtual Reality in the Real World.* Palo Alto, CA: Xerox PARC. 1993.

Curtis, Pavel. *Mudding : Social Phenomena in Text-Based Virtual Realities.* Proc. of DIAC, 1992.

De Vos, Loes. *Searching For The Holy Grail: Images Of Interactive Television.* University of Utrecht, 2000. 10 Mar. 2002 <*www.globalxs.nl/home/l/ldevos/itvresearch/total.pdf*>.

Dibbell, Julian. "A Rape in Cyberspace." *The Village Voice* 38 (51) (21 Dec. 1993).

———. *My Tiny Life: Crime and Passion in a Virtual World.* Owl Books, Henry Holt Inc., 1998.

Donath, Judith S. "Identity and Deception in the Virtual Community." *Communities in Cyberspace.* Eds. Marc A. Smith, Peter Kolloc, and Ian Heywood. London: Routledge, 1998.

Duncan, Starkey. "Interaction: Face-to-Face." *International Encyclopedia of Communications.* Oxford, NY: Oxford University Press, 1989.

Fulk, J., J. Schmitz, and D. Ryu. "Cognitive Elements in the Social Construction of Technology." *Management Communication Quarterly* 8 (1995): 259–288.

Ghani, Jawaid A, and Satish P. Deshpande. "Task Characteristics and the Experience of Optimal Flow in Human-Computer Interaction." *Journal of Psychology* 128 (4) (1994).

Goertz, Lutz. "Wie interaktiv sind Medien? Auf dem Weg zu einer Definition von Interaktivität." *Rundfunk und Fernsehen* 4 (1995).

Greely, Dave, and Ben Sawyer. "Has Origin Created the First True Online World?" *Gamasutra*, Online Report (1997).

Grossman, Austin. "Thoughts on Interactivity and the Question of Content." *Loonygames* 1 (8) (Guest Editorial, 1998).

Hanssen, Lucien, Nicholas W. Jankowski, and Renier Etienne. "Interactivity from the Perspective of Communication Studies." *Contours of Multimedia: Recent Technological, Theoretical, and Empirical Developments*. Eds. L. Hannsen and N.W. Jankowski. Luton, UK: Luton University Press, 1996.

Hayes, Trevor. "Computer Games: They Got Game." *Las Vegas Review-Journal* 30 (Oct. 2000).

Heeter, Carrie. "Implications of New Interactive Technologies for Conceptualizing Communication." *Media Use in the Information Age: Emerging Patterns of Adoption and Consumer Use*. Eds. J. L. Salvaggio and J. Bryant. Hillsdale, New Jersey: n.p., 1989.

———. "The Look and Feel of Direct Manipulation." *Hypernexus: Journal of Hypermedia and Multimedia Studies* (Fall 1991).

Horton, Donald, and R. Richard Wohl. "Mass Communication and Parasocial Interactivity: Observations of Intimacy at a Distance." *Psychiatry* 19 (1956).

Huhtamo, Erkki. "From Cybernation to Interaction: A Contribution to an Archaeology of Interactivity." *The Digital Dialectic: New Essays on New Media*. Ed. P. Lunenfeld. Cambridge, MA: MIT Press, 1999: 96–110.

———. "Seeking Deeper Contact: Interactive Art as Metacommentary." orig. "Commentaries on Metacommentaries on Interactivity" *Cultural Diversity in the Global Village*. Eds. Alessio Cavallaro et al. Sydney, Australia: The Third International Symposium on Electronic Art, 1992: 93–98.

Huizinga, Johan. *Homo Ludens: A Study of the Play-Element in Culture*. Boston: Beacon Press, 1950.

Jensen, Jens. "Interactivity: Tracking a New Concept in Media and Communication Studies." *Computer Media and Communication*. Ed. Paul A. Mayer, Oxford, NY: Oxford University Press, 1999: 160–187.

Kay, Alan, and Adele Goldberg. "Personal Dynamic Media." *Computer Media And Communication*. Ed. Paul A. Mayer, Oxford, NY: Oxford University Press, 1999.

Kayani, J. M., C. E. Wotring, and E. J. Forrest. "Relational Control and Interactive Media Choice in Technology-Mediated Communication Situations." *Human Communication Research* 22 (1996): 399–421.

Kim, Amy Jo. "Killers Have More Fun." *Wired Magazine* 6 (5) (May 1998).

———. *Community Building on the Web: Secret Strategies for Successful Online Communities*. Berkeley, CA: Peachpit Press, 2000.

Koster, Raphael. "Declaring the Rights of Players." *Imaginary Realities* 3 (10) (Oct. 2000).

———. "Current and Future Developments in Online Games." *Imaginary Realities* 3 (9) (Sep. 2000).

———. *Video Games And Online Worlds as Art*. 1999. 26 Feb. 2002 <*www.legendmud.org/raph/gaming/games-as-art.html*>.

Landow, George P. *Hypertext: The Convergence of Contemporary Critical Theory and Technology*. Baltimore, MD: Johns Hopkins University Press, 1992.

Laurel, Brenda. *The Art of Human Computer Interface Design*. Ed. Brenda Laurel. Reading, MA: Addison-Wesley Publishing Company, Inc., 1990.

Lindert, Eli. "The Fox's Den – Online Psychology." *RPGPlanet* (Apr. 2000) 13 Jan. 2002 <*www.rpgplanet.com/features/editorials/fox_onlinepsych/*>.

Macdougall, Alan. "'And the Word Was Made Flesh and Dwelt among Us . . .': Towards Pseudonymous Life on the Internet." *M/C: A Journal of Media and Culture* 2 (3) (1999).

Maltz, Damir. "Customary Law and Power in Internet Communities." *Journal of Computer Mediated Communication* 2 (1) (Special Issue, June 1996).

Markus, M. L. "Finding A Happy Medium: Explaining the Negative Effects of Electronic Communication on Social Life at Work." *ACM Transactions on Information Systems* 12 (1994): 119–149.

McGuire, T. W., S. Kiesler, and J. Siegel. "Group and computer-mediated discussion effects in risk decision making." *Journal of Personality and Social Psychology* 52 (1987): 917–930.

McMillan, Sally. *Models of Interactivity From Multiple Research Traditions: Users, Documents, and Systems*. Unpublished paper. University of Tennessee, 2000.

Michael, David. *Designing For Online Communities.* Game Developer Network, Sep. 1999. 18 Feb. 2002 <*www.gamedev.net/reference/articles/article889.asp*>.

Morningstar, Chip, and F. Randall Farmer. "The Lessons of Lucasfilm's Habitat." *Cyberspace: First Steps.* Ed. M. Benedikt. Cambridge, MA: MIT Press, 1992.

Mulligan, Jessica. "Happy 30th Birthday, Online Games." *Happy Puppy* 8 (36) (Oct. 1999).

Murray, Janet H. *Hamlet on the Holodeck: The Future of Narrative in Cyberspace.* New York: The Free Press, 1997.

Nielsen, Jakob. *Designing Web Usability.* Indianapolis: New Riders Publishing, 2000.

Norlund, Jan-Erik. "Media Interaction." *Communication Research* 5 (2) (1978): 150–175.

Norman, Donald. *The Psychology of Everyday Things.* New York: Basic Books, Inc., 1988

Novak, Marco. "Liquid Architectures in Cyberspace." Cyberspace: First Steps. Ed. Michael Benedikt. Cambridge, MA: MIT Press, 1991.

O' Sullivan. *Key Concepts in Communication and Cultural Studies.* London: Routledge, 1994.

Oren, Timothy. "Designing a New Medium." *The Art of Human Computer Interface Design.* Ed. Brenda Laurel. Reading, MA: Addison-Wesley Publishing Company, Inc., 1990: 467–480.

Pavlik, John V. *New Media Technology: Cultural and Commercial Perspectives.* 2nd ed. Boston: Allyn and Bacon, 1998.

Poole, Steven. *Happy Trigger: The Inner Life of Videogames.* London: Fourth Estate Limited, 2000.

Preece, Jenny, Y. Rogers, H. Sharp, D. Benyon, S. Holland, and T. Carey. *Human-Computer Interaction.* Wokingham, UK: Addison-Wesley Publishing Company, Inc., 1994.

Rafaeli, Sheizaf, and Fey Sudweeks. "Networked Interactivity." *Journal of Computer Mediated Communication* 2 (4) (1997).

Rafaeli, Sheizaf, and Robert J. LaRose. "Electronic Bulletin Boards and the 'Public Goods' Explanation of Collaborative Mass Media." *Communication Research* 20 (2) (1993): 277–297.

Rafaeli, Sheizaf. "Interactivity: From New Media to Communication." *Advancing Communication Science: Merging Mass and Interpersonal Process.* Eds. R. P. Hawkins and J. M. Wiemann and S. Pingree. Newbury Park, CA: Sage, 1988: 110.

Reeves, Byron, and Clifford Nass. *The Media Equation: How People Treat Computers, Television, and New Media Like Real People and Places.* New York: Cambridge University Press, 1996.

Reid, Elizabeth. "Cultural Formations in Text-Based Virtual Realities." Diss. University of Melbourne, 1994.

Rheingold, Howard. *The Virtual Community: Homesteading on the Electronic Frontier.* New York: Addison-Wesley, 1993.

Rosenberg, Michael. *Virtual Reality: Reflections of Life, Dreams, and Technology. An Ethnography of Computer Science.* Unpublished paper, 1992.

Schroeder, Ralph. "Networked Worlds: Social Aspects of Multi-User Virtual Reality Technology." *Social Research Online* 2 (4) (1997).

Schroeder, R. (Ed.) *The Social Life of Avatars: Presence and Interaction in Shared Virtual Environments.* London: Springer-Verlag, 2002.

Sims, Roderick. "Interactivity on stage: Strategies for Learner-Designer Communication." *Australian Journal of Educational Technology* 15(3) (1999): 257–272.

———. "Interactivity: A Forgotten Art?" *Computers in Human Behaviour* 3 (1997).

Sproull, L., and S. Kiesler. "Reducing Social Context Cues: Electronic Mail in Organizational Communication." *Management Science* 32 (1986): 1492–1512.

Sterling, Bruce. "The Wonderful Power of Storytelling." Game Developers Conference, 1991.

Steuer, Jonathan. "Defining Virtual Reality Dimensions Determining Telepresence." *Journal of Communication* 42(4) (Autumn, 1992): 73–93.

Turing, A. M. "Can a Machine Think?" *Machines, Music, and Puzzles.* Ed. J. R. Newman. New York: Simon & Schuster, 1956: 2099–2123.

Turkle, Sherry. "Constructions and Reconstructions of Self in Virtual Reality: Playing in the MUDs." *Mind, Culture, and Activity* 1 (3) (Summer 1994)

———. *Life On The Screen.* New York: Simon & Schuster, 1995.

———. *The Second Self: Computers and The Human Spirit.* New York: Simon & Schuster, 1984.

Turow, Joseph. "Talk Show Radio as Interpersonal Communication." *Journal of Broadcasting* 18 (2) (1974): 171–179.

Utz, Sonja. "Social Information Processing in MUDs: The Development of Friendships in Virtual Worlds." *Journal of Online Behavior* 1 (1) (2000).

Van Dijk, Jan. *The Network Society: Social Aspects Of New Media*. London, Thousand Oaks CA, New Delhi: Sage, 1999. Rpt. Of *De Netwerkmaatschappij*. Van Loghum, Houten, Netherlands: Bohn Stoflen, 1991.

Walther, Joseph B. "Computer-Mediated Communication: Impersonal, Interpersonal and Hyperpersonal Interaction." *Communication Research* 23 (1) (1996).

———. "Relational Aspects of Computer-Mediated Communication: Experimental Observations over Time in Computer-Mediated Interaction." *Organization Science* 6 (2) (1995).

Watzlawick, Paul, Janet H. Beavin, and Don D. Jackson. *Pragmatics of Human Communication: A Study of Interactional Patterns, Pathologies, and Paradoxes*. Palo Alto, CA: WW Norton & Company, 1967.

Wilson, Stephen. *The Aesthetics and Practice of Designing Interactive Computer Events*. Visual Proceedings Art Show Catalog SIGGRAPH 93, 1993.

ABOUT THE CD-ROM

The CD-ROM included with *Online Game Interactivity Theory* contains selected demo versions of various popular applications and plug-ins, all relevant to computer game development in general or even explicitly meant for the design and creation of multiplayer online games. Most of these products have already been mentioned throughout the previous chapters and are thus directly related to all theories, concepts, and case studies we have covered in written word. Now it's time to investigate your applications of choice and see how they can assist you in your endeavors to design and implement immersive, interactive, and captivating (multi-player) game experiences.

CD-ROM FOLDERS

The CD-ROM's root contains a Read Me document covering legal notices and additional information and a digital version of this "About the CD-ROM" section. Next to these two files is the "Demos" folder that includes demo versions (for *Microsoft Windows*) of many popular game development applications, SDKs, tools, and plug-ins. You can find brief descriptions of each product and additional installation instructions in the *Installation* section of this appendix. Each application is set up in its own folder that occasionally contains additional files such as tutorials or documentation you might find useful while evaluating the respective program. In addition, there is a text file (Info_[Product Title].txt) in each demo folder outlining the demo's minimum system requirements. Look at this file before running your demo of choice to see if your system meets a program's particular requirements.

SYSTEM REQUIREMENTS

In each demo folder is a raw text file describing the application's minimum system requirements in detail. Please refer to this information to ensure that your system meets the necessary hard and software requirements. For plug-ins, also be sure you have the according application installed on your system.

Here is the overall system requirements needed to run everything on the CD-ROM:

- Intel Pentium processor (class III recommended)
- Microsoft Windows 98, Windows 98 Second Edition, Windows Millennium Edition, or Windows 2000
- 128MB RAM (192MB recommended)
- Hard drive/CD-ROM drive
- Video display card supporting 1024 x 768 x 16-bit color or greater

INSTALLATION

To use the items on the CD-ROM, select the folder you want to use and then select the according files. Again, please make sure that your system matches at least the minimum system requirements to run these files by checking the accompanying text file (Info_[Product Title].txt) of the demo in question. Each demo is provided as an executable setup file or self-extracting installation archive and has its own installation instructions. If you encounter any problems installing the demos, please contact the developer directly.

Following is a brief overview of what you will find on the CD-ROM. If you are further interested in a special product and are ready to install it on your system you should consult the digital, extended version of this section provided on the CD-ROM: "About the CD-ROM.doc." This MS Word document contains detailed descriptions of each program, installation instructions, and contact information.

- **3D Gamestudio/A5** (Conitec Corporation)
 - [Demos\3DGamestudio\gsdemo.exe]
 - 3D Gamestudio is an authoring environment uniting 2D and 3D engine, a map and model editor, a proprietary C-style program-

ming language, and a set of libraries containing 3D objects, artwork, and pre-made games.

- **Adobe Atmosphere beta** (Adobe Systems, Inc.)
 - [Demos\Atmosphere\Atmosphere_Full.exe]
 - Adobe *Atmosphere* lets you author and create virtual 3D worlds for the Web.

- **Adobe Photoshop 6.0** (Adobe Systems, Inc.)
 - [Demos\Photoshop 6.0\ AdobePS6Tryout.exe]
 - Adobe Photoshop 6.0 is the standard software for professional image editing.

- **Alchemy ArtistPack** (Intrinsic Graphics, Inc.)
 - [Demos\Alchemy Artist Pack\3ds max\ArtistPackMaxv2-0r0315.exe]
 - [Demos\Alchemy Artist Pack\Maya\ ArtistPackMayav2-0r0315.exe]
 - ArtistPack—A subset of Intrinsic Graphics Alchemy middleware platform. Lets artists design the visual assets in the modeler and use the tool's real-time viewer that will show exactly how the art will be in the game engine before exporting.

- **AniMeter Tuner** (LIPSinc)
 - [Demos\Animeter Tuner\animetertuner100.exe]
 - LIPSinc's AniMeter is a batch processing application that takes audio files and automatically creates appropriate facial animation data complete with eye blinks, head nods, and lip synchronization.

- **Auran Jet 1.0** (Auran)
 - [Demos\Auran Jet\Auran_Jet_Demo.exe]
 - Auran Jet is a 3D development environment and engine designed for creating a variety of 3D applications in compressed timeframes.

- **Avatar Lab** (Curious Labs, Inc.)
 - [Demos\Avatar Lab\AvatarLabTrialSetup.exe]
 - Avatar Lab allows you to create custom, unique articulated 3D characters for use in online environments implemented via Adobe Atmosphere.

- **Cluster-O-Matic 1.0 for 3ds max** (Di-O-Matic, Inc.)
 - [Demos\Cluster-O-Matic\COM_Demo3.exe]
 - [Demos\Cluster-O-Matic\COM_Demo4.exe]
 - Cluster-O-Matic for 3ds max is a tool designed to assist you in working with complex animations and selections in the production environment.

- **Conveyor 1.0 RC1** (Quazal)
 - [Demos\Conveyor\ ConveyorSetup.exe]
 - Quazal Conveyor is a cross-platform message-passing toolkit that offers a simple method to networking and porting a multiplayer game.

- **Discreet gmax 1.1** (Autodesk, Inc.)
 - [Demos\gmax\gmaxinst_1-1.exe]
 - This is the free version of Discreet's gmax, a free content creation platform designed to let gamers create custom art and assets for their favorite titles.

- **Eterna 1.0** (Quazal)
 - [Demos\Eterna\ EternaSetup.exe]
 - Eterna is a scalable, fault-tolerant infrastructure for the development of massively multiplayer games with up to 100,000 simultaneous players.

- **FaceGen Modeller 2.0** (Singular Inversions)
 - [Demos\FaceGen Modeller\sifgm202.exe]
 - FaceGen Modeller is a stand-alone Windows application for parametric 3D human face modeling based on statistics of real human faces.

- **Life Forms Studio 3.9** (Credo Interactive, Inc.)
 - [Demos\Life Forms Studio\lf39Demo_Win.exe]
 - Life Forms Studio is a 3D software package dedicated to character animation and lets you easily create and edit character motion or animate bipeds, quadrupeds, or sea brine.

- **Macromedia Director 8.5 Shockwave Studio** (Macromedia, Inc.)
 - [Demos\Director\director851_trial_en.exe]
 - Macromedia Director 8.5 Shockwave Studio is a vigorous authoring environment to develop rich content for the Web, CD-ROM, or DVD.

- **Macromedia Flash MX** (Macromedia, Inc.)
 - [Demos\Flash MX\flashmx_trial_en.exe]
 - Macromedia Flash MX—the latest version of the Macromedia Flash development environment—offers you a very powerful framework to create a broad range of content and applications particularly, but not exclusively, suited for the Internet.

- **Mimic 1.0 for Poser** (LIPSinc)
 - [Demos\Mimic\mimicevaluation.exe]
 - Mimic for Poser is a voice analysis system that automatically generates the timing and lip position data for the animator using Curious Labs' character animation tool Poser.

- **Morph-O-Matic 1.02 for 3ds max** (Di-O-Matic, Inc.)

 - [Demos\Morph-O-Matic\MOM_Demo_R3.exe]
 - [Demos\Morph-O-Matic\MOM_Demo_R4.exe]
 - Morph-O-Matic—a morphing plug-in for 3ds max—is designed to aid the designer in creating facial, hand, and other morph animations from within the production environment.

- **Net-Z 2.5 Beta 1** (Quazal)
 - [Demos\Net-Z\ NetZSetup.exe]
 - Quazal *Net-Z* is a high-level game state engine for developing and deploying multiplayer games.

- **Poser Pro Pack** (Curious Labs, Inc.)
 - [Demos\Poser Pro Pack\Pro Pack Demo Setup.exe]
 - The Poser Pro Pack is an extension to Curious Labs' popular 3D character animation tool Poser 4 that provides a set of plug-ins enabling you to host Poser scene files inside 3ds max and LightWave.

- **Visual Intercept Enterprise** (Elsinore Technologies, Inc.)
 - [Demos\Visual Intercept\ viee152elsi.exe]
 - Visual Intercept is an incident management system and project-oriented bug-tracking tool for developers using Microsoft productivity tools.

- **Vue d' Esprit 4** (e-on software, Inc.)
 - [Demos\Vue d'Esprit 4\Vue4WebDemo.exe]
 - E-on software's Vue d' Esprit 4 is a 3D graphics package dedicated to the creation, rendering, and animation of realistic and natural 3D scenery.

- **WildTangent Web Driver 2.2 SDK** (WildTangent, Inc.)
 - [Demos\Web Driver SDK\WD_2_2_SDK.exe]
 - The WildTangent Web Driver SDK provides a full development architecture to create multimedia (3D) Web applications that users can access via the Web Driver plug-in using every standard Internet browser.

- **WildTangent Multiplayer Toolkit 1.0** (WildTangent, Inc.)
 - [Demos\Web Driver SDK\MultiplayerToolkit.exe]
 - This toolset is an abstraction layer for adding multiplayer functionality to your Web Driver games, giving you access to multiplayer functionality via a range of possible multiplayer modules.

INDEX